Constable

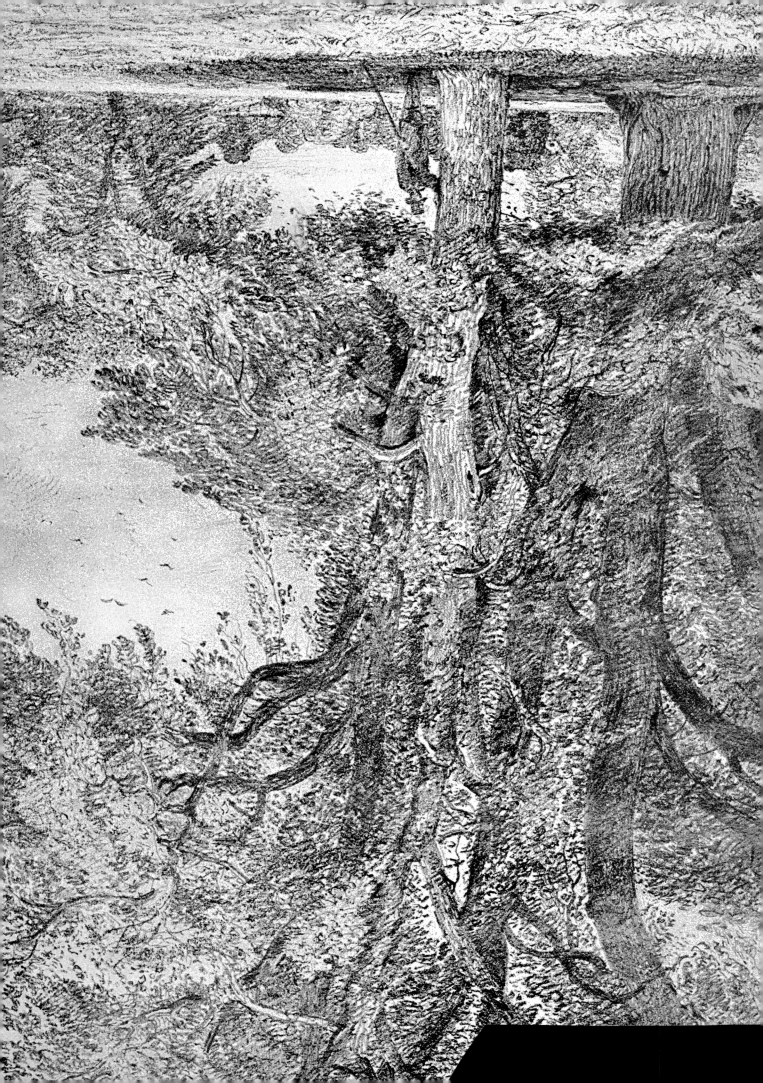

The Tate Gallery 1976

CONSTABLE
PAINTINGS, WATERCOLOURS & DRAWINGS

Leslie Parris
Ian Fleming-Williams
Conal Shields

Exclusively distributed in France and Italy by Idea Books
46–8 rue de Montreuil, 75011 and Via Cappuccio 21, 20123 Milan

ISBN 0 905005 15 5 paper 0 905005 20 1 cloth
Published by order of the Trustees 1976
for the exhibition of 18 February–25 April 1976
2nd edition, March 1976 ; reprinted with further revisions, April 1976
Copyright © 1976 The Tate Gallery
Designed and published by the Tate Gallery Publications Department,
Millbank, London SW1P 4RG
Blocks by Augustan Engravers Ltd, London
Colour separation by Adroit Photo Litho Ltd, Birmingham
Printed in Great Britain by Balding & Mansell Ltd, Wisbech, Cambs.

Contents

6 Colour Plates

7 Foreword *Sir Norman Reid*

9 Preface *Leslie Parris*

13 Constable and the Critics *Conal Shields*

29 **Catalogue** *Leslie Parris & Ian Fleming-Williams*

31 Background: The Constable Family and East Bergholt

35 John Constable 1776–1837

191 Friends and Followers

197 Supplement

201 Map of the Area around East Bergholt

202 Constable Family Tree

203 Notes and References

206 Additional Notes

207 Lenders

208 Acknowledgements

Cover/Jacket
Front: John Constable, *Hampstead Heath*, *c.* 1820
(detail of catalogue No.187)
Back: Daniel Maclise, *Constable Painting*, ?1831
(catalogue No.285a)

Frontispiece
John Constable, *'Elms'* (*in Old Hall Park, East Bergholt*), 1817
(detail of catalogue No.156)

Colour Plates

opposite page

32 *The Valley of the Stour c.1805 (No.55) detail*
33 *The Stour Valley 1805 (No.46)*
48 *A Lane near East Bergholt with a Man Resting 1809 (No.90)*
49 *Flatford Mill from the Lock c.1810–11 (No.96)*
64 *'Dedham Vale: Morning' exh.1811 (No.100) detail*
65 *Golding Constable's Kitchen Garden 1815 (No.135) detail*
80 *Osmington Bay ?1816 (No.147)*
81 *'Scene on a navigable river' (Flatford Mill) exh.1817 (No.151) detail*
112 *'Portrait of the Rev. J. Fisher' exh.1817 (No.152) detail*
113 *'Landscape: Noon' (The Hay-Wain) exh.1821 (No.192) detail*
128 *Sunset Study of Hampstead Heath, looking towards Harrow 1821 (No.195)*
129 *Full-size Sketch for 'The Leaping Horse' 1824–5 (No.236) detail*
160 *'Chain Pier, Brighton' exh.1827 (No.247) detail*
161 *'Landscape' (Dedham Vale) exh.1828 (No.253) detail*
176 *Sketch for 'Hadleigh Castle' c.1828–9 (No.261) detail*
177 *'Stonehenge' exh.1836 (No.331) detail*

Foreword

The bicentenary of Constable's birth comes at a time when his life and works are being more widely studied and in greater depth than ever before. It is appropriate, therefore, that this exhibition should be not simply a bicentenary tribute to a great artist but also an opportunity to reassess his work in the light of current scholarship. We have brought together a wide range of material for this purpose, unfamiliar items as well as the best-known of his works. Several major pictures which we would have liked to have seen at the Tate Gallery on this occasion have not been available, either because of conditions governing their ownership, or because of their state of conservation, or for other reasons. Nevertheless, we have been able, I believe, to present the largest and most comprehensive body of work ever seen in a Constable exhibition. This has been possible only through the great kindness of many private and public owners throughout the world, who have responded to our requests with a generosity we hardly dared hope for. A list of lenders will be found at the end of the catalogue but I would like to mention our particular gratitude to those who have made possible a special feature of this exhibition: the inclusion of nearly all the works which Constable himself exhibited that can still be identified. For the first time it is possible to see under one roof that marvellous sequence of 'set-pieces' that runs from the 'Dedham Vale' of 1811 to 'Arundel Mill and Castle' of 1837. I should also like to express our deep gratitude to those who have lent large or important groups of works from their collections, including the Executors of Lt. Col. J. H. Constable, Mr and Mrs Paul Mellon, the Trustees of the British Museum, the Fitzwilliam Museum, the J. G. Johnson Collection, Philadelphia, the Royal Academy of Arts, and the Victoria and Albert Museum. To the latter institution we owe our largest debt of all, but I am happy to say that, even after giving up more than eighty items to us, enough remains of the Victoria and Albert Museum's Constable collection for a complementary display to continue there during the period of our own exhibition.

The items in this exhibition have been selected by Leslie Parris, Deputy Keeper of the British Collection at the Tate Gallery, Ian Fleming-Williams, and Conal Shields, Head of the Department of Art History and Allied Studies at the Camberwell School of Art and Crafts. The design of the exhibition is by Ruth Rattenbury, Assistant Keeper in the Department of Exhibitions and Education at the Tate Gallery, and that of the catalogue by Pauline Key of the Publications Department. Some of the research for the catalogue was undertaken by Judy Egerton, Research Assistant in the British Collection. Further acknowledgements appear at the end of the catalogue but at this point I must mention the considerable help we have received from the staffs of the galleries and museums contributing to the exhibition, and from several people outside the museum world, notably Professor Charles Rhyne and Colonel C. A. Brooks. We are also greatly indebted to the following for helping to trace the whereabouts of paintings and drawings and, in many cases, helping to secure their loan: Thomas Agnew & Sons Ltd; John Baskett Ltd; Christie, Manson & Woods Ltd; P. & D. Colnaghi & Co. Ltd; Richard Green

Ltd; Hazlitt, Gooden & Fox Ltd; Oscar and Peter Johnson Ltd; Leger Galleries Ltd; Leggatt Brothers; Manning Galleries Ltd; Sotheby & Co.; Arthur Tooth & Sons Ltd. Extracts from Farington's Diary are quoted by gracious permission of Her Majesty the Queen.

NORMAN REID, Director

Preface

Some of the exhibitions of the work of older British artists which the Tate Gallery has organised in recent years have been as definitive as any exhibition is likely to be. With Constable, however, this sort of summing-up is not yet possible. While he may be the best-loved of British artists, he cannot be reckoned the best-known. Two hundred years after Constable's birth we still have much to learn of, and about, his work. Less than half his exhibits at the Royal Academy and other institutions have so far been identified (and the works he himself exhibited, it is reasonable to suppose, were the ones he considered his best efforts); surprising numbers of paintings and drawings in private collections remain unknown to students in the field, let alone anyone else; problems of authenticity and dating abound. For this sort of reason, the present exhibition must be very much in the nature of an exploration. What we have tried to do, in fact, is to track Constable through his works year by year (oddly, something not attempted in previous Constable exhibitions), using a high proportion of dated examples to find the way, and drawing on as wide a range of material as possible. In doing this, one thing becomes immediately apparent: Constable's course was by no means straightforward – not all roads led, say, to 'The Hay Wain'. At any one time we may find him pursuing a variety of interests. 1822, for example, was not only the year of the famous 'pure' sky studies but also the year when he produced a five-foot altarpiece for an Essex church, exhibited a painting of a country house and made two copies of an obscure eighteenth-century portrait of a lady in oriental costume. In 1823 he sent 'Salisbury Cathedral, from the Bishop's grounds' to the Academy but also set about copying Claude and Cozens. The 'natural painter' can be discovered in, what may seem at first, strangely unnatural positions.

A chronological survey also suggests that Constable's pace, especially in the early part of his career, was far from constant. For some years very little work is known, for others a great deal. 1803 and 1804, for instance, seem to have been rather unproductive, whereas 1805 and 1806 look like a time of rapid progress, followed again by a slacker period in 1807–8. To some extent, of course, this fitfulness may be more apparent than real – the result of work not having survived or, at least, not having been identified. 1806 has long been recognised as a time of activity because so many of the watercolours Constable made on his only visit to the Lake District that year have come down to us, yet, as we try to show in the exhibition, an impressive group of watercolours, not much noticed before, can be associated also with 1805, which previously may have looked a comparatively lean time. All the same, it is difficult to feel that Constable's output was ever very constant, and his better documented later years tend to bear out this impression.

Another characteristic of Constable's art which this survey may point up is the complexity of his working methods. Very rarely were his 'set-pieces' the result of any direct or short sequence from preliminary study to final canvas. Frequently the initial idea came from a drawing or oil sketch made a number of years before, which was taken up, elaborated by means of further studies

and perhaps tried out and modified again in a full-size sketch before being transferred to the final canvas. The whole process might take many years and even then not be complete. Constable annoyed more than one patron by trying to get back and rework a picture he had already sold. In many cases he gave his compositions a further lease of life by repeating them, sometimes as close replicas but often as distinct variants: Morrison's 'Lock' picture of 1824 (see No.227) was perpetuated in both ways. Comparison of the various versions and replicas included in the present exhibition may tell us more about this aspect of Constable's practice, and possibly more about the role of Johnny Dunthorne, his studio assistant for five years during the 1820s. Also included in the exhibition are one or two groups of outdoor oil sketches which show Constable working several times from the same motif within a fairly short period of time. They may suggest that his procedures out of the studio were not straightforward either – that 'nature' was not to be grasped by a rapid gesture here and there. What actually *was* painted on the spot rather than in the studio is one of the largest questions of all, and one prompted by a number of the items in this exhibition.

Another question which anyone attempting to pursue Constable must frequently ask himself is whether he is really on the right track at all. There are many misleading signs. At the end of the nineteenth century Robert Leslie (son of Constable's first biographer) estimated that there were probably then in existence more forgeries of Constable than genuine works by him. In the final section of the exhibition we suggest that there is in fact a whole range of work by other people which, for one reason or another, looks more or less like Constable's own. As well as outright deceptions, we have to contend with the genuine productions of Constable's family, friends and followers, none of whom has ever been properly investigated.

Some of our present difficulties will no doubt be resolved – indeed, many already have been – by study of the vast amount of documentary material which has been made available during recent years, chiefly through the labours of the late R. B. Beckett. Constable's correspondence, now published in something like its entirety, makes possible not only, say, the more accurate dating of particular works or the detailing of certain commissions: it helps us to see, as never before, what sort of person Constable really was, and what were his motivations as an artist. Much use has been made of this new material in our catalogue entries and in the biographical summaries which introduce each year – these summaries may convey a sense of the continual interplay in Constable's life between art and other concerns. The catalogue also draws upon other sorts of material only lately available. Recent topographical re-searches, for example, have identified many more of the sites where Constable painted, and this sort of information can lead to more than just a correct title for a work. Constable's correspondence often suggests what meaning he attached to particular spots – why, in fact, he painted them at all. The newly identified views of East Bergholt Rectory (see Nos.83, 93 and 120) are a striking illustration of this.

Walking through the exhibition itself we may be able to form a more general idea of the meaning Constable attached to his subject-matter and of the variety of uses to which he put it. Many subjects recur at intervals through the exhibition and we should watch out for their transformations – for the state of disrepair into which Constable allows Flatford lock to fall in the 1820s (something his brother Abram, responsible for the upkeep of the actual lock, would never have permitted), for Constable's gradual translation of the pleasant lime-washed house of Willy Lott into the sinister, rambling place seen in the 1835 'Valley Farm', or for the increasingly dramatic weather experienced at Constable's Salisbury (a dark cloud, chased off by the Bishop, in 1823, but the full

works, storms and rainbows, by 1831). Such things may tell us much about the needs of Constable's imagination.

Transformations of another sort might be involved as Constable worked from his private studies towards what he wanted the public to see and buy. In this exhibition we have made a physical division between the paintings and drawings which he himself exhibited and the other material (which does, however, include some 'finished' works that never reached exhibitions). The two sequences run parallel through most of the display and they should allow us to see both what was Constable's public image at any one time and what was his more private face. This division has also been made so that attention can more clearly be focussed on the works which were the basis of his contemporary reputation, a subject not inappropriate to this bicentenary occasion when his reputation will doubtless be again debated. While we do not present the 'complete Constable' in this exhibition, the works brought together here will, we hope, stimulate a new and fuller assessment of this master of the art of landscape.

LESLIE PARRIS

Note to the Second Edition
After the first edition of this catalogue went to press, several new items were added to the exhibition. Brief catalogue entries on these appear in a Supplement at the end of this second edition. We have also taken the opportunity to make many small corrections and amendments, some resulting from the examination of works as they arrived at the Tate Gallery, others from friendly observations made by visitors to the exhibition.

L.P.

Constable and the Critics

Nearly, if not quite, all Constable enthusiasts will be surprised to learn that the reputation of the artist has undergone marked change during the hundred and eighty years odd since he took to the brush.

He stalks the literature of landscape both above and below criticism – and is the subject of contention, too. At one period he was, seemingly, negligible if not downright vicious and at another of compelling interest and unimpeachable high merit. Different but contemporaneous critics thought him very good and very bad, on occasion for opposed reasons. Regard, moreover, has swayed to and fro rather than moved steadily forward. There are still those for whom Constable is a blank spot in the record of English Art.

While much of the admonition and eulogy is straightforward, a significant amount of it wants analysis of a kind, a range and flexibility, so far beyond us. We are today unsure of the expectations which Constable, through his career and even after, met or could not satisfy. We can readily see that the Constable of French puffs and prickles was unlike the Constable (or should I say 'Constables') of his native land: we can explain this only in the most vacuous of terms.

'The feild of Waterloo', wrote Constable of the art scene 'is a feild of mercy to ours' (JCC VI p.108, 1 February 1823). However, the inner life of artistic battles, the manoeuvres of the cognoscenti, the social, economic and, perhaps, political motivation of art journalism, remain obscure. Adverse comment is, too often, dismissed as the product of 'personal vendetta' and praise left hanging in the air. To glance at Constable's fortunes is indeed salutary.

Constable's wish to become an artist – a professional artist – was, on available evidence, fairly easily accepted by his family, but for long years there were worries about just what he should do and how do it, about his progress along a route which was known to be risk-strewn. In 1799, when Constable received permission from his father to study art, a young hopeful by the name of Salt consulted the eminent Academician Farington and was told:

> portrait painting undoubtedly offers more certain employ than any other branch . . . Landscape painting is not so much encouraged as it has not the advantage of being supported by self-love . . . there is a sort of Landscape *Portrait* Painting by which a good deal of money is got, viz: painting views of Houses &c. but where the picture will only be purchased for its intrinsic merit few will be found to command an income.

Though from the start Constable meant to concentrate on landscape of 'intrinsic merit', he tackled portraits, country house views – and religious art, too. The returns were meagre. Surely, he felt a need to justify his secession from the family business, which business, until Constable was forty-four provided the hard-core of his livelihood. We can detect diplomatic effort at many points, and a ceaseless sensitivity to adverse comment, eventually amounting to a species of paranoia, is traceable to the doubts of close relatives. The most vocal counsellor among the Constable kin, David Pike Watts, an uncle, proffered a barrage of abuse with a slight sweetening. In 1810, after an hour's

George Barret, **Burton Constable Hall,** 1777 (Coll. Mr & Mrs J. Chichester-Constable)

John Constable, **Feering Parsonage,** 1814 (whereabouts unknown)

meditation, Mr Watts wrote to Constable of his altarpiece for Nayland Church:

as a *Whole* the Picture has strong claims to praise. It is a fine Work impressively conceived, well designed, & the Attitude is suitable to the subject. There is no impropriety or deviation from the religious character of the Piece – its *Effect* at due point of distance is good and it strikes the beholder with satisfaction & serious contemplation. (JCC IV p.20, 24 November)
　　Yet...

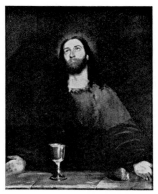

John Constable, **Christ Blessing the Sacraments**, 1810 (St. James's Church, Nayland)

Yet. Mr Watts went on to twenty-five remarks, the burden of which is that Constable lacked fundamental skills in drawing and handled a brush ineptly.

It is scarcely justifiable for any *Picture* to be shewn so *raw*, unless a Testimony was affix'd that the Artist died before he could finish it; no other excuse can reconcile a Picture being affix'd for Public View in so uncultivated a state.

Mr Watts must have made his thirty-four years old nephew wince. The chief criticism – of sketchiness, crudity – was to be frequent. And this, though little considered by scholars, touches Constable's art in a vital way. Rather than superficial polish, his very conception and realisation of form and texture, his grip on the world he painted, is the issue and, whether or no friends and enemies could see it, Constable did. Mr Watts in a letter of 1814 was close to the issue's heart:

What is any thing *unfinished*? It is as it were *Nothing* because a Thing does not exist as a Whole, that is incomplete. (JCC IV p.37, 12 April)

From letters and anecdotes we gain, quite soon, the image of a man intent on a decent living *and* more and more determined to develop a personal vision. Before Constable's day the idea that art's 'utility' and the expression of individual need might, let alone must, be at variance and perhaps mutually conflict was freakish: towards the latter end of the eighteenth century the apprentice system gave place to art-school training, the face-to-face artist/patron relationship was tempered by a new open market, the number of artists multiplied beyond public support, and the notion of 'private' art gained ground. Constable, constantly preoccupied with tradition and an outstandingly self-conscious creature, experienced to a painful degree the pushes and pulls of the period. His first biographer, C. R. Leslie, says:

I have often observed with surprise, how readily Constable would make alterations in his pictures by the advice of persons of very little judgement. (*Memoirs* . . . 1843 p.70)

Joseph Farington, **'Study from nature'**, *c.*1806 (whereabouts unknown)

But we know numerous instances of Constable's refusal to toe some other party's line. When, in 1834, the collector Vernon enquired if a picture were done for any particular person, Constable proudly and drily said:

Yes sir, it is painted for a *very particular person*, – the person for whom I have all my life painted. (*Memoirs* . . . 1845 p.262)

In 'whatever related to painting', Constable once declared, he was 'an Egotist'.

From his contacts with Joseph Farington we can discern the usual bounds of Constable's expediency and begin to identify the character of his 'egotism'. Farington was a mediocre landscapist (a pupil of Wilson). By dint of persistent machination he had got to the top in art politics and was rightly dubbed 'the Dictator of the Academy'. His *Diary* (1793–1821) is *the* great source of art gossip. Constable was introduced to Farington in 1799. He was thence an assiduous attendant, calling, especially, or requesting a visitation before the British Institution or Royal Academy exhibitions. Farington told him which of his works should be shown, which left aside, and, loftily, gave general advice. The tenor of the advice, over two decades, was that Constable ought to pay more attention to the Old Masters and – an insistent note here – to the final aspect, the 'finish', of his canvases. 'Constable I called on', he wrote (3 April 1809)

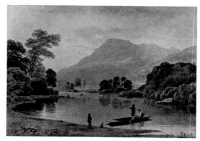

R. R. Reinagle, **'Loughrigg Mountain and River Brathay, near Ambleside – Sun-set'**, 1808 (Tate Gallery)

& saw the pictures intended for Exhibition. I gave my opinion against His Exhibiting His largest picture, 5 feet wide, a scene in Borrodaile as being in appearance only like a preparation for finishing, wanting variety of colour & effect.

The 'Borrodaile' – Constable's most ambitious piece to date – stayed at home. On a solitary occasion, which probably shook him, Constable was 'recommended' to

imitate nature & not to be affected by loose remarks of critics.

John Constable, **'Bowfell and Langdale Pikes'**, 1806 (Executors of Lt. Col. J. H. Constable)

Constable felt some regard for his mentor, from whom he could always procure a neat *résumé* of gentlemanly attitudes, but a lot of this must have irritated. And Farington reports several jibes at colleagues which Constable may well have silently aimed at him:

He said he had been much discouraged by the remarks of Reinagle &c though he did not acknowledge their justness. He said . . . They look only to the surface and not to the mind. The mechanism of painting is their delight. (9 March 1801)

We glimpse behind the tart responses to his fellows the matter of Constable's own activity:

He told me he had seen Calcott's large picture "Return from the Market". He said it was a fine picture, but treated in a *pedantick manner*, every part seeming to wish to shew itself; that it had not an air of *nature*; that the trees appeared crumbly – as if they might be rubbed in the hand like bread; not loose and waving, but as if the parts if bent would break; the whole not lived like Wilson's pictures, in which the objects appear floating in sunshine. (13 March 1807)

Farington puts it down and remains blind. The most notable feature, indeed, of Farington's record of these meetings is the total absence of a concern with Constable's aims and a consequent failure to notice his peculiar accomplishments. Farington was thoroughly familiar with conventional landscape practice, past and present, and in a privileged position to distinguish between calculated departure from it and mere hamhandedness. And he could only chastise Constable for his heroic attempts to check out the formulae, to try receipt against individual vision, to evoke a freshly intense awareness of nature.

I talked to him about his proceeding in art and recommended him to study nature & particular art less

writes Farington, laconically, in 1802 (7 April): Constable had just decided to expose himself with the most open mind possible to his native scenery. Nine years later:

I called upon Constable to see the painted Studies (Landscapes from nature) which He made in the Country during the autumn. I recommended to Him as He had been studying particular appearances, now to think of Atmosphere and general effect. (17 December 1811)

Between each entry lies a transformation. In front of Farington that December were the proofs of an intelligence more finely tuned to certain *minutiae* of the natural world – the precise configuration of tree against sky, tonal and colouristic balance, textural play – than was any bar that of Turner. They left Farington cold.

We hear – rather distantly – during the second decade of the century of approval. Farington, however, is silent about the reasons for it, and Constable's confidence in his audience did not increase apace. But the exhortations to tidy his canvases seem mainly to have been ineffective and this suggests that Constable's estimate of Constable was favourable. On 16 June 1819, Farington 'spoke to Constable' about the business of 'finish': and on 29 June

John Constable, **Dedham Vale**, *c.*1810 (Tate Gallery)

He brought a small landscape . . to shew me that he had profited by my remarks.

[15]

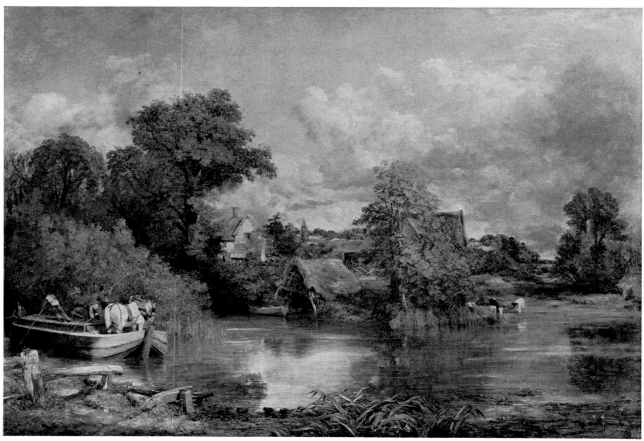

John Constable, **The White Horse**, 1819 (Frick Collection, New York)

Was this a sop to a sap?

Upon a wall of the Royal Academy, as Farington, ill in bed, wrote thus, hung 'The White Horse' (probably the subject of the 16 June entry). It was large ($51\frac{3}{4} \times 74\frac{1}{8}$ inches), extravagant in the range of greys and greens and earth-colours, furiously rich in handling. It was Constable's major effort so far to build from the mass of his fine percepts a general statement about the countryside and the natural life. It may have been for this that Constable devised the six-foot 'sketch', a uniquely comprehensive trial-run, a total novelty in landscape practice. C. R. Leslie calls 'The White Horse' 'too large to remain unnoticed' and says it 'attracted more attention' than any previous Constable picture. Constable cannot have entirely trusted the response. 'The White Horse' was bought, as a gesture of support he could ill-afford, by the dearest of the artist's friends, Archdeacon Fisher: and though in November, at the age of forty-three and after eleven years of pushing, Constable became an Associate of the Royal Academy – a title commonly believed to guarantee respectability and sales – nobody else, to the best of our knowledge sought it. The sequel, 'Stratford Mill (The Young Waltonians)', which Constable, seemingly, regarded as the representative work of mid-career, went also to Fisher. Once, Farington tells of Constable's delighted arrival with a newspaper containing a generous review of his work. Did Constable for a moment feel the shackles of direct patronage loosening and gaze hopefully at the open-market? If so, the moment must have quickly passed.

Art journalists, lurking in the shadows of an increasingly chaotic situation tried to identify new tastes and to reconcile them with their antecedents, tried to legislate: but the task proved impossible until Ruskin, virtually solo, could

reconstruct the vocabulary and grammar of critical discourse. Guess paraded as conviction while bets were hedged.

'I beg to congratulate you upon the appearance of your name in the newspapers,' wrote Archdeacon Fisher,

> Do not despise them *too* much. They cannot give you fame, but they attend on her. (12 February 1824)

Even this modest claim went awkwardly with Constable's vicissitudes.

The earliest discoverable newspaper reference to Constable is bland enough.

> No. 52. *View in Westmoreland* . . . This artist seems to pay great attention to nature and in this picture has produced a bold effect. We are not quite so well pleased with the colouring of No.98, *Keswick Lake*, in which the mountains are discriminated with too hard an outline. (*St. James's Chronicle*, 7 May 1807)

What are the criteria here? We should, some may suppose, be able to deduce them from the praise and dispraise attached to a sample of pictures over a period. But, alas, in the absence of contextual information, the terms employed are opaque and consistency is far from obvious.

We come across, intermittently, an indication of the *loading* given landscape by a journalist. The *Examiner*, 9 May 1815, for example, characterises the time of year: the reader should recollect

> that May does not properly commence till the day marked in the calendar as Old May Day. This throws the latter part of the month into June, and singularly warrants the ideal season chosen by Thomson as the proper one for his Castle of Indolence,
>
> A season *atween* June and May,
> Half prank'd with spring, with summer half-embrown'd
>
> Towards the end of the month, indeed, as it stands at present, if a very great blight does not occur, the treasures of summer are almost all laid open. The grass is in its greenest beauty; the young corn has covered the more naked fields; the hedges are powdered with the snowy and sweet-scented blossoms of the hawthorn, as beautiful as myrtle flowers; the orchards gives [sic] us trees, and the most lovely flowers at once; and the hedge-banks, woods, and the meadows, are sprinkled in profusion with the cow-slip, the wood-roof, the orchis, the blue germander, the white anemone, the lily of the valley, the marsh-marygold, and the children's favourites, daisies and buttercups, whose colours start in an instant to one's mind. The dragon-fly carries his long purple-shining body along the air; the butterflies enjoy their merry days; the bees send out their colonies; the birds sing with un-wearied love, while their partners are sitting; the later birds of passage arrive; the cattle enjoy the ripe and juicy herbage, and overflow with milk; most of the trees complete their foliage, filling the landscape with clumps and crowning woods, that "bosom" the village steeples; the distance echoes with the cheerful hark of the dog; the ladies are abroad in their spring dresses; the farmer does little, but leisurely weed his garden, and enjoy the sight of his flowering industry; the sun stops long, and begins to let us feel him warmly; and when the vital sparkle of the day is over, in sight and sound, the nightingale still continues to tell us its joy; and the little glow-worm lights up her trusting lamp to show her lover where she is.

And so forth. Poppies get a line from Shakespeare, the lily and rose a line from Spenser and Alamanni apiece. It might encourage us to assume that there was abroad the consciousness of seasonal shift which led the gentleman amateurs of science, like Gilbert White, to annotate their *Naturalist's Calendars*. But the passage comes from a country note and not from the arts pages, and there is hardly a sign of such stuff elsewhere. We read a thing is 'like'

nature but the conjunction is not detailed. And the linking of art and literature can be questionable. The *Examiner* (again) was pleasantly disposed to Constable and very hard on Wordsworth. Attacking *Peter Bell*, it rudely mimicked the poet:

> It has been my aim and my achievement to deduce moral thunder from buttercups, daisies, celandines . . . Out of sparrow's eggs I have hatched great truths, and with sexton's barrows have I wheeled into human hearts, piles of the weightiest philosophy.

The idea of a grand moral, an intellectual, sense of nature was laughable. We ought to remember, when a critic has kind words for Constable, landscape painting did not rate highly in the hierarchy of artistic *genres*.

After 1815 or so, Constable's name figures fairly regularly in the newspapers and praise grows. We may search to no purpose, though, for recognition of his novelties – the diffusion of interests, the calculated anti-climaxes at usual *focii* and the dramatisation of 'accessories', the sheer imaginativeness of his equivalences to natural phenomena. A simple opposition of earlier art and Constabelian innocence, the eye of 'a Faun or a Sylvan', does duty for critical sophistication. Did reviewers really think Constable merely looked and merely saw?

> *Scene on the River Stour* [*The White Horse*]; . . . – What a group of every thing beautiful in rural scenery! This young artist is rising very fast . . . and we do predict, that he will anon be at the very top of that line of the art . . .
> (*Literary Chronicle and Weekly Review*, 29 May 1815)

Mr Constable, though he

> is still far from pencilling with Nature's precision, gives her more contrasted features, such as a wood or windmill on a river, with more of her aspect. He does not give a sentiment, a soul, to the exterior of Nature as Mr. TURNER does; he does not at all exalt the spectator's mind . . . but he gives her outward look, her complexion and physical countenance with more exactness. He has none of the poetry of Nature like Mr. TURNER, but he has more of her portraiture. (*Examiner*, 27 June 1819)

> We shall rouse the jealousy of some professors and of some exclusive devotees of the Old Masters in saying that a *Landscape* by Mr. CONSTABLE has a more exact look of Nature than any picture we have ever seen by an Englishman, and has been equalled by very few of the most boasted foreigners of former days, except in finishing. (*Examiner*, 15 May 1820)

A glimmer of intelligence graces the *Observer*'s critic (25 June 1821) when he writes of 'Landscape: Noon (The Haywain)':

> There is a fine freshness of colouring, and a great tact in the disposition of the figures and the relief of the different objects, so as to make the entire harmonize, apparent throughout. The still life is excellent, and the great masses of foliage have a peculiar but not unnatural richness. If we were to make any objection we should say that the foreground was, perhaps, a little too light; but this might have been necessary for the relief of the masses in the back . . .

Yet Ruysdael is advanced as Constable's model and this rather qualifies the writer's perspicacity, since Rubens was clearly the preceptor.

It is well known that Charles Nodier saw 'The Haywain' and carried news of the picture to France. 'The palm of the Exhibition', he said (in his *Promenade de Dieppe aux Montagnes d'Écosse*, 1821),

> belongs to a very large landscape by Constable with which the ancient or modern masters have very few masterpieces that could be put in opposition.
>
> Near, it is only broad daubings of ill-laid colours, which offend the touch as well as the sight, they are so coarse and uneven. At the distance of a few

John Constable, **The Hay-Wain**, 1821 (National Gallery)

Rubens, **The Watering Place**, *c*.1615–17 (National Gallery)

steps it is a picturesque country, a rustic dwelling, a low river whose little
waves foam over the pebbles, a cart crossing a ford. It is water, air, and sky;
it is Ruysdael, Wouwerman, or Constable.

A couple of comments are appropriate. If Nodier saw Ruysdael and Wouwer-
man from 'a few steps' off, he had gone too far *and* not far enough. And Con-
stable, we are told in a letter of 1824, when 'The Haywain' was exhibited in
Paris, wanted his 'touch' to register: those 'ill-laid colours' were the signals of
conceptual innovation.

Constable was – briefly – taken up abroad. But he seems to have highlighted
local art disputes rather than broken through in his own right. On the invita-
tion of John Arrowsmith (a French dealer, despite the name) Constable ex-
ported a bunch of paintings and three were shown at the 1824 *Salon*. Scholars
have assumed (and assume) that Constable was accorded a vastly more sophis-
ticated reception by French critics than his countrymen could manage. The
evidence scarcely compels assent. Stendhal perhaps may stand for the most
literate and knowing of the continental fans:

> nous ont envoyé cette année des paysages magnifiques de M. Constable. Je
> ne sais si nous avons rien a leur opposer. La *vérité* saisit d'abord et entraîne
> dans ces charmants ouvrages. La négligence du pinceau . . . est outrée, et
> les plans de ces tableaux ne sont pas bien observés, d'ailleurs il n'a aucun
> idéal; mais son délicieux paysage [*View on the Stour*] . . . est le miroir de la
> nature, et il efface tout-à-fait un grand paysage de M. Watelet . . . qui est
> placé tout prés . . . (*Journal de Paris*, 30 August 1824)

Nought here goes beyond native comment, and the contumely of 'les plans'
betrays anaesthesia to the painter's reference-laden yet distinctive composi-
tional procedures. A subsequent article emphasises the narrowness of the
bounds within which Constable was allowed to operate:

> la perfection . . . , selon moi, serait de *dessiner* les sites d'Italia comme M.
> Chauvin, et de les peindre avec la naïveté de couleur de M. Constable
>
> Dans les tableaux de l'ancienne école, les arbres on du *style*: ils sont
> élégans, mais ils manquent de vérité. M. Constable, au contraire, est vrai
> comme un miroir; mais je voudrais que le miroir fut placé vis-à-vis un site
> magnifique, comme l'entrée du val de la Grande Chartreuse, près Grenoble,
> et non pas vis-à-vis une charrette de foin qui traverse à gué un canal d'eau
> dormante. (*Journal de Paris*, 24 October 1824)

Stendhal was knocking art officialdom and officialese. But he saw just a freak-
ish colourist and not a re-examiner of the whole landscape enterprise –
modes of perception, recreative devices. The shrewdest remarks, possibly,
occur in a critique by Étienne Delécluze, and they are unfriendly:

> on y remarque une negligence affectée, qui a sa pédanterie comme l'exces
> du soin et de la recherche, et je puis affirmer que la prétention à la naïvete
> dans la conversation, dans les lettres et dans les arts, est bien plus désagré-
> able, que celle qui l'on montre pour élever son style au niveau du sujet que
> l'on traite.

We read of 'imprecision', of the formal and colouristic disharmony which
follows a departure from classical schemes. Delécluze was in the right area,
though unable to reach a positive conclusion.

A *succés de scandale*, the award of a Gold Medal (one of the Establishment's
acts of ingestion?), a gaggle of imitators soon lost to sight, a call from Dela-
croix, and the Constable event was over. A second Gold Medal at Lille in 1825
– provincial mimicry – stressed the critical silence of the metropolis.

Constable bore French kicks and kindnesses with relative equanimity. He
was a student, let us remember, during the period – the unique period – when
English artists, whatever their arguments, united in the belief that the great
campaigns were being fought and several of the great battles being won on

home territory. He wished for acceptance by his immediate neighbours. And, where it counted, he was condemned to loneliness. Perhaps lesser claims would have gained readier approbation: but Constable considered his art as the embodiment of the grandest emotional and intellectual concerns. We ought to measure approval of his work against the questionable (and questioned) but still influential academic hierarchy of *genres* – *history* (subjects derived from ancient or modern myth and the Bible) atop, all else below and landscape with animal and plant portraiture belowest. Wilkie, amidst the *Salon* crowds, wondered why Constable was not a full member of the Academy. Shortly before the Academy election of 1828, Constable, a nervous candidate,

> was "pounced upon" by Mr. Shee [Martin Archer Shee, R.A.] ... and came in for my share of castigation . . . Mr. Phillips [Thomas Phillips, R.A., Professor of Painting] likewise caught me by the other ear – and kicked and cuffed me most severely . . . I have heard so much of the higher walks of the art, that I am quite sick. I had my own opinions even on that – but I was desired to hold my tongue . . . (JCC III p.12, to Leslie, 5 February)

The next year, Constable endured

> an ordeal . . . in which "kicks" are kind treatment to those "insults to the mind," which "we candidates, *wretches* of necessity" are exposed to, annually, from some "high-minded" members who stickle for the "elevated & noble" walks of art – i.e. preferring the *shaggy posteriors of a Satyr* to *the moral feeling of landscape.* (JCC III pp.18–19, to Leslie, 21 January)

From this, at long last, Constable emerged, by a single vote, an Academician: he was, he said, 'smarting'. We know not who spoke or what they said, but he was speedily insulted by the President, Sir Thomas Lawrence, who called him 'peculiarly fortunate' . . . since 'there were historical painters of great merit on the list.' Sitting on his first Academy selection committee in 1830, Constable witnessed colleagues revile and reject a picture of his – without recognising its authorship! Academicians were not required to submit their works for judgement. Was the picture put with the 'outsiders' by a guileless menial – or did Constable engineer the incident? Constable began to prepare the prints and texts of *English Landscape*, his *apologia pro vita sua*.

To compute the frequency of praise accorded the landscapist during the second half of his career is certainly not just to track fame. The compliments went, increasingly, with puzzlement and censure and there were bursts of malice. The choice phrase – the *Birmingham Journal* (20 September 1828) speaks of nature 'smiling through her tears' in a 'Gillingham Mill' – is jarred by grumbles about 'finish'. British Institution exhibits

> would excite much admiration were it not for the mannered and spotty whiteness which disfigures them. (*London Magazine*, March 1829)

The *Gentleman's Magazine* (1829) reproves

> a disagreeable custom of communicating to his scenes, the appearance of having been scattered over whilst the colouring was still fresh, with a huge quantity of chopped hay. It is in execrable taste, having no resemblance to any appearance in Nature – this artist's standard of excellence.

Failure to ask the *reason* for Constable's handling is ubiquitous. Those who enjoy certain aspects of the pictures – the colour matches, the suggestion of nature's variousness – stumble in his rough surfaces alongside the most doltish of detractors.

> This artist manages, by a fantastic and coarse style of painting . . . to produce powerful effects, and sometimes a remarkable degree of natural truth; . . . though not without great merits, much impaired by silly affectation, and various clumsy attempts at singularity, he . . . falls short of CALCOTT and LEE in their respective excellencies – most of all in the charms

William Etty, **Sleeping Nymph and Satyrs,** 1828 (Royal Academy of Arts)

David Lucas after Constable, Frontispiece to **English Landscape,** 1832

of poetry and good taste.' (The *Morning Chronicle*, 3 May 1830)

The line-up, common enough, of Constable, Augustus Wall Calcott and Frederick Richard Lee indicates the want of genuine sympathy and Constable's 'truth' if believed akin to the 'truth' of these can scarcely have been Constable's.

No wonder Constable, in his letters and in anecdotes, becomes sombre: 'my indispositions', he wrote, 'are all in my mind.'

Around 1834, Wilkie heard of

a sad freak with which I have been long "possessed" of feeling a *duty* . . . to tell the world that there is such a thing as landscape existing with "Art" – as I have in so great measure failed to "show" the world that it is possible to accomplish it. (JC:FDC p.5)

One of Constable's drafts for his lectures (Executors of Lt. Col. J. H. Constable)

Constable's lectures on the history of landscape painting, scrupulously assembled (*vide* the extant *ms.* fragments) and meant to establish a context for his own practice, could not transform his circumstances. The insistence on traditional values, the careful marking of artistic pedigrees, dramatise the predicament of a man whose new moves require, for their effective registration, a proper grasp of received ideas. Critics allude to Gainsborough, Rubens, the Dutch masters, but loosely: they never illuminate Constable's endeavour. Constable condemns mannerism, the mindless ritual of the artist who has lost his purchase on the external world and vacuumises art: critics call him a mannerist.

A single review starts a productive train of thought. The *Morning Post* (14 November 1833) said that 'A Wood', hung at the Society of British Artists, was Reynoldsian: there was

the same masterly arrangement . . . the same feeling for colour and freedom of execution, and . . . the same poetical sentiments by which the landscapes of REYNOLDS, in their most perfect state, are distinguished. We fear that the merits of this skillful performance are more appreciated by artists than by the public . . .

Sir Joshua Reynolds, **The Thames from Richmond Hill**, before 1788 (Tate Gallery)

Constable, reading for his lectures, was especially concerned with Sir Joshua. Ought we to seek out the mature Constable's notion *via* Reynoldsian eclecticism? The *Morning Chronicle* (7 October) had noted opposite *A Wood* a landscape 'smear' by Reynolds, 'the property of John Constable, R.A.' and detected 'the origins of [Constable's] happily inimitable style': 'It is not a secret worth knowing'.

There were, of course, sales. In 1804 Constable charged two guineas for a portrait head, an extra guinea with hands. In 1810 thirty guineas for a kit-kat sized landscape caused ecstacy. 'The White Horse' (1819) cost Archdeacon Fisher £100, 'Stratford Mill' (1821) probably the same. 'A SCALE OF MR. CONSTABLE'S PRICES', 1826, ran from twenty guineas to a hundred and twenty (for a picture 4ft 2in × 3ft 4in). And the summit of worldly reward was reached in 1835 when Robert Vernon paid £300 for 'The Valley Farm'. But numerous works which to the artist were of major importance remained unsold. He descended, time and again, from his initial charge. And he was, almost to the last, forced into semi-servile postures. In 1833 he wrote to a churlish patron, whose country seat he had slaved to depict, and who took exception to the amount of tree, grass and cow:

. . . I beg the favor that you will receive the following proposition: which is, that I now so thoroughly understand your wishes, I may be allowed to make a second trial . . . Being now so fully impressed with the subject I should feel great confidence and am assured that being so well acquainted with your wishes and with my mind so full of the subject . . . it would successfully fill the canvas. May I beg. . . . etc. (JCC IV pp.114–15, 23 March, to Richard Benyon-De Beauvoir)

[21]

After a potential customer's visit, this year, Constable threw wide the windows of his house to recover its 'tone'. 'Helmingham Dell', recently displayed at the British Institution, went to auction on its owner's death but was received too late to be catalogued and passed unnoticed. The *Morning Chronicle* jeered:

> 'its public estimation may serve to teach a little modesty to the Royal Academians . . . A good sized *Dell Scene* by Mr. Constable, R.A., in his usual style, and we should say preferable to anything he has in the present exhibition at the Academy, was knocked down at fifty shillings. (29 June 1833)

The Press, whether amiable or antagonistic, can rarely have pleased Constable. He was not the sole sufferer at journalistic hands, but his was the worst case of fair pretension abused. Constable vowed, in 1823, to 'have a proper opinion of myself': he would refuse 'vulgar writers' the chance to 'insult and intrude' upon him (JCC II p.292, to his wife, 27 October). The vow, no doubt, was tested hard. The weakness, the confusions, and contradictions, of the critics reflect a generally problematical situation. Despairing, Constable wrote: 'The art will be dead in thirty years'.

Of course, neither English art nor Constable's contribution to this were altogether extinguished. The tale of both, however, twists bizarrely and there are chapters of moribundity as well as lively episodes. Constable died 31 March 1837. The following June a group of friends bent on commemoration met in his house and decided to secure 'The Cornfield' for the nation. Three hundred guineas, a larger sum than the artist himself could ever raise, were duly collected and a presentation was made to the National Gallery. A mass of works, of different kinds, was sold quickly and rather cheaply by the family (Foster & Sons, 10–12 May, 15–16 May, 1838), and much seems to have been doctored for easier public consumption. C. R. Leslie, by 1843, had seen sketches '*finished* into worthlessness' (*Memoirs . . .* p.122), and, by 1845, 'Multitudes' of fakes, 'with astonishment that their wretchedness should impose upon purchasers . . . they are', he continues, 'put forth, in safe reliance on the little real knowledge of his style that, at present, exists among our connoisseurs' (*Memoirs . . .* p.307).

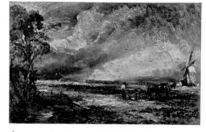

Anonymous copy after Lucas's mezzotint of Constable's 'Spring' (whereabouts unknown)

Leslie himself, with the greatest good will and a fund of special information, added signally to misunderstanding. His *Memoirs of the Life of John Constable Esq., R.A.*, 1843, is among the most persuasive of propaganda efforts for an artist. Leslie gives an account of Constable's career which for completeness, for its supple interweaving of works and everyday incident, has no precedent. Extensive use of Constable's correspondence fixes the image of a wholly committed artist, a man whose love of the English countryside found direct outlet in painting – a martyr to those simply incapable of acknowledging beauty and truth. The book alerts us to the sheer persistence, the obsessiveness of Constable's engagement with natural phenomena, and, because it convinces us that Constable was an intelligent creature, we respect.

But this is the hagiographer's triumph. Leslie, in the apt words of a contemporary, was 'careful of the reputation of his deceased friend'. He was determined to present a congenial type and he delicately edited or left aside a quantity of awkward material. 'When my mind is disturbed', wrote Constable to Archdeacon Fisher, 'it stirs up the mud.' Leslie quickly provides a footnote: 'He alludes to parts of his correspondence with Mr. Fisher relating to a third person, and which for that reason are not published' (*Memoirs . . .* 1845 p.169). Rancour, acidity of phrase, ridicule, were the reflexes of frustration: miss the sharp response to obtuseness and the contours of obtuseness's object are blurred. Leslie tends to shorten Constable's emotional range.

Perhaps because he wished to avoid re-opening controversy, no less than

because it is difficult *per se*, Leslie barely discusses the actual work. Retailing the painter's neat aphorisms, mentioning his activity as collector and copyist, he indicates Constable's deep concern with the art of others: but he never defines the connections between the loved, even idolised, '*Old Men*' and the Constabellian *modus operandi*. And he is altogether silent about the problems of conceptualisation which Constable condensed in a maxim Leslie came across among his papers:

> The art of reading nature is a thing almost as much to be acquired as the art of reading the Egyptian hieroglyphics (*Memoirs . . .* 1843 p.150)

(The Rosetta Stone, with Greek and ancient Egyptian inscriptions, was discovered in 1799. Its decipherment by Thomas Young and Jean Champollion provided the key to a lost civilisation.)

The original edition of Leslie's pious act must have been small. It was illustrated with proofs of the Lucas engravings remaindered from *English Landscape*: and Leslie took 180 sets from the family collection, leaving behind a lot. That a second edition – text slightly enlarged but no Lucas prints – was worthwhile two years after the first suggests an upturn of interest, but there is no substantiation of this: the third edition was published in 1896.

A curious pointer to the confinement of the taste for Constable around mid-century is John Ruskin's treatment of him. Ruskin began to publish *Modern Painters* the year the *Memoirs . . .* broke cover (further volumes are dated 1846, '56, '60). It was, like Constable's lectures, intended to fix the importance of landscape painting and, unlike Constable (and Leslie) Ruskin examines closely the relations of natural world and art and goes into the development of a visual understanding of botanical, geological, meteorological 'fact'. Ruskin notices Constable incidentally and impolitely. We should suppose he had, at best, glanced through Leslie's book. He says Constable's refusal to learn from predecessors was naïvely extreme and that the acceptance of crude pictorial recipes stopped him grasping the meaning of nature. Constable is, to his marked disadvantage, contrasted with Turner, the hero of *Modern Painters*:

> I will take a bit of Constable . . ., the principal tree out of the engraving of the lock on the Stour . . . It differs from the Claude outlines [Ruskin's graphic guide to Claude's inadequacies] merely in being the kind of work which is produced by an uninventive person dashing about idly, with a brush, instead of drawing determinately wrong, with a pen . . . worse than Claude's, in being lazier . . . a little better, in being more free, but as representative of tree form, of course still wholly barbarous . . . One can almost see him . . . bending it to the right; then, having gone long enough to the right, turning to the left; then having gone long enough to the left, away to the right again; then dividing it; and 'because there is another tree in the picture with two long branches . . ., he knows that this ought to have three or four, which must undulate or go backwards and forwards,' etc., etc.

Compare a specimen (from a drawing of Bolton Abbey) of Turner's tree-depiction – observe

> its quietness, unattractiveness, apparent carelessness whether you look at it or not; . . . the subtle curvatures within the narrowest limits, and, when it branches, the unexpected, out of the way things it does . . .; shooting out like a letter Y, with a nearly straight branch, and the correcting its stiffness with a zig-zag behind, so that the boughs, ugly individually, are beautiful in unison. (Vol.III, p.128)

Ruskin's displeasure is remarkable. How can he have remained immune to the perceptual innovations of Constable? Scholars suppose he was familiar with Lucas's prints alone. If such be correct it, too, deserves a ponder: Ruskin was a diligent exhibition visitor and, in the service of his treatise, a usually scrupulous analyst of the landscapes on hand. Why did Constable's virtues escape

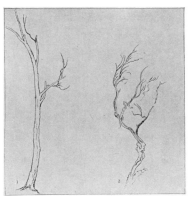

John Ruskin, **Modern Painters**, Vol.III, pl.5: 'Good and Bad Tree-Drawing'

him? Whatever the answer, we ought not to discard casually the terse comments of landscape art's most authoritative advocate. We need compelling exegesis of nature in art. Ruskin was tuned, uniquely among critics, to the 'inner and deep resemblance' of pictures to natural forces, the 'lines of growth', the organic verities. Perhaps his strictures should help us to refine our interpretation of Constable.

In his *Handbook for Young Painters* (1854), Leslie dared to challenge Ruskin. The chapter headed 'On Landscape' was a Constabelian sermon with a dig or two at Turner's champion:

> Mr. Ruskin alludes to the often-repeated saying of Fuseli . . . but . . . shows a very limited acquaintance with Constable's works when he calls his effects 'great-coat weather and nothing more'. Nobody has painted with more truth the finest English summer weather, – as in 'The White Horse', the 'Stratford Mill', the 'Hay Wain', the 'Waterloo Bridge', . . . ; and particularly in a little meadow scene of matchless beauty, and 'the Boat Building' . . . none of these pictures have much of what are called warm colours; but they express the warmth of summer so truly that in some of them (the last two especially) I can fancy I see the tremulous vibration of the heated air near the ground. Constable never fell into the common mistake by which even Turner appears to have been influenced, namely, that what are called warm colours are essential to convey the idea of warmth in a landscape. The truth is, that red, orange, and yellow, are only seen in the sky at the coolest hours of the day, and brown and yellow tints, in the foliage of England, prevail only in the spring and autumn. But he fearlessly painted midsummer noon-day heat, with blues, greens, and grays forming the predominant masses. And he succeeded: because his sensibility of eye directed him to the true tones and arrangements in Nature of these colours at the season he most loved to paint . . . (Section xv, p.277)

The *Handbook* is the public version of Leslie's lectures at the Royal Academy as Professor of Painting: 'On Landscape' was a radical emendation of the standard schedule: the 'little meadow scene' was, pretty certainly, the picture the selection committee of 1830 junked.

Ruskin, in volume III of *Modern Painters*, is brusque. He castigates Leslie's 'unadvised and unfortunate *réchauffé* of the fallacious art-maxims of the last century', and lays the *Handbook* aside.

Ruskin is the toughest of Constable's animadverters: he had no heir. As Constable gets exposure at exhibitions and sales, approval spreads – though it scarcely deepens. Discussion of pictorial techniques, painterly skills, features not. Instead Constable is slotted into, becomes a chief protagonist of, the myth of the paradisal English past, when man was inwardly serene because nicely geared to outward conditions: where winter arrived infrequently and mildly, where rich woods and ceaselessly fecund fields supported a benevolent patriarchy and a decent crew of labouring mutes: and where the church was the token of divine stasis. There were hints of this while Constable lived. The phrases 'emphatically', 'essentially', 'thoroughly English' speckle reviews of the 'thirties and the reviewers mean *what* Constable paints. I call the retrospect a myth. It was, momentarily, real. Constable's childhood coincided with the isolation of England by French expansionism, and, consequently, ardent patriotism and togetherness, the rapid advancement of agriculture. This state of affairs ended abruptly with the fall of Napoleon. English armies returned their troops to a countryside which had learnt to get along without them. Foreign competition unhinged the rural economy. Nostalgia is not surprising, nor is it strange that an artist emphatically associated with a 'good' era should become attractive. Constable's 'over-weaning affection' for the 'scenes "where once his careless childhood strayed"' was balm to troubled souls.

Prices mount. In 1866 'The Haywain' fetched £1,365: in 1886 'A Dell, Helmingham Park' £1,627.10s: in 1899 'The White Horse' £6,510: in 1895 'The Young Waltonians' £8,925. Works were lent and donated to national collections. The John Sheepshanks Gift to the South Kensington Museum (The Victoria and Albert) in 1857, the nucleus of a 'National Gallery of British Art', included six oils ('Boatbuilding near Flatford Mill', 'Salisbury Cathedral from the Bishop's Ground' etc.). Henry Vaughan lent to South Kensington (1862–) the six-foot 'sketches' for 'The Haywain' and 'The Leaping Horse'.

But we must observe that the growth of Constable's fame was gradual and faulty. The title-page of the Tate Gallery's copy of the third edition of Leslie's *Memoirs* . . . (1896) is inscribed 'only 350 copies printed', and the assertion is credible. The idea of Constable was, perhaps, as important as his achievement. In 1869 (21 June) Captain Charles Golding Constable, a son, wrote to *The Times*:

Sir, – I went among many others to see three large paintings, each six feet long, which were advertised for sale by auction at Messrs. Foster's gallery . . . , and called in the catalogue 'Magnificent pictures by John Constable, R.A.'

I think the public are greatly indebted to Messrs. Foster for declining to sell these pictures after the doubts expressed by myself and others. It now occurs to me that I might do a little good if I warned those wishing to purchase a Constable that there are a greater number of imitations about than usual. For one genuine picture offered there are six sham ones. I have seen them at auctions, at dealers, and in the houses of gentlemen who have been imposed upon, and I have come to the conclusion that there is a manufactory for them somewhere.

The bulk of the 'imitations', the Captain says, derive from Lucas's prints, and their makers do not realise Constable could draw and was a colourist. He also says, mysteriously, that every authentic work is 'catalogued' and 'known to artists and admirers'. In 1874, *à propos* of the London International Exhibition, the Captain rejoined battle (*The Times* 3 August), listing sixteen spurious pictures and lamenting the 'discredit and injustice done to my father's reputation'. He was not an immaculate arbiter (for the 'Helmingham Dell' he dismisses see No.295 below) but fakes were indeed circulating and several had alighted in public places. Possibly to correct taste, a selection of the Captain's Constables was lent to the South Kensington Museum between 1880 and 1883. 'Sketches' and 'studies', an unfamiliar aspect of Constable's oeuvre and unequivocal indices of his distinctiveness were displayed. No art journalist found them deserving of space. Isabel, the Captain's sister (according to a note by Hugh Constable in the family's possession) unsuccessfully requested the removal of two shams from the National Gallery. She then decided in 1888 to bestow the larger portion of her collection upon the South Kensington Museum, and the Museum thus came to hold the most coherent representation of an English artist outside the Turner Bequest. The bestowal was coolly received, and the small, badly lit room chosen for it can have accommodated very few pictures. Miss Constable said: 'I do not wish the pictures copied'. In 1911 a Miss Shales sought permission to make a copy and was turned down. A Keeper noted: 'We have had I suppose previous applications of this sort': a solitary example was recalled.

But some quickening of interest is detectable. The Grosvenor Gallery mounted, in 1889, an exhibition under the legend 'A Century of British Art', which was mainly Constable. Leggatt's, in 1899, acquired a sizeable and diverse body of the family pictures and offered them for sale. The 'illustrious landscape painter', wrote *The Times* critic,

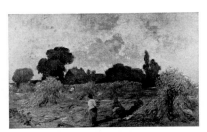

Formerly ascribed to Constable,
Sketch of a Cornfield with Figures,
(Tate Gallery)

left behind him a vast number of sketches and studies in oil, watercolour, and pencil, and with the increasing admiration for his pictures there has arisen a strong demand for these slighter efforts . . .

At Leggatt's were nigh on a hundred small oils

showing the genius of Constable in all its variety. Many are mere 'impressions', but others are practically finished . . . The delicacy and knowledge . . . is extraordinary, as is the vivid understanding of form and colour shown in the artist's cloud studies and in his slight transcripts of momentary natural effects.

There was a chorus of commendation – of the current exhibition and of Constable generally. The *Daily News*, calling Constable a 'rebel against the "brown tree" and other dead-wood conventionalisms', reminded readers he had taught his countrymen that

the daily beauties of English scenery were worthy subjects for a great artist, and worthy possessions for a man of taste.

The *Daily Telegraph* positively gushed over

these veritable 'impressions' of the highest order transcribed with an audacious truth, with a swift mastery, such as hardly any modern landscape painter among the avowed realists had achieved. Remembering even Constable's masterpieces . . . it is impossible not to regret that some of this beauty and variety, some of this tenderness, should evaporate in the elaboration of the swift sketch, or combination of sketches, into the noble picture.

From this date, presumably, runs the stream of bogus Constable 'sketches and small 'informal' works which has stained, and stains, collections here, in Europe, and in America.

From roughly this date, also, we must attend to serious scholarship, sustained attempts to explicate Constable's art. A sizeable book, *Constable and his Influence on Landscape Painting*, by Charles Holmes, was published in 1902. It is sensible stuff. Holmes tries to 'place' his subject, mark the bounds within which Constable operated. He discusses the European landscape tradition and the English offshoots of the eighteenth century. And he goes at Constable's work organically, admitting a need to 'consider the development of his art by itself in detail. This can only be done properly by a careful study of his pictures in relation to each other . . .' To further the intention, Holmes bravely tackled the business of a *catalogue raisonné*, a sorting of authentic works into chronological sequence.

The task was, at this stage, too hard. English art historians were wonderfully innocent of social, political, economic history and their understanding of the art world lacked definition. Holmes' account of Constable's situation is rudimentary and his grasp of the technical and emotional problems facing Constable uncertain. What should be the test of an art-historical text, the analysis of specific pictures, is sadly insubstantial.

Bit by bit, however, the materials for a depthy and subtle appreciation have been gathered and speculations better founded. Lord Windsor, in his otherwise unexceptional monograph, *John Constable R.A.* (1903), began the modern publication of Constable documents. Peter Leslie, a grandson of Constable's hagiographer, edited a volume of *Letters from John Constable, R.A. to C. R. Leslie, R.A.* (1931). The Hon. Andrew Shirley, in his edition of Leslie's *Memoirs . . .* (1937) significantly extended the documentary element. And R. B. Beckett, following a book about Constable and his friend Fisher, put forth, between 1962 and 1968, in *John Constable's Correspondence* the most complete assemblage ever of an artist's mail. The narrative which Beckett skilfully organised around the letters helps the reader to a unique insight into the very texture of an artistic life. The hefty *Catalogue of the Constable Collection* at the

Victoria and Albert Museum (1960, revised 1973) provides the basis for a complete *catalogue raisonné*, and Mr Reynolds has joined the American scholar Charles Rhyne on the compilation of just that.

Critical monographs and articles have, in sum, simultaneously complicated and rendered more intelligible our view of the job (or jobs) done by Constable. Sydney Key's neat and naïve book of 1948, wherein Constable moves like an automaton from limiting convention to 'naturalism', had already been outdated. Kenneth Clark's pamphlet on 'The Haywain' (1947) is a thought-provoking attempt to order the constituents in Constable's tortured and tortuous procedures. Clark trails 'The Haywain' from 'tiny pencil drawings', supposedly 'from nature', *via* a 'small and very rough sketch in oils which states the main theme with dramatic emphasis', and the full-scale 'study', to the *machine* proper. And he is judicious. The more, he says, we examine

the exhibited pictures in companion with their 'first states' the more we realise how many enduring qualities Constable has been able to add . . . he greatly enlarges the range of colour. The Victoria and Albert *Haywain* is almost a monochrome compared to the National Gallery version, the greens being kept down to khaki and the blues . . . to grey. Then he establishes all the planes more firmly . . . and enriches the drawing. Finally he makes the composition more classical and logical . . .

The original 'small sketch', he says

is full and agitated, and even the Victoria and Albert version has a nervous flicker which is ultimately restrained. In the exhibition picture the intervals are larger, the rhythms slower and an increased emphasis on horizontals confirms the sense of midday calm.

Constable's *machines*

must not be written off solely as concessions to contemporary taste; they are . . . evidence that he had studied the great masters . . . Rubens, Poussin, Claude, Ruisdael – and knew the value of the classical tradition . . .

If not comprehensively dealt with, the sequence of events postulated is reasonable and raises intriguing questions about the dynamics of art. What, precisely, gave rise to what?

In lectures delivered during 1956 (and published as *Art and Illusion* 1960), E. H. Gombrich firmly and wittily directed art historians to the psychological complexities of artistic perception, using Constable as a prime example. *Why* and *how*, he asks, do we represent the 'external world'? Constable scholars are beginning to grapple with the queries.

A paper (in the *Journal of the Warburg and Courtauld Institutes*, 1957) by Michael Kitson, 'John Constable, 1810–1816: a Chronological Study', initiated the exact classification and dating of works previously ill-located.

Graham Reynolds' *Constable the Natural Painter* (1965), while still silent in perceptual matters – Constable is called 'intuitive' – enhances our consciousness of the artist's drives, his emotional imperatives. The fixation on a given location is convincingly supported by a series of vignettes of the East Anglian countryside, its social and economic harmony, the comfortable balance of agriculture and industrial methods.

Close criticism of the secondary sources and of prior criticism has commenced. Louis Hawes' paper 'Constable's Sky Sketches' (*Journal of the Warburg and Courtauld Institutes*, 1969) sternly takes to task the slack linkage of Constable's skying and the meteorology of Luke Howard in Kurt Badt's book *John Constable's Clouds* (1950). Professor Hawes, enumerating the models in art, art theory, and meteorological science, available to Constable prompts further conjecture about the ramifications of 'reading nature'.

A Tate Gallery booklet (1969) by Conal Shields and Leslie Parris is devoted to the opening-up of fresh lines of enquiry, highlighting Constable's difficul-

ties and those of his audience and suggesting how thorough inspection of the period's history may clarify muzzy areas. Changes in the rural life-style, in the constitution of the art public and in the art establishment, recent moves in science and literature, are cited as illuminants. An exhibition, *Constable: The Art of Nature* (Tate Gallery, 1971), with the same pair as organisers, demonstrated to an unparalleled degree the range of Constable's interest. Writing to Archdeacon Fisher, the catalogue notes, Constable

John Constable, **Geometrical Analysis of the Rainbow**, ?1834 (Executors of Lt. Col. J. H. Constable)

imagined Richard Wilson's spirit 'walking arm in arm with Milton and Linnæus'. And this splendid trio – the founder of native landscape painting supported, so to speak, by the great poetical rhetorician and the great scientific categoriser – may well be taken to indicate the scope of Constable's ambition.

Scholars and enthusiasts generally are now approaching Constable on a broader front and Constable's course, of which aspect after aspect was hitherto intractable, comes nearer our comprehension.

This is (in the word's two senses) a partial survey of Constable's public face, of the modes of endorsement or disapprobation he stirred. Such a survey, though disfigured by sins of commission and omission, must soon lead us back to the man's art with our doubts and certainties aquiver. During Constable's bicentennial year we should, perhaps, be extraordinarily ready and willing to keep the doubts and certainties before us rather than content to leave them in the murky middles of the mind.

CONAL SHIELDS

Note. The essay above is based on Volume xx (unpublished) of the Constable documents collected by R. B. Beckett (Beckett's own typescripts are in the care of the Tate Gallery). But I have augmented Beckett and all newspaper items have been transcribed from the pristine texts. I am grateful to Caroline Odgers for her labours on my behalf in the fastness of the British Museum Newspaper library (Colindale). Michael Kauffmann of the Victoria and Albert Museum gave aid and comfort beyond the call of duty and to him, also, I reiterate thanks.

Catalogue

The catalogue is by Leslie Parris and Ian Fleming-Williams, though naturally it incorporates ideas of the third of the organisers, Conal Shields.

Explanations

Works exhibited by Constable at the Royal Academy and other institutions appear under the titles given in the original catalogues, with modern titles, where significantly different, in parentheses.

Measurements are in inches and (in parentheses) centimetres; height precedes width.

Exhibitions during Constable's lifetime only are listed.

Details of provenance are given when available. Constable family sales, at Christie's unless otherwise indicated, are referred to by date only, as follows:

15–16 May 1838	John Constable, Foster and Sons
15 April 1869	Charles Golding Constable
22 May 1869	Lionel Constable
14 June 1873	Lionel Constable
17 Feb. 1877	Constable family
11 July 1887	Charles Golding Constable
23 June 1890	Charles Golding Constable
28 May 1891	Isabel Constable, works from her collection [sold by E. Colquhoun]
17 June 1892	Isabel Constable
30 Nov. 1892	Anon. [F. J. A. White], presumably selling works on behalf of Constable family or works acquired from them
23 June 1894	Clifford Constable
16 April 1896	Eustace Constable

Where it has been possible to consult the original of a letter or other document, the following signs are used in the transcription:

[?Landscape]	doubtful reading
⟨Landscape⟩	deleted word
⟨. . .⟩	undeciphered deleted word

Abbreviations

Beckett (Typescript Catalogue)	Unpublished catalogue of Constable's work by the late R. B. Beckett. A copy is with the Beckett Papers at the Tate Gallery
B.I.	British Institution
bt.	bought

Constable Archive Letters and documents in the possession of the Constable family

d. dated

exh. exhibited

Holmes 1902 C. J. Holmes, *Constable and his influence on Landscape Painting*, 1902

JCC I [. . . VI] R. B. Beckett, *John Constable's Correspondence*, 6 vols., 1962–8 (quotations in the present catalogue have sometimes been silently corrected against the original manuscripts)

JCD R. B. Beckett, *John Constable's Discourses*, 1970

JC : FDC Leslie Parris, Conal Shields and Ian Fleming-Williams, *John Constable: Further Documents and Correspondence*, 1975

Leslie 1843 C. R. Leslie, *Memoirs of the Life of John Constable, Esq. R.A.*, 1843

———1845 2nd, revised edition, 1845

———1896 ed. R. C. Leslie, 1896

———1937 ed. Andrew Shirley, 1937

———1951 ed. J. H. Mayne, 1951

Prov: Provenance

R.A. Royal Academy or Royal Academician

Reynolds 1973 Graham Reynolds, *Victoria & Albert Museum, Catalogue of the Constable Collection*, 2nd ed., 1973. References are sometimes abbreviated to the letter 'R.' followed by the relevant catalogue number.

Shirley 1930 Andrew Shirley, *The Published Mezzotints of David Lucas after John Constable, R.A.*, 1930

V. & A. Victoria and Albert Museum

Windsor 1903 Lord Windsor, *John Constable R.A.*, 1903

Background

The Constable Family and East Bergholt

The artist's father, Golding Constable (1739–1816) came from a long line of Suffolk and Essex yeomen. His own father farmed at Bures St. Mary but it was rather to a bequest from his uncle Abram, a successful London corn-factor, that he owed his start in life. On Abram's death in 1764, the twenty-six year old Golding inherited his stock in trade, his shipping, over three thousand pounds in cash and securities, and property in the parish of East Bergholt, Suffolk, including the tenancy of Flatford Mill on the river Stour.

Flatford Mill was, at least until 1774, the centre of Golding's activity. When sold by the family in 1846, it was described as a 'Capital and substantially brick-built Water Corn Mill . . . driving 3 pairs of stones . . . with the machinery, going gears, flour mills, and tackle of every description, very spacious and excellent granary, with 2 floors, drying kiln, a convenient dry dock for barges, chalk wharf, and coal shed'. Attached to it was a 'Comfortable Brick-Built Residence, two Millers' Cottages' and various outbuildings (*East Anglian Miscellany*, Pt.IV, 1934, p.77). Flour ground at the Mill was taken by horse-drawn barges down the Stour (made navigable with locks in the early eighteenth century) to Golding's wharf on the estuary at Mistley, from where it was shipped to London in his own vessel. Coal and other commodities were carried on the return journey and sold locally by Golding. In addition to the coal shed at Flatford, he had a coal yard downstream at Brantham. In the 'convenient dry dock' mentioned above, Golding built the barges which carried on this trade. Later, he also acquired Dedham Mill, a few miles upstream from Flatford, though at first he was only part-proprietor with Peter Firmin, a Dedham solicitor. This watermill, larger than the one at Flatford, was also used for grinding corn and had the usual complement of granary, wharves, miller's cottage, and so on.

Probably on one of his visits to London to attend the Corn Market, Golding met Ann Watts (1748–1815), daughter of a prosperous cooper. They married in 1767 and settled in the residence at Flatford Mill, where their first three children were born – Ann, Martha and Golding. In 1774 the family moved to a more spacious and rather grand house which Golding had built in East Bergholt village, where he also owned and farmed

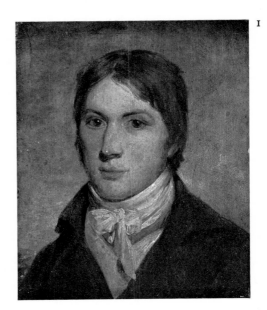

I

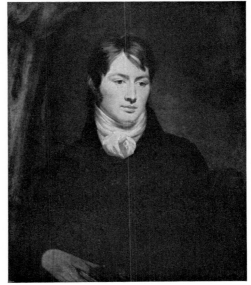

II

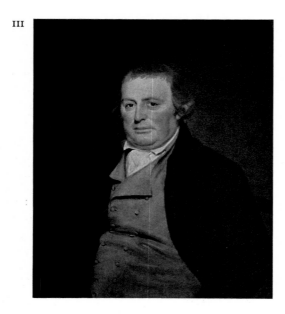

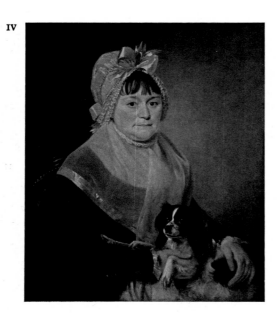

land and had a windmill. It was in this house, East Bergholt House, that their fourth child, the artist, was born in 1776. Two more children followed – Mary and Abram. Because Golding junior was unfitted (apparently, by some physical handicap) to take part in the family business, it was John who was first taken into the concern. His growing devotion to art, however, made this a short apprenticeship and Golding senior had soon to look to his youngest son, Abram, for a successor. Abram thus took charge of the business on Golding's death in 1816, John, and presumably the other children, receiving an income from him out of the profits.

The social character of East Bergholt and the appearance of the surrounding countryside were described by Constable many years later in the text to his book of mezzotints, *English Landscape*. He began by quoting from the relevant volume of *The Beauties of England and Wales* (1813): '"South of the church is 'Old Hall', the Manor House, the seat of Peter Godfrey, Esq.; which with the residences of the rector, the Reverend Dr. Rhudde, Mrs. Roberts, and Golding Constable, Esq., give this place an appearance far superior to that of most villages." It is pleasantly situated in the most cultivated part of Suffolk, on a spot which overlooks the fertile valley of the Stour, which river divides that county on the south from Essex. The beauty of the surrounding scenery, the gentle declivities, the luxuriant meadow flats sprinkled with flocks and herds, and well cultivated uplands, the woods and rivers, the numerous scattered villages and churches, with farms and picturesque cottages, all impart to this particular spot an amenity and elegance hardly anywhere else to be found' (JCD pp.12–13). When, after leaving home, Constable became a less and less frequent visitor to this richly cultivated landscape, his affection for the childhood he had spent in it grew into a nostalgia that became one of the driving forces of his art. Though he left to his brother, Abram, the actual business of the mills, barges and fields, he returned constantly to such things in his imagination, creating in his painting images of the countryside that today still embody, for most people, the whole idea of rural England.

HENRY HOWARD (1769–1847)

I John Constable d.1797
Oil on panel, $7\frac{1}{2} \times 5\frac{7}{8}$ (19 × 14.9)
Inscribed on verso 'Howard, pinx! 1797–', and, perhaps in another hand, 'John Constable
Aged 19'
The Executors of Lt. Col. J. H. Constable

A letter to Constable from Howard, dated 6 November 1829, is kept with the picture. Part of this reads: 'I send the Portrait with all its imperfections on its head, having merely wash'd off the *first* coat of dirt – leaving to you to do with it whatever you like' (see also JCC IV pl.11). The portrait was presumably made on Constable's visit to London in the autumn of 1797. At this time Constable was aged twenty-one, not nineteen as stated in the second inscription on the back. Howard later became Secretary of the Royal Academy.

RAMSAY RICHARD REINAGLE (1775–1862)

II John Constable *circa* 1799
Oil on canvas, $30 \times 25\frac{1}{4}$ (76.2 × 64.1)
Trustees of the National Portrait Gallery

55 **The Valley of the Stour** (detail) *c.*1805 (entry on p.58) ▶

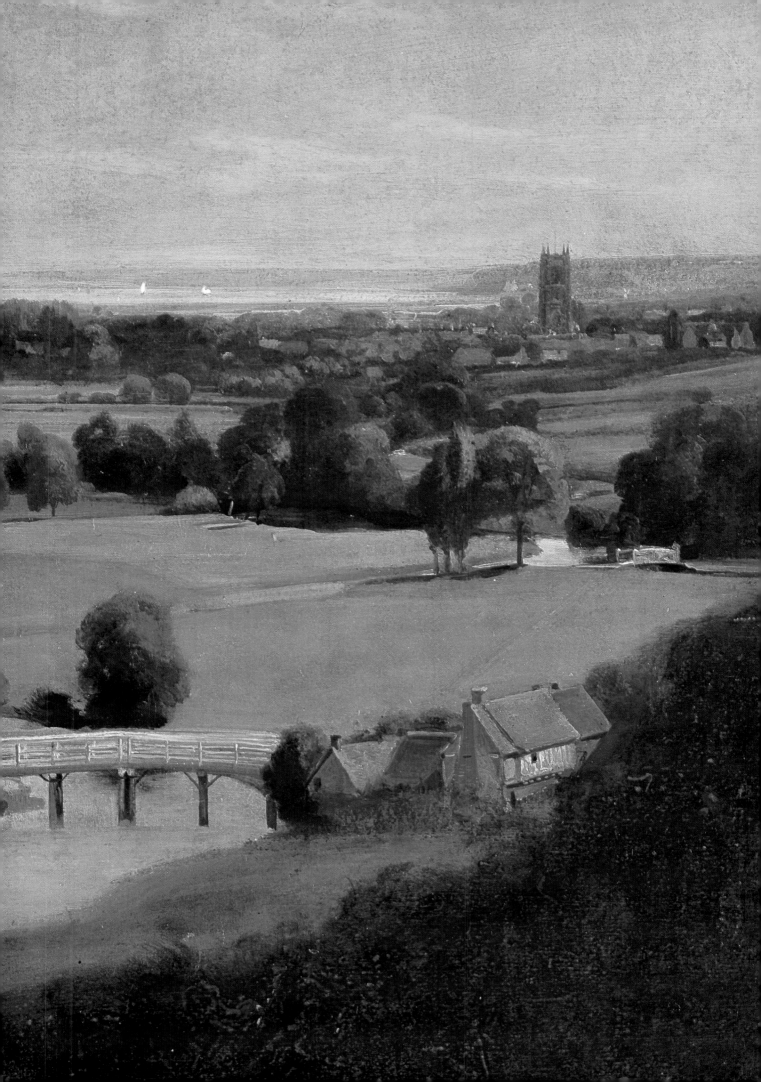

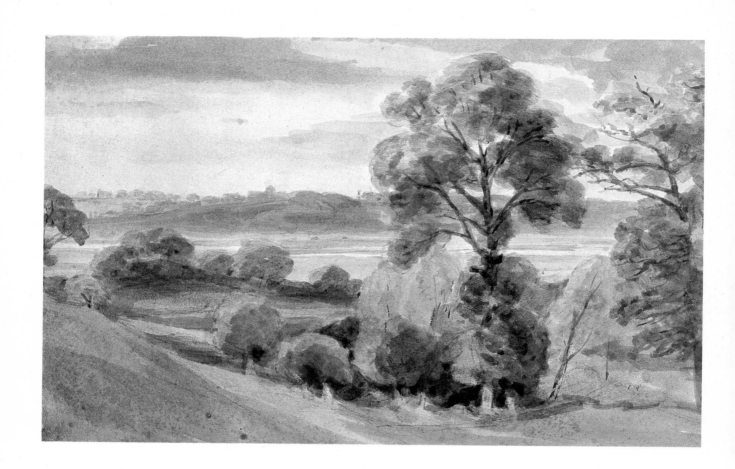

When sold from Captain Constable's collection at Christie's on 11 July 1887 (lot 88), this portrait was said to have been painted in 1798 or 1799. The latter year seems more likely. Constable is first recorded in company with R. R. Reinagle, a fellow student at the R.A. Schools, in May 1799 (see JC:FDC p.269). That summer Reinagle stayed with Constable at East Berg-holt and in the winter they took lodgings together in London. Ann Taylor, later Mrs Gilbert, remembered seeing at East Bergholt 'a portrait recently taken of him by his friend Mr. Reinagle' when she was introduced to the Constable family in December 1799. Then aged seventeen, Miss Taylor was even more struck by the original of the portrait: 'so finished a model of what is reckoned manly beauty I never met with as the young painter; while the report in the neighbourhood of his taste and excellence of character rendered him interest-ing in no small degree' (JCC II pp.17–18).

For later portraits of Constable see Nos.58, 70, 285a, and 337–8.

V

JOHN CONSTABLE

III Golding Constable, the artist's father ?1815
Oil on canvas, 29¾ × 24¾ (75.6 × 62.9)
The Executors of Lt. Col. J. H. Constable
See the introductory text above for comment on the artist's parents.

JOHN CONSTABLE

IV Ann Constable, the artist's mother
Oil on canvas, 30 × 25 (76.2 × 63.5)
The Executors of Lt. Col. J. H. Constable
Mrs Constable played an important role in encouraging her son during his early years as an artist in London. Her series of letters to him show how closely she fol-lowed and sympathised with what he was doing, and they contain many references to the Suffolk landscape that must have delighted him during his exiles from it.

JOHN CONSTABLE

V Abram Constable
Oil on canvas, 29¹⁵⁄₁₆ × 25 (76 × 63.5)
Ipswich Borough Council
The artist's younger brother (1783–1862), who took over the running of the family business on Golding Constable's death in 1816, and sold it on retirement in 1846.

VI

JOHN CONSTABLE

VI Ann and Mary Constable
Oil on canvas, 35⁷⁄₁₆ × 27⅜ (90 × 69.5)
Private collection
The artist's eldest and youngest sisters: Ann (1768–1854) and Mary (1781–1862). A smaller version of the portrait is in the Huntington Art Gallery, San Marino, California. After the sale of their parents' house in 1819, Ann went to live in 'Wheelers', a house at Bergholt, and Mary moved with Abram to Flatford Mill. Apart from the artist, the only one of Golding's children to marry was the second daughter, Martha, who married Nathaniel Whalley, son of the head of a firm of London cheese-mongers. No portrait by Constable is known of her or of the artist's elder brother, Golding.

John Constable

VII Golding Constable's House, East Bergholt

circa 1810

Oil on canvas, 8⅞ × 27 (22.5 × 68.5)

Tate Gallery (1235)

This is one of many paintings and drawings by Constable of the house in which he was born. His final celebration of it, as the place that 'first tinged my boyish fancy with a love of the art', was the frontispiece to his book of prints, *English Landscape* (see Nos.273–4). In preparation for the sale of the house after Golding Constable's death, Abram drafted the following advertisement: 'To be sold in the delightful pleasant village of East Bergholt, a Capital Brick Mansion Freehold, with about 37 acres of land, pasture and arable, in excellent condition, communicating with excellent roads. The Mansion consists of 4 very good rooms & spacious entrance hall on the ground floor, 4 excellent sleeping rooms, with light closets & spacious landing on the second floor, 4 exceeding good atticks, most capital cellars & offices, brick stables & coach house, & every convenience that can be thought of, &c.' (JCC I p.136). Constable's biographer, C. R. Leslie, visited the house in 1840 – 'a large and handsome mansion, at that time untenanted' – but it had been pulled down by 1845, when he published the second edition of his *Life* of the artist (Leslie 1845 p.313, 1951 p.285). Constable often drew and painted the views to be had from the upstairs windows at the back of the house – the side shown in No. VII (see Nos. 9, 26, 128, 134, 135).

VIII 'A Map of the Parish of East Bergholt in the County of Suffolk' 1817

34⅞ × 40¼ (88.5 × 102.2)

Suffolk Record Office

This map, surveyed by Robert Corby of Kirkstead, Norfolk, records the disposition of land in East Bergholt in 1817 following the Enclosure awards. Exchanges of land were made to consolidate holdings but the basic pattern of this already long-enclosed landscape remained much the same. For clarity, a marked photograph is placed alongside to show the Constable family holdings and some of the sites where Constable painted.

VII

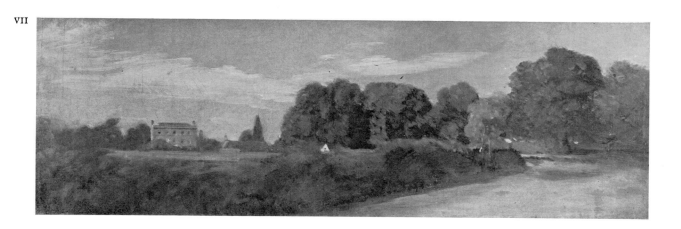

John Constable 1776-1837

BEFORE 1796

Circa 1783: Constable is sent to school at Ford Street, Essex; later to Lavenham, where the boys are flogged without mercy by the usher, the master being much absent; finally to Dedham Grammar School, where he is treated with tolerant understanding by the master, the Revd. Dr Grimwood. 1792: carves his name and the outline of a windmill on the timbers of his father's mill on East Bergholt Heath. *Circa* 1793: his father, Golding Constable, takes him into the business, as he does not want him to enter a profession; already 'devotedly fond of painting', he spends much of his spare time painting with John Dunthorne (1770–1844), the village plumber, glazier, house-decorator and constable, a near neighbour and keen amateur artist; makes a sketching tour of Norfolk with one of his father's clerks, a Mr Parmeter. 1794: two people who were to play important parts in Constable's life, Joseph Farington R.A. and Sir George Beaumont, both at the centre of art politics, stay with the dowager Lady Beaumont at Dedham, Farington noting that 'The country about Dedham presents a rich English landscape, the distance towards Harwich particularly beautiful'. 1795: Constable's mother obtains for him an introduction to Sir George Beaumont at Dedham; his copies of the Dorigny engravings after Raphael are shown to Beaumont, who allows him to see his Claude 'Hagar and the Angel'.

1 **Girl and Dog in a Landscape** *circa* 1789
Watercolour and pencil, $8\frac{5}{8} \times 8\frac{1}{16}$ (21.9 × 20.5)
Prov: given by Lionel Constable to Julie Myers before 1887 (when Lionel died) and by her to Annie Gertrude Chataway in 1898; . . . ; bt. from Tyne House Antiques, Lewes, Sussex by present owner 1971
Dr Roy Pryce

1

This appears to be Constable's earliest known work. The following inscription is on the back: 'By John Constable Given to Miss Julie Myers by Lionel Constable who said that it was drawn by his Father at about the age of 13 when he did many such compositions. Given by Miss J. M. to Miss Annie Gertrude Chataway in 1898.'. Without these particulars there would be little reason to associate the watercolour with Constable, but there seems equally little reason to doubt the information conveyed in the inscription. Lionel's reference to his father's age and to other works of a similar character suggests that he knew what he was talking about. The watercolour may have been, at least in part, copied from a print but so far no such source has been identified. Nor is it known whether Julie Myers was related to Lindo S. Myers, who purchased many drawings from Constable's grandson Eustace (see Reynolds 1973 p.236).

2

2 Two fragments from the Windmill on East Bergholt Heath d.1792
a) Incised outline of a windmill
Wood, $4\frac{7}{8} \times 3\frac{3}{8}$ (12.4 × 8.5)
b) Incised inscription: 'J. Constable 1792'
Wood, $3\frac{3}{4} \times 6\frac{11}{16}$ (9.5 × 17)
The Victor Batte-Lay Trust, The Minories, Colchester

These two fragments come from the Constable family windmill on East Bergholt Heath. The windmill figures in No.135 below and in many other works by Constable. 'For about a year', wrote Leslie, 'Constable was employed in his father's mills, where he performed the duties required of him carefully and well. He was remarkable among the young men of the village for personal strength, and being tall and well formed, with good features, a fresh complexion, and fine dark eyes, his white hat and coat were not unbecoming to him, and he was called in the neighbourhood the "handsome miller".' (1843 p.3, 1951 p.4.)

Leslie was evidently shown these carvings *in situ* when he visited Suffolk in 1840. He described them and another of Constable's juvenile works thus in a trial run for the opening pages of his *Life* of the artist: 'A drawing of a tower mill, made by him at that time, might be seen until within these few years pasted against one of the timbers in Flatford Mill; and in a windmill in which he also worked, and which is seen in the accompanying engraving ['Spring'] its outline is very accurately and neatly carved in miniature, with a penknife, and under it the name of "John Constable, 1792"' (Private collection; see JC:FDC p.252).

The Bergholt windmill was described in the conditions of sale when Abram Constable retired from the business in 1846 as a 'Capital Post Windmill, with round house, driving 2 pairs of stones' with 'Miller's Cottage, orchard, gardens, and 2 enclosures of arable land' (*East Anglian Miscellany*, Part IV, 1934, p.77).

3

3 Christ's Charge to Peter (Copy of Dorigny's engraving after Raphael) d.1795
Pen and wash, $19\frac{1}{4} \times 29\frac{3}{8}$ (48.9 × 74.6)
Inscribed 'John Constable delt 1795'
Prov: . . . ; J. P. Cochrane, sold Christie's 17 December 1948 (2), bt. Abbott; . . . ; bt. by Victor Batte-Lay Trust from K. F. Taylor 1961
The Victor Batte-Lay Trust, The Minories, Colchester

This is one of the earliest signed and dated drawing by Constable to survive. He copied at least two other of Nicholas Dorigny's engravings of the Raphael Cartoons: 'The Death of Ananias' and 'The Blinding of Elymas' (the copies were in the 17 June 1892 sale, lot 134, where described as made in 1795). Sir George Beaumont, the distinguished amateur artist and connoisseur, was shown Constable's copies of the prints and, according to Leslie, 'expressed himself pleased' with them (1843 p.3, 1951 p.5). Constable's introduction to Beaumont and the latter's approval of the copies were to have important repercussions.

1796

4
5

Summer: stays with relations, the Allens, at Edmonton, possibly in connection with his father's business; meets J. T. Smith, John Cranch and others with artistic and antiquarian interests; on Cranch's advice, buys books on art. *October:* draws Suffolk cottages for Smith, who sends him casts from the Antique; paints a moonlight and two figure subjects in the style of Cranch; studies anatomy in the evenings.

4 Cottage at Holton d.1796
Pen and ink, 7⅛ × 11¾ (18 × 29.9)
Inscribed 'Holton Suffolk with the Church in the Back Ground', and under the gable of the dormer window 'J.C 1796'
Prov: presented to the V. & A. by Isabel Constable 1888
Victoria and Albert Museum (R.10)
See No.5.

5 Cottage at East Bergholt, with a Well 1796
Pen and ink, 7⅛ × 11¾ (18 × 29.9)
Inscribed 'E Bergholt Suffolk'
Prov: presented to the V. & A. by Isabel Constable 1888
Victoria and Albert Museum (R.4)

The 'Cottage at Holton' and the Forty Hall 'Dell' (No.6) are the earliest known dated landscape drawings by Constable. With No.5 and eleven similar drawings at the V. & A. (R.2–3, 5–9, 11–13) the Holton view comes from the first sketchbook the artist is known to have used. The drawings it contained were probably made in the hope that they might please his new friend J. T. Smith. The first professional artist with whom Constable formed a friendship, at this time Smith was about to move to London (where his father kept a print shop) after some years as a drawing master at Edmonton. Smith remained Constable's only direct link with the art world during the next two years, and for a while was the dominating influence on his development as a draughtsman. In his first letter to Smith of 27 October 1796, Constable writes: 'I have in my walks pick'd up several cottages and peradventure I may have been fortunate enough to hit upon one, or two, that might please. If you think it is likely that I have, let me know and I'll send you my sketchbook and make a drawing of any you like if there should not be enough to work from' (JCC II p.5). This interest in picturesque cottages derived from a work Smith was preparing: *Remarks on Rural Scenery; With twenty etchings of Cottages, from Nature; and some observations and precepts relative to the pictoresque.* A little later Constable sent some of his drawings of cottages to Smith who, when replying, said that one or two were worthy of his needle (*ibid.*, p.8). None, however, appear to have been included amongst the twenty published etchings.

Holton St. Mary, where Constable drew his cottage, lies just across the main Ipswich–London road from East Bergholt. At Holton Hall lived the Cooks, a farming family considered to be true friends by the Constables (*ibid.*, p.246).

6

7

8

6 A Dell d.1796
Pencil and wash, 16 × 18 (40.6 × 45.7)
Inscribed 'J. Constable 1796'
Prov: . . . ; bt. by Forty Hall Museum from
Manning Galleries 1967
Forty Hall Museum, London Borough of Enfield
It is not easy to find a place for this proficient if rather
awkward drawing, as nothing quite like it is to be found
among Constable's known early work. Clearly, the
scene is not drawn from nature, but on the other hand
it does not look quite like a copy of a landscape drawing
or engraving. Could it have been inspired by the
theatre? In the memoirs of more than one artist who
was young at this time we read of the powerful im-
pression made by the brightly lit landscapes that they
saw in the London theatres, sets painted by artists such
as Michael Angelo Rooker and John Inigo Richards.
Constable could have visited the theatre when he was
staying with his relatives at Edmonton in the summer
of 1796. Could this have been drawn from memory
after one such visit, or was it a design dreamed up by a
youth who saw himself as a scenic artist? The unusual
proportions of the drawing point to a theatrical source,
being similar to those of a contemporary proscenium
arch.

7 The Chymist d.1796
Oil on panel, 7⅞ × 6⅜ (20 × 16.2)
Inscribed on verso '[. . .] 1796 The Chymist'
Prov: early history unknown; in the present
owner's family for a hundred years or more
Private collection
See No.8.

8 The Alchymist d.1796
Oil on panel, 7⅞ × 6⅜ (20 × 16.2)
Inscribed on verso 'John Constable pinx 1796
The Alchymist'
Prov: as for No.7
Private collection
Constable referred to this pair of pictures in a letter to
J. T. Smith of 16 January 1797: 'I have lately copied
Tempesta's large Battle, and painted two small pictures
in oil, viz: a Chymist and an Alchymist; for which I am
chiefly indebted to our immortal Bard. You remember
Romeo's ludicrous account of an Apothecary's shop.
This discription is undoubtedly natural, but certainly
unnatural for him to make at that time [i.e. when intent
on buying poison for himself]' (JCC II pp.8–9). Con-
stable's alchemist more or less resembles Shakespeare's
apothecary (*Romeo and Juliet*, v.i). He wears 'tatter'd
weeds', is 'meagre' in look and his shop contains
 An alligator stuff'd, and other skins
 Of ill-shap'd fishes; and about his shelves
 A beggarly account of empty boxes,
 Green earthen pots, bladders, and musty seeds . . .
By contrast, the 'Chymist' is respectably dressed and
his workroom tidy. As Leslie said, Constable 'probably
intended a moral by the ragged and poverty-struck ap-
pearance of the alchymist, while the chymist is neat and
comfortable' (1843 p.5, 1951 pp.7–8). He seems, in fact,
to be playing off two concepts of science here, as some-
thing magical and obscurantist and as a process of free
enquiry, just as in one of the 'separate scraps' found by
Leslie among Constable's papers he plays off two con-

cepts of art by means of the same allusion:

> The old rubbish of art, the musty, common place,
> wretched pictures which gentlemen collect, hang up,
> and display to their friends, may be compared to
> Shakespeare's
>> 'Beggarly account of empty boxes,
>> Alligators stuffed,' &c.
> Nature is anything but this, either in poetry, painting,
> or in the fields. (Leslie 1843 pp.118–19, 1951 p.273)

The actual appearance of the paintings owes something to the example of his friend John Cranch, whose own picture of 'the Alchymists' he offered to try to sell in October 1796 (JCC II p.5). Constable most likely used coach panels as supports. In the letter of 16 January 1797 already quoted from, he remarks to Smith: 'You say coach pannels are very scarce, do not trouble yourself to send any as since I wrote to you I have found out a place to get them'.

9

1797

January: tries his hand at etching; writes to Smith for more books; studies perspective. *March:* advised by Smith to attend to the family business; obtains subscribers for Smith's forthcoming *Remarks on Rural Scenery. May:* at Smith's request, makes enquiries about Gainsborough in Ipswich. *Autumn:* visits Smith in London; possibly attempts to obtain consent to leave family business.

9 View from Golding Constable's House 1797
Pen and ink, sheet size 10$\frac{13}{16}$ × 7$\frac{3}{16}$ (27.5 × 18.3), approx. size of drawing 5$\frac{1}{4}$ × 7$\frac{3}{16}$ (13.4 × 18.3)
Lower half of a letter written on one side of a single sheet to J. T. Smith; inscribed 'View from my Window'. Interleaved in a copy of Leslie's *Life*
Prov: the volume containing the letter formerly belonged to Lord Lee of Fareham but the earlier provenance of the letter itself is unknown
Mr and Mrs Paul Mellon

The letter under which Constable drew the view from his window was written to accompany a perspective drawing lent him by a London friend, William Thane, a drawing Thane had asked him to send on to Smith when he had done with it. The note was probably written in January or February 1797 (see JC:FDC pp.292–3). Constable had complained in his previous letter of 16 January (JCC II pp.8–9) because Smith had only filled half of his sheet of paper when last writing. In this note he apologises for having been so ungrateful. Was he dropping a hint when making his sketch as to how the blank half of a sheet might be filled?

Though crudely drawn, the scene is recognisable as part of the home farm at East Bergholt. The thatched building in this sketch of 1797 is depicted again in No.134, half-hidden behind a barn Golding Constable must have built in the intervening years.

10

11

10 East Bergholt Church: the exterior from the S.W. *circa* 1797
Pen and watercolour, squared for transfer,
10⅛ × 15⅝ (25.8 × 39.7)
Prov: presented to the V. & A. by Isabel
Constable 1888
Victoria and Albert Museum (R.15)

When writing to his eldest son in 1833 about a school-friend who wanted to learn to draw, Constable referred to perspective as 'the whole grammar of Painting & drawing' (JC:FDC p.86). It is likely that this attempt at East Bergholt Church was in fact an exercise in the application of two-point perspective.

In Constable's letters to Smith, there are references which suggest that the drawing was done during the winter of 1796–7. 'I shall soon send you our Church', he tells him on 9 November 1796, 'I was thinking of painting it in oil. would it suit you as well to etch from ?' (JCC II p.6). In No.9, a letter written early the following year, we have Constable writing about a perspective drawing which he had been lent. On 21 February 1797 he writes: 'I have begun the Church which I promised You and find it rather a troublesome and tedious job. I have had the misfortune to cut my thumb a little, sufficient to hinder me from holding my pencil with pleasure' (JC:FDC p.294). Holmes (1902, p.238) records having seen an oil painting of East Bergholt Church at Messrs Leggatt's exhibition of 1899 (No.55) which he describes as 'nearly identical' with No.10.

The two poplar trees to be seen in the drawing down the village street to the left of the church stood close by the Constables' house. They are a regular feature in the artist's drawings and paintings of his home.

11 A rider and companion crossing a bridge
circa 1797
Pen, black ink and grey wash, 8¹⁵⁄₁₆ × 8⅜ (22.7 × 21.2)
Prov: Mary Constable; Revd. D. C. Whalley; by descent to the present owner
Private collection

The five drawings grouped together here (Nos.11–15) are representative examples of some two dozen early studies by Constable, part of the contents of a portfolio that his sister Mary left to her nephew Daniel Whalley when she died in 1865. In addition, there are a number of drawings in pencil by Constable's early friend R. R. Reinagle from the same portfolio; two of these are signed and dated 1799, the year in which he stayed with Constable at Bergholt. The group of Constable drawings is here listed in a possible chronological order.

No.11 is clearly an invented scene, with some of its elements possibly derived from Continental engravings. Similar nervous little touches of the pen are to be seen in drawings of 1796 and 1797.

12 A figure resting beside a wooded track
circa 1798
Pen, brown ink and wash, 6⅝ × 8¹⁄₁₆ (16 × 20.5)
Inscribed on verso 'J. C. del.'
Prov: as for No.11
Private collection

Though hardly more impressive an invention than No.11, the handling in this is nevertheless not so tense, and appears to be closer in character to the drawings of the churches believed to be of 1798 (see No.17).

13 **A copse** *circa* 1799
Pencil, pen and brown ink, $8\frac{7}{8} \times 12\frac{3}{16}$ (22.5 × 31)
Prov: as for No.11
Private collection

Almost certainly a study from nature; it was not within his powers to invent such forms at this time. Though hesitant and in some ways inept, one characteristic has already begun to emerge, an avoidance of the more common conventions for foliage – repeated loops and scalloping – in favour of separate touches, considered individually.

15

14 **A track between trees, with a barn and water to the right** *circa* 1799
Pencil, 7×9 (17.8 × 22.8)
Prov: as for No.11
Private collection

Here Constable is obviously attempting to imitate the bravura of Ramsay Reinagle. All of the Whalley Reinagle drawings are in pencil, and all exhibit a masterly but entirely mechanical grasp of what has been termed 'the drawing master style'. Unable to emulate the other's all-too-skilful outlining, Constable can only manage to copy his rapidly dashed-in mode of shading.

15 **Valley among mountains**
Grey wash, $4\frac{15}{16} \times 7\frac{7}{8}$ (12.5 × 20)
Prov: as for No.11
Private collection

16

Alexander Cozens is possibly a name that springs to mind in relation to this mountain study in grey wash. Since Sir George Beaumont, Constable's mentor, had been a pupil of Cozens, it is not difficult to imagine a connection of some sort – Beaumont showing the young Constable compositions by his old drawing master, for example. But a resemblance such as this drawing certainly has to one of Cozens' inventions could so easily be fortuitous. With our limited knowledge of this stage of Constable's development, it is surely better to maintain an open mind and not start calling in the more familiar and obvious sources of influence.

1798

Autumn: Smith stays at East Bergholt and is introduced to local friends.

16 **John Brewse's Monument in Little Wenham Church, Suffolk** d.1798
Pen and wash with some tinting, $7\frac{1}{2} \times 5\frac{7}{8}$
(19 × 14.9)
Inscribed 'J. Constable delt 1798.' and 'John Brews's Monument in the Church of Wenham Parva, Suffolk.'
Prov: . . . ; private collector, Switzerland; Andrew Wyld 1973; bt. by present owner from Leger Galleries 1974
Miss Camilla Binny

Constable appears to have acquired a taste for antiquities when staying at Edmonton in 1796. Ruins of all

17

kinds and indeed any surviving evidence of the past – ancient houses and buildings, inscriptions, old bones, fossils – remained an abiding interest all his life.

It is likely that this careful study of a sixteenth-century monument in Little Wenham church was made with J. T. Smith in mind, and it is even possible that it was done in his company. In 1796, Constable had sent him a copy of an inscription over the doorway of an old building in the neighbourhood, and had promised to enclose a sketch of it in his next letter. A drawing by Constable of a Latin inscription dated 1569 within a cartouche carved in stone over a doorway at Little Wenham Hall is in the Victoria and Albert Museum (R.6). This is considered to be the inscription to which he refers in his letter. In later years Smith was to make a name for himself with his etchings of antiquities. We know that when he and Constable were driving to Ipswich in 1798 they stopped the gig so that Smith could make a drawing of a picturesque old well. Little Wenham Hall and its church lie not far off the Ipswich road, well within range of Bergholt by gig.

17 Stratford St. Mary Church *circa* 1799
Pen and watercolour, $6 \times 7\frac{5}{8}$ (15.2 × 19.4)
Prov: . . . ; from Kentwell Hall, Long Melford, Suffolk
Harold A. E. Day

The parish of Stratford St. Mary lies next to that of East Bergholt. The tower of the church is one of the three – the others being Langham and Stoke-by-Nayland – to be seen in many of the westward-looking views of the Stour valley which Constable painted from the slopes below his village and from viewpoints along the road to Flatford.

In the same collection as No.17, and almost a pair to it, is a tinted drawing of Little Wenham Church. Both are very much in the manner of J. T. Smith.

1799

January: at Mrs Cobbold's, in Ipswich, he meets Mrs Priscilla Wakefield, the author. *25 February:* calls on Joseph Farington, R.A., in London and presents a letter of introduction from Mrs Wakefield; has his father's consent to his studying art. *4 March:* admitted as a probationer to the Royal Academy Schools; continues to call on Farington, who lends him a painting by Wynants to copy. *May:* he is among many artists listed at William Beckford's London house to see the famous Altieri Claudes; copies from memory a landscape by Wilson at Sir George Beaumont's. *18 August:* staying with Cobbolds in Ipswich; sees 'Gainsborough in every hedge and hollow tree'; R. R. Reinagle, fellow-painter, stays with him at Bergholt. *23 September:* still in Suffolk. *December:* listed among students qualified to work in Antique Academy; lodging with Reinagle.

18 A Cottage among Trees d.1799
Pencil and grey wash, $9\frac{1}{2} \times 13$ (24.1 × 33)
Inscribed on verso 'Letitia Proby 23ᵈ Septʳ 1799'
Prov: . . . ; bt. by present owners from Mickelson's, Washington 1963
Mr and Mrs Paul Mellon

Constable made this sketch in the summer vacation following his first months of study at the Royal Academy Schools. As yet, he still draws in much the same way as before, with hesitant touches of the pencil and indecisive monochrome washes, a manner derived from his friend J. T. Smith. Smith's taste is also to be seen reflected in the choice of subject: the humble cottage with its air of cosy dilapidation. As only five weeks had passed since Constable had been telling Smith that he fancied he saw Gainsborough in every hedge and hollow tree (JCC II p.16), perhaps it would not be too fanciful if we saw a touch of Gainsborough as well in the drawing.

It is not known why Letitia Proby's name should appear on the back of the drawing, but it is very possible that she was a daughter of the Revd. Narcissus Proby (1737–1804), rector of Stratford St. Mary. A small portrait of Proby, said to be by Constable and dated prior to 1796 by Beckett, is believed to be still in the possession of the sitter's descendants (JCC II p.22; and Beckett Catalogue). From time to time in the Constable correspondence there are references to a Miss Proby; more than once in connection with Mrs Cobbold of Ipswich, the artistically-inclined lady with whom Constable was staying when he wrote to Smith about 'Gainsborough in every hedge'. Constable was still in touch with another Proby daughter, Sarah (by then Mrs Impey), many years later, in the 1830s.

19 Versailles d.1799
Pencil and watercolour, $5\frac{5}{16} \times 14\frac{5}{8}$ (13.4 × 37.2)
Inscribed 'J. Constable 1799'; colour notes in sky: 'bistre' and 'grey green'
Prov: . . . ; bt. by Ipswich from E. Samuel 1929
Ipswich Borough Council

As with No.1, without the inscription there would be little reason to associate this copy of an unidentified print of Versailles with Constable. The signature is unquestionably authentic, however, and the drawing must be allowed to find a place for itself among the other examples of his work of these early years.

20 Lamarsh House late 1790s
Oil on canvas, 21×30 (53.3 × 76.2)
Prov: said to have been painted for the Revd. Brooke Hurlock; his daughter, Lucy Blackburne; by descent to Margaret Avelina Blackburne, from whose executors bt. by Vicars Brothers Ltd, 1933[1]; . . . ; Vicars Brothers Ltd, 1948; Leggatt's; . . . ; 1st Baron Fairhaven; bequeathed by him to the National Trust 1966
The National Trust (Fairhaven Collection, Anglesey Abbey)

The attribution of this painting to Constable has been doubted in recent years but the organisers find the picture sufficiently credible to be worth including here in the context of Constable's more certain early work: comparison may show whether it is more or less than a likely candidate.

The subject and its associations certainly point in Constable's direction. Lamarsh House, on the Essex side of the Stour south-east of Sudbury, was the residence of the Revd. Brooke Hurlock, Rector of Lamarsh from 1761 onwards and from 1790 also Curate of Langham on behalf of its titular Rector, Dr John Fisher, later Bishop of Salisbury. It was Hurlock who, probably in 1798, introduced Constable to Dr Fisher, a meeting which the artist was later to describe (in the letterpress to his volume of prints *English Landscape*) as an event which 'entirely influenced his future life' because it led to his great friendship with the Bishop's nephew, Archdeacon John Fisher. The Constables and Hurlocks probably got to know each other when Brooke Hurlock moved to Dedham in 1790 to be closer to his new duties at Langham and also to his sons who were attending Dedham Grammar School (his curate officiated for him at Lamarsh from 1790 to 1800: JCC II p.18). As explained in the entry on No.22 below, Constable gave four watercolour panoramas of the Stour valley to Hurlock's daughter Lucy when she married Thomas Blackburne in 1800. According to a descendant, Margaret Avelina Blackburne[2], this oil painting of Lamarsh House was also a wedding present for Lucy, given in this case by her father, though Miss Blackburne apparently thought the marriage took place in 1803. Lucy was presumably born at Lamarsh House and the painting would therefore have reminded her of her native scenes when she moved to Norfolk on her marriage. Assuming the painting to be by Constable, it is unlikely to have been actually commissioned as a wedding present. Although there are some similarities with the picture of 'Old Hall' of 1801 (No.27), the differences seem too great to be explained by the interval of only a year: perhaps Brooke Hurlock had commissioned the work for himself a few years earlier.

There is another, unfinished, painting on the back of the canvas.

1800

January: Farington lends him a Wilson landscape to copy, and in *February* calls on him and Reinagle at their lodgings. Copies landscapes by Caracci, Wilson, Ruisdael and (at Beaumont's) Claude. *May:* dines at the Beaumonts' and is seen by Farington copying a Claude there. *June:* further calls on Farington. *July:* spends some time drawing alone among the oaks of Helmingham Park, the Dysarts' Suffolk estate.

21 Helmingham Dell d.1800
Pencil and grey wash, 21 × 26⅛ (53.3 × 66.4)
Inscribed 'July 23 1800. Afternoon'
Prov: . . . ; Anon., sold Christie's 9 June 1964
(229), bt. Spink for present owners
The Clonterbrook Trustees
This is one of the most important of Constable's early dated drawings. The subject it depicts, a watercourse running through the Park at Helmingham, in later

18

19

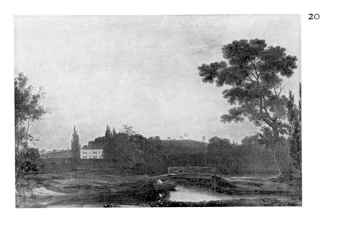

20

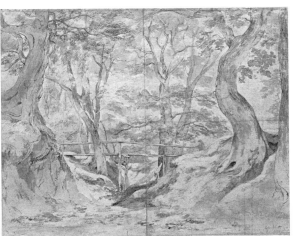

21

22

years became a favourite theme, and it appears to have been from this drawing that he painted some of the versions of 'the Dell', as he called it.

Helmingham was at this time owned by Wilbraham, 6th Earl of Dysart, and formed the greater part of his Suffolk estates. In the summer of 1807 an introduction to Lord Dysart was obtained for Constable by Peter Firmin, a Dedham solicitor and business associate of Golding Constable. As a result, the artist was given a number of commissions by members of the family. From the letter Firmin wrote to tell Constable of the Dysarts' interest in him, we gather that Constable had recently been to another of the Dysarts' properties, Ham House, Richmond, with a party of visitors. The Earl, Firmin wrote 'asked me *who* were of the party, on mentioning M^r Constable an artist and Connissieur, he asked if *the* M^r Constable who had Copied the Picture at Hellmingham, on my saying the same Gentleman Lord D. said I should like to see the Copy' (JC:FDC pp.114–16). We cannot tell from this whether the copy was made on his visit of 1800, when Constable certainly drew in the park, or on some other occasion, but the passage quoted does at least indicate that it had been done with the Earl's knowledge.

Two days after making this drawing (No.21), Constable wrote a short but memorable letter to Dunthorne at Bergholt: 'Here I am quite alone amongst the oaks and solitude of Helmingham Park. I have quite taken possession of the parsonage finding it quite emty. A woman comes from the farm house (where I eat) and makes the bed, and I am left at liberty to wander where I please during the day. There are abundance of trees of all sorts; though the place upon the whole affords good objects rather than fine scenery; but I can hardly judge yet what I may have to show you. I have made one or two drawings that may be usefull. I shall not come home yet.' (JCC II p.25.)

Leslie says that he had two drawings of Helmingham dated 23 and 24 July in his possession which, though slight, he praises for their composition (1843 p.6, 1951 p.11). No.21 might have been the first of the two he mentions; it is not a worked-up study, and Constable himself certainly approved of it as a composition.

In the past, 'Helmingham' has been a convenient title to attach to drawings which might be examples of Constable's early work. An indubitable Constable of Helmingham, a fine wash study of the same serpentine oak to be seen on the right-hand side of the present drawing, is owned by Leeds City Art Gallery. The tree itself, considerably stouter but recognisable by its position and unusual twisted form, is still to be seen in the Park on the north side of the watercourse. A black-and-white chalk drawing on grey paper in the Victoria and Albert Museum (R.57, 'Study of ash and other trees') also appears to be a study of the dell, but a little further upstream, where the banks are less high. It could also have been done that same summer. Constable was sketching on grey paper in Derbyshire the following year.

22 **Dedham Church and Vale** 1800
Pen and ink and watercolour, 13⅝ × 20¾
(34.6 × 52.7)
Prov: given by the artist to Lucy Hurlock on her marriage to Thomas Blackburne 1800; by

descent to Eva Ducat, sold Christie's 6 July 1934 (4), bt. Walker; Norman D. Newall; The Fine Art Society Ltd, from whom bt. by the Friends of the Whitworth Art Gallery and presented to the Gallery 1943.

Whitworth Art Gallery, University of Manchester
This is one of a set of four watercolours which Constable made in 1800 as a wedding gift for Lucy Hurlock, the daughter of the Revd. Brooke Hurlock, rector of Lamarsh and curate, for Dr John Fisher, of Langham. When seen together, the four drawings provide a panorama of the Stour valley from east to west as it appeared at the turn of the century. The drawings also provide a useful guide to the artist's estimation of his own capabilities at this time, and indicate the sort of performance with which he thought he could best please.

Three of these views were drawn from the same spot: the present view, No.22; 'The valley of the Stour, with Stratford St. Mary in the distance' (V. & A. R.16B); and 'The valley of the Stour, with Langham Church in the distance' (V. & A., R.16A). For these three, Constable chose as his viewpoint a position on the Essex side of the valley just above the toll-gate, after passing through which the traveller from London crossed over the Stour into Suffolk. The fourth in the series, 'The valley of the Stour, looking towards East Bergholt' (V. & A., R.16C), was taken from a spot a little to the east and rather lower down.

Later we shall find Constable painting another view of the Vale for a departing bride to remind her of the scenes of her childhood (No.133).

23 Academy study *circa* 1800
Black and white chalk on grey paper, $22\frac{3}{4} \times 14\frac{1}{8}$ (57.8 × 35.9)
Prov: always in the Constable family
The Executors of Lt. Col. J. H. Constable

Undoubtedly an early drawing, and probably a fair example of Constable's work in the life-class at the Academy around the turn of the century. During his years as a student, the Academy Schools were presided over by two Keepers: until 1803 by Joseph Wilton, the elderly sculptor (1722–1803), and thereafter by the dynamic Henry Fuseli (1741–1825). We have a description of their contrasting methods of instruction. Wilton, a man of 'very great personal neatness, frill and ruffles forming prominent features in his dress ... would gently come up to the draughtsman's side, and collecting his delicately white ruffles between the tips of his fingers and the palm of his hand, begin to rub over the offending parts, smudging the white with the black chalk, saying, "I do not see those lines in the figure before you".' Fuseli, on the other hand, demanded boldness of outline and vigour of execution, and disliked what he called, in his broken English, 'a neegeling tooch'. After a student had been a week or ten days working on his drawing with chalk and the stump, the Keeper would 'stealthily come behind him, and looking over his shoulder would grasp the porte-crayon, and, standing at arms length from the drawing, would give so terrific a score as to cut through the paper and leave a distinct outline on the board beneath . . . "There, Saar, you should have boldness of handling and a greater fweedom of tooch".'[1] It is perhaps worth bearing this des-

23

24

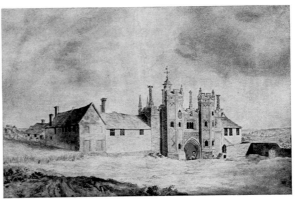

25

26

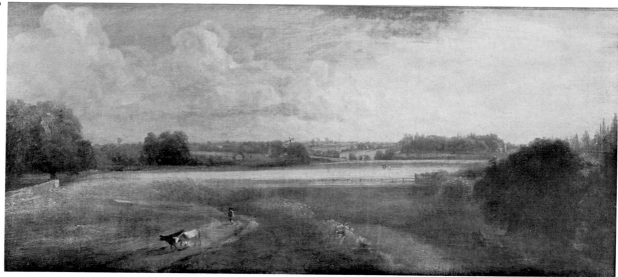

cription in mind when Constable's development as a draughtsman is under consideration. With its blurred treatment and avoidance of outline, No.23 might well have earned the approbation of the old sculptor, but it could hardly have been done to please the terrifying little Swiss.

24 The Interior of East Bergholt Church
circa 1800
Pen and grey wash, 24 × 16 (61 × 40.6)
Inscribed 'John Constable'
The Rector and Churchwardens of East Bergholt Parish Church

Though undoubtedly a view of the east end of the church, there seems to be no record of a Doric screen such as this ever having existed at East Bergholt. The drawing itself is also unusual, for pen and wash used thus by Constable is not to be seen before the Brighton drawings of 1824. This drawing, however, must be early. Perhaps the parish was considering the idea of commissioning local craftsmen to build a new screen and, as the local artist, Constable was asked by the council officers to draw out the kind of thing that they had in mind. For most of his life at Bergholt, Golding Constable, the artist's father, regularly served his terms as officer on the parish council – as Churchwarden, Surveyor or Overseer.

25 Giffords Hall circa 1800
Pen and ink and watercolour, 13⅝ × 20¾
(34.6 × 52.7)
Prov: . . . ; by descent in the Crouch family; bt. by present owner from A. E. Crouch 1969
Private collection

A number of Constable's portraits of country houses are to be seen in this exhibition – drawings as well as oil-paintings. This view of Giffords Hall must be among the earliest so far identified. When it is seen alongside a drawing such as the Whitworth 'Dedham Church and Vale' of 1800 (No.22) there seems little doubt that it is of the same period.

Hardly changed in appearance since Constable drew the entrance front, the early Tudor Hall is about three and a half miles, as the crow flies, from East Bergholt. A previous Giffords Hall of about 1200, which stood a short distance from the present one, was built by a Richard Constable who may have been an ancestor. In the summer of 1838, the year after his father's death, John Charles Constable was befriended by a Mr Kendal of Giffords Hall when he went to stay with his uncle and aunt at Flatford Mill (Constable Archive: Diary of John Charles Constable, 7 & 16 June 1838). There are a number of references to the Kendals in the Correspondence.

26 View from Golding Constable's House, East Bergholt circa 1800
Oil on canvas, 13 × 29½ (33 × 75)
Prov: . . . ; Wynn Ellis, sold Christie's 15 July 1876 (47, 'A Landscape: a view in Norfolk'), bt. Graystone; bequeathed by S. W. Graystone to Downing College
The Master, Fellows and Scholars of Downing College, Cambridge

The subject of this painting, which has not previously been identified, suggests that its old attribution to Constable should be taken seriously. Comparison with 'Golding Constable's Kitchen Garden' of 1815 (No.135), and with such other studies as Nos.93 and 120, shows quite clearly that the view is from an upstairs back window of Golding Constable's house at East Bergholt. Golding's windmill is on the horizon in the centre and the Rectory with its distinctive group of trees at the right. The wall in the left foreground forms the boundary of the flower garden seen in the other 1815 picture (No.134). The absence of the flower garden and kitchen garden from the foreground of No.26 is probably an indication of Constable's unwillingness at this early date to admit such particulars into a picture – a Gainsboroughian cowherd and cows seemed a more fitting foreground feature.

1801

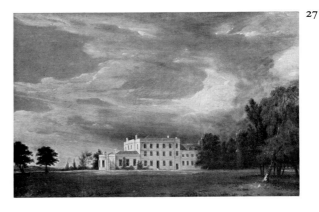

27

Leaves Reinagle and takes lodgings in Rathbone Place. *March:* pays a number of calls on Farington; speaks harshly of Reinagle and talks of his own low state of mind; after a visit to Beaumont is animated 'to proceed with resolution'; studies in Beaumont's gallery. *April:* spends much time with his married sister, Martha Whalley, at America Square, near the Tower of London; continues to call on Farington; thinks highly of Turner's 'Dutch Boats in a Gale' at the Academy. *May:* is often at America Square. *June:* tells Farington his father thinks that he pursues a shadow, 'wishes to see him employed'. *July:* asks Farington to call and see his picture of Old Hall, East Bergholt (No.27), and advise as to what he should charge. *23rd:* arrives at Fenton, Staffordshire, to stay with the Whalleys, his married sister's parents-in-law. *31st:* sets out with Daniel Whalley, the younger, on a tour of Derbyshire – Matlock, Baslow, Chatsworth, Dovedale, etc. *19 August:* a chance meeting with Farington at the entrance to Dovedale. *20th:* back at Fenton from tour; over the next few weeks joins Whalleys on many excursions, to Trentham, the Spode factory, etc. *17 November:* leaves Fenton for London.

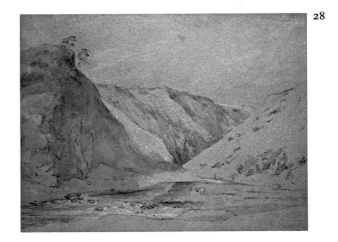

28

27 Old Hall, East Bergholt 1801
Oil on canvas, 28 × 42 (71.1 × 106.7)
Prov: painted for John Reade of Old Hall, East Bergholt 1801; acquired with the house by Peter Godfrey 1804; by descent to Miss Muriel Gore, sold Sotheby's 2 July 1958 (135), bt. Leger Galleries, from whom bt. by present owner.
Private collection

This is the first securely-dated landscape painting by Constable and one of his first excursions into house portraiture – later examples include 'Malvern Hall' (Nos. 88 and 202) and 'Englefield House' (No.296). It is not known how John Reade came to commission this painting of his house (a manor-house of East Bergholt) or what relations existed between him and the Constable family. The picture is, however, well documented by the entry in Farington's diary for 13 July 1801: 'Constable called on me & I on him to see a picture a view of M.r Reads house near Dedham. – It is painted on a coloured ground which he has preserved through the blue of his sky as well as the clouds. – His manner of painting the trees is so like Sir George Beaumont's that they might be taken for his. – He desired me to give him my opinion ab.t *price* & having mentioned 3 guineas I told him He could not ask less than 10 guineas. –'. When Reade died in 1804 the house (and with it the painting) was bought by Peter Godfrey of Woodford, who did not however become lord of the manor until 1811, this right being held by Mrs Sarah Roberts (see No.32) rather than by John Reade. The Godfreys were later to become some of Constable's most loyal local supporters (see No.133).

A slight pencil sketch of Old Hall, probably made in 1803, is in the V. & A. (R.42a), as is an elaborate drawing of trees in Old Hall park made in 1817 (No.156).

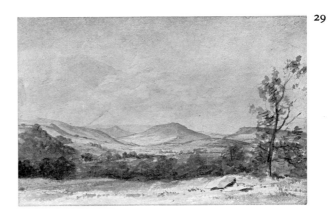

29

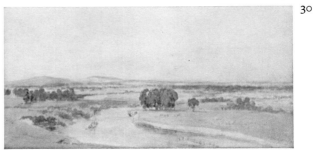

30

28 Dove Dale d.1801
Black and white chalk on blue paper, $11\frac{1}{8} \times 13\frac{7}{8}$
(28.2×35.2)
Inscribed 'Dove Dale [?August 1st] 1801'
Prov: . . . ; Karl Madsen; bt. by the Royal
Museum 1956
*Department of Prints and Drawings, The Royal
Museum of Fine Arts, Copenhagen*
See No.29.

29 View of Derwent Dale, Derbyshire 1801
Pencil and grey wash, $6\frac{5}{8} \times 10\frac{3}{8}$ (16.8×26.3)
Inscribed in a later hand over an erased
inscription: 'Derwent Dale Augst 8';
in a nineteenth-century hand on verso:
'Derwent Dale Aug 18–'
Prov: . . . ; H. A. C. Gregory by 1948, sold
Sotheby's 20 July 1949 (63), bt. Agnew, from
whom bt. by Friends of the Whitworth for
presentation to the Gallery 1949
Whitworth Art Gallery, University of Manchester

In contrast to the general run of contemporary land-
scape painters, Constable did not make a practice of
going on seasonal sketching tours. His drawings record
only two such journeys[1]: a three-week tour of Derby-
shire in 1801, and a longer visit to the Lake District in
1806. The two drawings shown here (Nos.28 and 29)
were done on the first of these.

On this trip his companion and guide was Daniel
Whalley, a brother-in-law of his married sister, Martha.
The Whalleys were City merchants, Freemen of the
Clothworkers' Company. Some years before, Daniel
Whalley senior (father of Constable's companion) had
retired. In 1801 he and his family were living at Fenton,
just outside Stoke-on-Trent (Martha was married to
Nathaniel, the second son, and lived at America Square,
near the Tower of London). Earlier this year Daniel
senior had spent a few days with the Constables at East
Bergholt. Reciprocally, the artist stayed with the
Whalleys in Staffordshire for nearly four months,
from the end of July to the middle of November. Mr
Whalley's diary records numerous expeditions into the
surrounding countryside (see JC:FDC pp.67–72), but no
drawings made by Constable on any of these trips have
as yet been traced – only the dozen or so commemorat-
ing his tour of the Peak District.

The influence of Sir George Beaumont is to be seen
in some of the Derbyshire drawings in the V. & A. (e.g.,
R.24, 25, 27 & 30). His mentor's manner is less evident
in the two present examples, although black and white
chalk on tinted paper was also a medium favoured by
Beaumont. In this case, Constable had probably chosen
to work in chalk because he had become accustomed to
its use in the life classes he was attending at the Aca-
demy (see No.23).

1802

January: attends Joshua Brookes' anatomical lectures;
is said to have made large coloured drawings from dis-
sections; paints a portrait and the background for a
needlework picture by Miss Linwood; remains in
London as there is 'much to be seen in the Art, more
than at another time of the year'. *6 April:* Farington
views his picture intended for the Academy; it is ac-
cepted, his first exhibit. *May:* to Windsor with Dr
Fisher (later Bishop of Salisbury) to be interviewed for
a post as military drawing master; both Benjamin
West, P.R.A. and Farington advise him against taking
the job, Farington because 'he stood in no need of it';
reports his decision to his painting companion at East
Bergholt, John Dunthorne, in a now famous letter – he
has resolved to return to Bergholt and make laborious
studies from nature, the fountain's head, 'the source
from whence all originality must spring'. *About June:* to
East Bergholt; three of a group of oil studies made there
are dated *July, September* and *October;* acquires a small
property across the street from his home for use as a
studio.

Exhibit. R.A.: (19) 'A landscape'

30 The Thames from Windsor Castle 1802
Pencil and watercolour, $7\frac{1}{4} \times 14\frac{3}{16}$ (18.4×36)
Prov: . . . ; M. Bernard; Agnew's, from whom bt.
1962 and presented anonymously to Rhode
Island School of Design 1969
Museum of Art, Rhode Island School of Design
See No.31.

31 Windsor Castle from the River 1802
Pencil and red chalk and watercolour,
$10\frac{1}{4} \times 14\frac{5}{8}$ (26×37.2)
Prov: presented to the V. & A. by Isabel
Constable 1888
Victoria and Albert Museum (R.34)

Nos.30 and 31 are two of the four drawings Constable
is known to have made while staying with Canon Fisher
(later Bishop of Salisbury) in May 1802, presumably in
the Canon's lodgings at the Castle. One of the four
drawings (V. & A., R.33), a similar view to No.31, is
inscribed 'May 17. 1802. 7 – morning'. The identifica-
tion of No.30 is based on a pen drawing Constable's
friend Archdeacon Fisher made to illustrate a letter
written from the Castle on 4 May 1829. The letter and
the drawing are reproduced in JCC VI p.247. Though
naïve and very different from Constable's watercolour
of 1802, the scene depicted by Fisher is recognisably the
same, even down to the group of trees the other side of
the river and the single tree nearby. Above and below
his drawing, Fisher wrote: 'I have here in snug lodgings
in the Canons Row in the Castle, the window com-
manding the vale of Eton, with the turn of the River &
the clump of Trees; with such glorious evening effects
as would drive you wild Lose not a day . . . [the sketch]
. . . & come & see it.' One would judge the other water-
colour of this group, 'The Thames, with Eton College
and Chapel' (V. & A., R.35), to have been painted from
the same viewpoint as No.30, only looking down-
stream, at what Fisher, as the father of an Etonian,

90 **A Lane near East Bergholt** 1809 (entry on p.72) ▶

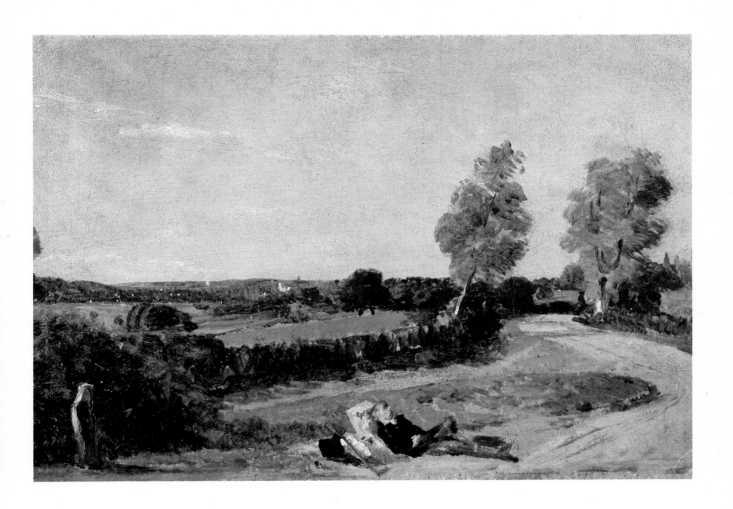

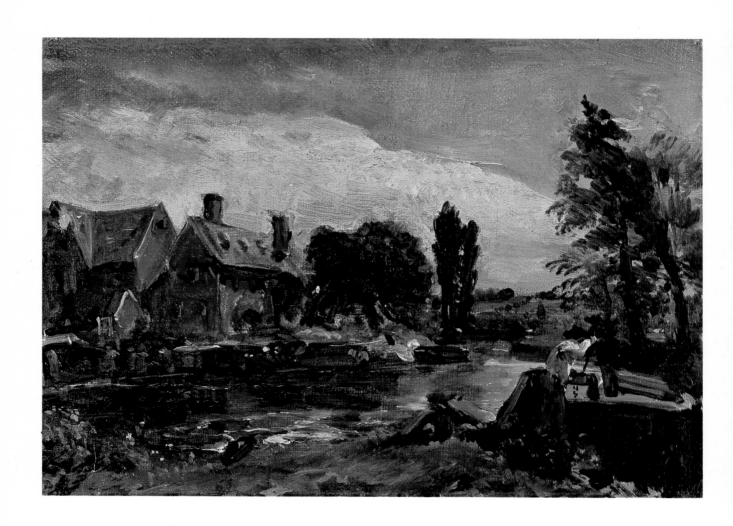

calls 'the vale of Eton'.

Reference has already been made to the post Constable had been offered as drawing master at the Military College at Marlow. These four drawings were made when he was at Windsor to be interviewed for the job by the Governor of the College, General Harcourt. In his letter to John Dunthorne on 29 May 1802 (JCC II p.31), Constable tells his friend of this visit: 'I hope I have done with the business that brought me to Town with Dr. Fisher . . . it is sufficient to say that had I accepted the situation offered it would have been a death blow to all my prospects of perfection in the Art I love'.

31

32 Dedham Vale: evening d.1802
Oil on canvas, 12½ × 17 (31.8 × 43.2)
Inscribed on stretcher (not in artist's hand but presumably based on inscriptions on original stretcher or canvas): 'July 1802' and 'Towards Evening painted by J. Constable RA 1802'
Prov: presented to the V. & A. by Isabel Constable 1888
Victoria and Albert Museum (R.36)

This view up the Stour valley towards Stoke-by-Nayland, with Langham just out of sight on the left, may have been painted from somewhere behind Mrs Roberts' house, West Lodge, East Bergholt. This side of the village (the opposite side to the Constable family home) was a favourite evening retreat of the artist and he may have been painting the view from there as early as 1799, when R. R. Reinagle, his guest at East Bergholt, made a sketch 'from Mrs Roberts's' (JC:FDC p.270). Constable chose a later painting of more or less the same view (No.103) to epitomise a 'Summer Evening' in *English Landscape*. It was near here also that he took a studio in September 1802. For further comment see No.103.

32

33 Dedham Vale d.1802
Oil on canvas, 17⅛ × 13½ (43.5 × 34.4)
Inscribed on stretcher (not in artist's hand but presumably based on inscriptions on original canvas or stretcher): 'Sep 1802 John [. . .] Isabel Constable'
Prov: presented to the V. & A. by Isabel Constable 1888
Victoria and Albert Museum (R.37)

In the spring of 1802 Constable was forced to think very seriously about his future. As already mentioned, he was offered a post in May as drawing-master at the Military College at Great Marlow but declined after Farington and West advised him that it would interfere with his career as an artist. The acceptance for the first time of one of his pictures for exhibition at the Royal Academy that year (probably after rejections in previous years) no doubt also influenced his decision. 'For these few weeks past', he wrote to John Dunthorne on 29 May, 'I beleive I have thought more seriously on my profession than at any other time of my life – that is, which is the shurest way to real excellence. And this morning I am the more inclined to mention the subject having just returned from a visit to Sir G. Beaumont's pictures. – I am returned with a deep conviction of the truth of Sir Joshua Reynolds's observation that "there is no *easy* way of becoming a good painter." It can only

33

◀ 96 **Flatford Mill from the Lock** *c.* 1810-11 (entry on p.74)

be obtained by long contemplation and incessant labour in the executive part . . . For these two years past I have been running after pictures and seeking the truth at second hand . . . I am come to a determination to make no idle visits this summer or to give up my time to common place people. I shall shortly return to Bergholt where I shall make some laborious studies from nature – and I shall endeavour to get a pure and unaffected representation of the scenes that may employ me with respect to colour particularly and any thing else – drawing I am pretty well master of. There is little or nothing in the exhibition worth looking up to – there is room enough for a natural painture' (JCC II pp.31–2).

It is interesting that Constable formed his determination to be 'a natural painture' after a visit to Sir George Beaumont's, where he would once again have seen the Claude 'Hagar'. The composition of No.33, one of the 'laborious studies from nature' which he made that summer, has long been recognised as deriving from that work. The same view (from Gun Hill, Langham, looking down the Stour valley towards Dedham with Harwich in the distance) figures in many of Constable's paintings and drawings and this particular composition is reproduced almost exactly, but with very different results, in the 'Dedham Vale' exhibited at the R.A. in 1828 (No.253). No.32 and probably also Nos.34 and 35 are other studies made during the very productive summer and autumn of 1802. Reynolds (1973 p.48) suggests that one or more of them may have been exhibited at the R.A. in 1803.

34

34 Dedham Vale ?1802
Oil on canvas, 13⅛ × 16⅜ (33.3 × 41.6)
Prov: . . . ; Skirwith Abbey, Cumberland;
H. E. M. Benn; bt. by present owners from
Horace Buttery 1962
Mr and Mrs Paul Mellon

Because of their similarity to No.33 and to another painting in the V. & A. (R.39, dated 16 October 1802), this work and 'Road near Dedham', also in the Mellon Collection, have reasonably been dated 1802 and they are probably further examples of those 'laborious studies from nature' which Constable made in Suffolk that summer and autumn (see No.33). The viewpoint in this case has not yet been identified. The figure at the left appears to be a Gainsboroughian touch, reminiscent, for example, of the figure in the so-called 'View of Dedham' in the Tate Gallery (No.1283).

35 Willy Lott's House ?1802
Oil on canvas, 13¼ × 16¾ (33.7 × 42.6)
Prov: . . . ; Sir William R. Drake, sold Christie's 27 June 1891 (15), bt. Dowdeswell; George Salting by ?1900[1]; his daughter Lady Binning 1910; by descent to present owner.
The Lord Binning

This work appears to be painted in a very similar way to Nos.33–34 above and is probably another of the studies from nature which Constable made in the summer and autumn of 1802. Willy Lott's house at Flatford is seen here from the south bank of the Stour, with the thickly-wooded island which separated the mill stream from the river proper forming the central feature. The extreme left hand part of this study is the germ of 'The Valley Farm' composition, seen next in a drawing of

circa 1812 (No.115) and finally in the painting exhibited in 1835 (No.320). The farmer Willy Lott lived in this house throughout Constable's lifetime and the building is a recurrent motif in his art. The barns discernible through the trees feature again in No.165, 'Study for "The White Horse"'.

1803

March: shows Farington several small studies painted around Dedham. *April:* Farington lends him 'Maecenas's Villa' by Wilson to copy; spends nearly four weeks on a trip in an East Indiaman down the Thames to Gravesend and then to the Downs; returns by Deal and Dover to London. *May:* has four works at the Academy; is critical of Turner's exhibits – 'more and more extravagant and less attentive to nature'; buys prints and drawings by Waterloo and paintings by Gaspard Poussin. *June:* attends the Academy dinner, where he is placed next to the Exeter landscape painter Francis Towne. *20th:* calls on Farington before leaving for Suffolk. *October:* draws with the amateur George Frost at Ipswich.

Exhibits. R.A.: (59) 'A study from Nature'; (694) 'A study, from Nature'; (724) 'A landscape'; (738) 'A landscape'.

36 Chalk Church d.1803
Pencil, squared for transfer, 8 × 10 (20.3 × 25.4)
Inscribed on verso 'Nʳ Gravesend Chalk Kent.
April 18. noon 1803', the first two words probably not in the artist's hand
Prov: . . . ; R. Dunthorne 1936; H. W. Wolifson; bt. by present owner from Leger Galleries 1959
Private collection

In the late spring of 1803, Constable spent nearly a month aboard the *Coutts*, an East Indiaman captained by a friend of his father, Robert Torin. While the ship was at Gravesend, Constable went on shore and walked to Rochester. There he had himself rowed out to the ships assembled in the Medway and from the boat made a number of drawings; of the newly painted *Victory*, for example, 'the flower of the flock' as he somewhat confusingly called her. A number of these sketches have survived. Less familiar are the drawings he made of the local architecture such as this pencil sketch of Chalk Church. From his drawing done on the spot Constable made a pen and wash study which he signed and dated 1803 (present whereabouts unknown: photograph in Witt Library).

37 Landguard Fort, near Felixstowe, looking towards Walton Tower ?1803
Watercolour, 6½ × 12 9⁄16 (16.6 × 32)
Prov: . . . ; bt. by present owners from Leggatt's
Mr and Mrs W. Katz
This would appear, at first sight, to be one of the drawings Constable made during his voyage round the Kent coast in 1803, and it does indeed resemble a watercolour in the V. & A. which has long been associated with that trip – R.42, 'View over the Thames or Medway'. Recent

36

37

research, however, shows that the view in No.37 is from near Felixstowe with Walton Tower on the distant promontory. A date of around 1803 is proposed until Constable's movements in these early years can be better charted. In the meantime, perhaps we should ask whether the V. & A. watercolour, R.42, may not also have been made on the Suffolk coast rather than on the Thames or Medway – in many ways, it is dissimilar to the other V. & A. drawings associated with the *Coutts* voyage.

38 Warehouses and Shipping on the Orwell at Ipswich d.1803
Pencil and watercolour, 9⅝ × 13 (24.5 × 33.1)
Inscribed on verso '5 Oct – 1803 Ipswich'
Prov: presented to the V. & A. by Isabel
Constable 1888
Victoria and Albert Museum (R.52)
See No.39.

GEORGE FROST (1745–1821)

39 Warehouses and Shipping on the Orwell at Ipswich 1803
Watercolour and pencil, 7½ × 11⅞ (19 × 30.2)
Prov: . . . ; at some time in the collection of
Sir Bruce Ingram
Stanhope Shelton

Constable and George Frost must have been sitting almost side by side when they were working on their two views of the river at Ipswich. Stylistically the two drawings are fairly close, but in handling there are perceptible differences to be noted. At a guess, one would say that neither drawing was finished on site.

In recent years Frost has been attracting some notice as an admirer of Gainsborough and a friend of Constable. Born in 1745, for most of his long life Frost worked as a clerk in an Ipswich coaching office, an employment which seems to have left him with time enough to pursue his real interest, the study and practice of art. Though apparently untutored, Frost gained a reputation for himself as a local artist and a number of his views of Ipswich were engraved and published. A collector of Gainsborough's work, Frost also produced a considerable number of drawings in the manner of Gainsborough. Many dozens of these were so described in the Esdaile sale of 1838. In the same year, there took place the three-day sale of Constable's collection of prints and drawings. Foster's catalogue for the sale describes lot 294 as fourteen 'Drawings in imitation of Gainsborough, *in black chalk*, by Frost', lot 295 as thirteen 'Ditto, by the same artist', and lot 296 as fourteen 'Others by the same'. There is no reason to suppose that this necessarily represented all of the drawings by Frost owned by Constable.

1804

February: tells Farington he feels there is nothing to be gained from exhibiting; no work of his in this year's Academy; relationship with the Beaumonts cooler; Lady Beaumont says he seems a weak man; sees

Rubens' 'Chateau de Steen' in West's studio. *June:* tells Farington he has been painting portraits of Suffolk farmers and members of their families for two and three guineas according to size; working in a small house of his own in Bergholt; paints landscapes in the afternoons. Drawings record a stay at Hursley, Hampshire, some time this year.

40 A View at Hursley, Hampshire d.1804
Black and white chalk and watercolour, 4⅜ × 14¾ (11.2 × 37.4)
Inscribed on verso 'Hursley Hants 1804'
Prov: presented to the V. & A. by Isabel
Constable 1888
Victoria and Albert Museum (R.53)

Dated works of this year are extremely rare. In the Constable family collection there is a drawing of the house at Epsom owned by relations, the Gubbins, similar in style to No.40. This drawing shows the Gubbins' house exactly as seen in the undated oil sketch, No.44. It is not known why Constable was at Hursley at this time. If he was staying at Hursley Park, then his host would have been Sir William Heathcote, a cousin of Sir Gilbert Heathcote who married Katherine Sophia Manners, eldest daughter of Lady Louisa Manners, later Countess of Dysart. Both Lady Louisa and her daughter were subsequently patrons of Constable, but at this time, as far as we know, neither was acquainted with the artist.

41 The Stour Estuary 1804
Oil on canvas, 8⅝ × 13⅝ (22 × 34.6)
Prov: 17 June 1892 (248), bt. Dowdeswell; . . . ;
Sir Michael Sadler by 1937; . . . ; Dr H. A. C.
Gregory by 1948, sold Sotheby's 20 July 1949
(112), bt. Tooth's; Agnew's, from whom bt. by
Borough of Southend-on-Sea 1953
Beecroft Art Gallery, Borough of Southend-on-Sea
The view is from near Brantham looking over the Stour estuary to Manningtree and Mistley. It was from Mistley that Constable's father, Golding, shipped his merchandise to London in his own boat, the *Telegraph* (see JCC I pp.5–6). Golding's nephew, John Sidey Constable, seems to have been in charge of the vessel and of the one that succeeded it, *The Balloon*. It is conceivable that the boat seen in this painting is the *Telegraph*.

In the Isabel Constable sale of 1892 this picture was called 'On the Stour, 1804' and the same title and date are given on a late nineteenth-century label on the back of the work. The date was presumably copied from an inscription by the artist which is no longer visible. If the date is accepted as authentic (and there seems no reason to doubt it), this little work assumes especial importance in the Constable chronology, there being no other securely dateable landscape painting between the Dedham pictures of 1802 and the oil sketches made on or after his Lake District visit of 1806 (with the possible exception of a work also said to be dated 1804 reproduced in Shirley 1937, pl.24).

42 Study for 'The Bridges Family' ?1804
Pencil, 9 × 7⅜ (22.9 × 18.8)
Prov: . . . ; E. H. Coles; A. H. Coles, who gave it to Paul Oppé 1949; his son Denys Oppé
Denys Oppé

This is a study for the left-hand side of the large portrait of the Bridges family of Lawford Place, Essex (Tate Gallery No.6130). The grouping of the figures at the harpsichord is different in the final picture. Another variation on the grouping appears in a drawing formerly in the Gregory Collection (sold Sotheby's 20 July 1949, lot 69, as 'Jesse Harden and her children at the piano').

The painting can be dated to 1804 because the baby who appears in it, Ann Bridges, was born in 1803 and seems to be about a year old in the picture. In 1867 Mary Ann Bridges (Mrs Evans), the elder of the two girls seated at the harpsichord in the painting, said she thought the picture was painted in the winter of 1805–6, while her sister Jane Monck Bridges (Mrs Bliss), the other girl at the keyboard, thought the year might have been 1803. They finally agreed that it was painted 'about the year 1804'. Both sisters remembered Constable staying at Lawford Place while working on the picture and Mrs Bliss recalled that he was there for several weeks (see the letters quoted by D. S. MacColl in 'Constable as a Portrait-Painter', *The Burlington Magazine*, XX, 1912, p.267).

43 The Stour Valley from Higham *circa* 1804
Oil on canvas, 18⅛ × 24 (46 × 61)
Prov: . . . ; presented to the Nationalgalerie by the Berliner Kunstfreunden 1896
Staatliche Museen Preussischer Kulturbesitz, Nationalgalerie, Berlin

In this unusual view of Dedham Vale, we are looking over the rooftops of Higham in a south-easterly direction towards Stratford St. Mary and Gun Hill. Higham is a village about three miles to the west of East Bergholt which has changed very little since Constable's day; most of the houses and cottages in this painting can be identified with little difficulty.[1]

The mill near Higham owned by Stephen Harris is mentioned several times in the Constable correspondence, as it was from this mill, with its machinery for seed-crushing and the extraction of oil, that Constable obtained the linseed oil he needed for his work. Later, this was shipped round to London for the artist in bulk, gallons at a time, by his brother Abram in their vessel, *The Balloon*. The following is from a letter Abram wrote on 10 October 1826 ('Sydey' was their cousin who commanded the vessel): 'I think I had better get a Gallon Tin Can & send you up with half the oil first. by Sydeys vessel, I think it would be safer than glass – Mr Harris has the oil ready. cold press'd I have not been negligent of it. tho tis not yet with you.' (JCC I p.229).

44 James Gubbins' House at Epsom *circa* 1804;
or 1806 or 1809
Oil on panel, 11¹³⁄₁₆ × 14¹⁵⁄₁₆ (30 × 38)
Prov: by descent from James Gubbins to the present owner
Private collection

Constable is known to have visited his uncle and aunt, James and Mary Gubbins, at Epsom in August and possibly November 1806, June 1809, April 1810, March, November and possibly December 1811, and briefly in June 1812 (see JCC I, pp.19, 31, 41–2, 57–9, 68, 72, II, p.72, and Reynolds 1973 p.95). This study of the Gubbins' house may have been made on his August 1806 or June 1809 visit, the only recorded visits of any

42

43

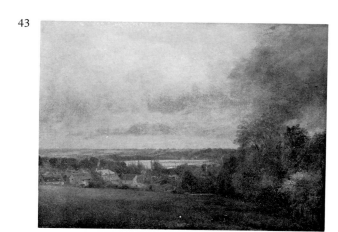

44

length that he made when the trees would have been in full-leaf as shown here, but the possibility that he stayed with his aunt and uncle before 1806 should not be excluded. A watercolour of James Gubbins' house in the Constable family collection[2], closely corresponding to No.44, is similar in handling to the 'View at Hursley' dated 1804 (No.40).

A label on the back of No.44 reads: 'I asked about the red streak in the Picture of Epsom House – Burton says it was our Aunt* – She happened to pop out as Constable was painting it – *in a red shawl – that induced him to put a dab to represent her – I should note it in Legendary Remarks on back of Picture'. This would seem to have been written by one of the children of James and Mary Gubbins' son Richard. 'Burton' was presumably Burton Archer-Burton, eldest son of the Gubbins' daughter Jane. The aunt in question may have been Jane, or, if she was an aunt of both the writer and of Burton, she may have been Ann Elizabeth Gubbins. The anecdote is reminiscent of J. T. Smith's advice to the young Constable: '"Do not", said Smith, "set about inventing figures for a landscape taken from nature, for you cannot remain an hour in any spot, however solitary, without the appearance of some living thing that will in all probability accord better with the scene and time of day than will any invention of your own."' (Leslie 1843 p.4, 1951 p.6.)

Constable also painted portraits of his cousins Ann and Richard Gubbins (repr. R. B. Beckett, 'Constable at Epsom', *Apollo*, LXXXI, 1965, p.191). His portrait of Ann seems to have been begun on his 1806 visit to Epsom and reworked when he returned in June 1809 (see JCC I p.31). For an oil study made on the 1809 visit see No.87.

1805

Lodges for a time in Spur Street, Leicester Square. *April:* shows Farington the work he intends for the Academy. *June:* commissioned to paint an altarpiece for a 'country church', presumably Brantham. *November:* three watercolours so dated.

Exhibit. R.A.: (148) 'A landscape: Moon-light'.

45 Trees in a Park d.1805
Pencil and watercolour, $6\frac{3}{4} \times 5\frac{3}{8}$ (17.3 × 13.7)
Inscribed on verso in ink, apparently over the artist's inscription: '3 Novr. 1805 – Noon – the Park'
Prov: presented to the V. & A. by Isabel Constable 1888
Victoria and Albert Museum (R.54)
See No.46.

46 The Stour Valley d.1805
Pencil and watercolour, $6\frac{11}{16} \times 10\frac{13}{16}$ (17 × 27.4)
Inscribed on verso 'Nov.r 4. 1805 – Noon very fine day. the [?Hou . . ./ ?Hon . . .]'
Prov: . . . ; Mrs M. H. Percy, from whom bt. by

45

Leger Galleries and sold to L. G. Duke 1950;
sold by him 1951 to Mrs Dorothy Moir; by
descent to present owner
Private collection
(colour plate facing p.33)

Only twice does Constable appear to have made his
major innovations in any other medium but oils – in the
period under review, 1805–6, when he worked in water-
colour, and in the summer of 1813. The watercolours
he did on his tour of the Lake District in the autumn
of 1806 are comparatively well known, but those he
made earlier in the year, and the group related to the
few dated studies of 1805, have received rather less
attention. Until further watercolours of the period
come to light, a consideration of the 1805 drawings
must start with the two dated 3 and 4 November
(Nos.45–6). It seems reasonable to place around
these two a number of works which are similar in
character.

Almost all in this group are autumnal in colouring.
Most have been painted over initial pencilling; some-
times the pencil has been used to indicate areas of
shadow. In all, the washes are broadly painted with a
generously loaded brush; occasionally a wash is applied
before the previous one has dried. In some, the colour
is applied over a grey underpainting. In quite a number
(see Nos.47, 53 and 54) we find him rounding the
trees into the ovoid and globular forms noted in No.52.
A characteristic mannerism to be seen in No.45 (also
in Nos.46 and 49) is the drawing of the stems and
branches in a darker tone with short, straight strokes of
the point of the brush.

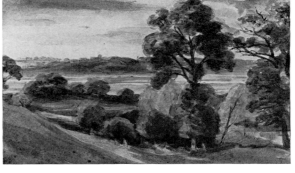

46

47 Dedham Vale *circa* 1805
Pencil and watercolour, $6\frac{3}{4} \times 10\frac{7}{8}$ (17.1 × 27)
Prov: presented to the V. & A. by Isabel
Constable 1888
Victoria and Albert Museum (R.56)

This view of Dedham Vale was drawn from a position
at the top of Fen Lane, a track that led down from the
Bergholt/Flatford road to a footbridge over the Stour
(see No.48) and thence to Dedham. As a boy, this had
been Constable's route to school. It was during the
period around 1805, while working in watercolour, that
he appears to have found some of the subjects now so
familiar to us. From within a few yards of this spot he
later painted the 'Dedham Vale: Morning' (No.100).
A little way down the hill, Fen Lane bends to the left
and then to the right; it is this bend that we see in 'The
Cornfield' (No.242).

48 New Fen Bridge *circa* 1805
Pencil and watercolour, $6\frac{3}{4} \times 8\frac{3}{4}$ (17.1 × 22.2)
Prov: presented to the V. & A. by Isabel
Constable 1888
Victoria and Albert Museum (R.59)

This was the footbridge that crossed the Stour about
half-way between Flatford and Dedham, the bridge
over which anyone would have passed when travelling
on foot from Bergholt to Dedham. No earlier work is
known of this subject, the banks of the Stour with
Dedham church in the distance, a subject that Con-
stable was to make so particularly his own.

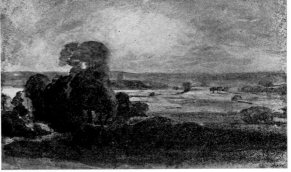

47

48

49

50

49 A Track through a Wood *circa* 1805
Pencil and watercolour, $9\frac{3}{4} \times 12\frac{1}{16}$ (23.5 × 30.6)
Private collection

It is for drawings like this and the Dublin 'Dedham Vale from near East Bergholt' (No.50) that it seems reasonable to claim a position of some importance in the early development of Constable's art. Muted, sober and lacking in lustre, it nevertheless appears to have been while making such drawings that he began to approach the frontiers of conventional landscape perception.

50 Dedham Vale from near East Bergholt
circa 1805
Pencil and watercolour, $7\frac{7}{8} \times 11\frac{3}{4}$ (20 × 29.9)
Prov: 17 June 1892 (lot unidentified), bt. for National Gallery of Ireland
National Gallery of Ireland, Dublin

When writing about Constable's first meeting with Sir George Beaumont in Dedham, Leslie tells us of the young painter's first glimpse of a painting by Claude, the 'Hagar and the Angel', which it pleased Sir George to carry round with him in a special mahogany case. 'Constable looked back on the first sight of this exquisite work', Leslie says, 'as an important epoch in his life.' He then continues: 'But the taste of a young artist is always the most affected by contemporary art. Sir George Beaumont possessed about thirty drawings in watercolours by Girtin, which he advised Constable to study as examples of great breadth and truth; and their influence on him may be traced more or less through the whole course of his practice. The first impressions of an artist, whether for good or evil, are never wholly effaced; and as Constable had till now no opportunity of seeing any pictures that he could rely on as guides to the study of nature, it was fortunate for him that he began with Claude and Girtin' (1845 p.6, 1951 pp.5–6). In recommending him to study his Girtins as examples of 'breadth' (a word both he and Farington were fond of using) we may perhaps assume that Beaumont was recommending the kind of simplicity and largeness of treatment to be seen in this watercolour from Dublin.

51 A Path among Trees
Pencil and wash, $6\frac{1}{2} \times 7\frac{3}{4}$ (16.5 × 19.7)
Inscribed on verso by David Lucas: 'By John Constable, R.A., had from his son Alfred Constable, 1851. David Lucas'
Prov: acquired from Alfred Constable by David Lucas 1851; ... ; Sir Henry S. Theobald, sold Christies 25–30 April 1910 (1096), bt. John Charrington and presented to Fitzwilliam Museum 1910
Fitzwilliam Museum, Cambridge
See No.52.

52 A Wooded Landscape *circa* 1805
Black chalk, wash and white heightening, $13\frac{1}{4} \times 19\frac{3}{4}$ (34.3 × 50.8)
Prov: ... ; H. W. Underdown 1921; ... ; Agnew's 1952; E. J. Speelman 1953; bt. from him by present owners 1961
Mr and Mrs Paul Mellon

Constable greatly admired Gainsborough, as we know,

51

and owned a number of his drawings. We also know that in his early years he imitated the work of those he admired. It is very natural, therefore, to expect to find paintings and drawings by him which show the influence of Gainsborough. In oils, such examples are not too difficult to identify (e.g. Nos.34 and 80), but it is less easy to find a drawing incontrovertibly by him which shows this influence.

In 1921, in his book *Constable, Gainsborough and Lucas*, Sir Charles Holmes published fourteen drawings which he believed to be the work of Constable in his early years. Almost all were given Essex or Suffolk titles – 'View near Nayland', 'Near East Bergholt', etc. Three are recognisably Stour views. Only one is inscribed: No.1, 'Langham'. Our No.52 appears in the book as 'A Dell Petworth ?', though Holmes expresses his doubts as to the correctness of the title, suggesting Helmingham as a more likely location. When he wrote his book, Holmes was evidently unaware of the existence of George Frost. If he had seen the albums of Frost's work at Ipswich, or the many dozens bearing the Esdaile stamp which are now available for study, he would doubtless have refrained from publishing at least five of the drawings illustrated.

The discovery of Frost as an artistic personality has created problems in the field of both Gainsborough and Constable studies. Those in connection with the former have been examined with scrupulous care, but so far we have not learned to distinguish confidently between Frost and Constable. When we have, it may be possible to give a more coherent and convincing account of Constable's development as a draughtsman in these early years. Nos.51 and 52 are representative examples of the kind of drawing about which we shall have to make up our minds. A little further on in the exhibition it may be possible in other drawings to see why the organisers regard No.52 as a probable work by Constable. Here it is only necessary to draw attention to a feature which is not to be found in dated work before 1805 – the rather gross, sculptural treatment and the reduction of certain trees and bushes into simple ovoid and globular forms.

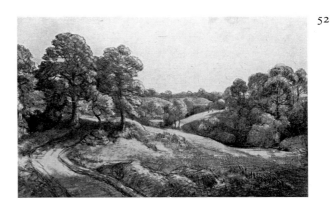

52

53 Cattle near the edge of a wood *circa* 1805
Pencil and watercolour, $8 \times 9\frac{3}{4}$ (20.3 × 24.9)
Prov: presented to the V. & A. by Isabel
Constable 1888
Victoria and Albert Museum (R.61)
See No.54.

54 Trees in a Meadow *circa* 1805
Pencil and watercolour, $11\frac{3}{8} \times 9\frac{5}{8}$ (29 × 24.5)
Prov: . . . ; S. Morse; Mrs Church; bt. by present owners from Agnew's 1960
Mr and Mrs Paul Mellon

As yet we do not know enough to place the watercolours of this period in a convincing chronological order. Opinions have differed about the dating of these two drawings. Holmes (1902, p.240) considered No.53 to be of 1805, but called it 'an imitation of Gainsborough'. This is surely too pat a stylistic classification: drawings of cattle with their hindquarters higher than their heads are often so labelled. Reynolds suggests an earlier date, 1803, for No.53, basing his argument on a similarity between this drawing and another watercolour at the

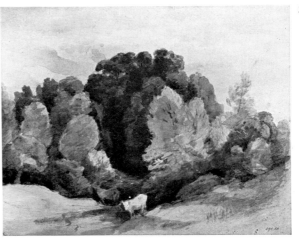

53

54

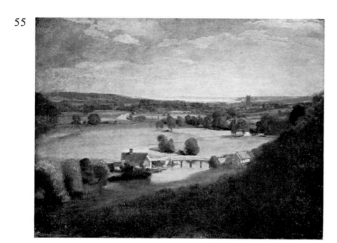

55

56

V. & A. (R.51) which is inscribed on the back 'Tuesday Noon June 1803' and 'J. Constable R.A.' This drawing has cattle in it, too, and trees, but otherwise the two do not appear to have much in common. One cannot even be certain of the authorship of R.51.

Some idea of the uncertainty that at present exists about the dating of these watercolours may be gained from the fact that in 1972 No.54 was catalogued as a work of the last phase of the artist's working life, of the years 1833–6. Having observed that the rounding of trees into globe-shaped forms was a characteristic of the 1805 watercolours, 'Trees in a Meadow' must be allowed to speak for itself in its present company.

55 The Valley of the Stour *circa* 1805
Oil on paper, laid on canvas, 19⅝ × 23¾ (49.8 × 60)
Prov: 17 Feb. 1877 (195: the sale stencil and lot number are on the stretcher), bt. in; presented to the V. & A. by Isabel Constable 1888
Victoria and Albert Museum (R.63)
(colour detail facing p.32)

The size of this work suggests that it may have been intended as an exhibition picture, which was later abandoned (see the unfinished foreground). The view is from the slopes of Gun Hill, near Langham, looking down the Stour valley towards Dedham, with Harwich in the extreme distance. The bridge in the foreground is that of Stratford St. Mary. A similar view is given in Nos.22, 33 and 253. Reynolds suggests that this painting pre-dates the 1802 pictures (Nos.32–3) because it shows little of the interest in tree structure visible in those works. On the other hand, the rather globular tree forms relate to Constable's drawings and watercolours of *circa* 1805 (Nos.45–54) and the comparatively brilliant colour certainly seems to point to a date some way after the less developed colouring of the 1802 group, and perhaps even to a date after 1805 – the possibility that Constable worked on the picture at different times should not be ruled out, especially in view of the unfinished nature of the work.

56 Christ blessing the Children *circa* 1805
Oil on canvas, 84 × 50 (213.4 × 127)
Prov: painted for St. Michael's Church, Brantham, Suffolk
St. Michael's Church, Brantham

And they brought young children to him, that he should touch them: and his disciples rebuked those that brought them.

But when Jesus saw it, he was much displeased, and said unto them, Suffer the little children to come unto me, and forbid them not : for of such is the kingdom of God.

Verily I say unto you, Whosoever shall not receive the kingdom of God as a little child, he shall not enter therein.

And he took them up in his arms, put his hands upon them, and blessed them.

Mark 10:13–16

Constable painted three altarpieces: this one for Brantham, 'Christ blessing the Sacraments' for St. James's Church, Nayland in 1810, and 'The Risen Christ' for St. Michael's Church, Manningtree in 1822 (No.212). Leslie (1843 p.8, 1951 p.18) thought the Brantham picture was painted in 1804 but an entry in

Farington's diary for 1 June 1805 suggests that the commission was given that year, 1805: 'Constable called. He told me He was engaged to paint an Altar piece for a Country Church.–'. The Rector of Brantham (as well as of East Bergholt) was Dr Rhudde, who was later to oppose his granddaughter's marriage to Constable but who at this stage was still well-disposed towards the young artist. Presumably Rhudde was connected in some way with the commission for the altarpiece, though it is not known who paid for it.

While generally reflecting the style of Benjamin West, Constable's altarpiece may also have owed something more directly to Raphael, a drawing for the composition in the Constable family collection being related to the Cartoon of the 'Healing of the Lame Man', as are the two male figures at the left of the final painting. A sheet of rather Fuselian studies of a woman's head and shoulders in the Fondazione Horne, Florence (Collobi No.65) may have some connection with the figure at the right of the painting. An undated letter to Constable from his uncle David Pike Watts (JCC IV pp.12–13) criticises the way the artist had completed the painting: 'it may be a more finished work of Art, but the Spirit the Devotion the *Effect* is gone', etc. The model for the child held by Christ is supposed (on what grounds is unclear) to have been a son of John Lewis of Dedham, whose daughters Constable painted around this time (see D. S. MacColl, 'Two Portraits by John Constable', *The Burlington Magazine*, XLIII, 1923, p.34).

57

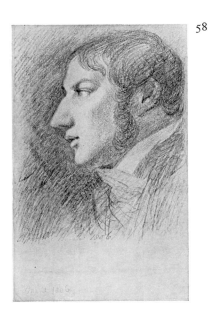

58

1806

Mentioned only once in Farington's Diary: *10 April,* talks of his Academy picture; knowledge of his activities is mainly derived from dated drawings, of which there is an unusually large number. *June:* at East Bergholt; draws the Cobbold daughters. *July:* at Markfield, Tottenham, with the Hobson family; makes many pencil studies of young women. *August:* stays with relations, the Gubbins, at Epsom. *1 September:* drawings of Kendal, Westmorland, mark the beginning of a tour of the Lake District which may have been financed by his uncle, David Watts; spends first few days near Ambleside, then stays at Brathay, Lake Windermere, with the Hardens; draws and paints with his host, an amateur artist of talent; paints his hostess, who says he is 'a clever young man . . . paints rather too much for effect'. By *19 September* he has moved further into the hills with a companion, son of the portrait painter Daniel Gardner. By *25th:* in Borrowdale; Gardner returns to Brathay, 'tired of looking on'. *15 October:* returns to Brathay; paints portrait of Harden. *19th:* the last dated drawing of the tour – of Langdale.

Exhibit. R.A.: (787) 'His Majesty's ship Victory, Capt. E. Harvey, in the memorable battle of Trafalgar, between two French ships of the line' (No.57).

59

60

61

Fig.i
(see No.61)

57 **'His Majesty's ship Victory, Capt. E. Harvey, in the memorable battle of Trafalgar, between two French ships of the line'**
exh.1806
Watercolour, $20\frac{3}{8} \times 28\frac{7}{8}$ (51.6 × 73.5)
Exh: R.A. 1806 (787)
Prov: presented to the V. & A. by Isabel Constable 1888.
Victoria and Albert Museum (R.65)

This is the first of Constable's exhibited works that can be identified today. According to Leslie, who had it from Constable's brother Abram, the subject 'was suggested to him by hearing an account of the battle from a Suffolk man who had been in Nelson's ship' (1843 p.8, 1951 p.18, though the reference to Abram is only in the 1843 edition). Constable had sketched the *Victory* at Chatham in 1803 during his trip aboard the *Coutts* (see JCC II pp.33–4 and No.36).

58 **Self-Portrait** d.1806
Pencil, approx. $7\frac{1}{2} \times 5\frac{11}{16}$ (19 × 14.5) on paper $9\frac{5}{16} \times 5\frac{11}{16}$ (23.7 × 14.5)
Inscribed 'April March 1806', the first word obliterated by the drawing; also inscribed 'March 1806' at the bottom of the sheet, possibly not in the artist's hand.
Prov: always in the Constable family.
Executors of Lt. Col. J. H. Constable

By an arrangement of mirrors, Constable was able to make this study of his own profile, the first dated drawing of this most prolific year, and the only incontestable self-portrait.

59 **Lawn at East Bergholt** d.1806
Watercolour, $4 \times 6\frac{5}{8}$ (10.1 × 16.8)
Inscribed on verso 'June=1806–'
Prov: presented to the British Museum by Isabel Constable 1888
Trustees of the British Museum (L.B.20a)

This is another of the views which Constable is thought to have taken from the grounds of West Lodge, the house belonging to Mrs Roberts that stood just across the village street from his home (see No.32 for an earlier example). The last dated drawing of this scene, a pencil sketch in the V. & A. (R.143) of the familiar solitary tree silhouetted against an evening sky, is inscribed '24 Augt 1815 – Lawn – EB –'. A comparison of this little watercolour with the Girtin-like view of Epsom (No.68) of only two months later, enables one to see how readily at this stage in his development Constable was shifting from one style and method of working to another.

60 **East Bergholt Church: north archway of the ruined tower** *circa* 1806
Pencil and watercolour, $9\frac{7}{8} \times 7\frac{7}{8}$ (25.1 × 20)
Inscribed on verso 'Drawing of East Bergholt Church by J. Constable'
Prov: presented to the V. & A. by Isabel Constable 1888
Victoria and Albert Museum (R.68)

There is a perceptible difference between Constable's watercolours of 1806 and those of the preceding year. This is most noticeable when comparing an 1805 watercolour of East Bergholt Church (National Gallery of

62

Canada, Ottawa) with two of the church dated June 1806 in the V. & A. (R.66 & 67). In the later drawings the medium is handled with much greater freedom and confidence and in them there is to be seen evidence of an increasing interest in light. No.60 is representative of this new phase of his development.

61 East Bergholt Churchyard: two girls and an elderly man looking at a tombstone
circa 1806
Pencil and watercolour, $4\frac{7}{16} \times 3\frac{1}{8}$ (11.2 × 7.9)
Prov: . . . ; presented to the Louvre by David Weill
Musée du Louvre, Paris (R.F.6110)
No.61 is a preliminary or alternative design for the earliest known book illustration by Constable, the frontispiece, engraved by Chapman, for *A Select collection of Epitaphs and monumental inscriptions*, published by J. Raw of Ipswich in 1806 (see fig.i). The lettering on the tombstone in the engraving reads: 'HERE REST . . ./A YOUTH . . .': appropriately enough, the first words of the first two lines of the epitaph with which Thomas Gray concludes his *Elegy* –
'Here rests his head upon the lap of earth
A youth to Fortune and to Fame unknown . . .'.

62 Girl posing at a Window *circa* 1806
Pencil and watercolour, $8\frac{1}{8} \times 7$ (20.6 × 17.8)
Prov: 30 November 1892 (108), bt. in; . . . ;
Meatyard, from whom bt. by Sir Robert Witt;
bequeathed by him to Courtauld Institute 1952
Courtauld Institute of Art (Witt collection)
See No.66.

63

63 Girl with a Parasol *circa* 1806
Pencil and watercolour, $6\frac{3}{8} \times 4\frac{1}{2}$ (16.2 × 11.4)
Prov: . . . ; presented to the British Museum by [?E.E.] Leggatt 1896
Trustees of the British Museum (L.B.36a)
See No.66.

64 Sophia d.1806
Pencil, $8\frac{5}{8} \times 5\frac{5}{8}$ (21.9 × 14.3)
Inscribed 'Sophia June 11 1806'
Prov: as for No.63.
Trustees of the British Museum (L.B.36b)
See No.66.

65 A Music Party *circa* 1806
Pencil, $9\frac{1}{2} \times 7\frac{7}{8}$ (24.1 × 19.7)
Prov: as for No.63
Trustees of the British Museum (L.B.42a)
See No.66 and also the note on p.206.

66 An Officer of Light Dragoons and a companion *circa* 1806
Pencil, $9\frac{1}{2} \times 7\frac{1}{4}$ (24.1 × 18.4)
Prov: as for No.63
Trustees of the British Museum (L.B.42b)
By nature Constable was gregarious and depended a great deal on companionship, but although there are pencil and oil-sketches of his wife and family and of a friend or two, in general he was not in the habit of recording the life around him at close quarters. When

64

65

66

67

working out in the open on a landscape subject or when carrying a sketchbook in the fields, few artists have been more aware of man, bird or beast as elements in the larger scheme of things, but he did not respond in the same way to the domestic and social scene, to life indoors.

It is therefore all the more extraordinary to find him for a few weeks in the summer of this year, 1806, filling page after page in his sketchbooks with swiftly-drawn studies of attractive young women. Some of these, we know, were the daughters of the households he was visiting. At present, about a hundred such sketches can be listed. Slightly over a dozen are inscribed with the names of his sitters – Sophia, Harriet, Susanna, Laura, Lydia, Jane, and so on. Two of these, Harriet and Sophia (perhaps the girl in No.64), were without doubt the youngest step-daughters of Constable's Ipswich friend, Mrs Elizabeth Cobbold. The greater number of the sketches, however, appear to have been drawn while Constable was staying with the Hobsons of Markfield, Tottenham (see No.67). The 'Laura' inscribed on four of the drawings was presumably the fourth daughter, of whom Constable painted a portrait two years later (see No.81). In appearance, the girl with the parasol (No.63) is very like a girl so named to be seen in two drawings in the Louvre (R.F.6076 & 6081).

67 In the grounds of Markfield House, Tottenham 1806

Pencil, 3⅜ × 4 (8.5 × 10.1)
Prov: . . . ; presented to the Louvre by David Weill
Musée du Louvre, Paris (R.F.6082)

Markfield was built by its owner, William Hobson, described at the time of his marriage (*circa* 1780) as 'Bricklayer [i.e. builder], citizen and Fishmonger' (*The Builder*, 11 Oct. 1912, p.419). Hobson is said to have been one of the biggest contractors of his time and to have built some of the London Docks as well as the Martello towers along the Essex coast. The house in the background of this drawing is identifiable as Hobson's by comparison with the engraving of 'Mark Field House' facing p.123 in William Robinson's *The History and Antiquities of the Parish of Tottenham*, 1840, in which work it is described as standing 'on an eminence on the east side of and at a distance from the high road at Stamford Hill, in the parish of Tottenham, a short distance northward from the turnpike'.

68 Epsom Common d.1806

Watercolour, 6⅛ × 9½ (15.5 × 24.1)
Inscribed 'Epsom. Aug.ˢᵗ 6ᵗʰ 1806.'; on verso 'This is done with my 3 Colors & Bister' and 'Epsom Common 6 Aug.ˢᵗ 1806.' A pencil sketch of a girl's head, full-face, and two diagrams of bells are also on the verso
Prov: . . . ; Sir Michael Sadler by 1937; . . . ; bt. from Spink by S. Girtin, who gave it to present owners *circa* 1954
Mr and Mrs Tom Girtin

Leslie's account of Sir George Beaumont's introduction of the watercolours of Girtin to Constable has already been given (see No.50). Full use has been made by writers on Constable of the advice Leslie says the young artist was given and of his statement that the influence

of Girtin may be traced 'through the whole course of his practice'. Sir Charles Holmes, in his main work on Constable, says that during the spring and summer of 1806 he made a number of drawings round Dedham and Flatford that 'in handling, pigment, and feeling might almost be mistaken for drawings by Girtin'. Later, he writes of the Lake District watercolours that they 'still show the overwhelming influence Girtin had upon his mind'. Apart from a group of Girtin watercolours after Beaumont's own sketches, several of which were of the Lakes (including three of Borrowdale), we do not know which Girtins Sir George had in his possession. However, while keeping in mind the possibility that there may have been other watercolourists, Cornelius Varley for instance, who influenced Constable at this important stage in his development, it is at the same time fairly safe to assume that the increasing mastery he shows in his control of the medium during 1806 was to a considerable extent based on his study of the thirty Girtins owned by Beaumont.

The view of Epsom (No.68) is one of two works that stylistically relate very closely to Girtin. The other is a pencil drawing in the V. & A. (R.62) of Guisborough Priory, Yorkshire, not a part of the country Constable is known to have visited. R.62 is of a view almost identical to a pencil drawing and two watercolours of this subject by Girtin. The architecture is drawn in a Girtin manner, with the point of the pencil pressing down on to the paper at the end of a stroke. Yet it is an exact copy of neither Girtin's pencil sketch nor his watercolours. If the drawing is by Constable – and the trees look very like his of around 1812 – then it is a puzzle.

69 Windermere 1806
Pencil and watercolour, 8 × 14⅞ (20.3 × 37.8)
Prov: ?17 June 1892 (190), bt. Shepherd; bt.
from Shepherd Brothers by T. W. Bacon 1894
and presented by him to the Fitzwilliam Museum
1950
Fitzwilliam Museum, Cambridge

Parts of Leslie's account of Constable's tour of the Lake District are frequently quoted. In full, he has the following to say of this, the artist's first, and last, experience of mountain scenery.

'In this year [1806] his maternal uncle, David Pike Watts, recommended to him a tour in Westmoreland and Cumberland in search of subjects for his pencil, and paid his expenses. He spent about two months among the English lakes and mountains, where he made a great number of sketches, of a large size, on tinted paper, sometimes in black and white, but more often coloured. They abound in grand and solemn effects of light, shade, and colour, but from these studies he never painted any considerable picture, for his mind was formed for the enjoyment of a different class of landscape. I have heard him say the solitude of mountains oppressed his spirits. His nature was peculiarly social and could not feel satisfied with scenery, however grand in itself, that did not abound in human associations. He required villages, churches, farmhouses, and cottages; and I believe it was as much from natural temperament as from early impressions that his first love, in landscape, was also his latest love' (1843 pp.19–20, 1951 pp.18–19).

If we go by the dated drawings (and there is little else to help us in mapping out his tour), Constable spent seven weeks exactly in the Lakes, from 1 September (Kendal) to 19 October (Langdale). For the first few days he stayed with his uncle's almoner, Mr Worgan, at a cottage in the grounds of Storrs Hall, an estate half-way up the eastern side of Windermere. He is then to be found staying with the Hardens, a family who had made their home at Brathay Hall at the head of the Lake. Mrs Harden wrote of him thus to her sister: 'On Monday [the 8th] Mr. Constable who came with Richard [Shannon] went out with John [Harden] & him to sketch. He is the keenest at the employment I ever saw & makes a very good hand of it. He is a nephew of Mr. Watts the late proprietor of Storrs, but chose the profession of an Artist against the inclination of his friends, at least so he says, & I dont doubt him. He is a genteel handsome youth.' (This and the following quotations are taken from Daphne Foskett, *John Harden of Brathay Hall*, 1974 pp.29–31.) Walking and sketching by day and musical evenings helped pass the time. Sunday, the 14th, was wet, so 'Mr. Constable got some oil colors [presumably his host's] & painted a portrait of me which he executed wonderfully well considering he was only 5 hrs. about it. He is a clever young man but I think paints rather too much for effect' (Mrs Harden was writing as a one-time pupil of Alexander Nasmyth). The next day Constable finished the portrait, '...which is generally thought like & tolerably well painted particularly on considering he was only 9 hours about it'.

Constable is not mentioned again for a while in Jessie Harden's letters. By 18 September, when the Brathay party visited Storrs, he may already have left for the hills and vales to the north with his companion George Gardner, son of the portrait painter Daniel Gardner. The next dated drawing was made on the 19th, in St. John's Vale, some twenty-five miles away. Saddleback (No.72), above Keswick, and Helvellyn were drawn on the 21st; on the 22nd they were in the Newlands valley, the other side of Keswick.

Borrowdale, where Constable spent the next three memorable weeks, was reached by the 25th (No.71). In her journal for the 30th, Mrs Harden recorded that Gardner visited them and stayed to dinner; he had 'left his friend Constable in Borrowdale drawing away at no allowance, but he got tired of looking on, so came off here.' 13 October is the last date to appear on a drawing of Borrowdale. For Wednesday, 15th, Mrs Harden wrote in her diary: '...Mr. Constable returned & being wet morning he occupied himself in beginning a portrait of John which I hope will prove like.' The last dated drawing of the tour, a large and handsome wash

study of Langdale (V. & A., R.86), was made on the 19th.

Much has been made of Constable's remark that the solitude of mountains oppressed his spirits. This may have been so. After the previous two or three months, much of which period appears to have been spent in the society of attractive young women, it is hardly surprising that he should have been deeply impressed by the contrasting experience of finding himself in those remote valleys and uplands in a season of rain and wind. If this is what he felt, then it is revealing of his character and of his seriousness of purpose as an artist that he should have chosen to stay on to work in Borrowdale by himself after George Gardner had returned to Brathay.

It is not yet known how many drawings Constable made during his seven weeks in Westmorland and Cumberland, but the total already listed runs well into the seventies, and the number is increasing, almost year by year, as new ones are discovered. Altogether, we have a considerable body of work, one of the largest of any period of his life.

When attempting an evaluation of this Lakeland tour of 1806 the oil-sketches made during it and the (so far unidentified) exhibited works which resulted from it must also be taken into the reckoning. As late as the spring of 1809, Constable was still painting scenes from this tour, and one was on a generous scale. Part of Farington's entry in his diary for 3 April 1809 runs, 'Constable I called on & saw his pictures intended for Exhibition. I gave my opinion against his exhibiting his largest picture 5 feet wide, a scene in Borrodaile, as being in appearance, only like a preparation for finishing, – wanting variety of colour & effect.'

This tour of 1806 was the last of the journeys Constable made specifically for the purpose of sketching and collecting material for paintings. Thenceforth, he drew and painted wherever his friendships, his family ties, or his professional engagements happened to take him.

JOHN HARDEN (1772–1847)
70 Constable Painting d.1806
Pencil, 4¾ × 4 (12.1 × 10.2)
Inscribed 'Sept. 1806'
Prov: by descent from the artist to A. S. Clay, by whom presented to the British Museum 1962
Trustees of the British Museum (1962-2-10-1)
This drawing by his host at Brathay Hall, John Harden, shows Constable painting the portrait of Mrs Harden mentioned in the entry on No.69. The only other representation of Constable at work is the drawing made many years later by Maclise (No.285a).

72

100 'Dedham Vale: Morning' exh.1811 detail (entry on p.76) ▶

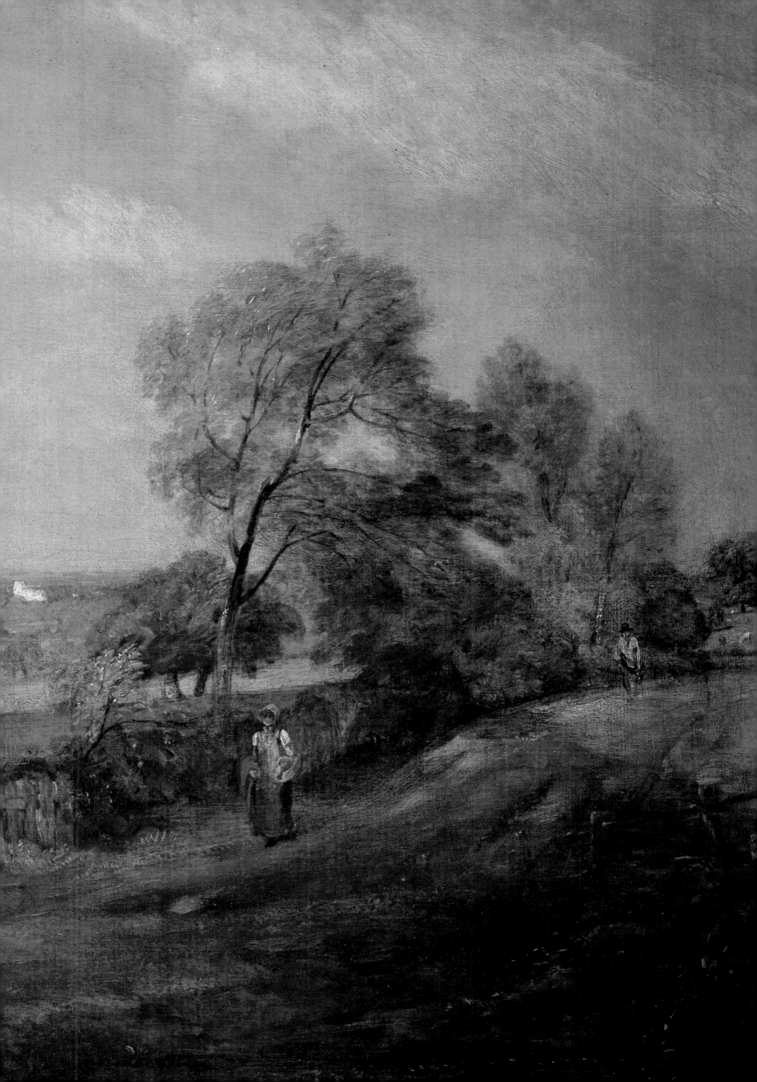

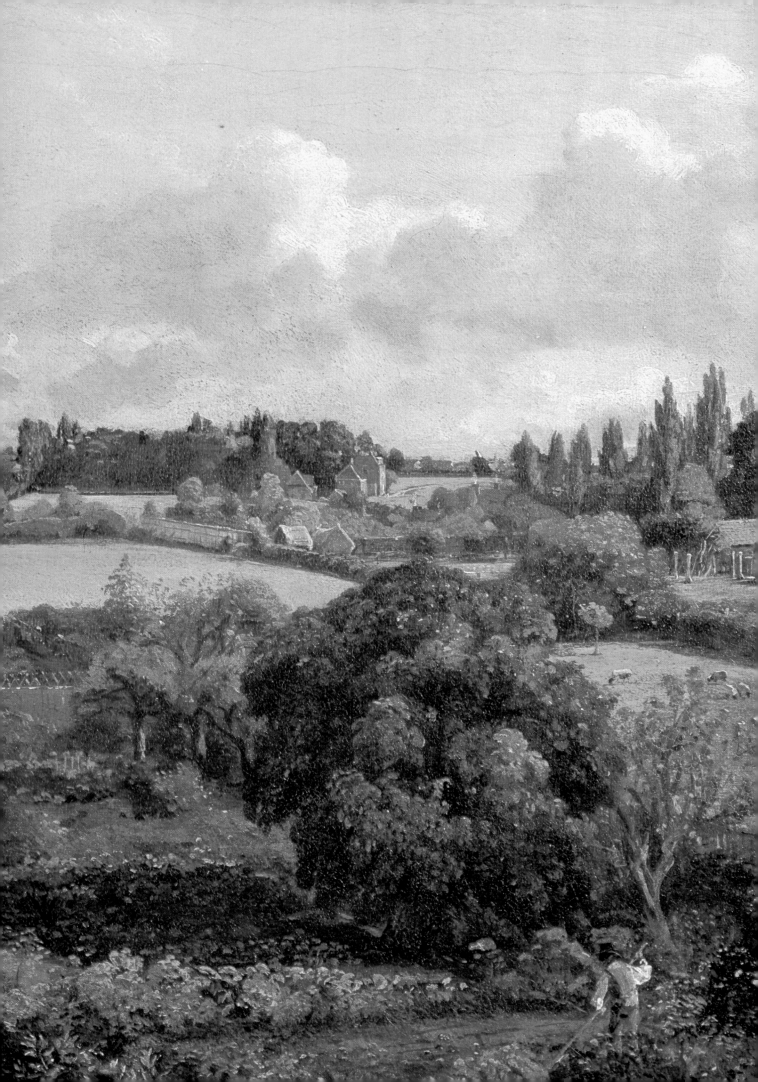

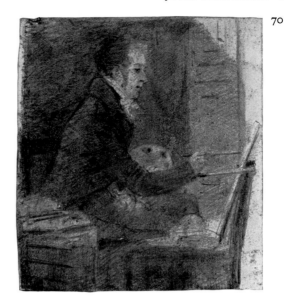

70

71 View in Borrowdale d.1806
Pencil and watercolour 9½ × 13⅝ (24.1 × 34.6)
Inscribed on verso '25 Sepr. 1806 – Borrowdale –
fine clouday day tone very mellow like – the
mildest of Gaspar Poussin and Sir G B & on the
whole deeper toned than this drawing –'
Prov: presented to the V. & A. by Isabel
Constable 1888
Victoria and Albert Museum (R.74)

This is the earliest of the dated drawings of Borrowdale,
the valley in which Constable spent some three weeks
of his tour, much of it by himself. It is interesting to
note that Gaspard Poussin and Sir George Beaumont
were in his thoughts while working on this view, for it
is one of the most conventionally seen and composed of
the watercolours. Gaspard and Beaumont were under-
standably linked in his mind; Sir George himself would
have been the first to acknowledge his indebtedness to
the then more popular of the two Poussins.

The scene has been identified as a view looking to-
wards Glaramara, of which part of the valley Constable
made several studies – No.73, for instance.

72 Saddleback and part of Skiddaw d.1806
Pencil and watercolour, 3 × 11⅝ (7.6 × 29.5)
Inscription on verso (the first half having been
lost when the drawing was trimmed): '21 Sep.
1806 Stormy Day – noon'. The card on which the
drawing has been laid bears the full inscription
'Saddle back and part of Skeddaw Sep 21 – 1806
Stormy Day – Noon', copied from the back of the
drawing
Prov: presented to the V. & A. by Isabel
Constable 1888
Victoria and Albert Museum (R.72)
See No.73.

71

73 View in Borrowdale d.1806
Pencil and watercolour, 5¼ × 14⅞ (13.5 × 37.8)
Inscribed on verso 'Borrowdale 13 Oct – 1806.
Evng –'
Prov: presented to the V. & A. by Isabel
Constable 1888
Victoria and Albert Museum (R.85)

Like many lowlanders experiencing mountain scenery
for the first time, Constable was clearly fascinated by
the constantly changing appearance of the landscape,
the sudden shafts of light and the shifting contrasts. Sir
Charles Holmes, in 1902, was one of the first to realise
the importance of these drawings of 1806 and his ap-
preciation of their worth has hardly been bettered: 'The
sketches made on this tour', he wrote, 'are most re-
markable. The watercolours still show the overwhelm-
ing influence Girtin had upon his mind, and include
many compositions of singular dignity and majesty. So
fine indeed are some of them that it is hard to think of
any other drawings in which the peculiar characteristics
of English mountain scenery have been more grandly
expressed. Such scenery is delightful to look at, but ex-
ceedingly difficult to paint; for the forms and colours of
mountains are so definite as to dominate unduly all but
the finest of designs. Constable overcame this difficulty
with wonderful skill, utilising for his purpose all the
devices which lowering clouds, drifting mists, sudden
bursts of light, broad spaces of mysterious shadow, and

73

◀ **135 Golding Constable's Kitchen Garden** 1815 detail (entry on p.94)

74

75

76

the flash of water far away provide for the impressionable mind.'

74 Helvellyn 1806
Pencil and watercolour, $7\frac{3}{4} \times 14\frac{1}{2}$ (19.7 × 36.8)
Prov: . . . ; H. Horne, 1902; Sir Edward Marsh;
P. M. Turner by 1937; present owner
Private collection

Among the several dozens of Constable's Lake District watercolours this drawing of Helvellyn appears to be almost the only one in which the original blue has been preserved in a condition approaching its original intensity. Most of the others have the faded-to-pink look to be seen in many of Girtin's drawings and in the greater number of watercolours by artists such as Francis Nicholson.

Like neo-romantic artists of a more recent period, Constable appears to have been particularly unfortunate with his weather. The inclemency he experienced, as well as the fine periods, is often to be found noted on the backs of his drawings – 'Stormy Day . . . stormy with slight rain . . . morning previous to a fine day . . . Clouds breaking away after rain . . . very stormy afternoon . . . Evening after a shower . . . Evening after a fine day . . .' – and the surface of more than one drawing is marked with spots of diluted colour, plainly not an effect intended by the artist. The V. & A. has a drawing (R.73) inscribed '⟨Hellvel⟩ Helvellin 21st Sepr. 1806 – ⟨rain⟩ evening – stormy with slight rain'. No.74 could have been done on the same day; the two drawings are not unlike.

75 Rydal Falls 1806
Pencil, $15\frac{1}{4} \times 10$ (38.7 × 25.4)
Inscribed 'Sept 1806'; verso '12 Sept 1806'
Prov: . . . ; bt. by present owner from Baskett and Day 1971
Private collection
See No.76.

76 Borrowdale, morning 1806
Pencil, $13 \times 18\frac{3}{8}$ (33 × 46.6)
Inscribed on verso 'Bord-dale – morning Bord ⟨Bordera⟩ ⟨. . .⟩ Border Gale marning morning'
Prov: . . . ; Sir Michael Sadler; Spink;
bequeathed to Leeds City Art Galleries by Agnes and Norman Lupton 1952
Leeds City Art Galleries

The pencil drawings Constable made during his tour of the Lakes have not yet received much attention, but in fact they appear to have played a significant part in his development during these important weeks. In technique they vary; some are combined with wash, but all are characterised by strong diagonal shading, and soft, flowing outlines. Most are drawn on quite large sheets of paper. Shading is employed for the modelling of form and occasionally to suggest sunlight and shadow; as yet we see no hint of colour or tone indication. In the Leeds drawing of Borrowdale (No.76) the rotund forms noted in earlier drawings (Nos.46 and 52) are a striking feature. With the 'lead' pencil in his hand, Constable seems to have been more keenly aware of the sculptural qualities latent in mountain landscape, of mass and space, than when he was using colour. Several of these pencil drawings are squared up for transfer –

two fine examples in the collections of the Clonterbrook Trustees and Sir John and Lady Witt, for example.

77 Lake District Scene 1806
Oil on paper, 9½ × 15 (24.1 × 38.1)
Prov: according to an old label on the back, from the collections of Captain Constable and Eustace Constable; . . . ; Galerie Sedelmeyer, Paris (seal on back); . . . ; L. Lindsay Smith; H. W. K. Wonter; present owner by 1963
Private collection

Since Constable's exhibits at the R.A. and B.I. in the following three years were almost exclusively oil paintings of Lake District subjects, it is perhaps surprising that less than half a dozen oil studies made there during his 1806 visit have been identified. Watercolour seems to have been very much his preferred medium on this occasion.

78 James Lloyd d.1806
Oil on canvas (oval, cut down from rectangular canvas), 32 × 22 (81.3 × 55.9)
Inscribed '[C]onstable. f Dec^r 1806'
Prov: by descent from the sitter to the present owner
Private collection

Constable met the poet Charles Lloyd, eldest son of the Birmingham banker of the same name, and his wife Sophia while he was staying with their neighbours the Hardens of Brathay Hall in September 1806 (see No.69). It was probably the Lloyds who introduced him to Wordsworth and Coleridge on this visit. A portrait by Constable of Sophia Lloyd with one of her children is in the Worcester Art Museum, Worcester, Massachusetts[1] and one of Charles Lloyd is also recorded[2]. Both are usually presumed to have been painted during Constable's visit to the Lake District. Commissions for other Lloyd portraits seem to have followed. Charles Lloyd's banker brother, James (1776–1853), the sitter in No.78, lived with his wife Sarah at Bingley House near Birmingham. His portrait and a missing companion portrait of his wife are thought to have been painted there, though there is no other record of a visit by Constable to Worcestershire in December 1806. Constable also painted James's sister Priscilla, wife of Christopher Wordsworth (the poet's brother) and Susannah, wife of another of the Lloyd brothers, Thomas. The former portrait is now in a private collection, the latter in the Tate Gallery (No.T.1141). Thomas also lived at Birmingham, which may make Constable's supposed visit there in 1806 seem more likely.

79 Lake District Scene *circa* 1806–8
Oil on canvas, 10⁷⁄₁₆ × 17⁵⁄₈ (26.5 × 44.7)
Prov: . . . ; Sir Charles Holmes 1902; . . . ;
D. Croal Thomson, from whom bt. 1926 for the Felton Bequest, National Gallery of Victoria
National Gallery of Victoria, Melbourne

Holmes identified the scene as Derwent Water and Skiddaw viewed from the foot of Cat Bells but Beckett (Typescript Catalogue) quoted a local resident as saying that the distant heights were Rowling End, Causey Pike and Grisedale. See also the note on p.206.

Constable exhibited at least ten Lake District sub-

77

78

79

jects at the R.A. and B.I. between 1807 and 1809, some of them no doubt appearing first at the R.A. and then at the B.I. None, however, has so far been certainly identified. No.79 has been proposed as the 'Keswick Lake' shown at the R.A. in 1807 but it seems hardly to be a lake scene at all. If the 1807 exhibit was also the work which appeared at the B.I. in 1809 with the same title, the identification is in any case unlikely since the framed size of the B.I. exhibit was given as 22 × 29 inches. If, as seems even more likely, the 'Kit Kat view of Keswick Lake' which Farington called on Constable to see on 13 March 1807 was the work of the same title shown at the R.A. that year, there is no possibility of the latter being No.79, the 'Kit Cat' size being 28 × 36 inches.

80 Lake District Scene *circa* 1806–8
Oil on canvas, 7⅞ × 9⅞ (20 × 25)
Prov: always in the Constable family
The Executors of Lt. Col. J. H. Constable
This has previously been known as 'Bowfell and Langdale Pikes' but the identification seems less certain now: as with Nos.77 and 79, expert local knowledge would be welcome. In this case Constable is anyway not really concerned with accurate topography. The painting is more an exercise in the manner of Gainsborough, reminiscent of his own Lake District pictures (see, for example, 'The Bridge', Tate Gallery No.2284). In the Constable family collection there is a squared-up watercolour, presumably made in 1806, which may have been the starting-point for this work (repr., Freda Constable, *John Constable*, 1975, p.37).
 See also the note on p.206.

1807

Takes new lodgings at 13 Percy Street. *13 March:* shows Farington a 'Kit Kat' (28 × 36 in. canvas) of Keswick Lake. *4 April:* shows Farington his pictures for the Academy. *23 June:* his mother writes to him (her earliest extant letter to him); he had told her he would have 'but little time to spare this Summer' from his profession. *6 July:* he is advised by Thomas Stothard R.A. to seek election to the Academy; Farington considers this premature; he has further talks with Farington during the summer. *30 August:* receives an introduction to the Earl of Dysart and his sister-in-law the Countess; he is commissioned by them to copy portraits (Reynolds, Hoppner) and to paint original likenesses. He does not appear to have left London this year. *16 November:* attends dinner at Thatched House Tavern for students of the British Institution. *12 December:* his uncle, David Watts, gives dinner, probably for his benefit; guests include Farington, Stothard, James Northcote and Dr Crotch, the musician.

Exhibits. R.A.: (52) 'View in Westmoreland'; (98) 'Keswick Lake'; (150) 'Bow Fell, Cumberland'.

1808

January: Mrs Fisher, the wife of the future Bishop of Salisbury, speaks warmly of him to Farington – 'his appearance is that of one guileless'. *1 April:* Farington calls to see his Academy pictures; he has much to tell Farington of the History painter B. R. Haydon during the next few months. *May:* is often mentioned in the diary of David Wilkie, Scottish-born genre-painter. *18th:* poses for the doctor in Wilkie's painting 'The Sick Lady'. Wilkie records him a number of times painting at the Academy Schools Life-classes. By *18 August* he had probably left London for the country; a drawing places him still in the country on *29 October*. *10 November:* he is seen by Wilkie at the Academy Schools. *25th:* Wilkie visits him and is pleased with his sketches. Probably remains in London over Christmas.

Exhibits. B.I.: (380) 'A mountainous scene in Westmorland', frame 40 × 48 inches; (480) 'Moon-light, a study', frame 23 × 20 inches. R.A.: (52) 'Winander-meer lake'; (100) 'A scene in Cumberland'; (103), 'Borrowdale'.

81 Laura Moubray 1808
Oil on canvas, 17½ × 14 (44.5 × 35.6)
Prov: by descent from the sitter to Major
W. H. H. C. Moubray; his nephew, Ivor
Moubray-Philipps 1944
Ivor Moubray-Philipps
An old inscription on a piece of wood secured to the frame (perhaps part of the original stretcher) reads 'Laura Moubray 1808 by J. Constable London'. The sitter was the fourth daughter of William Hobson of Markfield House, Tottenham. In September 1807 she married Robert Moubray of Cockairny and Otterston (1774–1848), who served in the army in India and the Mediterranean and was later Deputy Lieutenant of Fifeshire. He was knighted in 1825.
 It is not known how Constable was introduced to the Hobsons, though his old friend and supporter Priscilla Wakefield, who also lived at Tottenham, may have had something to do with it. Constable was at Markfield House in the summer of 1806 (see Nos.66–7) and sketched several of Hobson's daughters, including Laura. Presumably she sat for this portrait, painted the year after her marriage, in London, since no further visit by Constable to Markfield, and none to Scotland, is recorded.

82 View near Dedham d.1808
Oil on board, 5¾ × 10½ (14.6 × 26.7)
Inscribed on verso '[. . .] 22 Sepʳ 1808'
Prov: . . . ; H. L. Fison 1935, sold Christie's
6 November 1959 (10), bt. Paul Steiner
Paul Steiner
This and No.83 are the only surviving painted landscapes by Constable which can be securely dated to 1808. Comparison with the two dated studies of 1809 (Nos.87, 90) and those of 1810 (Nos.92–3) should reveal something about the early development of his highly individual oil-sketching style. The view, looking east towards Dedham Church, may have been taken from a road on top of the hills near Langham.

83 View towards the Rectory, East Bergholt
d.1808
Oil on board, $6\frac{3}{8} \times 9\frac{7}{8}$ (16.2 × 25.1)
Inscribed on verso 'E B', i.e. East Bergholt, and,
twice, '1808'
Prov: . . . ; ?P. M. Turner; . . . ; bequeathed to
the Fitzwilliam Museum by Sidney Ernest
Prestige 1965 with a life interest to his widow;
received on her death 1968.
Fitzwilliam Museum, Cambridge

The two paintings (Nos.134–5) which Constable later
made of the view from the back of his parents' home,
East Bergholt House, are well known. Much less fam-
iliar, and not previously recognised as such, are several
oil sketches which he made of a particular part of this
view. At least six studies survive of the area seen in the
centre distance of No.135, that is, of East Bergholt
Rectory with its distinctive group of trees. No.83 ap-
pears to be the earliest and it gives a closer view than the
others, two of which are in this exhibition: No.93,
dated 1810, and No.120, dated 1813. Another, again
dated 1813, is in the collection of Mr and Mrs Paul
Mellon, who also own a variation on the view, No.121
below.

East Bergholt Rectory and the fields around it were
to become more than usually charged with meaning for
Constable after he and Maria Bicknell fell in love in
1809 during one of her stays at the Rectory with her
grandfather Dr Rhudde. A letter quoted in connection
with a later study of the view, No.120, suggests that it
was actually in the fields separating East Bergholt House
from the Rectory that they reached some sort of under-
standing. It is little wonder that he painted the scene so
often, during his long separations from Maria and as
the opposition to their association increased.

84 Superimposed Life Studies *circa* 1808
Oil on canvas, 24 × 20 (61 × 50.8)
Prov: always in the Constable family
The Executors of Lt. Col. J. H. Constable
See No.86.

85 Life Study: man with both arms raised
d.1808
Black and white chalk on brown paper, $20\frac{7}{8} \times 12\frac{5}{8}$
(53 × 32)
Inscribed 'Nov.r 1808'
Prov: . . . ; bequeathed to Colchester by
L. J. Watts
Colchester Borough Council
See No.86.

**86 Life Study: man with right arm raised as if
holding a sword** *circa* 1808
Black and white chalk on brown paper, $20\frac{1}{2} \times 13\frac{1}{4}$
(52.1 × 33.6)
Prov: always in the Constable family
The Executors of Lt. Col. J. H. Constable

Apart from a few dated life-drawings, we have very
little information about Constable's attendance at the
Academy Schools. One of the rare sources is the diary
kept by Wilkie from which Allan Cunningham gives
extracts in his life of the artist. Wilkie began keeping
his diary in 1808, and there are several references to
Constable at the Academy in that year, the most

80

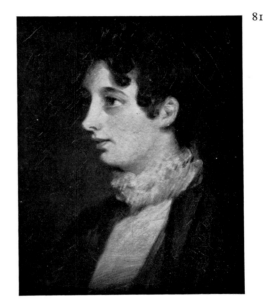

81

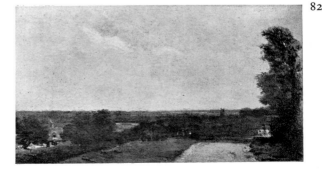

82

83

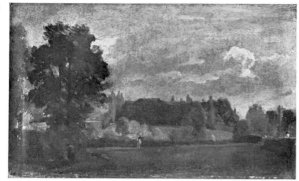

84

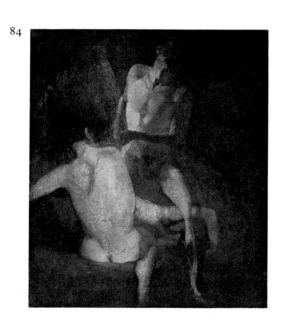

85

valuable being an entry which records Constable painting from 'the living figure' on 14 July. No.85 is dated November 1808; Wilkie notes having seen Constable at the Schools on the 10th of that month (Allan Cunningham, *The Life of Sir David Wilkie*, 3 vols. 1843: the references to Constable are reprinted in JC:FDC pp.313–15).

1809

15 January: dines with Dr Monro, collector, patron of young artists. *20th:* Wilkie calls and looks at prints with him. He is earning little by his painting at this time and lives on an allowance from his father – his mother occasionally sends him small sums of money. *3 April:* Farington calls to see his Academy paintings; advises him against sending in a five-foot picture of Borrowdale as being too unfinished and 'wanting variety of colour & effect'. *17th:* tells Farington that Haydon has renounced his acquaintance. *22 May:* visits Wilkie. Passes on a deal of gossip to Farington at their meetings. *June:* spends some time with the Gubbins at Epsom; sketches there. *15 July:* leaves London for Malvern Hall to paint a portrait of the ward of H. G. Lewis, brother of the Countess of Dysart. *1 August:* still at Malvern Hall. *12th:* his mother talks of his coming to Bergholt shortly. Some time during this summer or early autumn he renews an acquaintance with Maria Bicknell, twenty-one year-old daughter of Charles Bicknell, solicitor to the Admiralty, and granddaughter of Dr Rhudde, rector of East Bergholt; they see much of each other at Bergholt and fall in love. Two Suffolk oil-sketches are dated *October*. Still at Bergholt in the middle of *December;* his friends ask for him in London.

Exhibits. B.I.: (80) 'Windermere lake', frame 14×16 inches; (248) 'Borrowdale', frame 31×27 inches; (260) 'A cottage scene, a study', frame 25×22 inches; (282) 'Keswick Lake', frame 22×29 inches. R.A.: (26) 'A landscape'; (28) 'A landscape'; (183) 'A landscape'.

87 Epsom d.1809
Oil on board, $11\frac{3}{4} \times 14\frac{1}{8}$ (29.7×35.8)
Formerly inscribed on verso: 'Epsom June. 1809.' in pencil and 'Epsom. June. 1809 –' in ink (inscriptions removed when board marouflaged onto synthetic panel 1970)
Prov: 14 June 1873 (119), bt. Henry Vaughan; bequeathed by him to the National Gallery 1900 and transferred to Tate Gallery 1919
Tate Gallery (1818)
Painted on Constable's second visit to stay with his uncle and aunt, James and Mary Gubbins, at Epsom (see No.44).

88 Malvern Hall 1809
Oil on canvas, $20\frac{1}{4} \times 30\frac{1}{4}$ (51.5×76.5)
Formerly inscribed 'Malvern Hall Warwickshire Augt 1. 1809' according to J. H. Anderdon (see text below).
Prov: . . . ; J. H. Anderdon by 1840[1], sold

Christie's 30 May 1879 (111), bt. George Salting, by whom bequeathed to the National Gallery 1910; transferred to Tate Gallery 1968
Tate Gallery (2653)

Malvern Hall, Solihull, Warwickshire, was the seat of Henry Greswolde Lewis (1754–1829), a wealthy widower who employed Constable on various commissions and errands (not always to his liking) over a period of about twenty years. The house, which is now a school, was begun by Humphrey Greswold around 1690 but completely remodelled and extended for H. G. Lewis by Soane in the 1780s. Constable was probably introduced to Lewis by Magdalene, Dowager Countess of Dysart, Lewis's sister. Although he had visited their family seat, Helmingham Hall, in 1800 (see No.21), Constable first became acquainted with the Dysarts in 1807 when an introduction from the Dedham solicitor Peter Firmin led to his being employed by Wilbraham Tollemache, 6th Earl of Dysart, to make copies of Reynolds' portraits of the family as well as to execute new portraits; by 1808 he was also working for the Earl's sister, Lady Louisa Manners (see JCC IV pp.47–9, JC:FDC pp.114–15). The 1807 work was carried out at the Dysarts' town house in Piccadilly and it was presumably there that Constable met H. G. Lewis. His first portrait of him appears to have been painted the same year (see No.108).

Constable twice went to Malvern Hall, in 1809 and in 1820. He left London for his first visit on 15 July 1809 (see No.89) and was probably still there on 1 August (see the inscription mentioned below). The main purpose of this visit was, no doubt, to paint the portrait of Lewis' thirteen-year-old ward, Mary Freer (Collection Mr & Mrs Paul Mellon) but we know that he also painted a picture of the Hall on or following this visit: when trying to persuade Constable to return to the place in 1819, Lewis wrote 'Malverne is going on, & is much improved inside & out, & would make a much better figure in Landscape than when you painted it last' (JCC IV p.64). The picture referred to seems very likely to be No.88, on the stretcher of which a former owner, J. H. Anderdon, wrote (amongst other things): 'Lined in 1840– NB on the original stretcher was written in red chalk Malvern Hall Warwickshire Augt 1. 1809 x apparently in the autograph of the painter'[2].

Following his second visit to Malvern Hall in 1820, Constable produced another version of No.88 and several versions of a companion view (see No.202). Two of these later pictures were bought by Lewis's sister, the Dowager Countess. We do not know for whom the 1809 picture was painted: Lewis's taste was principally for things genealogical and antiquarian, not for landscape. Constable, however, is unlikely to have done any house portrait on spec or out of his own interest.

89 Malvern Hall d.1809
Pencil, $3\frac{3}{4} \times 6\frac{1}{16}$ (9.6 × 15.4)
Inscribed on verso 'Left Town for Malvern –
Saturday July 15 1809'
Prov: ?17 June 1892 (part of 152), bt. Leggatt;
Herbert P. Horne; bequeathed by him to the
City of Florence 1916
Fondazione Horne, Florence

For Constable's visit to Henry Greswolde Lewis at Malvern Hall in 1809 see No.88 above. The inscrip-

86

87

88

89

tion on this drawing establishes the approximate date of the beginning of his stay, which may have continued until at least 1 August (it was previously thought that Constable arrived after 17 July, when his mother wrote to say 'I hope you will go to Mr. Lewis's, as you mention': JCC I p.34). The entrance front of Malvern Hall is shown here, with Solihull church in the distance at the right, rather than the park side as in the 1809 painting, No.88. An almost identical view appears in a drawing made on Constable's second visit in 1820 (No.184). Comparison of the two drawings reveals the artist's increasingly sophisticated pencil-work and also the changing appearance of the Hall itself. Between Constable's two visits Lewis restored the string-courses, quoins and other external features removed by Soane in the 1780s, excavated the ground in front of the basement, built a balustraded terrace at the front of the house and a pair of gate piers based on a design by Inigo Jones[3].

90

90 A Lane near East Bergholt with a Man Resting d.1809
Oil, $8\frac{1}{2} \times 12\frac{7}{8}$ (21.6 × 32.7) on board, $12\frac{1}{8} \times 12\frac{7}{8}$ (30.8 × 32.7)
Inscribed 'Oct.' 13. 1809. E.B. [i.e. East Bergholt]' and '1809' again below
Prov: 28 May 1891 (E. Colquhoun, 135, with date as above and reference to sketch on back), bt. Miley; . . . ; H. A. C. Gregory, sold Sotheby's 20 July 1949 (116), bt. C. Cookson
Thos. Agnew & Son Ltd
(colour plate facing p.48)

On the back is a study of a country house, so far unidentified. The view on the front is almost the same as that in the 1811 'Dedham Vale: Morning' (No.100) and the related sketch in the collection of Anthony Bacon, that is, from the junction of the Bergholt–Flatford road with Fen Lane, south of East Bergholt, looking west along the Stour valley with Stratford St. Mary church in the distance. See also Supplement No.93a.

91 Dedham Vale *circa* 1809
Oil on (?) panel, $10\frac{1}{2} \times 15$ (26.7 × 38.1)
Prov: . . . ; Sir Michael Sadler by 1933; Dr H. A. C. Gregory by 1948, sold Sotheby's 20 July 1949 (114), bt. Katz
Private collection

The view here, from East Bergholt looking westwards up the Stour valley, is identical to the one later drawn on p.43 of the 1813 sketchbook (No.119), which is inscribed '28 July. 1813. E[ast] B[ergholt].' The church in the centre distance is Stratford St. Mary and that on the horizon towards the right, Stoke-by-Nayland. This study is painted over another work, traces of which are visible through the present paint surface: the bottom of the original composition, which includes gables and trees, is the right-hand side of the top painting.

91

1810

Receives a commission from an aunt, his father's sister, to paint an altarpiece for Nayland church; the subject is discussed at length with David Watts; he is received at Maria Bicknell's London home and becomes a regular visitor. *March:* is urged by his mother to exert himself, also to be wary of uniting himself 'with a House mate'. *28th:* Farington sees his three pictures for the Academy (only two are in the exhibition). Moves to new lodgings in Frith Street. *April:* dines with Bishop Fisher; stays at Epsom; the altarpiece now a regular topic in his mother's letters. *June:* Stothard and Farington recommend him to put his name down as a candidate for an Associateship of the Academy. *July:* Lord Dysart buys one of his Academy pictures; changes the subject of his altarpiece from 'The Agony' to 'Christ Blessing Bread and Wine'; to Suffolk, taking the altarpiece with him. *11 November:* back in London. *24th:* David Watts sends a long letter on the Nayland altarpiece; in *December,* Watts asks him for a small painting of Flatford Mill; forms an acquaintance with the History painter George Dawe.

Exhibits. R.A.: (74) 'A landscape'[1]; (116) 'A church-yard' (very likely No.99).

92

92 A View on the Stour d.1810
Oil on canvas, $10\frac{1}{2} \times 10\frac{1}{2}$ (26.7 × 26.7)
Inscribed '27. Sep.ʳ 1810.'
Prov: 28 May 1891 (E. Colquhoun, 118, 'On the Stour', with inscription as above), bt. Colnaghi; probably bt. by John G. Johnson from French Gallery, London 1891
John G. Johnson Collection, Philadelphia

The view here is from downstream at Flatford, looking towards the lock. So far as is known, this is the earliest dated example of the celebrated oil studies executed around 1810–12, in which Constable's mastery of the technique is usually said to be first apparent. The exhibition will provide an opportunity to see to what extent this mastery is anticipated in such earlier studies as Nos.82–3, 87 and 90.

93

93 View towards the Rectory, East Bergholt d.1810
Oil on canvas, laid on panel, $6 \times 9\frac{5}{8}$ (15.3 × 24.5)
Inscribed '30 Sep.ᵗ 1810 E. Bergholt Common'
Prov: . . . ; ?John Wilson; . . . ; John G. Johnson by 1914
John G. Johnson Collection, Philadelphia

See Nos.83 and 120 for comment on the various oil studies of this view and its especial meaning for Constable. The prominence allowed to the inscription seems to point up the private nature of such studies. Although previously thought of as a sunset study, the geography of the scene indicates that Constable was painting at sunrise.

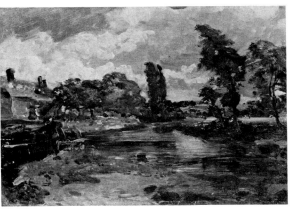

94

94 Flatford Mill from the Lock *circa* 1810–11
Oil on paper laid on canvas, $10\frac{1}{4} \times 14$ (26 × 35.5)
Prov: presented to the R.A. by Isabel Constable 1888
Royal Academy of Arts, London
See No.96.

95 **Flatford Mill from the Lock** 1810 or 1811
Oil on canvas, 10 × 12 (25.4 × 30.5)
Inscribed on stretcher: 'E B. [i.e. East Bergholt]
1810 or 1811 J Constable'
Prov: Isabel Constable; . . . ; George Salting by
1902; his daughter Lady Binning 1910; by
descent to present owner
The Lord Binning
See No.96.

96 **Flatford Mill from the Lock** *circa* 1810–11
Oil on canvas laid on board, 6 × 8¼ (15.2 × 21)
Prov: given by Isabel Constable *circa* 1888 to
R. A. Thompson, who died 1909; by descent to
his great-niece Mrs Bell Duckett, sold Morrison,
McChlery & Co., Glasgow, 18 March 1960 (100),
bt. Agnew's, from whom bt. by present owner.
Private collection
(colour plate facing p.49)

At least two other studies of more or less the same view
as Nos.94–6 are known: one in the V. & A. (R.103),
which is close to Nos.94–5, and No.96a (see Supple-
ment), which does not extend far enough on the left to
include the Mill and which shows a figure seated beside
the lock rather than engaged in opening it. Constable
worked in the same 'serial' fashion from other motifs,
for example, the view of East Bergholt rectory with its
surrounding trees (Nos.83, 93, 120) and, much later
one of the views from Hampstead Heath (Nos.194–6).
Other groups could probably be reconstructed.

The date inscribed on the back of No.95 reads '1810
or 1811'. Constable is known to have been painting
at Flatford in 1810 because his mother told him on
8 January 1811 that his uncle David Pike Watts 'was so
much taken with one of your sketches of Flatford Mills,
House &c. that he has requested you to finish it for him'
(JCC I p.55). It is quite possible that the sketch Watts
liked was one of the group under discussion, though
there is no actual proof that it was even of this particular
view. Watts himself had already written to Constable
about the picture he wanted. 'Have you touched the
small "Flatford Mill"?', he asked on 22 December
1810, 'When you do let it be *worked up* to bear a close
eye as a small Cabinet [?Picture]. I do not want it for
Effect as in a place where I will place it I cannot well
retreat to a distance for the *Effect*. It must bear close
examination' (JCC IV p.24). Watts seems to have been
after a small finished painting based on one of Con-
stable's sketches – the artist would not literally have
'worked up' a sketch itself. Mrs Constable again referred
to a painting of Flatford when she wrote to her son on
26 October 1811: 'Your Father . . . rode down to Flat-
ford on Friday – Your pretty View from thence is so
forward – that you can sit by the Fireside and finish it –
as highly as you please – & I am certain it will gain ap-
plause – for every one approves it – as it now is' (JCC I
p.67). The work in question here also seems to have
been not a sketch but a more finished painting, presum-
ably begun at Flatford that summer and still wanting
the final touches. It may have been the small cabinet
picture for Watts but it seems more likely to have been
the painting mentioned by Constable when he told
Maria on 12 November 1811 what he had been doing
that summer: 'I have tried flatford Mill again – from
the lock ([?where/ ?whence] you once made a drawing)

and some smaller things – one of them (a view of Mrs
Roberts's Lawn – by the summer's evening) – has been
quite a pet with me –' (JCC II p.54). The reference to
'smaller things' suggests that the other work mentioned,
the picture of Flatford Mill from the lock, was not a
sketch or small painting but something rather larger. At
the R.A. in 1812 Constable exhibited 'A water-mill',
which is described more specifically in his letter to
Maria of 16 April that year as '*flatford Mill*' (JCC II
p.63). Again there is no proof, but it does seem very
likely that the painting mentioned in the letters of
26 October and 12 November 1811 was the work which
appeared at the Academy the following spring. The
only candidate so far proposed for the exhibited picture
is one measuring 26 × 36½ inches which was in the sale
of Senator W. A. Clark's collection by the American
Art Association of New York on 12 January 1926 (lot
99, repr. in catalogue; present whereabouts unknown).
The composition of this picture corresponds with that
of Nos.94–5. It is tempting to suppose, therefore,
that such sketches as Nos.94–5 were made in 1810,
that D. P. Watts commissioned a small finished version
of one of them (either not executed or now untraced)
and that his interest prompted Constable to paint a
larger version which was well forward by October 1811
and shown at the R.A. in 1812.

If Nos.94 and 95 were painted in the same year,
No.94, which shows reapers at work, must have pre-
ceded No.95, in which the corn is seen standing in
stooks. Another reason for dating these sketches to 1810
or thereabouts is their similarity to the view on the
Stour of 27 September 1810 (No.92).

97 **Flatford Lock** *circa* 1810–12
Oil on paper laid on board, 6⅜ × 9 (16.2 × 22.9)
Prov: presented to the R.A. by Isabel Constable
1888
Royal Academy of Arts, London

Flatford Lock is seen here from beneath the trees which
appear at the right of the 'Flatford Mill from the Lock'
studies of *circa* 1810–11 (Nos.94–6). The bridge and
Bridge Cottage are in the distance. Constable's large
'Lock' pictures of the 1820s (Nos.227, 262) omit the
numerous cross-beams which are clearly visible on the
lock here. A similar view is given on page 54 of the 1813
sketchbook (No.119, repr. p.85) and Constable's early
mentor John Dunthorne also painted the subject,
though very differently, in 1814 (No.339).

98 **Barges on the Stour at Flatford Lock**
circa 1810–12
Oil on paper laid on canvas, 10¼ × 12¼ (26 × 31.1)
Prov: presented to the V. & A. by Isabel
Constable 1888
Victoria and Albert Museum (R.104)

As in No.97, the cross-beams on Flatford Lock are
shown here. Presumably Constable omitted them from
his large pictures of the subject in the 1820s because
they gave too repetitious and horizontal an accent to
the composition. For a similar reason he seems later to
have suppressed or disguised the long row of poplars
seen in the distance to the right of Dedham church.

1811

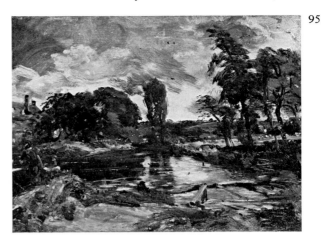

25 January: Watts gives another dinner; Stothard, Owen, Lawrence, Crotch among the guests. Constable's mother asks him to paint a watercolour of Bergholt church for her to give to Dr. Rhudde; he obliges. *March:* at Epsom for his health; further portraits commissioned by H. G. Lewis. *2 April:* Farington calls to see his pictures for the exhibition. *6th:* tells him his Dedham Vale (No.100) is 'much approved'. In recent months he has been a regular caller at Spring Gardens, Maria's home; she now leaves for a long stay at Bewdley, Worcestershire, with her widowed half-sister. *4 June:* calls on Farington after three weeks at Bergholt; has been painting there. His family and friends now worried by the effect the separation from Maria is having on him; long letters from Watts on the subject – 'cheerfulness is wanted in your landscapes; they are tinctured with a sombre darkness.' May have spent some weeks at Bergholt again. *27 August:* dines with Farington. *September:* second half at Salisbury with Bishop Fisher; forms a friendship with Rev. John Fisher, the Bishop's nephew; begins a commissioned portrait of the Bishop. Early *October:* at Stourhead for a few days with the Fishers. *23rd:* writes the first of many letters to Maria; she is still out of town and he is not received at Spring Gardens; her replies are not encouraging. *November/December:* spends two or three weeks at Bergholt. *17 December:* Maria asks him to cease thinking of her and to forget that he ever knew her; he takes an early coach to Worcestershire and is well received. He returns on *22nd;* their correspondence continues. *31st:* his father writes – regrets his too great anxiety to excel and thinks that he makes too serious a matter of the business of painting.

Exhibits. B.I.: (185) 'A church porch', frame 25 × 22 inches (No.99). R.A.: (71) 'Twilight'; (471) 'Dedham Vale: Morning' (No.100).

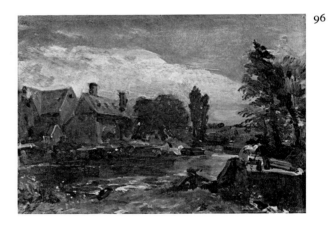

99 'A church porch' (The Church Porch, East Bergholt) exh.1811 (?also 1810)
Oil on canvas, 17½ × 14⅛ (44.5 × 35.9)
Exh: ?R.A. 1810 (116, 'A church-yard'); B.I.
1811 (185, size with frame 25 × 22 inches)
Prov: presented to the National Gallery by
Isabel Constable 1888; transferred to Tate
Gallery 1951
Tate Gallery (1245)

This is the first oil painting by Constable that can be identified with any certainty as an exhibited work. Leslie's account (1843 p.10, 1951 p.21) of 'A church porch' which Constable sent to the British Institution in 1811 corresponds closely with the picture: 'The "Porch" is that of Bergholt Church, and the stillness of a summer afternoon is broken only by the voice of an old man, to whom a woman and a girl sitting on one of the tombs are listening. As in many of the finest Dutch pictures, the fewness of the parts constitutes a charm in this little work; such is its extreme simplicity of effect, that it has nothing to arrest the attention, but when once noticed, few pictures would longer detain a mind of any sensibility.' David Lucas' engraving entitled 'Porch of the Church at East Bergholt, Suffolk', made

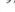

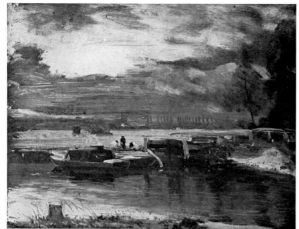

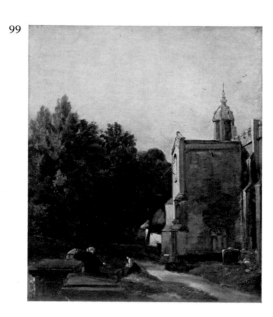

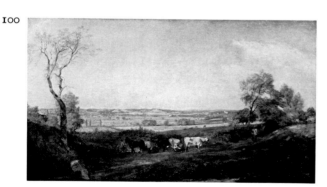

about 1843, also corresponds with this painting, and, in an annotation to the passage by Leslie quoted above, Lucas identified the 1811 exhibit with the work he had engraved (see JC:FDC p.55). Leslie himself made the same identification in the copy of his book which he presented to Samuel Rogers (Private collection). There is nothing to prove that No.99 was also the work exhibited at the R.A. in 1810 as 'A church-yard'. Leslie mentions both exhibits in their respective years without making the connection. However, it was common practice to exhibit at the B.I. a picture which had failed to sell at the previous year's Academy and the title of the 1810 exhibit is perfectly appropriate to No.99.

An old man with two girls grouped around a tombstone in East Bergholt churchyard is also the subject of an earlier drawing, No.61 above. Like that, this picture plainly belongs to the tradition of churchyard melancholy in painting and poetry of which Gray's *Elegy* was the progenitor. When Leslie borrowed No.99 in 1830 for his sister Ann to copy, Constable wrote: 'My dear Leslie, I send the "Churchyard", which my friends in Portman Place are welcome to use for any purpose but to go into it . . . The motto on the dial is "Ut umbra sic vita"' (Leslie 1843 p.68, 1951 p.182).

100 'Dedham Vale: Morning' exh.1811
Oil on canvas, 31 × 51 (78.8 × 129.5)
Inscribed 'John Constable pinxt. 1811' and
'DEDHAM VALE.'
Exh: R.A. 1811 (471): ?B.I. 1813 (104, 'Landscape, a scene in Suffolk', size with frame 43 × 62 inches)
Prov: ?16 May 1838 (65, 'Dedham Vale'), bt. Norton; presumably the work mentioned by Lucas in 1846 as belonging to George Oldnall of Worcester (see JCC IV p.441) and in his sale, Christie's 16 June 1847 (111, 'Dedham Vale with a group of cows – capital'), bt. Colls; . . . ;
W. Fuller Maitland, sold Christie's 10 May 1879 (71, 'Vale of Dedham', 1811, but size given as 29½ × 44½ inches), bt. Daniel; Agnew's 1907–8; 5th Earl of Carysfoot 1908; his nephew Col. D. J. Proby 1918–31; by descent to present owner.
Major Sir Richard Proby, Bt.
(colour plate facing p.64)

So far as is known, this was Constable's first large-scale exhibition picture, and it is clearly one to which he devoted a great deal of attention. Annotating Leslie's reference to it (1843 p.10, 1951 p.22) David Lucas said that Constable 'often told me this picture cost him more anxiety than any work of His before or since that period in which it was painted. that he had even said his prayers before it.' (JC:FDC p.55.) The view is from the junction of the Bergholt–Flatford road with Fen Lane, south of East Bergholt, looking west along the Stour Valley. Dedham church is on the left, Langham church on top of the hills in the centre and Stratford church on the right. Several oil sketches of more or less the same view seem to have led up to No.100: No.90 above, dated 1809, which includes a man reclining against a milestone (perhaps the origin of the inscribed stone in No.100); No.93a (see Supplement), in which a milestone and reclining figure also appear, though not in conjunction, and in which a female figure, similar to that in No.100, is introduced; and an oil sketch in the

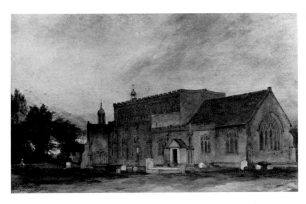

101

collection of Anthony Bacon, lacking figures but closest in other respects to the final painting. A pen and wash drawing in the Philadelphia Museum of Art is also related. The tall tree at the left of No.100 appears in none of the sketches and was presumably introduced for compositional reasons. The donkey reappears in 'The Cornfield' (No.242) and in a study associated with it (V. & A., R.287).

101 East Bergholt Church d.1811
Watercolour, 15⅝ × 23⅝ (39.7 × 60)
Inscribed 'John Constable feb^y. 1811.' and on a decorative label on verso: 'A South East View of East Bergholt Church in the County of Suffolk. a Drawing by J. Constable Esq^r and presented in testimony of Respect to the Rev^d Durand Rhudde. D. D the Rector. Feb^ry 25 1811.'
Prov: presented by the artist's mother, Mrs Ann Constable, to the Rev. Durand Rhudde 1811;...; James Orrock; acquired by W. H. Lever, later Lord Leverhulme, 1906
Trustees of the Lady Lever Art Gallery, Port Sunlight

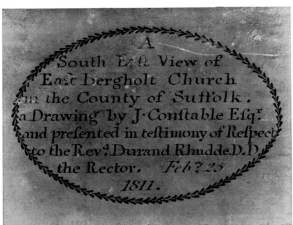

Fig.ii
(see No.101)

At an unknown date Constable gave his mother a watercolour which he had made of East Bergholt Church. When the attachment between Constable and Maria Bicknell was reaching a critical stage, Mrs Constable decided that it would be a diplomatic gesture if her son made another version of the watercolour for presentation to Maria's maternal grandfather, Dr Rhudde, Rector of East Bergholt. The original was sent to Constable in London around 18 January 1811 (see JCC I p.56) and, as the inscription on the back shows, the copy was ready for presentation to Dr Rhudde on 25 February. Mrs Constable reported its very favourable reception in a letter to her son on 6 March (JCC I p.57), in which she also described the 'small tablet' which Dunthorne had 'neatly lettered' for the back (and which is still there: fig.ii). Dr Rhudde himself wrote to thank the artist on 16 March (JCC II p.48), enclosing a bank note for him to buy 'some little article by which you may be reminded of me, when I am no more'. The following year, however, saw the beginning of Dr Rhudde's serious opposition to Constable's alliance with Maria, which continued until their marriage.

Beckett (Typescript Catalogue) suggests that the original watercolour was made around 1805–6 since the copy is similar in character to the watercolour of East Bergholt Church in the National Gallery of Canada, Ottawa, which is dated 1805, and to one in the V. & A. dated 1806 (R.67). In 1843 the original belonged to Constable's sister Ann (see Leslie 1843 p.19) but its present whereabouts is unknown.

102 A Cart on the Road from East Bergholt to Flatford d.1811
Oil on paper laid on canvas, 6 × 8½ (15.2 × 21.6)
Inscribed by Lionel Bicknell Constable on label on stretcher, presumably copying original inscription on back of paper: '17 May, 1811 L. B. C.'
Prov: presented to the V. & A. by Isabel Constable 1888
Victoria and Albert Museum (R.100)
Another sketch of the same view (V. & A., R.329) has

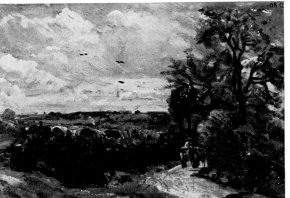

102

been dated *circa* 1830 but is clearly also of this period. An oil sketch given by Isabel Constable to Alfred Tidey (6¼ × 8⅞ inches; with Agnew's 1960) and the left-hand side of page 32 of the 1813 sketchbook (No.119) look as though they were made at more or less the same spot.

103 Summer Evening ?1811

Oil on canvas, 12½ × 19½ (31.7 × 49.5)
Inscribed: see Reynolds 1973 for inscriptions, not in the artist's hand, on the back of the picture.
Prov: 22 May 1869 (104)¹, bt. in by Bourne; presented to the V. & A. by Isabel Constable 1888
Victoria and Albert Museum (R.98)

The view, similar to that in Nos.32 and 59, is from behind West Lodge, East Bergholt, where Mrs Sarah Roberts lived. Langham church is on the hills towards the left and Stratford church in the valley in the centre of the picture.

On 12 November 1811 Constable told Maria what he had painted that summer: 'I have tried flatford Mill again – from the lock . . . and some smaller things – one of them (a view of Mrs Roberts's Lawn – by the summer's evening) – has been quite a pet with me –' (JCC II p.54). If, as suggested in the entry on No.96, the Flatford Mill picture was of a reasonable size and was possibly the work measuring 26 × 36½ inches later in the collection of Senator Clark, No.103 could be the 'smaller thing' Constable had painted of Mrs Roberts' meadow. Certainly, No.103 was 'quite a pet' with him because it was one of the pictures he later chose for inclusion in *English Landscape*. The title he gave that print, 'Summer Evening', also corresponds with the reference in his letter to Maria.

Constable had painted more or less the same view as early as 1802 and perhaps even before that (see No.32). Mrs Roberts grew to associate him with it, telling his mother in 1809 that she always thought of him 'at the setting sun, thro' her trees' (JCC I p.36). After Mrs Roberts' death on 2 December 1811, Mrs Constable told her son that she had got back 'the Picture – you did for Mʳˢ Roberts – our late Friend & Neighbour which is of great Value to me, because it is your Performance and so well done in every respect, I wish the Nayland Picture [Constable's altarpiece for Stoke-by-Nayland church] was as highly finished' (JCC I p.72). Possibly Mrs Roberts' picture was also an evening view from her 'lawn'.

No.103 is a finished composition of the kind Constable would have exhibited but it seems unlikely to have been '*Exhibited* in 1811' as stated in the 1869 sale catalogue. The only work shown that year and not otherwise accounted for is the 'Twilight' sent to the R.A. and its title seems inappropriate to No.103, in which the sun has not yet set. If the painting was exhibited, it is much more likely to have been the 'Landscape: Evening' shown at the R.A. in 1812.

104 Salisbury Cathedral: exterior from the South-West d.1811

Black and white chalk on grey paper, 7⅝ × 11¾ (19.5 × 29.9)
Inscribed verso 'Salisbury Cathedral Sepr. 11 & 12 – 1811 – S.W. view –'
Prov: presented to the V. & A. by Isabel

Constable 1888
Victoria and Albert Museum (R.105)

After his attempt in 1802 to help Constable in his career (see No.31), Dr Fisher did not lose interest in his protégé, and when he acquired a London residence in Seymour Street, Constable became a regular visitor there. Mrs Fisher seems to have had a particularly soft spot for him. In 1808 she spoke to Farington of him 'with much commendation. She said his countenance is like one of the young figures in the works of Raphael: – and that his appearance is that of one "guileless".' For many years a friend of George III (and known, it was said, as the King's Fisher), in 1803 Fisher was chosen by the King to succeed to the Bishopric of Exeter. In 1807, he was translated to the more richly endowed Salisbury.

There had apparently been talk of Constable staying with the Fishers at Salisbury in the autumn of 1810, but it was not until September of the following year that he made the first of his many visits to Wiltshire. After his return, he told Maria Bicknell of his reception by the Fishers. 'The great kindness (I may almost say affection) ⟨of the⟩ that the good Bishop and Mʳˢ Fisher have so long shown me was now exerted in an unusual degree ⟨to me⟩ to make every thing agreeable to me – During my stay his Lordship & Mʳˢ F – made a visit for a few days ⟨at⟩ to Sir Richard Hoare – at Stourhead – (a most beautifull spot) – and took me with them – we were not fortunate in the weather but the inside of the House made ample recompense – Sir Richard is no inconsiderable Artist himself –' (JCC II p.50). It appears to have been during this visit of some three weeks that there took root the friendship between Constable and the Bishop's nephew, John Fisher – the longest-lasting and most valuable of all the artist's friendships.

Compared with some of his earlier and later jaunts into the country, this visit was not as productive as it might have been. This Constable admits in a letter written in November to Maria: 'I did not however do so much as I might when there – I was not in the humour – as to avail myself of many interesting plans which the Bishop and Mrs. Fisher proposed to me –' (*ibid.*, p.54).

It was the view of the Cathedral to be seen in this present drawing that Constable was later to paint as 'Salisbury Cathedral from the Bishop's Grounds', a picture commissioned by the Bishop (No.216). We do not know whether it was the artist or his patron who removed the tree that obscures the chapter-house in No.104 but is absent from the later painting.

105 Old Sarum d.1811

Black and white chalk on grey paper, 7½ × 11¾ (19 × 29.8)
Inscribed on verso, twice, 'Old Sarum Sept. 14ᵗʰ, 1811'
Prov: 11 July 1887 (41 or 42), bt. Shepherd; given to Oldham Art Gallery by Charles E. Lees 1888
Oldham Art Galleries and Museums
See No.106.

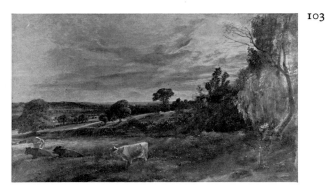

103

106 Salisbury Cathedral from Old Sarum 1811
Black and white chalk on grey paper,
$7\frac{1}{2} \times 11\frac{3}{4}$ (19 × 29.8)
Prov: 11 July 1887 (41 or 42), bt. Shepherd;
given to Oldham Art Gallery by Charles E. Lees
1888
Oldham Art Galleries and Museums

Black and white chalk on tinted paper was Constable's
customary medium when drawing from the model at
the Academy Schools, but not often did he choose it for
sketching out-of-doors. After these Wiltshire drawings
of 1811 and a few studies made the following year in
Suffolk, he does not appear to have used tinted paper
again until 1819 when he made a few tentative experiments in coloured chalks (see Nos.169–72).

'Salisbury has offered some sketches –', Constable
told Maria in his letter of 12 November, 'Mr Stothard
admired them and one in particular (a general view of
Sarum) he recomends me to paint – & of a respectable
size –' (JCC II p.54). Constable apparently acted upon
the Academician's advice, for one of his exhibits in the
next Academy was called 'Salisbury: Morning'. This
painting has not yet been identified. A general view of
Salisbury in the Louvre might be considered as a possible candidate for the work were it not for the fact that
the time of day depicted, an hour when the sun was well
past its zenith, does not agree with the title as printed
in the Academy catalogue.

107 Jacob's Vision (Copy after Salvator Rosa)
d.1811
Pencil, $3\frac{9}{16} \times 6$ (9 × 15.2)
Inscribed 'Devonshire House – Oct. 11. 1811 –'
and on verso: 'from Salvator Rosa Drawn at
Devonshire House'
Prov: . . . ; Dunthorne Gallery 1936; . . . ;
?Anon., sold Sotheby's 24 Nov. 1948 (85), bt.
K. Hall; . . . ; McGregor 1950; . . . ; Anon., sold
Christie's 5 March 1974 (81), bt. for present owner
Private collection

Constable was only just back from his visit to Salisbury
and Stourhead when he noted this painting by Salvator
Rosa in his sketchbook, the same sketchbook in which
he had recently drawn views of the Cathedral (V. & A.,
R.106–8), and of Stourhead (Fogg Art Museum).

Salvator's painting (still in the Devonshire collection)
evidently made an impression on Constable. Many
years later, in 1830, when staying at the *Pelican* at
Newbury, John Fisher wrote the following to Constable: 'You recollect a copy, hanging upon the staircase of this Inn, of Salvator Rosas Jacobs Ladder. And
you always admired it [they had been there together in
1821]. It is now newly varnished, which has discharged
the dust & grime, & brought out the colours. It has such
an appearance of "art", & appears so much a good
memorandum of a picture . . . that I have half a mind to
purchase it. The widow here leaves the price to my
honour. Now shall I possess myself of it?' (JCC VI
p.260). Constable replied by return: 'With respect to
the picture at Newbury I have an imperfect recollection
of it, but only that *we* thought it respectable. Indeed the
principle on which it is built is so unique & decided that
the most clumsy hand could not miss it.'

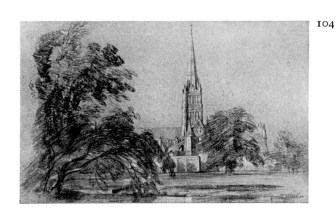

104

105

106

108 Henry Greswolde Lewis 1811

Oil on canvas, 31 × 26 (78.8 × 66)
Inscribed 'Hen.^y Greswold Lewis Esq.^re 1809.'
Prov: commissioned by the sitter for presentation
to his brother-in-law, the 1st Earl of Bradford;
by descent to the present owner
Private collection

As mentioned in the entry on No.88, Constable was probably introduced to Henry Greswolde Lewis (1754–1829)[2] of Malvern Hall by the Dowager Countess of Dysart, Lewis' sister. This was in 1807. During the following twenty or so years Lewis employed, or tried to employ, Constable on a variety of jobs, including his own portrait (repeated several times) and that of his ward Mary Freer, a miniature of Miss Freer's eye for a shirt-pin, a nine-foot high image of Lewis' Norman ancestor 'Humphri de Grousewolde' for the stairwell at Malvern Hall, and a sign for The Mermaid and Greswolde Arms Inn. Grateful though he must have been for Lewis's patronage, Constable could hardly feel flattered by the curious forms it so often assumed. The 'Mermaid' job provoked a bitter comment in a letter to C. R. Leslie in 1829, shortly after Maria Constable's death: 'I have just received a commission to paint a *"Mermaid"* – for a *"sign"* on an inn in Warwickshire. This is encouraging – and affords no small solace to my previous labours at landscape for the last twenty years – however I shall not quarrel with the lady – now – she may help to educate my children' (JCC III p.18).

The history of the various versions of Constable's portrait of H. G. Lewis is too complicated to be thoroughly investigated here but some facts emerge from his letters to Constable published in JCC IV pp.49–72. A few months after Constable's return from Malvern Hall in 1809 (see No.88) Lewis asked the artist, on 19 November 1809, to make a copy of his original portrait of him for presentation to his brother-in-law, the Earl of Bradford. This copy, the work shown here as No.108, was finished (and probably entirely painted) in 1811, perhaps after further sittings from Lewis. The date inscribed on this picture, '1809', has usually been taken as a reference to the year when the original portrait was painted but Lewis's letters suggest otherwise. When he commissioned the copy in November 1809 Lewis said that it was 'so long since it was promised, I feel quite ashamed': if the original also dated from 1809, he could not have promised Lord Bradford a copy of it for so very long. In the same letter Lewis told Constable, 'Your dash of the paint brush, has left me undelineated two years', which suggests that the original was painted in 1807. A later reference shows that Lewis had in fact promised his brother-in-law a copy the same year, 1807: when the copy went astray on its journey to Lord Bradford in 1811, Lewis wrote to Constable on 15 December, 'After 4 years delay to have the picture lost at last is unsufferable'. The original picture may well have been one of the new portraits commissioned by the Earl of Dysart in 1807 in addition to the Reynolds copies (see under No.88). Possibly the '1809' on Lord Bradford's picture refers to the date of the commissioning of the copy or perhaps for some reason Lewis wanted the work to carry the same date as Mary Freer's portrait – there is a hint that the inscription on this was added in 1811, when Constable was

preparing the Bradford copy (see JCC IV p.51).

Lewis also commissioned two miniature replicas of his portrait and in referring to one of these in 1813 he suggested that it might be improved if Constable took another look at a version of the portrait which he called 'my second self in Mr. Bossonet's custody'. A letter from Lewis of 4 September 1816 indicates that Bossonet had recently died and that the portrait of Lewis which he had in his care had been sent to the sitter at Malvern by the Dowager Countess of Dysart. Lewis described this painting as 'the best picture of Henry Greswold Lewis now extant'. Who Bossonet was is unclear but Lewis's high opinion of this version, coupled with the fact that the Dysarts were in some way involved with it, may suggest that his was the original portrait of 1807. In 1824 Constable produced another copy of the portrait with Johnny Dunthorne's assistance (JCC II pp.343–61) and in 1828 Lewis mentioned a version, possibly the same, which had been painted for Mrs ffrance, the former Mary Freer (JCC IV p.72). One of the Lewis portraits is now at Somerville College, Oxford[3]. It was acquired from descendants of Mary ffrance and is presumably the picture mentioned by Lewis in 1828.

1812

January: his sister Mary joins him to keep him company; Maria returns to Spring Gardens – her family apparently unaware that they arrange meetings. *20 February:* Maria writes, then leaves again for Worcestershire. *March:* tells her he finds London 'a gloom of solitude'. *April:* complimented by West on Academy pictures; paints portraits, including one of his uncle, David Watts. *May:* further praise for his pictures; thinks Turner's 'Hannibal' 'scarcely intelligible in parts', yet as a whole 'novel and affecting'; continues to copy portraits for the Dysart family; tells Maria that she has very distinctly marked out a path for himself in painting and is 'desirous of pursuing it uninterruptedly.' *5 June:* a long country walk with Stothard. *19th:* to Suffolk with his mother. *July:* writes that he is living a hermit-like life, always with his 'pencils' (i.e. brushes) in his hands. Late *August:* a short visit to London and some surreptitious meetings with Maria. *6 September:* writes from Suffolk that he has not been able to resume painting. To Wivenhoe, Essex, to paint a portrait. His mother calls on the Bicknells in Spring Gardens. *25 October:* tells Maria that painting seems their greatest enemy, but that 'nevertheless I love it more and more dayly.' *3 November:* Maria returns to London; occasionally they manage to meet. Completes a second portrait of Bishop Fisher. *December:* in Suffolk, begins a portrait of Capt. Western.

Exhibits. R.A.: (9) 'A water-mill' (see under No.96); (72) 'Landscape: Evening' (see under No.103); (133) 'Landscape: A recent shower'; (372) 'Salisbury: Morning' (see under No.106).

147 **Osmington Bay** ?1816 (entry on p.99) ▶

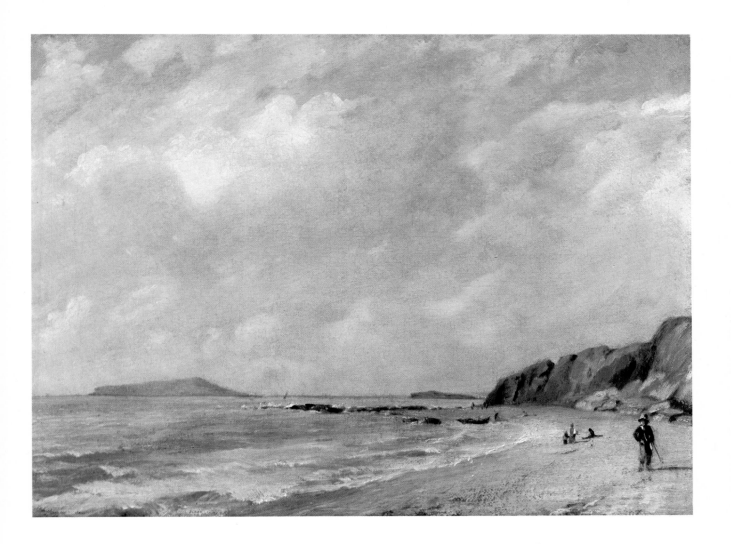

109 Mary Constable d.1812
Pencil, 6 × 3 9/16 (15.2 × 9.1)
Inscribed '22ᵈ Apˡ 1812'
Prov: bt. from Hugh Constable by Leggatt's
1899; ...; Sir Harry Baldwin, sold Sotheby's
19 June 1933 (125), bt. Sir Robert Witt and
bequeathed by him to Courtauld Institute 1952
Courtauld Institute of Art (Witt Collection)

Constable had been in serious need of a companion in
the autumn of 1811. In a letter to Maria Bicknell (in
Worcestershire) on 24 December, he had spoken of the
effect that hours of despondency could have on the
health, and had told her that he was going to ask his
sister Mary to come to stay with him that winter (JCC II
p.57). On 31 December his father wrote: 'At your
earnest request your mother & Mary, have made up
their minds & you may expect to see your Sister at
No.63 next Thursday afternoon' (JCC I p.74). Mary was
with him by 7 January and did not finally leave him
until towards the middle of June. By her presence she
apparently succeeded in dispelling the effects of what
his mother called 'those gloomy hours of thinking'
(*ibid.*, p.74).

A pair to this drawing of the artist's sister, inscribed
'22ᵈ April. 1812 – C.Sᵗ [i.e. Charlotte Street]', was sold
at Sotheby's, 26 March 1975, lot 222.

110 Richmond Hill ?1812
Pencil, 3⅝ × 6⅛ (9.2 × 15.5)
Prov: ...; bt. by the Gallery 1922
City Museum and Art Gallery, Birmingham

In the collection of Mr and Mrs Paul Mellon, there is a
small pencil drawing by Constable, inscribed 'Coombe
Wood. June 5ᵗʰ. 1812', which was done on an outing
into the country with Thomas Stothard R.A., a senior
Academician who had taken an interest in him. Coombe
Wood lies between Wimbledon Common and Rich-
mond Park. The size of paper, the style of draughts-
manship and the subject, all point to No.110 having
been made on the same day. The following day, Con-
stable wrote to tell Maria Bicknell about the expedition:
'Yesterday I took a long walk with Mr Stothard I left
my door about 6 in the morning – we breakfasted at
putney – went over Wimbledon Common – & passed
three hours at least in Coomb Wood (Stothard is a
butterfly catcher) where we dined by a Spring – then to
Richmond by the park – and enjoyed the view – and
home by the River – all this on foot and I do not feel
tired now though I was a little in the morning –' (JCC II
p.72). After quoting this passage, Leslie (1843 p.14,
1951 p.32) added: 'Constable had for some years been
honoured with the friendship of Stothard, and had be-
come the chosen companion of his long walks, the chief
relaxation of that admirable artist from the drudgery of
working for the publishers. These walks lengthened
with the lengthening days, and I have heard Constable
speak of the hilarity with which Stothard would enter
his room on a fine afternoon in the Spring, and say;
"Come, sir, put on your hat, my boys tell me the lilacs
are out in Kensington Gardens." Constable showed me
a beautiful drawing of a shady lane which he made,
during their excursion to Coombe Wood, while his
companion, who was introduced into it, was engaged
with his butterfly nets. Stothard was then about fifty
years of age, his deafness precluded him from the en-

107

108

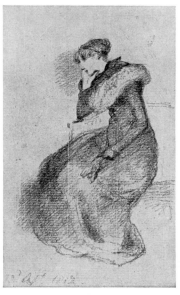
109

◀ 151 **'Scene on a navigable river' (Flatford Mill)** exh.1817 detail (entry on p.101)

110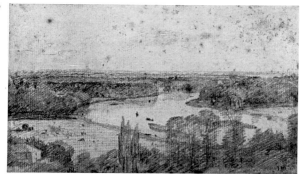

111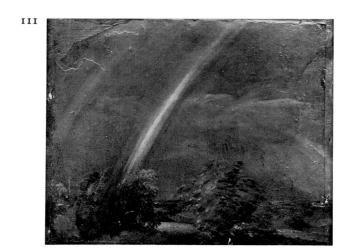

joyment of general society, but with a single friend, and in this instance, a younger man, who looked up to him with great respect and admiration, and whose mind was in many respects a kindred one, he was very communicative. In their walks together, he, no doubt, felt his infirmity as little as possible; while the hours so passed must have contributed to soothe the spirits of Constable, disquieted as they then were.' A fine landscape draughtsman and watercolourist in his own right, Stothard should be reckoned as having been amongst those who influenced Constable in these early years.

111 Landscape with a Double Rainbow d.1812
Oil on paper laid on canvas, $13\frac{1}{4} \times 15\frac{1}{8}$ (33.7 × 38.4)
Inscribed '28 July 1812'
Prov: 16 May 1838 (part of 48, 'Three – Moonlight; Landscape, and a ditto, with a Rainbow'; the lot number is still on the back), bt. in by Leslie; presented to the V. & A. by Isabel Constable 1888
Victoria and Albert Museum (R.117)

Constable spent a total of about four months at East Bergholt in the summer and autumn of 1812. A number of dated oil sketches, of which Nos.111–12 are examples, survive from this period. His letters to Maria (especially JCC II pp.78–81) give vivid glimpses of his state of mind at this time. We hear of the 'melancholy pleasure' he took in revisiting the places he particularly associated with her, of his reading Cowper – 'the poet of Religion and Nature' – and of the 'hermit-like life' he was leading, 'though always with my pencils in my hand'. 'How much real delight', he wrote on 22 July, 'have I had with the study of Landscape this summer either I am myself much improved in "*the Art of seeing Nature*" (which Sir Joshua Reynolds calls painting) or Nature has unveiled her beauties to me with a less fastidious hand – perhaps there may be something of both so we will divide these fine compliments between us – but I am writing this nonsense to you with a really sad heart – when I think what would be my happiness could I have this enjoyment with you then indeed would my mind be calm to contemplate the endless beauties of this happy country' (JCC II p.81). After a few meetings with Maria in London towards the end of August, Constable returned to Bergholt but could not resume his landscape studies: 'I have not found myself equal to that vivid pencil that that class of painting requires' (*ibid.*, p.84).

112 Dedham from Langham d.1812
Oil on canvas, $7\frac{1}{2} \times 12\frac{5}{8}$ (19 × 32)
Inscribed '13 July 1812'
Prov: . . . ; bequeathed to the Ashmolean Museum by the Rev. W. Fothergill Robinson 1929
The Visitors of the Ashmolean Museum, Oxford

The panorama of the Stour valley from Langham was a favourite of Constable's and he later chose one of his studies of it (V. & A., R.332) for Lucas to engrave in *English Landscape*, where it epitomised a 'Summer Morning'. Other versions of the view are Nos.113 and 114 below. There are also drawings of it on pages 39, 51 and 52 of the 1813 sketchbook (No.119), that on page 39 being especially close to the painted versions. As in the views from nearby Gun Hill (e.g. Nos.33, 55, 253), Dedham church forms a conspicuous feature and,

112

Constable wrote, 'is seen to much advantage, being opposed to a branch of the sea at Harwich, where this meandering river [the Stour] loses itself' (letterpress to 'Summer Morning' in *English Landscape*).

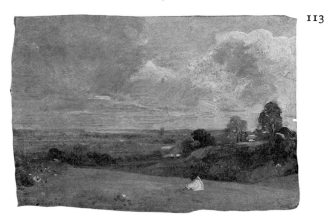

113

113 Dedham from Langham *circa* 1812
Oil on canvas laid on board, $5\frac{3}{8} \times 7\frac{1}{2}$ (13.6 × 19)
Inscribed '24. Au[g]'
Prov: . . . ; George Salting by 1883 and bequeathed by him to the National Gallery 1910; transferred to the Tate Gallery 1951
Tate Gallery (2654)

This sketch is placed here so that it can be compared with the Ashmolean Museum version of the subject, No.112. The Tate Gallery sketch, however, cannot also have been painted in 1812 because Constable was in London on 24 August that year (see JCC II pp.82–3).

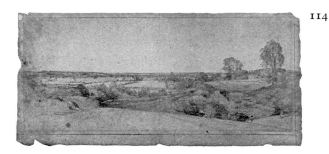

114

114 Dedham from Langham *circa* 1812
Pencil with white heightening, $12\frac{5}{8} \times 26\frac{1}{4}$
(32.1 × 66.7)
Prov: . . . ; the Royal Museum by 1887
Department of Prints and Drawings, The Royal Museum of Fine Arts, Copenhagen

This important drawing cannot be assigned with absolute confidence to any one year, but it is difficult to imagine it having been done earlier than 1812 or later than 1813, and there are reasons for thinking that it is more likely to have been drawn in the earlier year. The view was one in which he was particularly interested at this time. He may even have been contemplating a major painting of the valley from this spot, a companion to the view from almost exactly the opposite viewpoint, the 'Dedham Vale: Morning' of 1811 (No.100). The time of day had featured again in a work he had shown in the Academy of 1812 – 'Salisbury: Morning' (possibly a general view, i.e. of a panoramic character: see JCC II p.54) – and it is not beyond the bounds of possibility that he had it in mind to follow up with another panoramic view, similarly titled: a 'Dedham Vale: Afternoon', or '. . . : Evening'. See No.112 for further references to drawings and paintings of this subject.

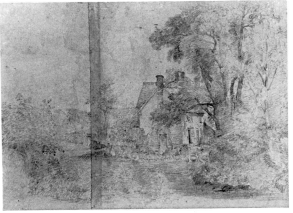

115

115 Willy Lott's House *circa* 1812
Pencil, $7\frac{7}{8} \times 11\frac{3}{16}$ (20 × 28.4) on paper watermarked 1807
Prov: 30 November 1892 (85), bt.
in ; . . . ; bt. from Leggatt's by Sir Robert Witt and bequeathed by him to Courtauld Institute 1952
Courtauld Institute of Art (Witt Collection)

The oil-sketch of *circa* 1802 (No.35) is the earliest known work to feature Willy Lott's house. This drawing, No.115, is the first that we know of in which the house assumes the centre of the composition. Though undoubtedly of 1812–13, it contains certain inconsistencies of style – some parts looking as though they were drawn in 1812 and others as if they were sketched towards the end of the following year. The study is drawn on three sheets joined together (the third is only a thin strip down the right-hand margin). It is possible that Constable drew the house and the area immediately around it on the first sheet and then, the following autumn, attached the other sheets to extend the drawing.

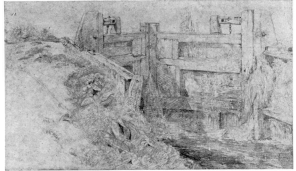

116

116 Study of Flatford Lock *circa* 1812
Black chalk, 10¾ × 17¹¹⁄₁₆ (27.3 × 45)
Prov: . . . ; bt. from Oscar & Peter Johnson Ltd.,
by present owner 1963
Private collection

Constable used this study for No.118, which is thought
to have been the 'Landscape: Boys fishing' exhibited in
1813. The painting follows the drawing very closely.
Another drawing used for the picture is No.117 below.
Both are squared for transfer to the canvas.

117 Study of Trees at Flatford *circa* 1812
Pencil, 18½ × 11⁷⁄₁₆ (47 × 29.1)
Prov: . . . ; Herbert P. Horne; bequeathed by
him to the City of Florence 1916
Fondazione Horne, Florence

Like No.116, this drawing was used in 'Landscape:
Boys fishing' (No.118). The trees shown here figure
again in 'Flatford Mill' of 1817 (No.151), where they
are seen from the other side. Linseed oil, spilt by the
artist when working from the drawing, may have
caused the somewhat unsightly stains.

1813

January: 3rd week, to London; sees Maria; Mr Bicknell
disapproves of their correspondence; Constable is re-
fused admission to Spring Gardens. *April:* Mrs Con-
stable calls on Bicknells in London. Unable to paint
because of ill-health. *May:* again congratulated by
West on the pictures he has sent to the Academy; his
work is well thought of by the Council. *June:* sees
Maria at the exhibition; sits next to Turner at the
Academy dinner – 'he is uncouth but has a wonderfull
range of mind'; portraits delay his departure for
Suffolk. *30th:* leaving London for first time with 'pock-
ets full of money'; before he leaves, has presumably
arranged to send a picture to Liverpool Academy,
opening in (?) August – his first exhibit outside
London. *10 July:* first dated drawing in little sketch-
book. *August:* paints views of the Rectory at Bergholt
where Maria had stayed. Until *22 October,* drawings are
the sole record of his movements and activities. Returns
to London, *mid-November;* meets Maria, briefly.
23 December: tells her that after seeing her, 'when I
return to my room – I detest the sight of my wretched
pictures'.

Exhibits. B.I.: (104) 'Landscape, a scene in Suffolk',
frame 43 × 62 inches (No.100). R.A.: (266) 'Landscape:
Boys fishing' (see No.118); (325) 'Landscape: Morn-
ing'. Liverpool Academy: (94) 'Landscape', price
40 gns.

118 'Landscape: Boys fishing' ?exh.1813
Oil on canvas, 40 × 49½ (101.6 × 125.8)
Exh: ?R.A. 1813 (266): ?B.I. 1814 (98,
'Landscape; a lock on the Stour', size with frame
49 × 59 inches)
Prov: ?bt. by James Carpenter at the B.I. 1814
(see text below); . . . ; Col. Unthank 1897;
William Hartree, sold Christie's 25 April 1918

(96; sale stencil is on stretcher), bt. in; . . . ;
Leggatt's; 1st Baron Fairhaven; bequeathed by
him to the National Trust 1966
*National Trust (Fairhaven Collection, Anglesey
Abbey)*

The scene is Flatford lock, with the bridge and Bridge
Cottage beyond, that is, the opposite view to that given
in the Tate Gallery 'Flatford Mill' of 1817 (No.151).
The same lock figures in the paintings exhibited in 1824
(No.227) and 1829 (No.262).

The picture which Constable exhibited at the R.A. in
1813 as 'Landscape: Boys fishing' was presumably the
same work that he showed again as 'Landscape; a lock
on the Stour' at the B.I. the following January, and
presumably also the composition which Lucas later
engraved for *English Landscape* as 'A Lock on the Stour',
which includes two boys fishing. Lucas's print corres-
ponds more or less (there are differences in the trees)
with No.118, the size of which is consistent with
measurements of the 1814 exhibit. Only one full-size
painting of the composition is known, the one shown
here. In recent years, however, No.118 has been totally
discredited and is not even mentioned in the latest
monographs. This seems too sweeping a dismissal.
There are, it is true, areas of uncharacteristic handling
but these could be the result of later tidying-up. There
are passages of very high quality indeed which it is diffi-
cult to imagine as being by anybody but Constable.

When Constable's picture was at the B.I. in 1814, his
uncle David Pike Watts sent one of his typical criti-
cisms: 'I really had a great struggle between Inclination
& Interest, between the desire to oblige you in the pur-
chase of your Picture (*Water Gates*) and the Revolt
which will check such a desire when the Eye perceives
Unfinished Traits. Will any Person voluntarily prefer
an imperfect Object when he can have a more perfect
one?' (JCC IV p.37). Constable replied on the same day,
12 April: 'Your kind solicitude respecting my picture of
the Lock is highly gratifying to me – but it may now
cease, as the picture has become the property of Mr.
Carpenter, who purchased it this morning. He is a
stranger, and bought it because he liked it' (*ibid.,*
pp.38–9). Farington gave a fuller account of the trans-
action in his diary on 13 April: 'Constable called to
inform me that at the close of the British Institution
Exhibition to make room for the works of Wilson, –
Hogarth, & Gainsborough, He not having sold His
picture of the Lock scene (Landscape) was applied to
by Charpenter, the Bookseller in Bond st who said He
cᵈ not afford to pay the money He wᵈ willingly do, but
He wᵈ give Him 20 guineas in money, and Books to a
certain amount beyond that Sum. Constable accepted
the offer, & I told Him I thought He did well. –'. Con-
stable was later to have many dealings with James
Carpenter and with his son William. James bought
'Landscape and Lock' (No.262), a different view of the
subject he had bought in 1814, and William supplied
Constable with many of the books used in the prepara-
tion of his lectures. James lived long enough to publish
Leslie's biography of Constable in 1843.

Drawings related to 'Landscape: Boys fishing' are
Nos.116–17 above. An oil study of the subject, now
in a private collection, is reproduced in Shirley 1930,
pl.xx. A similar crouching boy appears in 'Arundel
mill and castle' of 1837 (No.335).

119 Sketchbook used in 1813 d.1813

Pencil, $3\frac{1}{2} \times 4\frac{3}{4}$ (8.9 × 12.1)

The sketchbook of 90 pages, with an intercalated leaf ($3\frac{1}{8} \times 4$: 7.9 × 10.1) from a sketchbook of 1815, is half-bound in black leather. The paper is watermarked: J WHATMAN 1810

Prov: presented to the V. & A. by Isabel Constable 1888

Victoria and Albert Museum (R.121)

This little sketchbook is one of the most valuable documents we have for the study and understanding of Constable's development as an artist, for it contains a record of every object, event or view noted with his pencil that summer and early autumn, a period during which he reached maturity as a draughtsman.

Apart from the first drawing in the book, a tomb at Widford, near Chelmsford, and a few views of Colchester, all the sketches are of places or things seen within easy walking distance of East Bergholt – Dedham, Stoke-by-Nayland, Flatford, Mistley, Langham. A number are of views he found within a few hundred yards of his home. Though the pages are not drawn on consecutively, like a diary, it appears that he regarded it as a kind of journal, for he referred to it as such in a letter to Maria the following spring: 'You once talked to me about a journal – I have a little one that I ⟨kept⟩ made last summer that might amuse you could you see it – you will then see how I amused my leisure walks – picking up little scraps of trees – plants – ferns – distances &c &c –' (JCC II p.120). Altogether, there are seventy-two pages of drawings, often three or four sketches to a page, some partly drawn over earlier ones. Thirty-seven of them are dated: the earliest, of the barn at Flatford (p.14), being inscribed 'July 10'; the last, of an unidentified water-mill, '22 Ocr. 1813 friday The Martin Cats – Shot – by G. C. [i.e. Golding, his brother]'.

Within the narrow field of his choice, there is a remarkable range of subject noted in the book: page-sized views (such as the two on view, pp.36 & 37); miniature compositions from nature contained within a drawn frame; the river and its traffic; ploughmen and their teams at work; cattle; sheep sheltering from the heat under a tree; cottages, farms and churches; a figure in a top-hat crouched over a sketch (who else but Dunthorne?); mooring-posts; horses working a threshing-pit; water-lilies; a length of rope; rowing boats on the shore; even the cuff of a soldier's (or servant's) jacket.

In later years Constable turned frequently to No.119 in search of material for his pictures, and within its covers there are to be found original notes used for the Huntington 'View on the River Stour', p.11 (see No.201); 'Ploughing scene in Suffolk', pp.12, 71 & 72 (No.123); 'The Valley Farm', pp.31 & 70 (No.320); an illustration to Gray's *Elegy*, p.49 (No.298); 'The White Horse', p.55; 'The Leaping Horse', p.76 (No.238); and 'Stratford Mill', p.77 (No.177).

During the fifteen weeks Constable was making use of this sketchbook there took place a subtle but none-theless remarkable change in his manner of drawing, a change that brought into focus a new vision of landscape. Photographs of a few key drawings have been arranged beside the book to show something of the nature of this change.

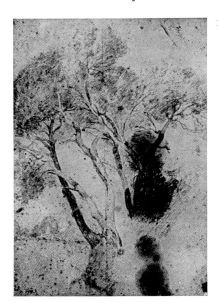

117

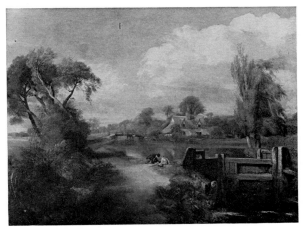

118

Three pages
(37, 54 & 36)
of No.119

120

121

122

120 View towards the Rectory, East Bergholt
?d.1813
Oil on canvas, 8 × 11 (20.4 × 28)
Inscribed '18 Aug^st [?1813]'
Prov: 28 May 1891 (E. Colquhoun, 124, 'A
Sketch', with date given as 18 August 1813, as it
is on an old label still on verso: corresponds with
No.246 in 1889 Grosvenor Gallery exhibition,
where size is given as 8 × 11 inches), bt. in by
Bourne; by descent to present owner
Private collection

This is another version of the view seen, from closer to,
in No.83, and, from more to the right, in No.93.
If the date on No.120 was correctly read in 1891, Con-
stable painted the view again at sunrise on the following
day, 19 August 1813, in a study now in the Mellon Col-
lection (repr. in catalogue of exhibition, *John Constable.
A Selection of Paintings from the Collection of Mr and
Mrs Paul Mellon*, National Gallery of Art, Washington,
1969, No.10; probably lot 97 in the 23 June 1890 sale).

The subject was a very emotive one for him at this
stage of his long courtship of Maria. 'From the window
where I am now writing', he told her in the summer of
the previous year, 1812, 'I see all those sweet feilds
where we have passed so many happy hours together –
it is with a melancholy pleasure that I revisit those
scenes that once saw us so happy – yet it is gratifying
to me to think that the scenes of my boyish days should
have witnissed by far the most affecting event of my
life' (JCC II p.78). The window in question would have
been at the back of his father's house, looking towards
the Rectory, where Maria had stayed on her visits to
Bergholt. No.120 and the related views of the Rectory
were made in the 'sweet feilds' behind the house.

121 View at East Bergholt *circa* 1813
Oil on canvas, 12½ × 18½ (31.8 × 47)
Prov: . . . ; Thomas Churchyard; . . . ; Thomas
Woolner R.A. by 1872, ?sold Christie's 12 June
1875 (135), bt. (?in) Young, certainly sold
Christie's 18 May 1895 (112), bt. George Salting,
from whom bt. by Agnew 1900 and sold to
Leggatt; . . . ; Anon., sold Christie's 20 December
1946 (120); . . . ; Anon., sold Christie's 9 April
1954 (95), bt. Leggatt; Peter Wilding; John
Curtey; bt. from Leggatt Brothers by present
owners 1962
Mr and Mrs Paul Mellon

This has long been known as 'Highgate' but is actually
another view near East Bergholt Rectory. Golding Con-
stable's house is well out of the picture to the right and
the Rectory is hidden behind the trees at the left, that is,
the view is at right angles to that seen in Nos.83, 93
and 120. The small valley in the centre is that formed
by the stream called the Ryber.

122 Rear-Admiral Thomas Western *circa* 1813
Oil on canvas, 30 × 25 (76.2 × 63.5)
Prov: . . . ; Galeries Montmartre, Paris 1880; . . . ;
'in storage' 1910–50; . . . ; Walter J. Goldsmith
circa 1966–70; Anon. sold Christie's 13 March
1970 (9), bt. A. Kaye; Alexander Karoo-Sessoeff
1970; present owner 1971
Jane Findlater

An old inscription on the stretcher reads: '[. . .] portrait

of [. . .] Western of Tattingstone by J. [Consta]ble'. Tattingstone Place, Suffolk, was Admiral Western's seat; the tower seen in the background of No.122 is the folly known as the Tattingstone Wonder, erected in the grounds by the original owner of the house.

A commission for Constable to paint Captain (as he then was) Western's portrait was secured, not to say extracted, by Mrs Godfrey, one of Constable's most devoted local supporters (see No.133). She 'seemed determined', Constable wrote on 6 November 1812, 'to shew me every act of fr[ien]dship in her power in being of use to me in my profession – she would give Capⁿ and M^{rs} Western no quarter till he agreed to sit to me' (JCC II p.94). The sittings took place at Tattingstone in late December 1812 and early January 1813 and in a letter of 15 January 1813 Constable said that he had completed the portrait (*ibid.*, p.102). Constable's mother, however, referred to it as still wanting the finishing touches in letters of 9 and 22 February (JCC I, pp.90, 92); she also remarked upon the smile which her son had given the sitter in the portrait. Nothing more is heard about the work until 28 August 1814 when, following Western's promotion from Captain to Rear-Admiral, Constable told Maria that he had had to go to Tattingstone to paint 'an entire new uniform into ⟨admi⟩ the large picture of admiral Western' (JCC II, p.130). Western died on 26 December that year.

Although there is every reason to think that the sitter is Admiral Western, No.122 is obviously not the portrait referred to in these quotations. It is hardly a 'large picture' and Western is neither smiling nor wearing naval uniform. The deletion in the passage quoted above from Constable's 1814 letter may support the idea that there were two portraits of Western: Constable seems to have intended to write 'admiral Western's picture' before specifying 'the large picture of admiral Western'. Until the large portrait is found, it is difficult to say what relation No.122 had to it. It actually looks like a sketch rather than a small finished painting and, if so, it is unique in Constable's portraiture.

Beckett pointed to a possible connection between Constable's portrait of Western and Hogarth's 'Captain Coram'[1].

1814

Unable to see Maria, his letters become increasingly melancholy. *February:* 'I am alienated from my own family and society and all intercourse with . . . the only woman I ever loved in the world'; asks John Dunthorne, old Bergholt friend, to send his son Johnny (aged sixteen) to act as assistant. *April:* short stay in Suffolk. *May:* meets Maria fleetingly from time to time. Early *June:* to Suffolk again, '. . . the village is in great beauty'; spends two weeks at Feering, Essex; visits Southend and Hadleigh Castle. *13 July:* in London. *23rd:* discusses with Farington his future and the importance of his being elected Associate in November; on Farington's recommendation, studies Angerstein Claudes for 'finishing'. *30th:* leaves for Suffolk after painting two portraits. *18 September:* tells Maria he has

painted some landscapes 'better than is usual'. *20 October:* writes that it is many years since he had pursued his studies so uninterruptedly and so calmly. *4 November:* returns to London. *7th:* fails to get one vote in election; Reinagle successful. *9th:* tells Farington his uncle had seen his new landscape studies – 'noticed their being *more finished* than his other works, & bespoke one of them'. *12th:* tells Maria he is hardly yet reconciled to brick walls and dirty streets after Suffolk.

Exhibits. B.I.: (98) 'Landscape; a lock on the Stour', frame 49 × 59 inches (see No.118); (216) 'Martin Cats', frame 36 × 52 inches. R.A.: (28) 'Landscape: Ploughing scene in Suffolk' (No.123); (261) 'Landscape: The ferry' (see under No.129). Liverpool Academy: (9) 'A Landscape – Ploughman', price 25 gns. (probably No.123).

123 'Landscape: Ploughing scene in Suffolk' (A Summerland) exh.1814
Oil on canvas, 20¼ × 30¼ (51.4 × 76.8)
Exh: R.A. 1814 (28); ? Liverpool Academy 1814 (9, 'A Landscape – Ploughman', price 25 gns.[1]); ?B.I. 1815 (115, 'Landscape', size with frame 32 × 41 inches)
Prov: bt. by John Allnutt, probably at the 1815 B.I. (see below); reacquired by Constable before 1825 (see JCC IV p.84); . . . ; ?George Simms 1846 (see JCC IV pp.440–1); . . . ; bt. from a London dealer by Miss Atkinson 1891; her niece Mrs L. Childs *circa* 1941–54; Leggatt's
Private collection

The view is taken from just outside the park pales of Old Hall, East Bergholt, where the Godfreys (see No.133) lived. Langham church is seen on the other side of the Stour Valley at the left and Stratford church towards the right.

Two versions of this painting are known. The other, measuring 16¾ × 30 inches, is now in the collection of Mr and Mrs Paul Mellon. Both originally belonged to John Allnutt, wine merchant and collector, who lived at Clapham. A long letter from him to Leslie in 1843 (Leslie 1843 pp.116–17; JCC IV p.83) explains the history of the pictures. From this we learn that Allnutt purchased one version of the painting at the British Institution 'Many years ago', that he was not quite happy with the sky and asked another artist (identified by Lucas as John Linnell: see JC:FDC p.62) to repaint it, that subsequently Allnutt asked Constable to restore the original sky and to reduce the height of the picture so that it would match a work by Callcott with which he wished to pair it, and that Constable instead painted a new version of the picture for him. Constable made no charge for this because Allnutt had been 'the means of making a painter of him, by buying the first picture he had ever sold to a stranger, which gave him so much encouragement that he determined to pursue a profession in which his friends had great doubts of his success'. We know that the composition in question was the 'Ploughing scene' because it is described in some detail in the catalogue of Allnutt's sale in 1863 (see JCC IV p.84), which also included 'the companion', a landscape by Callcott. No.123 can be identified as the original version because it is taller than the Mellon picture. It can also be identified with the painting

Constable exhibited at the R.A. in 1814 as 'Landscape: Ploughing scene in Suffolk': the title is apt and a reference by Constable to a painting he was finishing in February 1814 (presumably for the R.A. exhibition in May) also corresponds: 'I have added some ploughmen to the landscape from the park pales which is a great help, but I must try and warm the picture a little more if I can. But it will be difficult as 'tis now all of a peice – it is bleak and looks as if there would be a shower of sleet, and that you know is too much the case with my things' (JCC I p.101). Lucas thought the work was painted the year before No.118, i.e. in 1812, which at least places it in the right period (see JCC IV p.441).

Allnutt said that he purchased the picture at the British Institution and Leslie, introducing Allnutt's letter, dated the occasion to 1814. Leslie was obviously mistaken on this point: neither of Constable's exhibits at the B.I. in 1814 can have been this work (see *Exhibits* above). But Allnutt may well have remembered correctly. Constable exhibited 'A Landscape – Ploughman' at the Liverpool Academy after the R.A. closed in 1814. If, as its title suggests, this was the same painting, we must conclude that it had failed to find a purchaser at the R.A. because it was marked as 'on Sale' in the Liverpool catalogue. Assuming that the work did not sell at Liverpool either, it would have been natural for Constable to give it another chance at the B.I. in 1815, and the size of the 'Landscape' which he showed there that year is reasonably consistent with No.123. This seems as likely an explanation as the suggestion that Allnutt forgot where he had bought the work. And, of course, if he did purchase it at the 1814 R.A., another candidate has to be found for the Liverpool exhibit.

Beckett (JCC IV pp.84, 135) has pointed out that the 'Ploughing scene' was not, as Constable apparently told Allnutt, the first painting he sold to a stranger. James Carpenter had already acquired 'Landscape: Boys fishing' (see No.118). But, as Beckett also suggests, Constable may have discounted this sale, which was not entirely a cash transaction. Clearly, Constable felt very grateful to Allnutt. The idea of having one of his pictures first gone over by another artist and then reduced in size to match the work of a third is not one that he would normally have countenanced with such equanimity.

The composition derives from a study Constable made in his sketchbook in July 1813 (p.12 of No.119 above), which also contains sketches (on pp.52, 71, 72) of ploughmen used when he decided to add figures to the work in February 1814.

This painting was the first work that Constable exhibited with an accompanying quotation in the catalogue. The lines he chose were from Robert Bloomfield's *The Farmer's Boy* ('Spring', lines 71–2):

But unassisted through each toilsome day,

With smiling brow the ploughman cleaves his way.

He quoted Bloomfield again in connection with one of his 1817 exhibits (see No.139) and on a cloud study, No.173 below.

No.123 was engraved by Lucas for Constable's *English Landscape* as 'A Summerland'. The term is synonymous with 'summer-fallow', i.e. a field ploughed and harrowed but left uncropped during the summer months.

124 The Marquess of Abercorn (Copy after Sir Thomas Lawrence) d.1814

Pencil, drawn area 3$\frac{7}{16}$ × 1$\frac{15}{16}$ (8.7 × 5)

Inscribed 'Exhibition 28th May – 1814 – Lord Abercorn'

Prov: . . . ; presented to the Louvre by David Weill

Musée du Louvre, Paris (R.F.6119)

Constable quite often made notes of pictures by Old Masters seen at exhibitions or in private collections, but it was not his habit to record paintings by his contemporaries, and we do not know why on this occasion the portrait of the Marquess of Abercorn caught his eye. In the accounts he gives in his letters of the current exhibitions at Somerset House, Lawrence and his paintings are not infrequently mentioned, but this year Constable only refers to him in passing when writing to Maria about his own picture, the 'Ploughing scene in Suffolk' (No.123) and Turner's 'Dido and Aeneas': 'I have seen the Exhibition – 'tis natural that we should look first for our own children in a Crowd – I am much pleased with the look and situation of a small picture there of my own – I understand that many of the members consider it as genuine a peice of study as there is to be found in the room – it is an amusing Exhibition on the whole – a large Landscape of Turners seems to attract much attention – should we ever have the happiness to meet again it may afford us some conversation – my own opinion was decided the instant I saw it – which I find differs from that of Lawrence and many others entirely – but I may tell you (because you know that I am not a vain fool) that I would rather be the author of my Landscape with the ploughman than the picture in question –' (JCC II, pp.121–2).

Lawrence had exhibited a previous portrait of John James, 1st Marquess of Abercorn (1756–1818) in the Academy of 1790.

125 Feering Church and Parsonage, near Kelvedon, Essex 1814

Pencil and watercolour, 10$\frac{1}{2}$ × 14$\frac{1}{4}$ (26.7 × 36.2)

Prov: Captain C. G. Constable (according to inscription on mount); . . . ; presented to Whitworth Art Gallery by J. E. Taylor 1892

Whitworth Art Gallery, University of Manchester

In 1814, the vicar of Feering, in mid-Essex, was the Revd. W. W. Driffield. Constable had told Maria Bicknell in a letter of 22 September 1812 of his meeting with Driffield while staying at Wivenhoe Park to paint a portrait of the daughter of the owner, General Rebow: 'I met a very old friend of my fathers who is often there', he wrote, 'the Revd. Mr Driffeild who once lived in this village – he always remembers me as he had to go in the night over the Heath to make a christian of me at a cottage where I was dying – when I was an infant' (JCC II p.85). In his letter of 3 July 1814 he gives Maria an account of his stay at Feering, from which visit he had just returned: 'I have been absent from this place for near a fortnight, on a visit to the Revd. Mr. Driffeild . . . Some time ago I promised him a drawing of his house and church at Feering, and during my visit he had occasion to visit his living of Southchurch, and I was happy to embrace his offer of accompanying him – by which I saw much more of the county of Essex than I ever had before and the most beautifull

123

part of it, as I was at Maldon, Rochford, South End, Hadleigh, Danbury &c &c. While Mr. D. was engaged at his parish I walked upon the beach at South End. I was always delighted with the melancholy grandeur of a sea shore. At Hadleigh there is a ruin of a castle which from its situation is a really fine place – it commands a view of the Kent hills, the Nore and the North Foreland & looking many miles to sea' (*ibid.*, p.127).

Further on in the same letter, Constable wrote: 'I have filled as usual a little book of hasty memorandums of the places which I saw which you will see'. This sketchbook has been broken up, but a number of the pages from it are in the V. & A. (R.124–8), including the little pencil sketch of Hadleigh Castle which, years later, he was to use for his large exhibition piece, No.263.

An elaborate and highly-finished pencil drawing of the Parsonage from close to (Sotheby's 20 July 1949, lot 85; present whereabouts unknown, repr. p.13) seems to have been the origin of the watercolour which Constable later made for Driffield (Supplement No.125a).

124

126　Sketchbook used in 1814 d.1814
　　Pencil (p.15 pencil and wash), $3\frac{3}{8} \times 4\frac{1}{4}$ (8×10.8)
　　The sketchbook of 84 pages is bound in brown leather. One leaf (between pp.24 & 25) is missing; another, two sketches of the family home (R.133), was extracted before the sketchbook entered the V. & A.
　　Prov: presented to the V. & A. by Isabel Constable 1888
　　Victoria and Albert Museum (R.132)

The thirty-three dated drawings in this sketchbook cover a similar period to those in No.119 of the previous year – in this case, 1 August to 23 October. Apart from a few of Tattingstone and Stoke-by-Nayland, all the sketches this year were made around Bergholt or in the Stour valley.

The contents of No.126 contrast strongly with those of the previous year's sketchbook, in which a great many of the drawings are miniature works of art in their own right, final statements requiring no elaboration. No.126 is essentially a painter's notebook, much less of a little picture gallery. Most of the time, when working in this book of 1814, Constable seems to have been collecting material for paintings or to be drawing with pictures in mind. On eight of the pages (pp.54, 60, 62, 65, 68, 73, 74 & 81) there are studies for a picture actually in progress, the 'Stour Valley and Dedham Village' (No.133). Other pictures for which there are studies or related sketches include 'View on the Stour', pp.27, 52 & 59 (see No.201); 'Boat-building', pp.55–7 (No.132); 'Flatford Mill', p.61 (No.151); and 'The White Horse', p.66. There are also three drawings of a subject that Constable was evidently considering for a picture, a view looking upstream from below Flatford Lock, pp.24, 48 & 51.

See Supplement No.346b for John Fisher's copy of 'Landscape with Windmill', p.75 in this sketchbook.

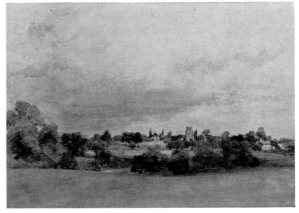

125

Three pages
(59, 61 & 62)
of No.126

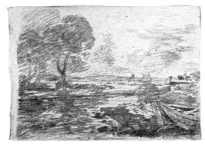

127

127 Stour Valley and Dedham Village d.1814
Oil on canvas, $15\frac{1}{2} \times 22$ (39.4 × 55.9)
Inscribed '5 Sepr 1814'
Prov: ... ; J. N. Drysdale; Tooth's, from whom
bt. by Leeds City Art Galleries 1934
Leeds City Art Galleries

A study for No.133, the painting commissioned by
Thomas Fitzhugh for his bride Philadelphia Godfrey.
See the entry on that work for further information
about the commission and its progress. In this study
harvesting is still going on in the fields in the middle
distance, while in the foreground two men are digging
out a dunghill in preparation for the muck-spreading
which preceded the winter ploughing. In the final
painting the harvest is over and ploughing is begin-
ning[2]. Related drawings in Constable's 1814 sketch-
book are mentioned under No.126.

128 Golding Constable's Garden ?1814
Pencil, $11\frac{7}{8} \times 17\frac{3}{4}$ (30.2 × 44.9)
Inscribed on back of original mount 'From the
Garden', written over an inscription, probably by
the artist, which appears to read: 'The Garden
belonging to G Constable Esq.'
Prov: presented to the V. & A. by Isabel
Constable 1888
Victoria and Albert Museum (R.176)

This is a view from an upstairs window at the back of
the Constable family home, East Bergholt House. In
the foreground a path separates the flower garden at the
left from the kitchen garden at the right. Beyond lie
Golding Constable's fields and, on the horizon, his
windmill on East Bergholt Common. In the distance at
the right is the Rectory. The drawing is on paper water-
marked 1811 and the family moved out of the house in
March 1819, so a date of *circa* 1812–18 can be proposed
for No.128, allowing for the time paper took to reach its
market and the season indicated in the drawing. If
correctly read, the reference in the inscription to Gold-
ing Constable would narrow the date down to *circa*
1812–16, since Golding died in the latter year. Michael
Rosenthal has recently argued for the more precise date
of 1814. He points out that in another drawing of part
of the same view, on p.38 of the 1814 sketchbook
(No.126), the field beyond the fence is partly ploughed
and that at the time of year this drawing (dated 22 Sep-
tember 1814) was made, such ploughing would have
been in preparation for the sowing of winter wheat, one
of the crops in the four-course 'Norfolk' system em-
ployed at East Bergholt. In No.128 the same field is also
partly ploughed and, Rosenthal maintains, No.128 must
therefore have been made about the same time as the
1814 sketchbook drawing, since the previous and fol-
lowing years in which wheat, grown only once every
four years, would have been sown here, 1810 and 1818,
are ruled out by the 1811 watermark and the sale of the
house in 1818 ('Golding Constable's Gardens', *The
Connoisseur*, Vol. 187, 1974, pp.88–91). Although his
conclusion is probably correct, it has to be pointed out
that the family did not vacate East Bergholt House until
after the sale of contents in March 1819 (see JCC I
pp.174–8), that Constable was at the house briefly in
July 1818 (JCC II p.236), and that there is no evidence
that in No.128 the field is being ploughed for wheat
rather than one of the other crops grown in the four-

128

course rotation.

Agricultural matters apart, it is certainly true that in 1814 Constable was as obsessed with the view over the fields behind East Bergholt House as he had been in 1808, 1810 and 1813, when the oil sketches shown above as Nos.83, 93 and 120 were painted. On 18 September 1814 he told Maria, 'I beleive we can do nothing worse than indulge in an useless sensibility – but I can hardly tell you what I feel at the sight from the window where I am now writing of the feilds in which we have so often walked a beautifull calm Autumnal setting sun is glowing upon the Gardens of the R[ector]y and adjacent feilds – where some of the happiest hours of my life were passed' (JCC II p.132).

No.128 seems to have been mounted by the artist, which may lend weight to Rosenthal's suggestion that it could have been one of the untitled drawings which Constable exhibited at the R.A. in 1815. For two paintings of the view probably made in 1815 see Nos.134–5.

129 The Mill Stream *circa* 1814

Oil on canvas, 28 × 36 (71.1 × 91.5)
Prov: . . . ; Thomas Turton, Bishop of Ely, sold Christie's 15 April 1864 (149), bt. S. Dunning, sold Christie's 3 May 1884 (137), bt. Agnew's and sold by them the same year to Frederick Fish, sold Christie's 24 March 1888 (280), bt. Lesser, from whom bt. same year by Henry Yates Thompson, sold Sotheby's 2 July 1941 (210), bt. Ipswich Art Gallery and Museum
Ipswich Borough Council

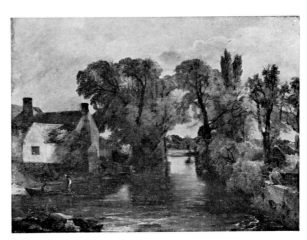

129

The Mill Stream and Willy Lott's cottage are seen here from the parapet behind Flatford Mill. As C. R. Leslie noticed (1843 p.18, 1951 p.45) the surface of the water in the foreground of the picture is slightly disturbed because of the action of the wheel inside the mill; this was the smaller of the mill's two wheels, the larger one being on the other side of the building. A ferry operated across the Mill Stream, connecting the bank on which Lott's cottage stands with the far bank of the more or less parallel main course of the Stour, which was separated from the Mill Stream by a narrow, tree-lined island. The channel through which the ferry passed from the Mill Stream to the Stour lay a short way beyond the parapet at the right of this painting. Constable was later to use almost the same view for 'The Hay Wain' (No.192), in which the channel itself is clearly visible. In 'The Valley Farm' (No.320) we look from the main branch of the Stour through the gap to the Mill Stream and Willy Lott's cottage.

No.129 has often been taken to be the work which Constable exhibited at the R.A. in 1814 as 'Landscape: The ferry' but the documentary evidence goes against the identification. In his Diary entry for 5 April 1814 Farington said that he had called on Constable and seen 'his upright Landscape intended for the Exhibition'. The only other picture Constable exhibited at the R.A. that year was 'Landscape: Ploughing scene in Suffolk', here identified with No.123, which is a horizontal composition. If the painting seen by Farington actually appeared at the R.A., it cannot have been 'The Mill Stream', which is not by any stretch of the imagination an 'upright Landscape'. Again, Farington reported on 23 April 1814 that Constable had seen 'Thomson at the Academy who was very cordial with Him & spoke

130

particularly of the merits of his small picture, saying also that his large picture had good parts in it'. 'The Mill Stream' is not sufficiently larger than No.123 for the one to have been called 'large' and the other 'small'. Lord Forteviot's 'The Valley Farm', which also includes a ferry, seems a more promising candidate, being both an upright composition and noticeably larger (49½ × 39½ inches) than the 'Ploughing scene'[3].

A small oil study connected with No.129 is in the Tate Gallery (No.1816). Various other studies of the view relate more closely to the composition of 'The Hay Wain', being made from the left bank of the mill stream rather than from the bridge of the mill. No.129 was engraved by Lucas for Constable's *English Landscape* as 'Mill Stream'.

130 Flatford Mill from the Bridge after 1814

Oil on paper, laid down, 4½ × 6⅛ (11.4 × 15.6)
Prov: . . . ; bt. from Agnew's *circa* 1914 by mother of present owner
Private collection

This is a variation on the view which later appeared in the 1817 'Flatford Mill' (No.151). Here we see the river and mill buildings from the bridge itself rather than, as in the large picture, from the slope up to the southern end of it. No.130 has been dated to 1810–11[4] but the tree at the right lacks a large branch which is still visible in a drawing Constable made of it in August 1814 (p.61 of No.126, repr. p.90) and this oil study was therefore presumably made after that date. It is impossible to tell whether the small branch higher up which had fallen by the time Constable made a detailed drawing of the tree in October 1817 (No.154) is still present here.

131 Flatford Mill after 1814

Oil on canvas, 9½ × 7½ (24.1 × 19)
Prov: 28 May 1891 (E. Colquhoun, 129, 'Sketch on the Stour')[5], bt. in by Bourne; by descent to present owner
Private collection

This study appears to be more directly related than No.130 to the 1817 'Flatford Mill' (No.151), being taken from the bank rather than the bridge. Again, the foremost tree lacks the large branch noted by Constable on 14 August 1814.

1815

8 February: illness of father takes him down to Bergholt. Mr Bicknell gives consent to Maria receiving him at Spring Gardens. *9 March:* his mother attacked by partial paralysis. *14th:* is called to her bedside; she dies a few days after his return to London; does not attend funeral. *12 May:* calls at Spring Gardens prior to leaving for Suffolk and learns of Mrs Bicknell's death. At Bergholt, paints father's portrait. Bicknells take house at Putney. *31st:* back in London. *June:* painting background in life-size portrait of Eliza O'Neill by George

Dawe; sees Maria at Dawe's studio, also at Putney. *6 July:* leaves for Suffolk. *31st:* visits Woodbridge area to paint view of Brightwell. Writes contentedly of his painting to Maria; tells her he lives almost wholly in the fields. By *October* is working on a landscape larger than any he had yet painted; tells Maria the fine weather has kept him out of doors a great deal. Early *November:* spends a few days in London to see Maria. *14th:* returns to Bergholt, his picture, and his father; writes that he will remain there until his pictures are ready for the Academy. *December:* father confined to room and is seriously ill at the end of month.

Exhibits. B.I.: (115) 'Landscape', frame 32 × 41 inches. R.A.: (20) 'View of Dedham' (probably No.133); (146) 'Landscape: A sketch'; (215) 'Boat building' (No.132); (268) 'Village in Suffolk'; (310) 'Landscape'; (415) 'A drawing'; (446) 'A drawing'; (510) 'A drawing' (see No.128 for what may be one of these three drawings).

132 'Boat building' exh.1815

Oil on canvas, 20 × 24¼ (50.8 × 61.6)
Exh: R.A. 1815 (215)
Prov: 16 May 1838 (59, 'View at Flatford, with barge building'), bt. Smith of Lyall Street; . . . ; John Sheepshanks by *circa* 1850 (see Reynolds 1973 p.106) and presented by him to the V. & A. 1857
Victoria and Albert Museum (R.137)

The scene is the boat-yard owned by Constable's father, a short distance upstream from the mill at Flatford. Many of the barges which figure in his son's paintings of the Stour must have been built here. The composition derives from a drawing dated 7 September 1814 on page 57 of the 1814 sketchbook (No.126), with some details taken from page 56 in the same sketchbook, but the painting itself was, wrote Leslie, 'one which I have heard him say he painted entirely in the open air' (1843 p.19, 1951 p.49). Only one other picture of any size is said by Leslie to have been painted completely outdoors, the Hampstead Heath work shown below as No.186. It would not be surprising if Constable rarely tried to work in this way – the problems must have been formidable. It is questionable whether even No.132 was totally an outside job: some of the accessories have a decidedly studio look.

Constable painted No.132 at about the same time as the 'View of Dedham', No.133 below, the preliminary oil study for which is dated two days before the sketchbook drawing upon which No.132 is based. It has been suggested that the two pictures were, in fact, worked on concurrently, No.133 in the mornings and 'Boat building' in the afternoons[1]. The angle of the shadows certainly indicates that one is a morning and the other an afternoon view. One of Lucas's annotations to Leslie's *Life* also shows that Constable was working on 'Boat building' in the afternoons: Constable told him that 'he was always informed of the time to leave off by the film of smoke ascending from a chimney in the distance that the fire was lighted for the preperation of supper. on the labourers return for the night' (JC:FDC p.56).

133 **'View of Dedham' (Stour Valley and Dedham Village)** ?exh.1815
Oil on canvas, 21¾ × 30¾ (55.3 × 78.1)
Exh: ?R.A. 1815 (20)
Prov: commissioned from Constable by Thomas Fitzhugh (1770–1856) for his bride Philadelphia Godfrey 1814; she died 1869; . . . ; acquired by James McLean *circa* 1885–1900; his daughter; . . . ; purchased from John Mitchell, New York, by Museum of Fine Arts, Boston 1948
Museum of Fine Arts, Boston, Massachusetts (William W. Warren Fund)

131

Thomas Fitzhugh of Plas Power, Deputy Lieutenant and High Sheriff of Denbighshire, commissioned this work as a gift to his bride Philadelphia, daughter of Peter Godfrey of Old Hall, East Bergholt (for Old Hall, see No.27). Their marriage took place on 11 November 1814. The Godfreys gave Constable considerable encouragement around this time. 'Mrs Godfrey seemed determined to shew me every act of fr[ien]dship in her power in being of use to me in my profession –', Constable told Maria on 6 November 1812 (JCC II p.94). They commissioned a portrait of their son William (see JCC II p.80) and arranged for Constable to paint Rear-Admiral Western (see No.122). In 1814 Mrs Godfrey asked Constable to mark a catalogue of the Royal Academy exhibition for her and her husband (JCC II p.122) and it is possible that the sight of his 'Ploughing scene in Suffolk' (No.123) in this exhibition had something to do with their prospective son-in-law's commissioning of the 'View of Dedham': it would, at any rate, have shown the Godfreys how acceptably Constable could handle a local farming scene.

The preparatory oil study for the picture (No.127) is dated 5 September 1814 and drawings in the 1814 sketchbook connected in various degrees with the work have dates ranging from 23 September to 9 October (No.126, pp.36, 54, 60, 62, 65, 68, 73, 74, 81). Two oil studies of the cart, one dated 24 October 1814, are in the V. & A. On 25 October Constable wrote to Maria from East Bergholt: 'I am considered rather unsociable here – my cousins could never get me to walk with them once as I was never at home 'till night – I was willing to make the most of the fine weather by working out of doors – I have almost done a picture of *"the Valley"* for Mr Fitzhugh – (a present for Miss G. to contemplate in London)' (JCC II pp.134–5). This may suggest that he had been working outdoors on No.133, just as he is reported to have done on 'Boat Building'. It is even possible that the two pictures were being painted at the same time, the Fitzhugh commission in the mornings and 'Boat building' in the afternoons (see under No.132). No.133 shows a panorama of the Stour Valley with Dedham church in the centre and Langham church on the hills at the right. As in the 'Ploughing scene' (No.123), the view is taken from just outside the Godfreys' land. Mrs Fitzhugh would therefore 'contemplate in London' a scene with which she had been familiar from childhood, and it was probably not only to her visual sense that the picture would have appealed: as has recently been pointed out, the men in the foreground are digging out a dung-hill, not a gravel-pit as was previously supposed (Ian Fleming-Williams, 'A Runover Dungle and a Possible Date for "Spring"', *Burlington Magazine*, CXIV, 1972, pp.386–93).

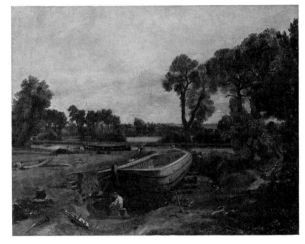
132

133

134

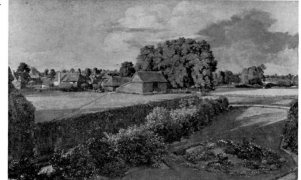

135

Because Constable told Maria on 30 June 1815 that he was 'now going to send home Mrs. Fitzhugh's picture of Dedham' (JCC II p.145), it has been assumed that the painting was not finished until about that date. A different explanation is, however, possible. As Constable said that he had 'almost done' the picture on 25 October 1814, it seems likely that it was, in fact, finished in time for the Fitzhughs' marriage on 11 November. The couple may well have lent the work to Constable for him to exhibit at the R.A. in 1815 as 'View of Dedham': an old label on the back of the picture reads 'N° 2 View of Dedham – John Constable.' – the same title as the R.A. exhibit (the number '2' may refer to the artist's own listing of his works submitted to the Academy that year). Constable told Maria on 28 June 1815 that he expected to get his pictures back from the exhibition that day (JCC II p.144). If the Fitzhugh painting was among them, he would very likely be 'going to send home' the work two days later.

134 Golding Constable's Flower Garden 1815
Oil on canvas, 13 × 20 (33 × 50.8)
Prov: 11 July 1887 (86), bt. Agnew; . . . ; Sir Cuthbert Quilter, sold Christie's 26 June 1936 (18), bt. Gooden and Fox; Ernest Cook, by whom bequeathed to Ipswich through the N.A.C.F. 1955
Ipswich Borough Council
See No.135.

135 Golding Constable's Kitchen Garden 1815
Oil on canvas, 13 × 20 (33 × 50.8)
Prov: 11 July 1887 (85), bt. Agnew; then as for No.134 (but Lot No. in 1936 sale was 19)
Ipswich Borough Council
(colour plate facing p.65)

As we have already shown, the view from the back of his parents' house at East Bergholt was of more than usual significance for Constable, the scenes it presented being intimately associated not only with his boyhood but also with his long courtship of Maria. This pair of pictures, Nos.134–5, is Constable's definitive treatment of the subject, first, in oil, stated rather baldly in the Downing College painting of *circa* 1800 (No.26). In contrast to that work, Nos.134–5 reveal the closest attention to the minutiae of the scene and not least to the detail of the gardens of the house, which are not even indicated in the earlier picture. The care which Constable was now prepared to devote to such things as barns and kitchen gardens would have been incomprehensible to most of his contemporaries, for whom material of this kind would have seemed so prosaic as to be beneath notice.

Michael Rosenthal's arguments for dating the pencil drawing of Golding Constable's gardens, No.128, have been cited in the entry on that work. If he is correct in saying that the smaller, sketchbook drawing of September 1814 shows the field behind the house being ploughed for the sowing of wheat, then, as he points out, Nos.134–5 almost certainly date from the following year since in them the same field is shown standing with wheat, which would only have been grown here once every four years. Rosenthal suggests that No.135, in which the wheat is not quite ripe, was painted in July and No.134, in which a reaper is at work in the field and a thresher in the barn, in August 1815. Between the

time that the drawing of the gardens, No.128, was made, probably in 1814, and the date of the paintings, the Constables seem to have had the large bushes in the flower garden removed and the circular bed planted with flowers instead.

136 Cottage in a Cornfield ?1815
 Pencil, 4 × 3⅛ (10.2 × 7.8)
 Inscription includes 'E B', i.e. East Bergholt, but is otherwise illegible
 Prov: presented to the V. & A. by Isabel Constable 1888
 Victoria and Albert Museum (R.145)

This is a page from a dismembered sketchbook, of which other pages are dated 1815 (see Reynolds 1973 No.121, pp.91–2, and Nos.140, 143). Constable used the drawing for his painting of the same title (No.297) exhibited in 1833 and possibly also for the untraced work called 'A cottage' shown at the R.A. in 1817.

136

137 The Valley Farm *circa* 1815
 Oil on canvas, 24 × 20 (61 × 50.8)
 Prov: . . . ; Jonathan Peel, sold Christie's 11 March 1848 (47), bt. James Lennox, New York; New York Public Library, sold Parke-Bernet 17 October 1956 (41), bt. Agnew; bt. from Agnew's and Tooth's by present owner 1956
 Private collection

Constable painted and drew Willy Lott's house, or 'The Valley Farm' as he sometimes called it, on numerous occasions. The first known version of this particular view, from the main branch of the Stour looking through the gap to the mill stream, occurs in No.35, probably painted in 1802, while the last is the painting of 'The Valley Farm' which he exhibited in 1835 (No.320). A brief survey of his treatments of the subject is given in the entry on the latter work. The present painting seems both to look back to the picture now in Lord Forteviot's collection, which may have been exhibited in 1814 (see under No.129) and forward to the final composition of 1835. The large tree at the right is not dissimilar to the one in Lord Forteviot's painting and is certainly not based on the drawing, probably made at Hampstead in or after 1819, which Constable used for the corresponding tree in the 1835 picture. On the other hand, the figures and boat beside the cottage, as well as the bird skimming the water in the foreground, are close to those in the final picture, and there is even a painted-out boat and boatman in the same place as in the 1835 picture. The same piece of woodwork occurs in the left foreground of both paintings. It is also found in 'The White Horse' exhibited in 1819 (see No.165), though this is not necessarily a pointer to the date of No.137.

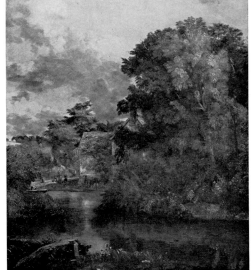

137

In a letter of 10 March 1848 to the American collector James Lennox, who bought the picture at Christie's the following day, Leslie said of No.137, 'The Constable is genuine, and I think a very good specimen. It is a view of "Willy Lott's house," at Flatford. He afterwards painted a larger picture of it, which is in Mr. Vernon's collection, and there is much said of this in the *Memoirs*' (quoted in the 1956 Parke-Bernet catalogue). Vernon's picture is the final version of 1835 (No.320), which Leslie said was painted 'from an early sketch' (1843 p.98, 1951 p.240). It is not clear whether he is

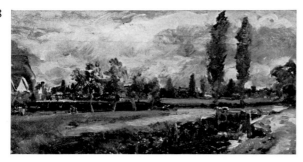

referring here to No.137, which is hardly a sketch, or to one of the other early versions of the composition.

138 River Scene *circa* 1815
 Oil on canvas, 6⅛ × 11¼ (15.5 × 28.6)
 Prov: . . . ; John G. Johnson by 1914
 John G. Johnson Collection, Philadelphia

Beckett pointed out that the title by which this work is usually known, 'The Weir', is inappropriate since the structure in the right foreground is simply a sluice-gate. Actually it seems rather to be a lock, though the view depicted remains a mystery. It may be somewhere on the Stour. A remarkably assured piece of work, No.138 probably dates from a few years after the Stour oil studies of 1810–12.

139 Two Gleaners *circa* 1815
 Pencil, 2¹⁵⁄₁₆ × 3¹¹⁄₁₆ (7.5 × 9.4)
 Inscribed: see text below
 Prov: . . . ; presented to the Louvre by David Weill
 Musée du Louvre, Paris (RF.6099)

This sketch and No.140 may have some connection with 'The wheat field' which Constable exhibited at the R.A. in 1816 and which probably re-appeared at the B.I. the following year as 'A Harvest Field: Reapers, Gleaners', when it was accompanied by a quotation from Bloomfield. Two other drawings of similar subjects are in the Louvre: RF.6100, which is a faint outline sketch of the composition seen in the painting catalogued as No.141 below, and RF.6103, which is inscribed 'A Gleaner'.

On the back of No.139 is part of a draft letter from Constable to Maria which has some bearing on the question. Although (so far) almost illegible, the following can be made out: 'the Dʳˢ not considering You any longer [. . .] rest with [. . .]self – [. . .]s enough for us to kn[?ow] that there is nothing we [. . .] any part of [. . .]'. Following Dr Rhudde's discovery that Constable had been visiting her at her father's London house, Maria told Constable on 13 February 1816 that 'the kind Doctor says he considers me no longer as his Granddaughter' (JCC II p.176). This appears to be what Constable is referring to in the first line on the back of the sketch. The rest of the draft seems to relate to the following passage in the reply he sent to Maria on 18 February: 'I shall not concern myself with the justice or injustice of others that must rest with themselfs alone it is sufficient for us to know that we have at no time done any thing that is blamable – or to deserve the ill opinion of any one' (*ibid.*, p.176). At this time Constable was preparing his pictures for the forthcoming R.A. exhibition and it is tempting to suppose that he drafted a letter on the back of one of the sketches he was using to paint 'The wheat field'. However, until No.139 can be re-examined, a slight doubt remains as to whether the sketch preceded the draft letter or vice versa.

140 Gleaners *circa* 1815
 Pencil, 4 × 3¹⁄₁₆ (10.2 × 7.8)
 Prov: . . . ; presented to the Louvre by David Weill
 Musée du Louvre, Paris (RF.6101)

See No.139.

141 Reapers ?*circa* 1815
Oil on canvas, $17\frac{1}{2} \times 14\frac{1}{2}$ (44.5 × 36.8)
Prov: . . . ; Charles Lees ; . . .; Spink & Son Ltd.,
from whom bt. by present owner 1961
Private collection

Like the sketches above, Nos.139–40, this painting may
in some way be related to 'The wheat field' which was
shown at the R.A. in 1816 and probably re-exhibited at
the B.I. in 1817 as 'A Harvest Field: Reapers, Gleaners',
though the framed size of the latter, 33 × 42 inches,
shows that it was a different shape to No.141. As men-
tioned under No.139, there is a drawing in the Louvre
which corresponds with the composition of No.141.

See also the note on p.206.

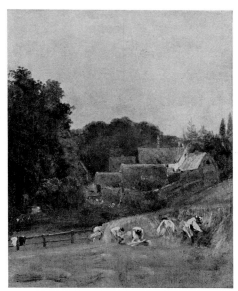

141

1816

Father remains weak. Village 'in a bustle' about en-
closure of the Common, where stands the family wind-
mill. *20 January:* in London over weekend. *February:*
for reasons not fully understood, breaks off friendship
with Dunthorne, the elder; Dr Rhudde learns that
Constable has been visiting Spring Gardens, and is
incensed; considers Maria to be no longer his grand-
daughter. Early *March:* in London again for the week-
end; father by now very weak and talks of providing for
the future of the family. *30th:* in London to prepare for
the exhibition. Early *May:* short visit to Bergholt;
father failing. Returns to London. *14th:* his father dies.
19th: leaves for Bergholt; in London again by *30th.* As
father's will makes provision for the future, he and
Maria plan to marry. *July:* John Fisher marries. *16th:*
leaves for Suffolk. *29th:* death of uncle, David Watts;
is not a beneficiary in his will. *3 August:* to London
with a puppy for Maria, returning on *12th. 26th:* at
Wivenhoe Park, Essex, to paint two views for the
owner. *6 September:* tells Maria that Fisher will marry
them. Has completed work at Wivenhoe by *19th. 24th:*
at Brightwell to paint a portrait. *28th:* in London.
2 October: marries Maria Bicknell at St Martin-in-the-
Fields; most of their honeymoon is spent with the
Fishers at Osmington, on the Dorset coast. Early
December: to London (63 Charlotte Street) after a short
stay with the Bishop at Salisbury and a night (*6th–7th*)
at Binfield.

Exhibits. R.A.: (169) 'The wheat field' (see No.139);
(298) 'A wood: Autumn'.

142 The Gamekeeper's hut d.1816
Pencil, $4\frac{1}{2} \times 7$ (11.4 × 17.8)
Inscribed 'May 21st. 1816'
Prov: . . . ; presented to the Royal Institution of
Cornwall by A. A. de Pass 1925
Royal Institution of Cornwall, Truro

Constable made this drawing the day after his father's
funeral. Since the May following the death of his mother
(in March of the previous year) Constable had spent the
greater part of his time at Bergholt to be with his
father. By January 1816 Golding was confined to his
room and Constable told Maria on the 19th (JCC II
p.169) that he had taken a large painting he had been

142

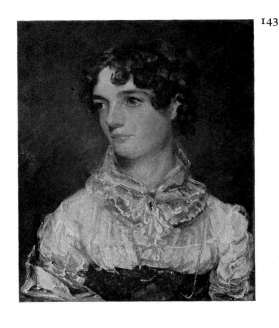

143

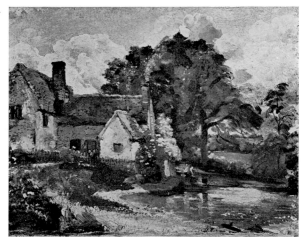

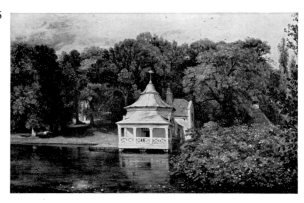

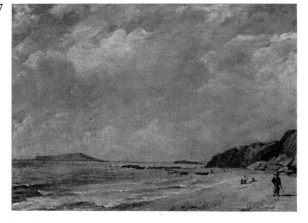

working on into his father's room, and that his father had been well enough to walk across to examine it. The Academy's forthcoming exhibition took Constable away from Suffolk for most of April. He managed to get back to see his father briefly for the last time after the exhibition opened, but he was in London again when Golding finally died on the 14th. This event he described in a letter to Maria as it had been told to him when he went down for the funeral: '... he died while sitting in his chair as usual – without a sigh or a pang – and without the smallest alteration in his position or features – except a gentle inclination of his head forwards – and my sister Ann who was near had to put her face close to his to asure herself that he breathed no more – thus has it pleased God to take (I doubt not) this good man to himself' (*ibid.*, p.184).

No other drawing is known of this shelter, but it is quite possible that Constable associated it in some way with his father. Two days later, at 8 o'clock in the morning, he made a drawing of a fallen tree in a landscape (Sotheby's 20 July 1949, Lot 55, bt. Frost & Reed).

143 Maria Bicknell, Mrs John Constable d.1816
Oil on canvas, 11 $\frac{15}{16}$ × 9 $\frac{7}{8}$ (30.4 × 25)
Inscribed 'July. 10 1816'
Prov: 17 June 1892 (270), bt. Murray;
bequeathed by George Salting to the National Gallery 1910; transferred to Tate Gallery 1951
Tate Gallery (2655)

Constable painted this portrait in London shortly after he and Maria had decided to marry as soon as possible, despite the continuing opposition of her grandfather Dr Rhudde. A date in September was fixed on and Constable returned to East Bergholt, taking the portrait with him. Writing to Maria from there on 28 July 1816 he said he was 'sitting before your portrait – which when I look off the paper – is so extremely like that I can hardly help going up to it – I never had an idea before of the real pleasure that a portrait could afford' (JCC II p.189). On 1 August he was going to call on Mrs Godfrey who wanted to see the portrait '& as she cannot come out ⟨she⟩ I have promised to take it to her – so that *we* shall have a walk in the fair together – which is an honor that perhaps you did not expect' (*ibid.*, p.191: the annual fair was in progress). Constable again mentioned the picture when he wrote to Maria on 16 August: 'I would not be without your portrait for the world the sight of it soon calms my spirit under all trouble and it is always the first thing I see in the morning and the last at night' (*ibid.*, p.195).

144 Willy Lott's House d.1816
Oil on paper mounted on canvas, 7 $\frac{5}{8}$ × 9 $\frac{3}{8}$
(19.4 × 23.8)
Inscribed on verso 'J. Constable – 29 July 1816'
Prov: ... ; C. R. Leslie, sold Foster's 25 April 1860 (90), bt. (according to inscription on stretcher) by Thomas Churchyard, who died 1865; ... ; S. Herman de Zoete, sold Christie's 8 May 1885 (159), bt. McLean; ... ;
B. W. Leader, who died 1923; his widow, sold Christie's 8 April 1927 (34), bt. Blaker; Anon., sold Christie's 15 February 1929 (57), bt. for Ipswich Museums
Ipswich Borough Council

This could be one of the sketches Farington saw when he called on Constable on 2 January 1817 to look at 'Flatford Mill' (No.151) and at 'several painted studies from nature made by Him last Summer & autumn'. Constable may have used it when he came to paint 'The Hay Wain' (No.192): unlike the other associated studies, this one includes the tall chimney seen at the left of that work.

No.144 appears to have been owned by three artists after Constable's death: Leslie, Churchyard, the Wood-bridge lawyer whose paintings sometimes reflect the influence of Constable, and Benjamin Williams Leader, the artist of 'February Fill-Dyke' whose father, Edward Leader Williams, had been Honorary Secretary of the Worcester Institution, in which capacity he was involved with Constable's contributions to its exhibitions and with his lectures there in 1835.

145 The Quarters, Alresford Hall 1816
Pencil, 9 × 14½ (22.9 × 36.9)
Prov: Charles Golding Constable's daughter Ella, Mrs I. B. A. Mackinnon; acquired from her by Leggatt Brothers, who sold it to A. A. de Pass 1898; presented by him to the Royal Institution of Cornwall 1925
Royal Institution of Cornwall, Truro
See No.146.

146 The Quarters, Alresford Hall 1816
Oil on canvas, 13¼ × 20⅜ (33.7 × 51.7)
Prov: painted for General F. Slater-Rebow; . . . ; Benjamin Brookman, Adelaide, who moved to London 1890; by descent to Mrs Ethel Brookman Kirkpatrick 1940; given into safe keeping at Victoria House, London 1941 and acquired by National Gallery of Victoria 1959
National Gallery of Victoria, Melbourne

No.146 and a larger companion picture, 'Wivenhoe Park' (National Gallery of Art, Washington), were painted for General Francis Slater-Rebow of Wivenhoe Park and Alresford Hall, both near Colchester. The structure seen in No.146, and in the related drawing No.145, is an eighteenth-century fishing lodge in the 'Chinese' style, later known as 'The Quarters'. Constable told Maria about the commission on 21 August 1816: 'I am going to paint two small Landscapes for the General – views one in the park of the house & a beautifull wood and peice of water – and another a scene in a wood with a beautifull little fishing house – where the young Lady (who is the heroine of all these scenes) goes occasionally to angle' (JCC II p.196). The 'young Lady' was the Rebows' daughter Mary, of whom Constable had painted a portrait in September 1812 (ibid., pp.83–7). Constable went to Wivenhoe on 26 August and a few days later described to Maria his kind reception by the Rebows, who, he said, 'make me indeed *quite at home* – They often talk of you – because they know it will please me . . . I am going on very well with my pictures for them – the park is the most forward . . . I live in the park and Mrs Rebow says I am very unsociable' (ibid., pp.198–9). He returned to East Bergholt on 7 September and then went back to Wivenhoe on the 17th for two days. On 19 September he was able to tell Maria that he had completed the picture of the park, i.e. the painting now in Washington.

There is no further reference to 'The Quarters' but presumably this was also completed before Constable and Maria got married on 2 October. The Washington picture was exhibited at the R.A. in 1817.

147 Osmington Bay ?1816
Oil on canvas, 9⅛ × 12⅛ (23.2 × 30.8)
Prov: presumably given by Constable to John Fisher; by descent to his great-granddaughter, Hilda M. Burn; Hazlitt, Gooden & Fox, from whom bt. by present owner 1973
Private collection
(colour plate facing p.80)

For their honeymoon John and Maria joined the (also newly married) Fishers at their vicarage at Osmington in Dorset. They took a leisurely route down, stopping at Netley Abbey and elsewhere and probably not arriving at Osmington until after 11 October. They spent about six weeks at Osmington, from there making excursions to Weymouth and Portland, and returned in equally leisurely fashion, reaching London on 9 December.

At Osmington Constable probably painted, or at least began, the portrait of Fisher exhibited at the R.A. the following year (No.152) and a companion portrait of his wife Mary. Two small landscapes, which later descended in the Fisher family, may also have been painted on the spot: one, a view of Osmington village, now in the collection of Mr and Mrs Paul Mellon (repr. JCC VI, plate 5), and the other, approximately the same size, this view from Osmington Bay looking towards Portland Island. One of the two was certainly in existence by 15 December 1817, when Fisher wrote to Constable: 'You painted me a little picture of Osmington which was not in your box? Do you want it? or may I claim my own? Perhaps Mrs. Constable has taken a fancy to it. If so I must waive my right' (JCC VI p.35). References in two letters from Fisher in 1822 are more clearly to No.147. On 1 October that year he asked Constable to return 'my *wifes* coast scene' (JC:FDC p.118) and on 30 November thanked him 'for returning so punctually the Osmington Coast' (JCC VI p.105). Constable mentioned the picture the following year after explaining to Fisher that he had no versions of his 'Harwich Lighthouse' or 'Yarmouth Jetty' left: 'you have my sketch of Osmington' (ibid., p.128).

148 Weymouth Bay d.1816
Pencil, 6⅞ × 12¼ (17.5 × 31.1)
Inscribed 'Nov.ʳ 5. 1816. Weymouth.'
Prov: . . . ; H. A. C. Gregory, sold Sotheby's 20 July 1949 (91), bt. Agnew; presented to the Whitworth Art Gallery by the National Art-Collections Fund 1949
Whitworth Art Gallery, University of Manchester

The view here is from the downs above Sutton Poyntz, looking towards Portland Island. The drawing is rather larger than those made on the honeymoon which are now in the V. & A. (R.147–54). The latter come from a sketchbook measuring approximately 4½ × 7⅛ inches.

148

149

150

149 Osmington and Weymouth Bays *circa* 1816
Oil on canvas, 22 × 30¼ (55.9 × 76.9)
Prov: ?16 May 1838 (part of 45, 'Weymouth
Bay'), bt. in by Archer-Burton for Constable
family; 11 July 1887 (75, 'Weymouth Bay'), bt.
Agnew, from whom bt. by W. H. Fuller 1888
and in his sale, New York 25 February 1898
(20); Mr and Mrs W. C. Loring 1898 and
bequeathed by them to Museum of Fine Arts,
Boston 1930
*Museum of Fine Arts, Boston (Bequest of Mr and
Mrs William Caleb Loring)*

This painting displays a meticulous topographical ac-
curacy which seems to presuppose either direct work
on the spot or a very detailed (and so far unknown)
drawing. The view is from a point about half a mile
south of Osmington village looking down on Osmington
Bay, with Redcliff Point clearly visible and beyond it
Weymouth Bay. Portland Island is on the horizon at the
left. The figure is similar to the one at the right of
No.147.

It is not always appreciated how wide-angled were
the views in some of Constable's panoramas. Here,
the angle is almost 110°.

150 Osmington Bay after 1816: ?*circa* 1824
Oil on canvas, 13½ × 20⅜ (34.3 × 51.8)
Prov: ?16 April 1896 (34, 'Chesil Beach,
Weymouth Bay'), bt. Agnew;...; ?Humphrey
Roberts, sold Christie's 21 May 1908 (11,
'Chessil Beach: Weymouth Bay'), bt. Agnew;
John Levy 1919; C. S. Gulbenkian; Anon., sold
Christie's 11 June 1923 (80, 'Chesil Beach'), bt.
Willson;...; bt. from Nicholson Gallery, New
York by Wadsworth Atheneum 1949
*Wadsworth Atheneum, Hartford (The Ella Gallup
Sumner and Mary Catlin Sumner Collection)*

At least two other versions of this composition are
known: a more finished one of about the same size, with
birds in the sky but omitting the figures seen here on the
beach (Private collection, exhibited Leggatt Brothers
October 1963) and No.349, which is an unfinished
painting, apparently worked on by another hand. The
composition is much less well-known than that of the
'Weymouth Bay' engraved by Lucas for *English Land-
scape* and of which there are three painted versions: in
the National Gallery (No.2652), the V. & A. (R.155)
and the Louvre. The Louvre painting, measuring
34¾ × 44 inches, is usually taken to be the 'Osmington
Shore, near Weymouth' which Constable exhibited at
the B.I. in 1819 but it definitely depicts Weymouth
Bay, not Osmington. Was the title a mistake (a rather
unlikely one for Constable) or has the exhibited paint-
ing still to be found?

In his journal for 18 June 1824 Constable noted,
'After dinner Fisher called. I was at work & had been
so all day – on the little Osmington Coast' (JCC II
p.335). This was no doubt one of the versions of No.150,
and perhaps the one mentioned above as with Leggatt
Brothers in 1963, which bears nineteenth-century
labels stating (on what authority is not known) that it
was painted in 1824 for the Paris dealer John Arrow-
smith (see letter from Michael Kitson in *Country Life*,
31 October 1963 p.1120).

1817

1 January: Mr and Mrs John Constable are of the company at a dinner given by Farington; next day Farington is shown several painted studies from nature and a large landscape which he exhorts the artist to complete. *12th:* they hear that Dr Rhudde is partially reconciled to the marriage, but for many months yet the rector's favour hangs on a thread. Maria occasionally spends a few days at Putney. *14 April:* at Bergholt alone; fails to gain interview with Rhudde; returns to London. *9 May:* seeks Farington's advice about vacant house in Charlotte Street. *June:* takes No.1 Keppel Street on a seven-year lease; prepares the house for their occupation; Maria, meanwhile, is at Putney. By *25 July* at East Bergholt with Maria; this is to prove his last long holiday in Suffolk. *29 August:* at Wivenhoe Park. Fares better in the *November* elections at the Academy: five votes, against E. H. Bailey's nineteen; and in the election for the second vacancy, eight votes to Abraham Cooper's fifteen. *11th:* tells Farington he is well satisfied with these results. His oil studies of that summer well spoken of (none of these has as yet been identified). *4 December:* Maria gives birth to a son, John Charles.

Exhibits. B.I.: (132) 'A Harvest Field: Reapers, Gleaners', frame 33 × 42 inches (see No.139). R.A.: (85) 'Wivenhoe Park, Essex, the seat of Major-General Rebow' (National Gallery of Art, Washington); (141) 'A cottage' (see No.297); (216) 'Portrait of the Rev. J. Fisher' (No.152); (255) 'Scene on a navigable river' (No.151).

151 'Scene on a navigable river' (Flatford Mill)

d. & exh.1817
Oil on canvas, 40 × 50 (101.7 × 127)
Inscribed 'Jon Constable. f:1817.'
Exh: R.A. 1817 (255); B.I. 1818 (91, 'Scene on the Banks of a River', size with frame 58 × 68 inches)
Prov: ?16 May 1838 (54, 'Flatford Mills, Horse and Barge'), bt. in by Leslie; bequeathed to the National Gallery by Isabel Constable 1888; transferred to Tate Gallery 1957
Tate Gallery (1273)
(colour plate facing p.81)

'Scene on a navigable river', or 'Flatford Mill' as it is generally known today, was the forerunner of the series of 6-foot canvases of river subjects which Constable began exhibiting in 1819. He had already shown a river landscape of the same size as No.151 – 'Landscape: Boys fishing' (see No.118) – but this did not depict the working life of the Stour. In 'Flatford Mill' and the larger canvases which followed, barges and bargemen, towing-horses and their riders, and the operation of locks became central features.

'Flatford Mill' shows the view from the southern end of the footbridge at Flatford, looking along the tow-path to Flatford lock and the mill buildings beyond. The view is a slightly elevated one because it is taken from the slope up to the bridge. On the left, barges are being disconnected from the towing-horse so that they can be poled under the bridge.

Like so many of Constable's pictures, the composition had its origin in the 1814 sketchbook (No.126), page 61 of which corresponds fairly closely with the centre and right hand side of the painting. Page 63 in the same sketchbook is not directly related but shows from a different angle the clump of trees seen at the fork of the river in the left middle-distance of No.151. Page 10 in the 1813 sketchbook (No.119) gives a view of the whole scene but from ground level and from beyond the bridge. This variant composition appears again in an oil study now in the collection of Mr A. L. Gordon. No.130 above shows another variation on the view, taken this time from the bridge itself. Something more closely approaching the final composition is seen in another study, No.131. However, the oil study (if study it is) most directly related to No.151 is one measuring 13½ × 16¼ inches which was formerly in the collection of P. A. B. Widener (repr. W. Roberts, *P. A. B. Widener Collection, British and Modern French Schools*, 1915, No.2). This lacks the barges and human figures but includes the foreground horse (less rider) and shows another horse further along the tow-path, where the two boys appear in No.151. Judging from the reproduction of it published in 1915, it is an odd object (its size, too, is strange) and Beckett, for one, doubted its authenticity (Typescript Catalogue). However, a point in its favour has recently come to light. X-rays of No.151 taken at the Courtauld Institute in 1975 (see fig.iii) show there to have been a horse exactly in the position indicated in the Widener painting, i.e. where the reclining boy is now. Once looked for, the painted-out horse can still be seen with the 'naked' eye. It seems likely that the standing boy with his long stick was originally shown feeding this horse and, perhaps because the incident distracted too much from the distant view, that Constable decided to move the horse to its present, less conspicuous position beside the lock, substituting for it a second, reclining boy. The horse's collar and towing gear were, however, left behind on the grass beside the boys.

On 12 September 1816, three weeks before their marriage, Constable wrote to Maria from East Bergholt: 'I am now in the midst of a large picture here which I had contemplated for the next exhibition – it would have made my mind easy had it been forwarder' (JCC II p.203). The picture was probably No.151[1]. Farington certainly saw 'Flatford Mill' when he called on Constable on 2 January 1817 'to look at several painted studies from nature made by Him last Summer & autumn; also a large landscape composed of the Scenery abt Dedham in Essex. I exhorted Him to compleat them.–'. Though much approved by some of the Academicians (including Beechey, who seems to have set going a rumour about Constable's imminent election to the Academy: see JCC II pp.219–20), the painting failed to sell at the 1817 exhibition. When he got it back again Constable appears to have repainted the foliage at the top of the large tree on the right and most of the smaller tree behind it. Pentimenti can be seen in these areas and X-rays show the shape of the smaller tree to have been more regularly curved as on p.61 of the 1814 sketchbook. A large detailed drawing of the two trees (No.154) made on 17 October 1817, i.e. well after the R.A. exhibition, corresponds very exactly with the repainted areas and was presumably made specifically for the purpose.

151

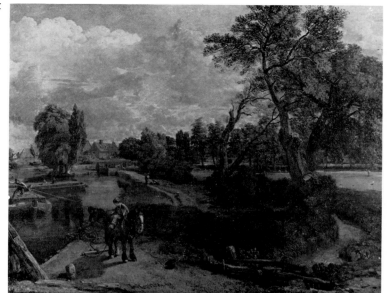

Fig iii (see No.151)

152 'Portrait of the Rev. J. Fisher' exh.1817
Oil on canvas, 14⅛ × 12 (36.2 × 30)
Inscribed: the remains of the 1817 R.A. label
are on the verso: the work was 'N°4' in
Constable's list of exhibits for the year
Exh: R.A. 1817 (216)
Prov: by family descent from the sitter to
John P. Fisher, from whom bt. by Fitzwilliam
Museum 1972
Fitzwilliam Museum, Cambridge
(colour plate facing p.112)

It is known that Constable painted a portrait of Mrs
Fisher, when he and his wife were on their honeymoon
with the Fishers at Osmington, Dorset (see JCC I
pp.144 & 145). This is now also in the Fitzwilliam
Museum. No.152 was almost certainly painted at the
same time. Fisher himself refers to the portraits in a
letter to Constable of 15 December 1817: 'Your por-
traits are hanging up in the room in which I am now
writing and are by the few judges I can procure to look
at them much admired. – I myself & my wife are de-
lighted with them' (JCC VI p.34).

Though twelve years younger than Constable, Fisher
became his closest friend. An amateur artist himself, he
proved an invaluable counsellor and confidant who gave
both moral and financial support whenever it was most
needed. In 1819 he bought the first of Constable's 6-
foot canvases, 'The White Horse', the title of which
stems from an humorous allusion of his to the picture
in a letter of 1 July 1819 (*ibid.*, p.44). In 1821, he
bought 'Stratford Mill' to give to a friend, but also to
help Constable. When at work on 'The Hay Wain' (an-
other title that we first meet in a letter of Fisher's –
ibid., p.62) Constable acknowledged his debt to his
friend thus: '. . . I should almost faint by the way when
I am standing before my large canvasses was I not
cheered and encouraged by your friendship and appro-
bation. I now fear (for my family's sake) I shall never

be a popular artist – a Gentlemen and Ladies painter –
but I am spared making a fool of myself – and your
hand stretched forth teaches me to value my own
natural dignity of mind (if I may say so) above all
things' (*ibid.*, p.63).

It is in the correspondence between Fisher and the
artist that we are brought closest to Constable's inner-
most thoughts and feelings about his art. One of the
most famous passages of all comes in a letter written in
reply to one he had received from the Archdeacon in
the autumn of 1821. Fisher had described a recent visit
of his to Hampshire: 'I was the other day fishing in the
New Forest in a fine, deep, broad river, with mills,
roaring back-waters, withy beds, &c. I thought often of
you during the day. I caught two pike, was up to the
middle in watery meadows, ate my dinner under a
willow, and was as happy as when I was a "careless
boy"' (JCC VI p.76).

'How much I can Imagine myself with you on your
fishing excursion,' Constable wrote in answer, 'But the
sound of water escaping from Mill dams, so do Willows,
Old rotten Banks, slimy posts, & brickwork. I love such
things . . . They have always been my delight – & I
should indeed have delighted in seeing what you
describe in your company "in the company of a man to
whom nature does not spread her volume or utter her
voice in vain". But I should paint my own places best –
Painting is but another word for feeling. I associate my
"careless boyhood" to all that lies on the banks of the
Stour. They made me a painter (and I am gratefull)
that is I had often thought of pictures of them before I
had ever touched a pencil, and your picture [The White
Horse ?] is one of the strongest instances I can recollect
of it' (*ibid.*, pp.77–8).

Fisher's early death in 1832 came as a bitter blow to
Constable. 'I cannot say but this very sudden and awfull
event has strongly affected me', he told Leslie, 'The
closest intimacy had subsisted for many years between

152

us – we loved each other and confided in each other entirely – and this makes a sad gap in my life & wordly prospects. He would have helped my children, for he was a good adviser though impetuous – and a truly religious man' (JCC III p.79).

153 Reapers, Summer Evening d.1817

Pencil, $4\frac{3}{8} \times 7\frac{1}{16}$ (11.1 × 17.9)
Inscribed '15 Augt 1817 6. to 7. Evening.'
Prov: ?11 July 1887 (14), bt. Agnew; . . . ; Sir Cuthbert Quilter; H. A. C. Gregory by 1948, sold Sotheby's 20 July 1949 (97), bt. Tooth; bt. by present owners from Agnew's 1953
Mr and Mrs D. M. Freudenthal

Constable's stay at Bergholt during the summer of 1817 was to be the last of his long working holidays in Suffolk. Though he returned many times for business and family reasons and for an occasional brief holiday, henceforth his home was with his wife and family in London, his life in Suffolk a thing of the past. It was some time yet, however, before he ceased to think of Bergholt as his true home. Six years later, in a letter to Maria, we find him crossing out the word 'home' and substituting 'E. B' when writing about his relations at East Bergholt (JCC II p.304).

In his diary for 11 November 1817, Farington recorded: 'Constable called & told me he had passed 10 weeks at Bergholt in Suffolk with his friends, & painted many studies.' On 24 November, the diarist noted that W. R. Bigg, R.A. (a close friend of Constable) had spoken 'favourably of Constable's oil sketches that summer'. None of these oil-paintings has as yet been identified, but drawings such as 153 and 154, and others from the same sketchbook as No.153 (V. & A., R.156–60, etc.) show that Constable returned from his stay in the country with a considerable haul.

153

154 Study of Trees at Flatford d.1817

Pencil, $21\frac{3}{4} \times 15\frac{1}{8}$ (55.2 × 38.5)
Inscribed 'Octr 17th 1817. E Bergholt'
Prov: presented to the V. & A. by Isabel Constable 1888
Victoria and Albert Museum (R.161)

These are the trees which appear at the right of Constable's painting 'Flatford Mill' (No.151), which was exhibited at the R.A. in 1817, several months before the date on this drawing. No.154 was made from slightly to the right of the viewpoint in the painting yet the relative position of the two trees is exactly as in the painting and the two works also precisely correspond in the foliage at the top of the largest tree and in the whole drawing of the smaller tree behind. There are pentimenti in the corresponding areas of the painting, suggesting that Constable made the drawing, which is squared for transfer, so that he could repaint these details of the picture. Elsewhere the drawing and painting do not exactly match. One interesting difference is the absence from the drawing of one of the upper branches shown in the painting on the left fork of the foreground tree. The branch itself had presumably fallen between the time the painting was made and October 1817, just as a larger branch further down had disappeared between the time Constable made a sketch of the trees in 1814 (page 61 of No.126) and the painting in 1816–17.

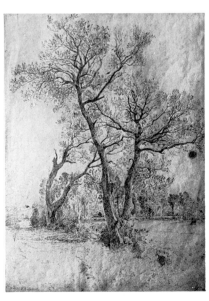

154

155

155 East Bergholt Church *circa* 1817
Pencil, 12½ × 9⅜ (31.7 × 23.8)
Prov: . . . ; Gilbert Davis ; Mr and Mrs W. W.
Spooner ; bequeathed to Courtauld Institute by
W. W. Spooner 1967
Courtauld Institute of Art (Spooner Bequest)

It is reasonably certain that No.156 below was a work
shown at the Academy of 1818 – No.483 in the cata-
logue of that year's exhibition and plainly titled: 'Elms'.
Another of Constable's exhibits that year was No.446 in
the catalogue with the title 'A Gothic porch'. Both were
hung in the Antique Academy – the gallery generally
reserved for miniatures, watercolours and drawings. It
is almost certain, therefore, that the 'Gothic porch' was
also a drawing and, as Constable does not seem to have
been using watercolour at this time, almost certainly a
pencil drawing. No.155 is a study of the uncompleted
and by then part-ruined west tower of East Bergholt
church. It might well have been exhibited as a Gothic
porch, for the stump of the tower with its two archways
does serve as a kind of porch, but a more likely candi-
date for No.446 would appear to be an equally fine
drawing of the south porch of the church in the Henry
E. Huntington Gallery (*John Constable Drawings and
Sketches*, Henry E. Huntington Library and Art Gal-
lery, San Marino, 1961, No.23, Pl.2).

1818

156

31 January: Farington sees his paintings and drawings
of the previous summer, 'but he had not any principal
work on hand'. *19 February:* invited to Malvern Hall to
paint a warrior ancestor for a wall panel; undertakes
panel, but visit deferred. Farington's Diary records
regular visits. *6 April:* tells Farington he has sold two
landscapes, at 45 and 20 guineas. *14 May:* elected a
Director of the Artists' General Benevolent Institution
(A.G.B.I.). Henceforth, he is much concerned with the
charity's affairs. Directors represent all sides of the
Fine Art professions and trades, as well as patrons etc.
J. M. W. Turner is most often in the chair at meetings.
June: begins loathed canvassing for November Academy
election. Much time this summer is given to portraits.
July: teaching Dorothea, daughter of Bishop Fisher,
landscape painting; at Bergholt for a short stay to settle
family affairs. Maria at Putney during *August* and
September: drawings record some of his visits there.
21 October: writes to Maria from Bergholt; his brothers'
and sisters' future being discussed; Abram (who now
runs the business) and Mary will return to live at
Flatford Mill; they plan to sell the family home. Returns
to London. *November:* learns that the price for Bergholt
House has been agreed; in Academy election receives
only one vote. *December:* Farington helps him work out
his annual expenses and accounts.

Exhibits. B.I.: (91) 'Scene on the Banks of a River',
frame 58 × 68 inches (No.151); (129) 'A Cottage in a
Cornfield', frame 19 × 17 inches (see No.297). R.A.:
(11) 'Landscape: Breaking up of a shower'; (34) 'Land-

scape'; (142) 'Landscape: A study'; (446) 'A Gothic porch' (see No.155); (483) 'Elms' (No.156).

156 'Elms' (in Old Hall Park, East Bergholt)

d.1817, exh.1818

Pencil with slight grey and white washes, 23¼ × 19½ (59.2 × 49.4)

Inscribed 'Oct.ʳ 22ᵈ 1817 East Bergholt' and 'John Constable 1817' and on verso: 'This noble Elm – stood in the Park of Peter Godfrey Esq – called "Old Hall" Park at East Bergholt – Suffolk it was blown down April 1835. it broke even with ground – it measured when standing [?upright] 10 × d [?having formerly] lost the large arm on the Right J. C. This drawing was made 1816. in the Autumn'. Also on the verso is the following, in another hand: 'The above is the Handwriting of John Constable R.A. (who made the Drawing) – Purchased at the sale of his Pictures and Drawings, at Fosters in – Pall Mall. 16 May 1838 – A. James'

Exh: R.A. 1818 (483)

Prov: 16 May 1838 (63), bt. White Jr. for A. James; Miss James, sold Christie's 22 June 1891 (168), bt. for V. & A.

Victoria and Albert Museum (R.162)

Constable showed three drawings at the R.A. in 1815 and two in 1818. They were almost certainly in pencil, a medium which he otherwise rarely used for exhibition works. To judge from a group of very fine, elaborate pencil studies that survive, the years 1815–17 represent one of the peaks in his drawing style. This group includes No.128, which is perhaps one of the 1815 exhibits, No.154, No.155 and other drawings of East Bergholt Church in the V. & A. (R.177) and the Huntington Art Gallery (see under No.155), the latter perhaps the drawing exhibited as 'A Gothic porch' in 1818. The present work, No.156, is however the only one that can be more or less certainly identified as an exhibited pencil drawing. Both its date and subject point fairly conclusively to it being the 'Elms' shown in 1818.

Reynolds (1973 p.118) suggests that '10 × d' in the inscription may mean that the tree measured 'ten times the height of a man, or ten diameters', though he also points out that the tree in the drawing is actually more like twelve times the height of the man seen standing beside it. It is curious that Constable should have later inscribed the drawing as having been made in 1816 when the front presumably already bore the date 1817; possibly the latter was obscured by a mount.

For Old Hall see the entry on No.27, Constable's painting of the house made in 1801. His relations with the Godfreys are mentioned under No.133.

157 Dr Walker d.1818

Oil on canvas, 29½ × 24½ (74.9 × 62.2)

Inscribed 'J. Constable. pinxᵗ: 1818'

Prov: presumably painted for the sitter; . . . ; J. K. Tuder, R.N., of Penally; his daughter Elizabeth Mary, who married Captain Richard James Hereford; their son James Tuder Hereford, who died 1952; Leger Galleries, from whom bt. by present owner 1954

Private collection

The Revd. William Walker (?1765–1835) was Rector of Layham, Suffolk, from 1812 until his death. As Layham is only a few miles from East Bergholt, it was presumably through some local connection that Constable received a commission to paint his portrait. It was engraved by William Ward A.R.A. in 1826, apparently at the expense of a Captain Tuder (see JCC IV p.310). The portrait itself descended through the Tuder family but it is not clear what Walker's relationship to them was. Portraits by Constable of Mrs Tuder and her daughter, Mrs Edwards, descended in the same way to J. T. Hereford (the portrait of Mrs Tuder is reproduced in a Leger Galleries advertisement in *The Connoisseur* for April 1959). Walker was a friend of another of Constable's sitters, Dr John Wingfield, one-time Headmaster of Westminster School (see JC:FDC p.141).

158 Mrs Pulham 1818

Oil on canvas, 29¾ × 24¾ (75.6 × 62.9)

Prov: the sitter's eldest son, James Brook Pulham, who died 1860; his widow Maria, who on her death in 1868 bequeathed it to her executor Captain Rolla Rouse of Melton; . . . ; presented to the Metropolitan Museum of Art by George A. Hearn 1906

Metropolitan Museum of Art, New York

(Gift of George A. Hearn)

The sitter was Frances (née Amys), wife of the Woodbridge solicitor James Pulham. She died in 1856 at the age of ninety. Pulham procured Constable a commission in 1816 to paint the portrait of an aged clergyman near Woodbridge (JCC IV p.88), bought a landscape from him in 1818 (*ibid.*, pp.89–90), was given one of the versions of 'Harwich light-house' (see Nos.178–9) in 1824 (*ibid.*, p.91) and bought a 'Helmingham Dell' (No.295) in 1826 (*ibid.*, pp.92–3). His wife's portrait was evidently painted in 1818. On 30 April that year Pulham told Constable that 'The portrait arrived safe on Saturday last, and I cannot but express myself greatly obliged by your masterly execution of it. It will give Mʳˢ Pulham & myself much pleasure to have you, Mʳˢ Constable & your little one with us this Summer, when Mʳˢ P. will feel gratified in being able to return the Compliment which you have so handsomely bestowed on her' (*ibid.*, p.88).

159 Bristol House, Putney Heath d.1818

Pencil, 3⅞ × 10¼ (10 × 26.1)

Inscribed 'Augt 13. 1818. Putney Heath'

Prov: 17 June 1892 (part of 143), bt. C. Fairfax Murray, by whom presented to Fitzwilliam Museum 1917

Fitzwilliam Museum, Cambridge

After the death of his wife in 1815, Charles Bicknell, Constable's future father-in-law, had taken a house for his three daughters (of whom Maria was the eldest) in the country at Putney. Here, Constable visited Maria on a number of occasions before their marriage; and here Maria came to stay in the summer of 1818 with their small son while Constable remained behind in Keppel Street to work, possibly at his portraits. Drawings such as Nos.159–60 record the occasions when he was able to join his family for short holidays. From this double spread in his sketchbook of 'Louisa Cottage' (as it came to be called after the elder of Maria's un-

157

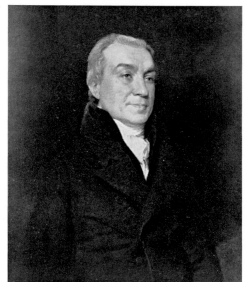

158

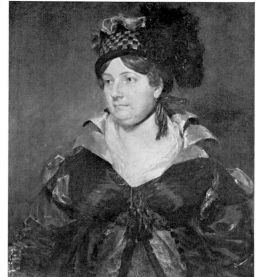

159

married sisters) Constable made three delicately tinted drawings of the house, conceivably one for each of the sisters. One of these is in the V. & A. (R.165) and another in the Whitworth Art Gallery, Manchester.

160 The Semaphore on Putney Heath d.1818
Pencil, $3\frac{15}{16} \times 5\frac{3}{16}$ (10 × 13.1)
Inscribed '8 Sepr 1818'
Prov: as for No.159
Fitzwilliam Museum, Cambridge

The semaphore Constable sketched on 8 September was part of a communication system that enabled signals to be speedily passed from Admiralty to Portsmouth when the weather was clear. Constable made two other pencil drawings on the same day: a study of a windmill at Barnes (in the same sketchbook), and a large sketch of Fulham church seen from across the river (Mellon Collection). On the following day (9 September) he was drawing in his sketchbook at Richmond. The identification of the subject of No.160 was made by Reg Gadney.

161 Golding Constable's House, and East Bergholt Church d.1818
Pencil, 4 × 5 (10.2 × 12.7)
Inscribed '27th Octr 1818.'
Prov: always in the Constable family
Richard Constable

This is the view of the back of Constable's home that was obtainable from the fields close to the Rectory. When he made the drawing Constable was down on a short visit, the purpose of which was to discuss with the family and its legal advisers the sale of the house and its contents, and his brothers' and sisters' future. An offer for the house had already been made; the people who had made it were known and approved of; and they were just about to accept and put an end to the business.

On the day of his arrival, 21 October, Constable had been very moved by the memories associated with his home, and his eyes had filled with tears when attempting to describe his sensations to Maria. In the second of his letters he tells her something of the pleasure it was to be back. 'I have been twice at church to day –' he writes, 'it delights me to hear the kind enquiries after you & our darling which I have on every side – this has been a lovely day – early this morn – I walked into a wood at Stratford – which was lovely with its rich autumnal tints – after all this is the painters season –' (JCC II p.240).

162 East Bergholt Church with the tomb of the artist's parents d.1818
Pencil, $7\frac{13}{16} \times 12\frac{5}{8}$ (19.9 × 32.1)
Inscription, not in artist's hand, on the card on which the drawing is laid: 'East Bergholt Church. With the Tomb of Golding and Ann Constable, parents of J. Constable, by whom this was drawn Oct 28, 1818. Golding died 1816 aged 78. Ann died 1815 aged 67. By the side of their tomb are the tombs of Jas. Revans, his wife, and son and daughter. Revans was Golding Constable's faithful Steward.'
Prov: 11 July 1887 (22), bt. Noseda; . . . ;
J. P. Heseltine, sold Sotheby's 25 March 1920 (112), bt. Agnew
Sir John and Lady Witt

160

Constable told David Lucas that his father, when on his death-bed, had called in James Revans, his trusted steward who had been his right-hand man for many years, and asked him as a dying man 'if he could recollect an instance in which h[e] had dealt unfairly or taken advantage of the necessities of the poor. the widow or the fatherless that he might make compensation whilst he had the power'. Revans is said to have found 'on consideration no trace left on his memory of a single act of that kind' (JC:FDC p.56).

Part, at least, of the above inscription must have been added later. According to the wording on the Revans' tombstone, James Revans died on 10 April 1823, in his seventy-third year, and his wife, of whom the Constables appear to have been equally fond, on 17 March 1841, aged eighty.

161

163 The Wheatfield (Copy after Jacob van Ruisdael) d.1818

Pen and brown ink, 4 × 6 (10.1 × 15.2)
Inscribed, in imitation of the etched signature, 'Ruysdael. fe:'; verso 'J. C. fe: 1818'
Prov: presented to the V. & A. by Isabel Constable 1888
Victoria and Albert Museum (R.169)

A copy of Ruisdael's etching 'The Wheatfield' (Bartsch 5). See No.164.

164 Cows and herdboy (Copy after Aelbert Cuyp)

Pencil, 4 × 5 (10.1 × 15.2)
Inscribed on verso 'Copy from Cuype by J. Constable', the last eight letters apparently filled in by another hand
Prov: presented to the V. & A. by Isabel Constable 1888
Victoria and Albert Museum (R.170)

162

Ruisdael is one of the artists most often mentioned in the correspondence with John Fisher. In one of his letters to the Archdeacon Constable describes a picture he had just been examining at a dealer's in Great Marlborough Street: 'I have seen an affecting picture this morning, by Ruisdael. It haunts my mind and clings to my heart – and has stood between me & you while I am now talking to you. It is a watermill, not unlike "*Perne's Mill*" [at Gillingham] – a man & boy are cutting rushes in the running stream (in the "tail water") – the whole so true clear & fresh – & brisk as champagne – a shower has not long passed. It was beside the large one at Smiths – & showed Ruisdaels compass of mind' (JCC VI p.229).

It was with the name of Ruisdael that Fisher would join Constable's own when he was attempting to console or please the artist: 'You are painting for a name to be remembered hereafter: for the time when men shall talk of Wilson & Vanderneer & Ruisdale & Constable in the same breath', he wrote in 1822, after Constable had been defeated by a nonentity, Richard Cook, in the election at the Academy (*ibid.*, p.83).

In 1818, when sending Constable a letter by hand from the Charterhouse, Smithfield, where he was staying with his father, Fisher addressed it to 'Reysdale House'; a few days later, he sent another, this time with the address, 'Ruysdale House'. No.163 is dated the same year. With its 'J. C. fe:' on the back in imitation

163

164

of Ruisdael's own 'fe:', could it have been with Fisher in mind that Constable made this facsimile of the etching?

So closely does he follow the original in No.163 that even the plate-mark on the etching is reproduced. Constable went on copying Ruisdael until near the end of his life; a painted copy made in 1832 is No.292 below.

Among the mounted drawings in the Louvre, there is another pencil drawing after a painting by Cuyp, this time an upright of figures and cattle seen against a sunset (R.F.6122).

165 Study for 'The White Horse' *circa* 1818
Oil on canvas, $9\frac{1}{4} \times 11\frac{7}{8}$ (23.5 × 30.2)
Prov:...; Alexander Young by 1902; Lady
Mary Stewart Tollemache 1907; Lt. Col. the
Rt. Hon. Denis Plantagenet Tollemache; Anon.,
sold Sotheby's 24 November 1965 (150), bt.
Quentin
Private collection

At the R.A. in 1819 Constable exhibited one work only, 'A scene on the river Stour', which Fisher promptly christened 'The White Horse', the name it has gone under ever since. This painting, now in the Frick Collection, New York, was the first of Constable's 6-foot canvases depicting the river and the men and animals who worked on it. The incident chosen in this case was the ferrying of a white barge-horse across the Stour at a point where the tow-path crossed from one bank to the other. Despite its unspectacular subject, the painting was, said Leslie, 'too large to remain unnoticed' at the Academy and it 'attracted more attention than anything he had before exhibited' (1843 p.24, 1951 p.73). Fisher bought the work at the price asked by Constable, 100 guineas, the largest sum he had so far received for a picture. It reached Salisbury in April 1820 and the Archdeacon had it 'hung on a level with the eye, the lower frame resting on the ogee: in a western side light, right for the light of the picture, opposite the fire place. It looks magnificently. My wife says she carries her eye from the picture to the garden & back & observes the same sort of look in both' (JCC VI p.53). Constable borrowed the painting for the special exhibition of works by 'Living Artists of the English School' held at the B.I. in 1825 and for the Lille Salon of the same year. In 1829 Fisher's financial difficulties obliged him to part with it and Constable bought it back from him.

The view depicted in the 'White Horse' composition is probably from downstream at Flatford, looking towards Willy Lott's house with its adjacent barns and outbuildings on the opposite bank at the left. If so, the shadowed channel below the house would be the mill stream and an observer placed near the thatched boathouses would be able to look up the mill stream to Flatford Mill – would, in fact, have more or less the opposite view to that presented in 'The Mill Stream', No.129 above. The left-hand side of the composition was derived from a drawing on page 66 of the 1814 sketchbook (No.126), which was developed in the present oil sketch and in a similar one, measuring 20 × 24 inches, now in a private collection in Switzerland. None of these however includes the barge and horse, which presumably were taken from a separate drawing. One

of the bits of woodwork seen in the foreground of the final painting was introduced also in two versions of 'The Valley Farm', Nos. 137 and 320.

Working for the first time on this large scale, it might be imagined that Constable would have had recourse to the sort of full-size preparatory sketch which he used for 'The Hay Wain' shown in 1821 and for subsequent 6-foot compositions. What is usually supposed to be a full-scale study for 'The White Horse', a painting in the National Gallery of Art, Washington, does, however, have some curious features which suggest that the question should be looked at again. Among these is the left hand building, which bears little relation to the one depicted in both the final painting and the earlier material. The position of the boathouse in the Washington picture is equally difficult to reconcile with the information conveyed by the other works, and, among other features, the shape of the barge seems curiously misunderstood.

1819

We hear little of him for the first three months of the year, probably because he is preoccupied with the first of his 6-foot canvases, 'The White Horse'. Abram asks him to come to Bergholt to help divide the contents of East Bergholt House but he does not leave London. *March:* a three-day sale at the house. *2 April:* as usual, Farington calls to see his Academy picture, 'The White Horse', and makes observations on it which Constable says he will 'attend to'; at the Academy the picture is generally well received. *3 May:* Abram writes to say that he is needed to settle the sale of the house. *6th:* arrives at Bergholt as the bells are tolling for Dr Rhudde, who has died that morning. Maria is a beneficiary under the terms of her grandfather's will. The family business is happily concluded. By *18th:* in London. The Rector of Helmingham orders a landscape. *2 July:* John Fisher writes to ask the price of his picture at the Academy. *19th:* birth of their second child, Maria Louisa. Fisher says he wishes to buy 'The White Horse', at 100 guineas. Rents Albion Cottage, Upper Heath, Hampstead for two or three months; makes his first sketches there. *24 October:* writes to Maria from East Bergholt where the plate, linen, etc., are being divided 'to our mutual satisfaction'. *29th:* in London; *1 November:* elections at Academy. *2nd:* Farington informs him that he has been elected an Associate by eight votes to Leslie's five. *8 December:* with Maria, calls on Farington to thank him for his help.

Exhibits. B.I.: (44) 'Osmington Shore, near Weymouth', frame 40 × 48 inches (see under No.150); (78) 'A Mill', frame 39 × 47 inches (probably No.166). R.A.: (251) 'A scene on the river Stour' (Frick Collection, New York – 'The White Horse').

165

166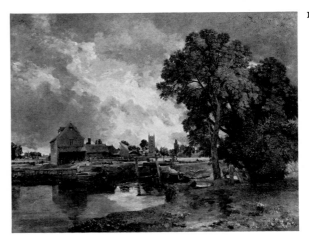

166 'A Mill' (Dedham Lock and Mill) ?exh.1819
Oil on canvas, 28 × 35½ (71 × 90.2)
Exh: ?B.I. 1819 (78, size with frame
39 × 47 inches)
Prov: ?J. Pinhorn (named as purchaser of 1819
exhibit in *Literary Gazette*); . . . ; perhaps
acquired by Thomas Miller *circa* 1850 (see
Reynolds 1973 under No.184); T. Horrocks
Miller; Thomas Pitt Miller, sold Christie's
26 April 1946 (17), bt. Leggatt
Private collection

Dedham Mill was one of the watermills worked by
Constable's father and, after his death in 1816, by the
artist's brother Abram. The mill was sold when Abram
gave up business in 1846. As a subject it does not
figure to any extent in Constable's art until around
1818–20, when several versions of the composition seen
here were painted.

The painting of 'A Mill' which Constable sent to the
British Institution in January 1819 can reasonably be
identified with one of these versions: the title is appro-
priate and two of the pictures are known to date from
the right period. Of the three finished paintings, No.166
is the most likely candidate for the exhibited work.
Larger than the others, its size seems a little more con-
sistent with the framed measurements recorded in the
B.I. catalogue (which are, incidentally, almost exactly
matched by the picture's present frame). A 39 × 47 inch
frame around either of the other two versions would be
8 or 9 inches wide, which is, perhaps, too generous.
One of the other two versions, in the V. & A. (No.180
below), is in any case dated 1820 and is unlikely for that
reason to be the painting shown in 1819. The other, in
the Currier Gallery of Art, Manchester, New Hamp-
shire, derives from the Spedding family and was, ap-
parently, acquired by Miss Spedding from Constable's
daughter Maria in 1841[1], whereas the exhibited work is
reported (see above) to have been sold by Constable to
a Mr Pinhorn in 1819. And according to Leslie[2], the
Spedding picture, like the one in the V. & A., was
painted in 1820.

That No.166 is the first of the three finished versions
is also suggested by certain features of its design. An
earlier oil sketch of the subject (V. & A., R.113) shows
very little space to the left of the mill. What seems to be
the next representation, a drawing in the Henry E.
Huntington Library and Art Gallery, San Marino,
California (No.20, Pl.4, in its exhibition *John Constable.
Drawings & Sketches* 1961), extends the composition on
the left to allow a glimpse of distant landscape and to
give the mill itself a more central place (in R.113 Ded-
ham church is more the focus). In most respects the
painting under discussion, No.166, follows this draw-
ing. In the V. & A. picture of 1820, however, a boat is
introduced in a prominent position at the left and a
second grazing horse appears in the right foreground.
These new features are repeated with minor variations
in the Currier Gallery version. It would appear that
Constable was dissatisfied with the rather empty fore-
ground of No.166 and that the boat and additional
horse were introduced in an attempt to solve the prob-
lem. An abandoned version of the composition (Tate
Gallery No.2661) closely corresponds with No.166 and
supports the idea that Constable was aware of difficul-
ties at this stage.

A curious feature of both No.166 and the Tate Gal-
lery picture is the straight edge given to the bottom of
the roof over the mill wheel: in the original oil sketch
and in the V. & A. and Currier Gallery paintings a
central lip projects below the bottom edge of the roof.
In the Huntington drawing this detail is not very clear
but the bottom of the roof does appear to be straight.
Did Constable modify this detail half-way through the
sequence for the sake of some, not very obvious,
pictorial advantage, or was he misled by a failing
memory and a drawing which was inexplicit on this
point?

Another curious feature of No.166 is the tight, fussy
treatment of the foliage on the trees at the right, which
is very unlike the fluent handling of the rest of the
picture and, indeed, very unlike anything else we know
by Constable at this period.

167

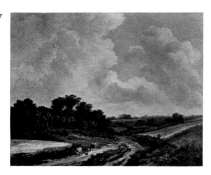

Fig.iv

168

168

168

167 A Landscape with a Cornfield (Copy after Ruisdael) d.1819

Pencil, $3\frac{1}{2} \times 4\frac{3}{8}$ (8.9 × 11)

Inscribed 'V. W[?elde] – I foot $4\frac{1}{2}$ I d° $7\frac{1}{4}$ hight of Hor[?se] 3 Inches Ruysdeal I foot 6 I d° $9\frac{1}{2}$ British Gallery July 13. 1819'

Prov: always in the Constable family

The Executors of Lt. Col. J. H. Constable

Until Mr Robert Hoozee identified this drawing as a copy of an oil-painting by Jacob van Ruisdael, it had always been regarded as one of Constable's Suffolk views. The identification now makes sense of the second half of the inscription on the back of the drawing. The original (fig.iv, Thos. Agnew & Sons Ltd; exh. Agnew's 1974, No.21) was evidently seen, and presumably drawn, by Constable at the exhibition of Old Masters at the British Institution in 1819, in the catalogue of which exhibition it is entered as No.51 'Landscape, with Figures and Cattle Ruysdael and A Vandevelde', the owner being the Earl of Musgrave.

168 Sketchbook used in 1819 d.1819

Various media, $2\frac{5}{8} \times 3\frac{5}{8}$ (6.5 × 9.2)

Inscribed inside cover 'Hampstead – Sepr. 9th. 1819'

Prov: . . . ; presented to the British Museum by C. Keith Denny 1972

Trustees of the British Museum (1972-6-17-15)

It is probable that the greater number of Constable's drawings were made in sketchbooks: some pocket-sized, like those of 1813 and 1814 (Nos.119 and 126), others of larger dimensions such as the one he used in 1835 (No.322, $4\frac{1}{2} \times 7\frac{3}{8}$) and the now dismembered one also of 1835 which measured $8\frac{3}{4} \times 11\frac{1}{4}$ inches. Only eight of the sketchbooks are known to have survived intact. This Lilliputian one (No.168) was used by Constable during the first season in which he rented a house for his family in Hampstead. The first dated drawing it contains is a view from near Whitestone Pond looking towards Harrow inscribed '10 Octr 181[?9]'; the last is a sketch of a cedar tree – 'Putney 18 Novr 1819'. Views of the Heath predominate, but there is a wide selection of subjects besides – men at work, animals (both indoors and out), figure studies, trees, boats. Several have been scribbled over by a child. Three of the sketches – two of the church and one of his parents' tomb – were done on his visit to Bergholt in October; one is dated the 28th.

169 Sky Study d.1819

Crayons on blue paper, $4\frac{5}{16} \times 7\frac{1}{16}$ (11 × 18)

Inscribed 'July 9 1819 –'

Prov: . . . ; C. R. Leslie; his son Sir Bradford Leslie; his daughter Jenny, who married Captain Spence; their daughter Margaret Lydia Spence; her cousin A. L. Gordon

A. L. Gordon

The date on this study shows it to have been made just before Constable first took a house at Hampstead, where his 'skying' is usually thought to have got under way. Nos.170–2 below presumably date from about the same time. A smaller crayon sky study, with chimney pots in the bottom right hand corner, is also in the Gordon collection. Another drawing of this type, again dated 9 July 1819, was in Captain Constable's sale, 23

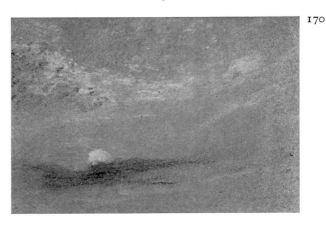

170

June 1890 (102, bt. Vivian). No.169 appears to be the earliest securely dated 'pure' sky study by Constable that survives. His first oil sketches of skies without any land date from 1822 (see No.207). Two other crayon sky studies, in the Louvre and a private collection in New York, have been attributed to *circa* 1806[3], presumably because the one in the Louvre is mounted on the cover of a sketchbook (R.F.8700) used by Constable in 1806, but there is no evidence that this study dates from the same period as the sketchbook itself; another insertion in the book, a sheet with translations of the Latin verses used on the frontispiece to *English Landscape*, is dated 8 August 1820.

170 Sky Study *circa* 1819
Crayons on blue paper, $4\frac{15}{16} \times 7\frac{1}{4}$ (12.5 × 18.5)
Prov: as for No.169
A. L. Gordon
See No.169.

171 Sky Study *circa* 1819
Crayons on blue paper, $5\frac{1}{8} \times 7\frac{1}{4}$ (13 × 18.5)
Prov: as for No.169
A. L. Gordon
See No.169.

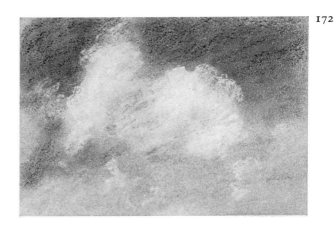

172

172 Sky Study *circa* 1819
Crayons on blue paper, $5\frac{1}{8} \times 7\frac{1}{4}$ (13 × 18.5)
Prov: as for No.169
A. L. Gordon
See No.169.

173 Cloud Study with Verses from Bloomfield
Ink, $13\frac{3}{16} \times 8\frac{5}{16}$ (33.5 × 21.1) on paper watermarked 1817; area of drawing approximately $6 \times 8\frac{5}{16}$ (15.3 × 21.1)
Prov: presumably given by the artist to David Lucas, from whose brother Alfred it was bought by E. E. Leggatt[4]; . . . ; R. B. Beckett by 1956; his widow Mrs Norah Beckett 1970; purchased from her executrix by the Tate Gallery (Gytha Trust) 1974
Tate Gallery (T.1940)

The verses are from Robert Bloomfield's *The Farmer's Boy* ('Winter', lines 245–62)[5], first published in 1800:

With saunt'ring step he climbs the distant stile,
Whilst all around him wears a placid smile;
There views the white-rob'd clouds in clusters driven,
And all the glorious pageantry of Heaven.
Low, on the utmost bound'ry of the sight,
The rising vapours catch the silver light;
Thence Fancy measures, as they parting fly,
Which first will throw its shadow on the eye,
Passing the source of light; and thence away,
Succeeded quick by brighter still than they.
Far yet above these wafted clouds are seen
(In a remoter sky, still more serene,)
Others, detach'd in ranges through the air,
Spotless as snow, and countless as they're fair;
Scatter'd immensely wide from east to west,
The beauteous 'semblance of a *Flock* at rest.
These, to the raptur'd mind, aloud proclaim
Their MIGHTY SHEPHERD's everlasting Name.

Bloomfield appears to have been one of Constable's favourite poets. Other lines from *The Farmer's Boy*

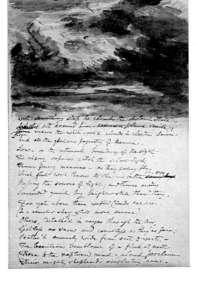

173

174

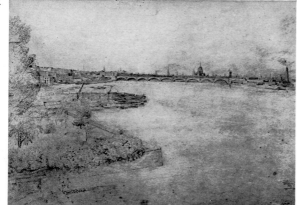

175

176

177

were quoted by him in connection with paintings exhibited in 1814 (No.123) and 1817 (see under No.139). It is not known when or why he made this drawing, though the attraction for him of these particular verses is clear enough, 'the glorious pageantry of Heaven' being one of his own especial studies.

174 Waterloo Bridge *circa* 1819
Pencil, 12 × 16⅛ (30.6 × 41) on paper
watermarked 1811
Prov: presented to the V. & A. by Isabel
Constable 1888
Victoria and Albert Museum (R.173)

Nos.174–6 represent early stages in the development of Constable's ideas for a painting showing Waterloo Bridge on the day of its opening in 1817. He first considered such a work in 1819 but it was not until 1832 that he finally exhibited a painting of the subject, as 'Whitehall stairs, June 18th, 1817'. The complicated history of the composition is discussed in the entry on the final painting, No.286 below.

From the very beginning Constable appears to have made drawings and paintings of the bridge which either included or omitted the ceremonies that attended the opening. Nos.174–6 are 'unceremonial' but an oil sketch which he showed to Farington on 11 August 1819 must have included the festivities: 'Constable called, and brought a painted sketch of his view of Waterloo bridge &c and the river as it appeared on the day of the *opening the Bridge*. I objected to his having made it so much a "*Birds eye view*" and thereby lessening magnificence of the bridge & buildings. – He s.d he would reconsider his sketch'. Since the present drawing, No.174, also gives a bird's-eye view, it seems likely to date from about the same time as the oil sketch Farington saw. The drawing may have been made from one of the balconies of the narrow, bow-fronted house, No.5 Whitehall Yard, which stood between Michael Angelo Taylor's house and Lady Grantham's on the embankment, and which appears (its balconies swarming with spectators) in the final painting. Whitehall Stairs, to figure prominently in the painting, was approached by a passage between Lady Grantham's house and the garden of Fife House. The men seen towards the bottom left of the drawing are standing on Whitehall Stairs, with the garden of Fife House beyond them.

175 Waterloo Bridge from near Whitehall Stairs
Pencil, 4½ × 7¼ (11.4 × 18.4)
Prov: given by Constable's grandson Hugh to the present owner's mother
Private collection
See No.176.

176 Waterloo Bridge from near Whitehall Stairs
Oil on paper laid on canvas, 8¼ × 12½ (21 × 31.8)
Prov: presented to the R.A. by Isabel Constable 1888
Royal Academy of Arts, London

Unlike No.174, Nos.175–6 depict Waterloo Bridge from more or less water level, but like No.174 they omit any of the ceremony associated with the opening of the bridge. It is not clear whether Constable saw them as preparatory studies for a painting of the festivities of 18 June 1817 or whether they were a

152 'Portrait of the Rev. J. Fisher' exh.1817 detail (entry on p.102) ▶

deliberate offshoot from the main composition: perhaps they began as one and ended as the other. Despite its appearance of being an on-the-spot sketch, No.176 is clearly derived from No.175, and translates it very accurately, though the drawing does not include the large tree seen at the left of the oil study. In turn, No.176 may have been the basis of a painting measuring $21\frac{3}{4} \times 30\frac{3}{4}$ inches which is now in the Cincinnati Museum.

On the verso of No.175 is a pencil drawing which corresponds with the left-hand third of a pen and wash drawing of the Waterloo Bridge subject in the V. & A. (R.175). There are faint indications of the figures of soldiers lined up against the parapet wall, as in the V. & A. drawing and the final picture, No.286.

1820

Again, little is heard of him for the first three months of the year, probably because 'Stratford Mill', another large canvas, is on his easel. Occasionally, he calls on Farington for a gossip: on *9 January* with news from Chantrey of Turner in Rome. *1 April:* talks to Farington about his new picture, but this time says he does not seek an opinion on it. *14th:* Fisher writes for 'The White Horse'; it is sent, and when hung 'looks magnificently'. *28th:* tells Farington he has been to the private view. *May:* as Steward for the A.G.B.I. annual dinner, attends extra meetings. *9 June:* shows Farington a review panegyrizing his landscape. *3 July:* is placed between Turner and the deaf and dumb painter, Samuel Lane, at the Academy dinner. Takes his wife and two children to stay with the Fishers at their house in Salisbury Close. Drawings record excursions to Old Sarum, Stonehenge, the New Forest and to Gillingham, Fisher's new parish. *22 August:* last dated drawing of the visit. *1 September:* tells Fisher he has moved his family to Hampstead; also that he has begun his 'Waterloo Bridge' on a large canvas. *10th:* staying at Malvern Hall with H. G. Lewis. Several oil-sketches of Hampstead dated *October*. *21 November:* shows Farington a 'Waterloo'; he is advised to 'complete for the Exhibition a subject more corresponding with his successful picture exhibited last May' (i.e. 'Stratford Mill'). Before long, has commenced work on 'The Hay Wain'.

Exhibits. R.A.: (17) 'Landscape' (No.177); (148) 'Harwich light-house' (see Nos.178–9).

177 'Landscape' (Stratford Mill) exh.1820
Oil on canvas, 50 × 72 (127 × 182.9)
Exh: R.A. 1820 (17); *Living Artists of the English School* (loan exhibition), B.I. 1825 (114, 'Landscape: a Water-mill, with Children angling')
Prov: bt. from Constable by Archdeacon Fisher 1821 for presentation to John Pern Tinney, who died 1832; his widow; . . . ; C. F. Huth, sold Christie's 6 July 1895 (77), bt. Agnew; 1st Baron Swaythling 1896; 2nd Baron Swaythling 1911,

sold Christie's 12 July 1946 (19), bt. Ellis & Smith for Walter Hutchinson; Hutchinson & Co. (Publishers) Ltd., sold Christie's 20 July 1951 (85), bt. present owner
Private collection

'Stratford Mill', known after Constable's death as 'The Young Waltonians', was the second of the artist's 6-foot canvases of scenes on the Stour. The mill at Stratford St. Mary, upstream from Dedham, was used for paper-making and might be thought to have been of special interest to Constable for that reason, yet it seems to figure in his art only in this composition. The only drawings used in the picture that survive today are a study of a mooring-post in the 1813 sketchbook (page 77 of No.119), which was the model for the post in the right foreground, and one of water-lilies on page 55 of the same sketchbook, which seems to have been used for the water-lilies not only in this picture but also in 'The White Horse' and 'View on the Stour, near Dedham'. A small oil sketch of the composition is in a private collection (exh., *Constable: The Art of Nature*, Tate Gallery 1971, No.96, repr. Pl.v).

One of David Lucas's annotations to Leslie's *Life* records the way Constable 'read' (and presumably expected others to read) the painting: 'Mr C. explained to me if I may so call it the natural history of this picture among his remarks were the following that when water reaches the roots of plants or trees the action on the extremities of their roots is such they no longer . vegetate but die which explains the appearance of the dead tree on the edge of the stream. The principal group of trees being exposed to the currents of wind blowing over the meadows continually acting on their boles inclines them from their natural upright position and accounts for their leaning to the right [actually left] side of the picture' (JC:FDC p.57). The 'natural history' of a picture was Constable's own expression, used by him, for example, in the letterpress to 'Spring' in *English Landscape*. In his third lecture at the Royal Institution in 1836 Constable analysed a painting by Ruisdael in similar terms, concluding that 'Ruysdael *understood* what he was painting': '*We see nothing truly till we understand it*' (Leslie 1843 pp.144–5, 1951 p.318).

'Stratford Mill' was bought from Constable by John Fisher in 1821 as a present for his solicitor, John Pern Tinney, who had been successful in a lawsuit on his behalf (JCC VI pp.50, 60). It reached Tinney in July that year (*ibid.*, p.69). On 26 September Fisher told Constable that a 'grand critical party' had raised objections to the sky, apparently because of its prominence. This led Constable to make his well-known pronouncement on the subject: 'That Landscape painter who does not make his skies a very material part of his composition – neglects to avail himself of one of his greatest aids . . . It will be difficult to name a class of Landscape, in which the sky is not the "*key note*", the *standard of* "*Scale*", and the chief "*Organ of sentiment*"' (*ibid.*, pp.76–7; see also under No.207). Another criticism came from the Treasurer of Salisbury Cathedral, who liked the sky and water but found the trees 'shocking' (*ibid.*, p.104). Tinney himself was pleased with the painting and resisted most of Constable's attempts to get it back for further exhibitions. However, Constable did manage to work on the picture again in 1824 and to borrow it for a special exhibition at the B.I. in 1825.

Fisher described to him the unflattering surroundings in which it hung in Tinney's Salisbury house: 'You have often talked of an emerald in a dish of rubbish. Old iron, bits of rag, flints, broken glass or tarnished lace. Such is the appearance of your picture at Salisbury. The room which in it's proportions is magnificent is furnished exactly like the best parlour of an opulent pawnbroker. An enormous brass chandelier with twenty branches: a clock stuck round with gilt cupids like the chimney peice ornaments in the breakfast scene of Marriage a la mode. And to crown all, the walls covered with pannels of brown varnish yclept "old masters". The light on your picture is excellent, it receives the South sun standing on the Western wall. – [Sketch of the room, with 'Stratford Mill' hanging on a level with the spectator's head below a Venetian picture from Canon Douglas's collection: on one side is "A Douglas lake peice copied by Miss Benson" and on the other a picture marked "rubbish"] However it puts out all the other pictures & attracts general attention & will do you much service' (ibid., p.84; the description of the sketch is Beckett's).

178 **'Harwich light-house'** ?exh.1820
Oil on canvas, 13 × 20 (33 × 50.8)
Exh: ?R.A. 1820 (148)
Prov: . . . ; Seymour Leslie; Sir John Leslie; Stanley A. Kisch; bt. by present owner from Gooden & Fox 1968
Mr and Mrs Paul Mellon
See No.179.

179 **'Harwich light-house'** ?exh.1820
Oil on canvas, 12⅞ × 19¾ (32.7 × 50.2)
Exh: ?R.A. 1820 (148)
Prov: bequeathed to the National Gallery by Isabel Constable 1888; transferred to the Tate Gallery 1897, back to National Gallery 1956 and again to Tate Gallery 1968.
Tate Gallery (1276)

The composition of Constable's pictures of Harwich lighthouse was taken from a drawing now in the V. & A. (R.142) which is inscribed 'Harwich 22d Augst 181[?]': the last digit was read as '5' when the drawing entered the Museum in 1888 but Reynolds suggests that the date was 1817. Constable shows the lower of the two lighthouses at Harwich, the upkeep of which was the responsibility of General Rebow of Wivenhoe Park, one of the artist's patrons (see No.146). Rebow does not, however, seem to have been involved in any way with these pictures. The two lighthouses appear to have been rebuilt in a different form in 1817–18 (see Martin Davies, *National Gallery Catalogues. The British School*, 1959, pp.18–19, n.5).

Three candidates are known for the 'Harwich light-house' which Constable exhibited at the R.A. in 1820: Nos.178–9 and a picture in a private collection (exh. Manchester 1956, No.60). All are approximately the same size and, at least in photographs, extremely similar. The Tate picture and the one in a private collection show two birds in the right foreground, the Mellon work only one, and the figure on the beach below the lighthouse in the other two versions has disappeared, or is disappearing, in the Mellon picture. Comparison of the paintings themselves may (or,

rather, might, since one of the versions is not available on this occasion) reveal more substantial differences.

Just as it is difficult to know which of these was the picture exhibited in 1820, there seems at present little means of identifying any of the existing versions with the two which are mentioned in Constable's correspondence. One of these is referred to by Constable in a letter to Fisher on 18 August 1823: 'I have not a sea peice – or "*Windmill Coast Scene*" "at all". I gave it to Gooch for his kind attention to my children. Half an hour ago I received a letter from Woodburne to purchase it or one of my seapeices – but I am without one – they are much liked' (JCC VI p.128). We know that the 'Windmill Coast Scene' was the Harwich lighthouse subject because Fisher had referred to one of Constable's exhibits at the R.A. in 1820 as 'the sea-coast windmill' (ibid., p.53), alluding to the windmill-like appearance of the lighthouse. The grammar of Constable's letter indicates that the work given to Dr Gooch, the Constables' doctor, was a Harwich picture, but there is also evidence that Gooch owned a 'Yarmouth Jetty', which is usually thought to be what Constable means by a 'sea peice' here (see No.214). Perhaps he meant to say that he had given Gooch a 'sea peice', or perhaps Gooch eventually acquired a version of both compositions. If he did have a 'Harwich lighthouse', there seems no reason why it should not have been the one exhibited in 1820. The other version mentioned in the correspondence, however, cannot have been the exhibition picture. It was painted and given to Constable's Woodbridge patron James Pulham in July 1824 (JCC II pp.362–3) after Pulham had written to congratulate the artist on his success at the Paris Salon, saying that he would now have to 'forego all pretensions of Gratification from your Pencil, – whilst you are rewarded according to your merits'. Pulham was especially attached to Harwich and told Constable 'I do not know that you cd have pleased me more, than by giving me a correct Resemblance of a Scene, that brought to my mind the remembrance of many a youthful Ramble over the very Spot you have so faithfully delineated' (JCC IV p.91). After Pulham's death in 1830 Constable purchased the picture from his widow and in July 1831 offered it to John Martin, the bibliographer, telling him that it had been painted 'some years ago (6 or 7)' (JCC V p.88). There is nothing to show that Martin took up Constable's offer. If Constable retained the work, it may have been No.179, which descended to his daughter Isabel. A 'Harwich Lighthouse' in the Jesse Watts-Russell sale (Christie's 3 July 1875, Lot 26) was said in the catalogue to have been acquired directly from the artist. If so, it could have been the one Constable got back from Mrs Pulham or a version not otherwise mentioned in the correspondence. The version referred to earlier in this entry as now in a private collection was purchased from Murietta in 1892 but its previous history is not known.

180 **Dedham Lock and Mill** d.1820
Oil on canvas, 21⅛ × 30 (53.7 × 76.2)
Inscribed 'John Constable. ARA. pinxt. 1820.'
Prov: ?16 May 1838 (80, 'Dedham Mill and Church', bt. Brown £45 3s.); presented to the V. & A. by John Sheepshanks 1857
Victoria and Albert Museum (R.184)

For a discussion of the various versions of this composition see No.166 above. This painting appears to be based on No.166 but with variations, the most important being the boat introduced at the left and the second grazing horse at the right. If No.166 was the work Constable exhibited at the B.I. in 1819, he may have decided to paint this second version because – as we know – the earlier one had found a purchaser at the exhibition.

181 Stonehenge d.1820
 Pencil, 4½ × 7⅜ (11.5 × 18.7)
 Inscribed '15 July 1820'; verso 'Stone Henge'
 Prov: presented to the V. & A. by Isabel
 Constable 1888
 Victoria and Albert Museum (R.186)

No.181 and another drawing of the site from afar provide the only known record of a visit by Constable to Stonehenge. Some fifteen years later, in less happy circumstances, he chose to paint a large watercolour of the scene (No.331). In that work, which he sent to the Academy of 1836, the subject is fully dramatised, with storm clouds, a double rainbow, a startled hare fleeing in the foreground, and a great wagon passing by on the plain in the distance. Of these props, only the last, the wagon and its team, was noted at the time.

182 Salisbury Cathedral and Close 1820
 Pencil, from a sketchbook, 6¹⁶⁄₁₆ × 4 (17.8 × 10.2),
 squared for transfer
 Prov: . . . ; C. Fairfax Murray; E. W. Forbes
 Private collection

There is every reason for believing that No.182 is either a preparatory study for the small oil sketch of this subject in the V. & A., 'Salisbury Cathedral and the Close', R.196, or that both were studies for a larger, unrecorded and untraced work. The top of the stretcher of R.196 is inscribed 'Close Salisbury Augst. 1820.' Although the perspective angles are rather more acute, in other respects the oil-sketch is almost identical to No.182. See also the note on p.206.

183 Harnham Bridge 1820
 Pencil, 6⅛ × 9¹⁄₁₆ (15.6 × 23)
 Prov: . . . ; bequeathed to British Museum by
 George Salting 1910
 Trustees of the British Museum (1910-2-12-228)

From the measurements of the paper, No.183 appears to have come from a sketchbook used on the artist's visits to Salisbury in 1820 and 1821. According to Beckett (Typescript Catalogue), the view is from the garden of the Rose and Crown Inn at East Harnham, showing the west side of the bridge. The drawing was evidently used as a study for a painting of the subject now in the Wernher collection.

Constable was a keen observer of bird-life and in many of his sketches he is to be seen indicating with deft touches the birds that caught his eye as he glanced up from his work (see Nos.50, 88, 93, 102, 156, 159, 219, 256, 315, 326, etc.). Flights of rooks always seem to have attracted his notice, and the swallow just above the surface of a river is a constant theme in his finished paintings as well as in his sketches.

In this drawing (No.183) a number of otherwise inexplicable pencil-marks in the sky and over the river

178

179

180

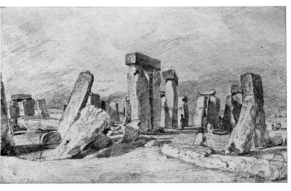
181

182

183

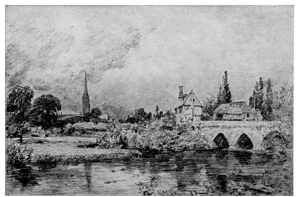

184

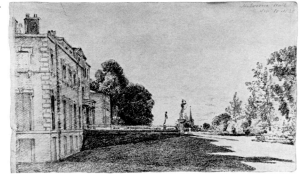

were evidently notes of the birds he saw. The swallows (or martins) skimming over the water are a feature of the Wernher painting. It is these migratory birds he noted in No.183 that enable us to date the drawing, for there would surely have been swallows down by the river during his visit of 1820 when he was there in July and August, but hardly in November, the month he stayed at Salisbury in 1821.

184 Malvern Hall d.1820
Pencil, $4\frac{5}{8} \times 7\frac{1}{4}$ (11.8 × 18.4)
Inscribed 'Malverne Hall Sepr 10. 1820'
Prov: always in the Constable family
Richard Constable

The artist's patronage by Henry Greswolde Lewis of Malvern Hall, Solihull, Warwickshire, has been described in the entry on No.108. Constable paid his second visit to the Hall in September 1820 and afterwards produced several paintings of the place (see No.202), two of which were acquired by Lewis's sister, Magdalene, Dowager Countess of Dysart. It is not known whether Constable's visit was prompted by a commission from the Countess or whether he went in the first instance to carry out further work for Lewis. This drawing, which is not directly related to the Countess's paintings, shows the entrance front of the Hall from the same viewpoint as a drawing Constable made on his first visit in 1809 (No.89). Between the two visits Lewis had carried out various alterations. 'Malverne is going on', he told Constable in 1819, '& is much improved inside & out, & would make a much better figure in Landscape than when you painted it last' (JCC IV p.64). Despite this show of interest, Lewis seems never to have acquired any of Constable's paintings of the Hall.

Other pages from the sketchbook from which No.184 derives are in the V. & A., including a drawing of Knowle Hall, Warwickshire, made on 13 September (R.199). A larger drawing of corbels in Solihull church is also in the V. & A. (R.200).

185 Fir Trees at Hampstead d.1820
Pencil, $9\frac{1}{8} \times 6\frac{1}{4}$ (23.3 × 15.9)
Inscribed 'Wedding day. Hampstead Octr. 2. 1820.'
Prov: presented to the V. & A. by Isabel Constable 1888
Victoria and Albert Museum (R.203)

When Constable returned from Salisbury with his wife and children towards the end of August, he found London in an uproar over the 'Trial' of Queen Caroline. It was as much for the safety of his family as it was for his wife's health, therefore, that he decided to settle them again in a temporary home in Hampstead. 'I am glad to get them out of London for every reason', he told John Fisher in a letter of 1 September (JCC VI p.56), 'things do not look well though I fear nothing – but the Royal Strumpet has a large party – in short she is the rallying point (and a very fit one) for all evil minded persons.' No.185 was drawn on 2 October. The last of the Hampstead views of this year is an oil sketch in the Victoria and Albert Museum (R.208) inscribed '28th Octr. fine Evening Wind Gentle at S.W.'

Graham Reynolds has suggested that No.185 may have been the subject of the anecdote Leslie tells of

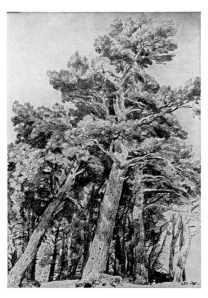

Constable and Blake: 'The amiable but eccentric Blake, looking through one of Constable's sketch books, said of a beautiful drawing of an avenue of fir trees on Hampstead Heath, "Why, this is not drawing, but *inspiration*"; and Constable replied, "I never knew it before; I meant it for drawing".' (Leslie 1843, p.123, 1951 p.280). John Linnell records a meeting between Constable and Blake in the entry in his Journal for 12 September 1818 (see G. E. Bentley, *Blake Records*, 1969, p.258. For a letter from Constable to Linnell of 14 August 1827 on the subject of Blake's death and the care of his widow, see *ibid.*, p.343, also JC:FDC pp.255-6).

186 Hampstead Heath: the House called 'The Salt Box' in the Distance *circa* 1820
Oil on canvas, $15\frac{1}{8} \times 26\frac{5}{16}$ (38.4 × 66.8)
Prov: presented to the National Gallery by Isabel Constable 1887; transferred to the Tate Gallery 1962
Tate Gallery (1236)

Constable's earliest surviving painting of a Hampstead subject appears to be a study of Branch Hill Pond in the V. & A. (R.171), which is inscribed on the stretcher 'End of Octr. 1819'. It may have been one of the 'two pictures, studies on Hampstead Heath' which he showed Farington on 2 November that year. Constable first exhibited paintings of the area at the R.A. in 1821, when he showed a 'Hampstead Heath' and a 'Harrow'. Another 'Hampstead-heath' appeared at the R.A. the following year. Nos.186-8 are possible candidates for these exhibition works but so far no positive identification has been made.

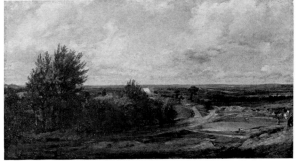

No.186 is, however, certainly one of Constable's first Hampstead pictures. When Isabel Constable presented it to the National Gallery in 1887 she identified it[1] with a painting described by Leslie in the second edition of his *Life* (pp.78-9, 1951 pp.72-3). The passage follows Leslie's account of R.A. exhibition of 1818 and precedes his comments on the year 1819:

> Constable's art was never more perfect, perhaps never so perfect, as at this period of his life. I remember being greatly struck by a small picture, a view from Hampstead Heath, which I first saw at *Ruysdael House*, as Mr Fisher called his residence in Keppel Street. I have before noticed that what are commonly called warm colours are not necessary to produce the impression of warmth in landscape; and this picture affords, to me, the strongest possible proof of the truth of this. The sky is of the blue of an English summer day, with large, but not threatening, clouds of a silvery whiteness. The distance is of a deep blue, and the near trees and grass of the freshest green; for Constable could never consent to parch up the verdure of nature to obtain warmth. These tints are balanced by a very little warm colour on a road and gravel pit in the foreground, a single house in the middle distance, and the scarlet jacket of a labourer... I am writing of this picture, which appears to have been wholly painted in the open air, after an acquaintance with it of five-and-twenty years . . .'.

Leslie says he first saw the painting at Keppel Street, where Constable lived from June 1817 to June 1822, and that he is writing of it after an acquaintance of twenty-five years. As the passage first occurs in the

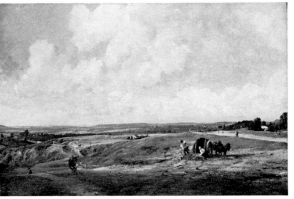

188

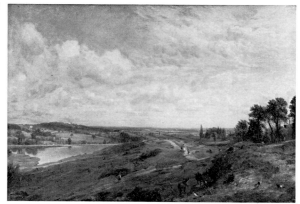

189

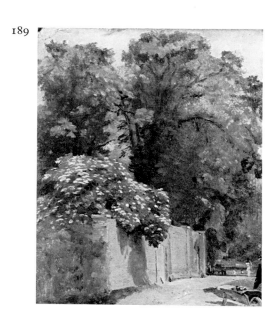

190

1845 edition of the *Life*, Leslie had presumably known the painting since about 1820.

The view is from somewhere near the Branch Hill end of Judges' Walk, looking roughly north-west. The spire of Harrow church can be seen in the extreme distance at the left. The site of 'The Salt Box', seen here in the centre middle-distance, is now occupied by a house called 'The Grange'. At some date, probably after Constable's death, the canvas was relined on a slightly wider stretcher and the painting extended to cover the newly-exposed strips at the left and right. The picture is now framed so as to mask these additions, which include (at the right) a figure based on the labourer standing beside the foremost cart in No.187 below.

187 Hampstead Heath *circa* 1820
Oil on canvas, 21¼ × 30¼ (54 × 76.9)
Prov: . . . ; William Sharp, Handsworth, near Birmingham, sold Christie's 9 July 1881 (72), bt. Agnew, from whom bt. by Walter Holland, who died 1915; sold with the contents of his house by Ellis & Sons, Liverpool, 15–21 November 1932 (1000), bt. in; bt. from Miss A. E. Holland by Leggatt Brothers, who sold it to Vicars Brothers 1933; bt. from them by Sir Bernard Eckstein 1933, sold Sotheby's 8 December 1948 (64), bt. in and acquired from his executors by the Fitzwilliam Museum 1948
Fitzwilliam Museum, Cambridge

The view here seems to be from near Whitestone Pond, looking in more or less the same direction as in No.186. Harrow church is again in the distance at the left and below it can be seen part of the house called 'The Salt Box' which figures more prominently in No.186. Comparable carts, workmen and donkeys occur in the 1819 sketchbook (No.168), while a drawing related to (and by some regarded as a study for) the right-hand side of the composition is in the Fitzwilliam Museum (P.D.208-1948). The painting is almost exactly the same size as No.188, which presents a view in the opposite direction taken from a point a few hundred yards away.

The labourers in many of Constable's paintings of Hampstead Heath are shown excavating sand or gravel. Those in No.187, however, are clearly engaged in dumping material of some kind. Exactly what they are doing is unclear, though it has been suggested that they are filling in ponds or making-good areas of badly drained ground. Local research might eventually produce a more definite explanation.

188 Hampstead Heath *circa* 1820
Oil on canvas, 21 × 30½ (53.3 × 77.6)
Prov: . . . ; John Sheepshanks by *circa* 1850 and presented by him to the V. & A. 1857
Victoria and Albert Museum (R.323)

This can be regarded as a companion to No.187, which is very close in size and depicts an almost complementary view in the opposite direction. The viewpoint in this case is from what is now called the Vale of Health Pond, looking east and north-east. Highgate Hill appears in the distance towards the left; the building below it and further to the left seems to be Kenwood House. The Vale of Health Pond was dammed in 1777 and, like the other Hampstead ponds, contributed towards London's water supply.

189 The Elder Tree ?*circa* 1820–5
Oil on board, 11¼ × 8¾ (28.6 × 22.2)
Prov: bequeathed by Isabel Constable to her
niece Ella (Mrs Mackinnon) 1888; . . . ; J. Staats
Forbes, from whose executors bt. by the Princess
of Wales for presentation to the Municipal
Gallery of Modern Art, Dublin, 1905
Municipal Gallery of Modern Art, Dublin

It has not been discovered exactly where this study was
painted but Hampstead seems the most likely place.
Elder had a special significance for Constable. He told
Leslie on 21 June 1835, the day before his second
lecture at Hampstead: 'I never saw the elder bushes so
filled with blossom – they are quite beautifull, & some
of their blossoms forshortened as they curve over the
round head of the tree itself are quite elegant. It is a
favourite of mine & always was – but 'tis melancholy'
(JCC III p.126). In his first lecture at Hampstead in
1833 Constable had spoken of the 'pale funereal
flowers' of the elder in Titian's 'Peter Martyr' (Leslie
1843 p.132, 1951 p.294; see also JC:FDC p.15).

190 Sketch for 'The Hay-Wain' *circa* 1820–1
Oil on canvas, 54 × 74 (137 × 188)
Prov: ?16 May 1838 (part of 38, 'Two – Sketches
of Landscapes, *the pictures now in France*'), bt.
in by Purton for the Constable family; in Leslie's
care for some time; acquired by D. T. White,
probably before 1853, and sold by him to Henry
Vaughan; lent by Vaughan to the V. & A. from at
least 1862 until his death in 1900, when
bequeathed by him to the Museum
Victoria and Albert Museum (R.209)

This is a full-size sketch for No.192, which was exhibit-
ed at the R.A. in 1821. The materials used for the com-
position are discussed in the entry on the final painting.

There was no precedent for the full-size sketches
which Constable made for some of his larger land-
scapes. Time-consuming and expensive in terms of
paint and canvas, they must have been devised to meet
a very real need in his working methods. Their exist-
ence, probably unsuspected even by his friends until
some were included in the 1838 sale, points to the
extreme difficulty Constable had in reconciling to
traditional patterns a comprehensive but confused mass
of personal observation. As has been suggested else-
where², his attempt to draw things together on these
large trial canvases has similarities with Alexander
Cozens' method for producing new combinations of old
images by semi-random doodling. Constable may have
made a full-size sketch for 'The White Horse', shown in
1819, and he certainly adopted the procedure for 'The
Hay Wain', 'View on the Stour near Dedham' and later
compositions. In some cases, however, he seems to have
felt more confident that his ideas would work on a large
scale and that this stage could be dispensed with. In
some of the sketches a good deal appears to have hap-
pened – different ideas tried out, elements in the com-
position pushed around, and so on. In others the
realisation of the final design seems to have come more
easily. The 'Hay-Wain' sketch is one of these, and be-
tween it and the final picture no substantial changes
were made. The figure on horseback in the foreground
of the sketch was originally introduced in the final work
but then painted out.

191 Study of a Boat
Black and white chalk on blue paper, 3⁹⁄₁₆ × 4¹⁵⁄₁₆
(9 × 12.6)
Prov: said to be from the collection of Captain
Constable; . . . ; bt. by Sir Robert Witt from
Beaux Arts; bequeathed by him to Courtauld
Institute 1952
Courtauld Institute of Art (*Witt Collection*)

Constable used this study for the boat at the right of
'The Hay Wain' (No.192). The same boat reappears
in 'Salisbury Cathedral from the Meadows' (No.282).
See No.106 for the artist's use of tinted paper.

1821

January: Fisher buys 'Stratford Mill' to give to his
lawyer, Tinney. *22nd:* reports progress on his Academy
picture ('The Hay Wain') to Farington; tells Abram
that it is going well. *14 February:* Fisher asks 'And how
thrives the "hay wain"?' *25th:* Abram sends a drawing
Johnny Dunthorne has done of a harvest wagon.
29 March: birth of third child, Charles Golding. Early
April: at Bergholt for short holiday. Writes to Maria of
the beauty of the countryside, and wishes they had a
small house there: 'I think there may be one to be had –
here is so much entertainment for the children.' By
29th: in London again. *May:* 'The Hay Wain' well
reviewed; it is seen and written about by French
visitors. *June:* accompanies Fisher on his Visitation of
Berkshire as Archdeacon; draws at Newbury, Reading,
Abingdon, Oxford. Takes a house at Hampstead for the
season: No.2 Lower Terrace. *July:* Abram tells him of a
£200 commission for an altarpiece at Manningtree,
Essex; applies for this and is given the job. *20 Septem-
ber:* planning to visit Suffolk and probably Manning-
tree. *23 October:* tells Fisher he has made more 'par-
ticular and general study' than he had ever done in one
summer and a 'good deal of skying'. Talks of his next
6-foot canvas. *2 November:* last dated Hampstead view
of the year. *9th:* staying with Fisher in Salisbury. They
visit Winchester, and Longford Castle for the Claudes.
19th: still at Salisbury, but probably returns soon after.
20 December: death of his old friend Joseph Farington.

Exhibits. R.A.: (89) 'Hampstead Heath' (see Nos.186–
8); (132) 'A shower'; (135) 'Harrow'; (339) 'Land-
scape: Noon' (No.192).

192 'Landscape: Noon' (The Hay-Wain)
d. & exh.1821
Oil on canvas, 51¼ × 73 (130.5 × 185.5)
Inscribed 'John Constable pinxͭ London 1821'
Exh: R.A. 1821 (339); B.I. 1822 (197,
'Landscape; Noon', size with frame 68 × 91
inches); Salon, Paris 1824 (25 August 1824–
January 1825, 358, 'Une charrette à foin
traversant un gué au pied d'une ferme; paysage')
Prov: bt. from Constable by the Paris dealer John
Arrowsmith 1824 and sold by him 1825; Anon.,
sold Henry, Paris, 31 March–1 April 1828¹, bt.
Jean-François Boursault, with whose collection
bt. *circa* 1838 by Henry Artaria for Edmund
Higginson, sold Christie's 4 June 1846 (77), bt.
Rought; D. T. White, sold by 1853 to George

Young, sold Christie's 19 May 1866 (25), bt.
Cox for Henry Vaughan, by whom presented to
the National Gallery 1886
National Gallery (1207)
(colour plate facing p.113)

The third of Constable's large river scenes and probably
the most famous of all his paintings, 'The Hay Wain'
appears to have been conceived and executed in a re-
markably short time. On 21 November 1820 Farington
noted in his Diary: 'Constable brought a new begun
picture, "A view on the Thames on the day of opening
Waterloo Bridge". At his request for my opinion I
recommended to him to proceed on & complete for the
Exhibition a subject more corresponding with his suc-
cesful picture exhibited last May. –'. The latter was
'Stratford Mill' (No.177). Constable followed Faring-
ton's advice and the Waterloo Bridge composition was
put aside, the final picture not appearing at the R.A.
until 1832. The new composition was 'The Hay-Wain',
the finished version of which was ready for exhibition
in under five months.

Constable had previously painted a similar subject,
'The Mill Stream' (No.129), which also shows Willy
Lott's house but from the parapet of Flatford Mill
rather than, as in No.192, from the left bank of the mill
stream. Although slight, the shift towards the left pre-
sented quite a different view. The tree-framed channel
down to the main course of the Stour was obscured and
no longer provided a central focus: in No.192 this was
to be supplied by the hay-wain. For the left-hand side
of the new composition Constable may have turned to
several oil studies made around 1810–16 which show
Willy Lott's house from more or less the same angle.
Two of these are in the V. & A. One, a double-sided
study (R.110–110a), shows on one side Willy Lott's
house with in the foreground a black and white dog
which is not dissimilar to the dog in the final painting,
and on the other side a view of the house from slightly
further to the right with a horse similar to the one which
Constable tried out in the full-size sketch (No.190). The
other related study in the V. & A. (R.329a) includes no
animals. A study of Willy Lott's house dated 1816
(No.144) was probably also consulted: unlike the
V. & A. studies, this includes the taller chimney seen
at the left of the finished picture.

The first attempt to develop these earlier studies by
extending the composition to the right may have been
the tiny oil sketch formerly belonging to Mrs L. W.
Vicars and now in the Mellon Collection (repr. Basil
Taylor, *Constable*, 1973, Pl.70). This also includes a
rudimentary cart. In the full-size sketch (No.190) the
essential features of the final composition are estab-
lished. The rowing-boat introduced at the right of this
large sketch was taken from a drawing now in the Witt
Collection (No.191). For the hay-wain itself Constable
enlisted Johnny Dunthorne's help. On 25 February
1821 Constable's brother Abram wrote from Suffolk to
say that he was about to send 'John Dunthorne's out-
lines of a scrave or harvest waggon. I hope it will
answer the desired end; he had a very cold job but the
old Gentleman urged him forward saying he was sure
you must want it as the time drew near fast. I hope you
will have your picture ready but from what I saw I have
faint hopes of it, there appear'd everything to do'
(JCC I p.193: 'the old Gentleman' is not identified – was

he Dunthorne Senior or perhaps even Willy Lott him-
self?). Pentimenti in the final painting show that Con-
stable first introduced the figure on horseback which
appears in the foreground of the full-size sketch and
then substituted for it a barrel, which was in turn
painted out (but is now clearly visible again).

The picture was shown at the Academy as 'Land-
scape: Noon' but was already known to the artist and
his friends as 'The Hay-Wain' – Fisher referred to it as
such in a letter of 14 February 1821 (JCC VI p.62).
Writing to Fisher on 1 April, not long before the picture
was moved from the Keppel Street painting room to
the Academy, Constable compared it to 'Stratford
Mill', then owned by J. P. Tinney and the picture to
which Farington had originally advised him to paint a
sequel: 'The present picture is not so grand as Tinny's
owing perhaps to the masses not being so impressive –
the power of the Chiaro Oscuro is lessened – but it has
rather a more novel look than I expected. I have yet
much to do to it – and I calculate for 3 or 4 days there'
(JCC VI p.65).

'The Hay-Wain' did not find a buyer at the Academy
and Constable had it back at Keppel Street; in August
he told Fisher that he would 'do more to it' (JCC VI
p.71). Interest in the picture had, however, been
aroused in an unexpected quarter. Charles Nodier saw
the work at the R.A. and published an enthusiastic
account of it in his *Promenade de Dieppe aux Montagnes
d'Écosse* later in 1821[2]. Gericault also saw the picture at
the Academy and, as Delacroix later recalled[3], was
'quite stunned' by it. In April 1823 Constable received
an offer of £70 for the picture, then at the British Insti-
tution, from the Paris dealer Arrowsmith who, said
Constable, was planning 'an exhibition in Paris – to
show them the nature of the English art' (JCC VI
pp.87–8), but Constable was reluctant to sell the work
for a price 'less by over one half than I asked' (*ibid.*,
p.91), so the matter was dropped for the time being. In
July 1823 both Fisher and Sir William Curtis expressed
great interest in the painting (*ibid.*, pp.123–4) and
Constable told Fisher that he would prefer him to have
it because 'It was born a companion to your picture
['The White Horse'] in sentiment'. Arrowsmith re-
newed his overtures in January 1824 and Fisher was
forced to give up his option on the work: 'Let your
⟨. . .⟩ Hay Cart go to Paris by all means. I am too much
pulled down by agricultural distress to hope to possess
it. I would (I *think*) let it go at less than its price for the
sake of the eclat it may give you. The stupid English
public, which has no judgement of its own, will begin
to think that there is something in you if the French
make your works national property' (*ibid.*, p.151).
Arrowsmith accordingly bought the painting, together
with 'View on the Stour' (see No.201) and a 'Yarmouth
Jetty', paying £250 for the three. None of these was,
however, bought from him by the French nation (per-
haps because he insisted on selling the two large works
together), though the sensation they created when
exhibited at the Salon in 1824 was sufficiently remark-
able for Charles X to award the artist a gold medal. The
controversy provoked by his paintings at the Salon
prompted one of Constable's most revealing statements
about his art. He found the French critics 'very amusing
and acute – but very shallow and feeble. Thus one –
after saying, "it is but justice to admire the *truth* – the

color – and *general vivacity* & richness" – yet they want the objects more formed & defined, &c, and say that they are like the rich preludes in musick, and the full harmonious warblings of the Aeolian lyre, which *mean* nothing, and they call them orations – and harangues – and highflown conversations affecting a careless ease – &c &c &c – Is not some of this *blame* the highest *praise* – what is poetry ? – What is Coleridges Ancient Mariner (the very best modern poem) but something like this ?' (*ibid.*, p.186).

193 A Lock near Newbury d.1821

Pencil, 6¾ × 10 (17.2 × 25.4)
Inscribed 'A Lock near Newbury June 5 1821'
Prov: 11 July 1887 (9), bt. Noseda; . . . ;
J. P. Heseltine; Francis L. Bery; P. M. Turner
Private collection

In June 1821, Constable accompanied John Fisher on one of his Visitations of Berkshire in his official capacity as Archdeacon. The tour, of six days' duration, took them to Newbury, Reading, Abingdon, Woodstock and Oxford. While Fisher went on his rounds Constable appears to have been quite content with the subjects he found to sketch, almost all scenes on the banks of the Kennet, its accompanying canal, or of the Thames – scenes reminiscent of his native valley with its own navigable waters. About half of the drawings he is known to have made on this jaunt, are in the V. & A.

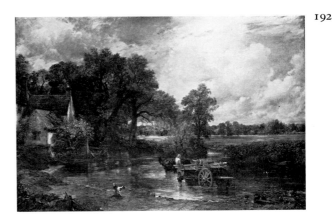

194 Study of Hampstead Heath, looking West
d.1821

Oil on paper, laid on canvas, 10 × 11¾
(25.4 × 29.8)
Inscribed on stretcher 'Hampstead July 14 1821
6 to 7 P.M N.W. breeze strong'
Prov: presented by Isabel Constable 1888
Royal Academy of Arts, London

Nos.194–6 are a selection from the large number of oil sketches Constable made in the early 1820s of the distant views from Hampstead Heath. These three have been chosen because they show him studying similar views on different days and under different conditions. The spire of Harrow church appears in each, in this case in the extreme distance at the left.

195 Sunset Study of Hampstead Heath, looking towards Harrow d.1821

Oil on paper, laid down, 9½ × 11½ (24.1 × 29.2)
Inscribed on verso 'Sep^r 12. 1821. Sun seting over Harrow This appearance of the Evening was ⟨aft⟩ just after a very heavy rain more rain in the night and very light wind which continued all the day following – (the 13th) while making this sketch observed the Moon rising very beautifully ⟨in the⟩ / due / East over the heavy clouds from which the late showers had fallen.' and 'Wind Gentle rather ⟨. . .⟩ increasing from the North west. rather'
Prov: 28 May 1891 (E. Colquhoun, 141: corresponds with No.262 in the 1889 Grosvenor Gallery exhibition, where the same date and more or less the same size are given), bt. in; . . . ;
?D. W. Freshfield 1903–4; . . . ; Sir Gervase Beckett by 1937; acquired by present owner 1972
Private collection
(colour plate facing p.128)

191

192

193

194

A view from higher up and further south than in No.194. Here the spire of Harrow church is dramatically silhouetted against the sunset in the centre distance. The water in the right foreground is probably Branch Hill Pond. A similar view painted around 5 p.m. on a day in August 1821 is in the City Art Gallery, Manchester, while another, undated, belongs to the Royal Academy. A sketch made around noon on the same day as No.195, but of a different subject, is in the V. & A. (R.222). The inscription on No.195, longer than most, points up Constable's understanding of weather as a continuous phenomenon – he is interested not only in the sunset but in the rain which preceded it, giving the sunset its particular character, and in what happened during the night and following day.

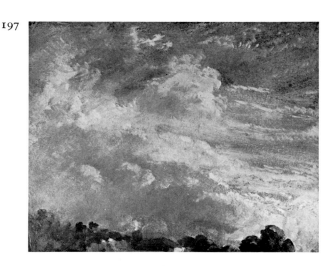

196 Study of Hampstead Heath, looking towards Harrow d.1821
Oil on paper, laid on board, $9\frac{1}{4} \times 11\frac{1}{4}$ (23.5 × 28.6)
Inscribed on verso '4 afternoon 27 Septr 1821 wood bank of Vale very [?warm] & bright after rain'
Prov: presented to the R.A. by Isabel Constable 1888
Royal Academy of Arts, London

Another view westwards from Hampstead Heath, with Harrow church again visible on the horizon. The sky study shown as No.197 was probably made on the same day.

197 Cloud Study with an horizon of trees 1821
Oil on paper laid on board, $9\frac{3}{4} \times 11\frac{1}{2}$ (24.8 × 29.2)
Inscribed on verso 'Noon 27 sepr very bright after rain wind West'
Prov: presented to the R.A. by Isabel Constable 1888
Royal Academy of Arts, London

In the years 1821–2 Constable made an intensive study of skies at Hampstead, producing a large number of oil sketches showing clouds either alone or with a fringe of trees, buildings, etc., at the bottom. The extent and purpose of this activity is more fully commented on in the entry on No.207 below. For reasons explained in the same place, the present example is more likely to date from 1821 than 1822. If so, it was made on the same day as No.196 above, the inscription on which indicates a state of weather similar to that recorded on the back of this study. Captain Constable's sale on 23 June 1890 included another cloud study made on 27 September 1821 (lot 88).

198 Trees, sky and a red house ?1821
Pencil and watercolour, $6\frac{3}{4} \times 10$ (17.2 × 25.4)
Prov: presented to the V. & A. by Isabel Constable 1888
Victoria and Albert Museum (R.242)

No.198 appears to have come from one of the sketchbooks Constable used in 1821 and 1823. In the former year he made a number of oil-sketches at Hampstead in which parts of buildings and the tops of trees and bushes are seen against the sky. One of these, an undated study at the V. & A. (R.232), is a view of a garden with two poplars and the upper part of a house, a line of washing and a stormy sky. John Baskett has suggested that this sketch was painted from one of the back

windows of No.2 Lower Terrace, the house at Hampstead occupied by the Constables during the summer seasons of 1821 and 1822 (John Baskett, *Constable Oil Sketches*, 1966, p.60). If this was the case, then in view of the similarity of No.198 to R.232, it is possible that the present drawing was also done at the back of No.2.

Constable told Fisher in a letter of 4 August 1821 that he was spending as much of his time as possible with his family at Hampstead; '. . . at this little place', he wrote, 'I have [sundry] small works going on – for which purpose I have cleared a small shed in the garden, which held sand, coal, mops & brooms & that is literally a coal hole, and have made it a workshop, & a place of refuge – when I am down from the house. I have done a good deal of work here' (JCC VI p.71).

199 A group of trees on broken ground 1821 or
 1823
Pencil and wash, $6\frac{3}{4} \times 10\frac{1}{4}$ (17.2 × 26)
Prov: presented to the V. & A. by Isabel
Constable 1888
Victoria and Albert Museum (R.241)

The measurements of No.199 indicate that it came from one of the sketchbooks Constable is known to have used in 1821 and 1823. It is possible that he made the drawing during his short tour of Berkshire with John Fisher in June 1821, but he could have come upon a subject such as this at Hampstead or in any of the several other areas where he is known to have worked at this time.

**200 The Revd. Edmund Benson wearing a
 medieval chasuble, Salisbury** d.1821
Pencil and watercolour, $9\frac{3}{8} \times 6\frac{3}{8}$ (23.8 × 16.2)
Inscribed, possibly by Isabel Constable, 'Study
of a Chasuble Salisbury – The other leaf of
sketch-book finishing head is lost'. The top of the
head and the following inscription in the artist's
hand are on the back of another drawing in the
V. & A. (R.238): 'very ancient Cope in the
Cathedral – Salisbury Novr. 1821 portrait of the
Revd. E. Benson'
Prov: presented to the V. & A. by Isabel
Constable 1888
Victoria and Albert Museum (R.239)

The Revd. Benson was priest-vicar of Salisbury Cathedral. He and his family are mentioned a number of times in the Correspondence. In a letter to Maria of 6 November 1812, Constable writes of the Bensons as 'a very able family who are fond of drawing – and very musical' (JCC II, p.94); later he refers to Benson as 'that really good man'. He mentions him again to Maria when writing from Salisbury on 15 November 1821, i.e. during the visit when this drawing was made: 'I have a great name in this city – old Benson quite enthusiastic' (*ibid.*, p.273). Presumably in order to show off the beauty of the embroidery, Benson is seen here wearing the vestment back to front.

201 Sketch for 'View on the Stour, near Dedham'
circa 1821–2
Oil on canvas, 51 × 73 (129.5 × 185.4)
Prov: ?16 May 1838 (part of 36, 'Sketch for the
picture, View on the Stour'), bt. Morris; . . . ;
?Thomas Woolner, sold Christie's 12 June 1875
(134); . . . ; J. M. Dunlop, sold Christie's 5 May
1883 (61), bt. Martin, on behalf of Thomas
Holloway, for Royal Holloway College, which
opened 1886
Royal Holloway College, University of London

'View on the Stour, near Dedham', for which this
is the full-size sketch, was the fourth of Constable's
great river pictures, following 'The White Horse',
'Stratford Mill' and 'The Hay Wain'. Exhibited at the
R.A. in 1822 and again at the B.I. in 1823, the picture
was purchased by the Paris dealer Arrowsmith in 1824
and exhibited by him at the Paris Salon that year, where,
together with 'The Hay Wain', it earned Constable a
gold medal from the King of France. The picture seems
to have returned to England in the 1830s and is now in
the Huntington Art Gallery, San Marino, California.

For this composition Constable chose a view from
beside the boat-building yard at Flatford, looking to-
wards Flatford bridge with Dedham church in the
distance. Three drawings of this view are in the 1814
sketchbook (No.126, pp.27, 52, 59) and these were no
doubt the basis of the 1822 composition. In two of
them, pp.27 and 59, the trees at the right hand side of
the 1817 'Flatford Mill' (No.151) can be seen on the far
bank (but seen, of course, from the opposite side to the
1817 painting). The other drawing, p.52 of the sketch-
book, does not extend as far as the trees on the far bank
but includes instead more of the bridge and the cottage.
The sluice at the entrance to the boatyard appears at
the bottom of all three sketches and on p.59 part of a
boat in the yard is also included. Constable combined
the views given on pp.52 and 59 when he came to paint
No.201 but he invented a new tree mass on the left and
also dramatically heightened the tower of Dedham
church. Further changes were made during the paint-
ing of this sketch. Traces of a painted-out sail at the
left of the barge and of a figure at the stern can still be
seen. The position of the barge-pole was altered and the
cows on the bridge were moved to the right and an
accompanying figure painted out.

Still further changes were made in the final painting,
as Constable explained to Fisher in April 1822: 'The
composition is almost totally changed from what you saw.
I have taken away the sail, and added another barge in
the middle of the picture, with a principal figure,
altered the group of trees, and made the bridge entire.
The picture has now a rich centre, and the right hand
side becomes only an accessory. I have endeavoured to
paint with more delicacy' (Leslie 1843 p.30, 1951
pp.89–90; see JCC VI p.89 for the dating of this letter).
The 'principal figure' on the new barge was probably
taken from the tiny study on p.11 of the 1813 sketch-
book (No.119). Other differences between No.201 and
the final painting include the replacement of the cow on
the bridge by a female figure, the omission of the two
children in the right foreground, the reduction of the
sail on the distant boat, which previously dwarfed the
tower of Dedham church, the introduction of a towing-
horse on the far bank (similar to the one which gives its

name to 'The White Horse'), the omission of the rowing
boat at the left and the introduction of a different row-
ing boat at the right. With so many last-minute altera-
tions to the composition, it is not surprising that Con-
stable, having just sent the picture to the R.A., told
Fisher on 13 April 1822: 'I never worked so hard before
& now time was so short for me – it wanted much – but
still I hope the work in it is better than any I have yet
done –' (JCC VI p.87).

Because the finished picture was still in France,
No.201 was the version of the composition which, with
minor variations, Lucas engraved for *English Land-
scape.*

1822

January: asked by Fisher if he will accompany him to
Paris in June. He is now a candidate at the *February*
elections of Academicians. *16th:* Fisher consoles him in
his defeat this year. With Maria, looks over Farington's
house, 35 Charlotte Street with a view to leasing it.
13 April: tells Fisher that he has sent his new large
picture to the Academy, the 'View on the Stour'; also
that he has had some 'nibbles' at 'The Hay Wain'. From
Abram hears of agrarian distress and unrest in Suffolk:
'never a night without fires'; also of the rector and
squire having 'forsaken the village'. Late *April:*
negotiating for Farington's house. Commissioned by
Tinney, Salisbury lawyer, to paint a companion to
'Stratford Mill'. *11 May:* at Bergholt, probably in con-
nection with the Manningtree altarpiece. No.2, Lower
Terrace, Hampstead, again taken for the season; when
family settled there, he prepares the Charlotte Street
house for occupation. By *16 June,* has moved into 35
Charlotte Street. *July* to *October:* numerous oil-studies
painted at Hampstead. *23 August:* fourth child, Isabel,
born. He is unable to pay a visit to Salisbury as planned,
owing to pressure of work; has several commissions on
his hands. *7 October:* tells Fisher he has 'made about 50
carefull studies of skies tolerably large'. *15th:* moves
his family into Charlotte Street house; now has a large
'painting room'. *31st:* has two 'six-footers' in hand. By
6 December, the Manningtree altarpiece dispatched. Ill-
ness among the children over Christmas.

Exhibits. B.I.: (197) 'Landscape; Noon', frame
68 × 91 inches. (No.192). R.A.: (111) 'Hampstead-
heath' (see Nos.186–8); (183) 'View on the Stour, near
Dedham' (Huntington Art Gallery, San Marino, Cali-
fornia); (219) 'Malvern Hall, Warwickshire' (see
No.202); (295) 'View from the Terrace, Hampstead'[1];
(314) 'A study of trees from Nature' (see No.203).

202 'Malvern Hall, Warwickshire' ?exh.1822
Oil on canvas, 21 5/16 × 30 3/4 (54.2 × 78.1)
Exh: ?R.A. 1822 (219)
Prov: Magdalene, Dowager Countess of Dysart,
who died 1823; her brother, Henry Greswolde
Lewis, who died 1829; Edmund Meysey Wigley
Greswolde, who died 1833; by descent to his

201

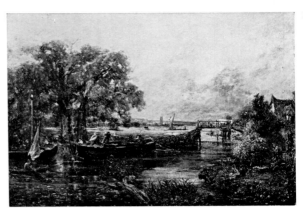

great-niece, Mrs Florence Horatio Nelson Suckling, sold Sotheby's 23 July 1924 (112), bt. Knoedler, from whom bt. by Robert Sterling Clark 1926
The Sterling and Francine Clark Art Institute, Williamstown, Massachusetts

Constable's visit in 1809 to Henry Greswolde Lewis's seat, Malvern Hall, Warwickshire, has been mentioned in the entry on No.88, the painting of the Hall which he produced on, or shortly following, that visit. He returned in 1820 (see No.184), perhaps because Lewis's sister, Magdalene, Dowager Countess of Dysart, had commissioned paintings of the Hall. Before her death in 1823 the Countess certainly owned two such paintings, No.202 and a view of the Hall from the lake (the view earlier depicted in No.88). The latter, measuring 24 × 30 inches and inscribed 'John Constable A.R.A. 1821', was sold from the collection of Marsden J. Perry in 1948 (Parke-Bernet, 7 May) but its present whereabouts has not been discovered. Both pictures descended from the Countess to Mrs Suckling (see provenance above), the catalogue of whose sale said that both bore labels declaring 'This Picture belongs to Magdalena, Countess of Dysart, 1821.', and that No.202 carried a further label: 'Malvern Hall, John Constable'. A document[2], probably drawn up by Knoedler's, who purchased both pictures at the Suckling sale, transcribes the labels differently: each is said to read 'Malverne Hall, Warwickshire. The Seat of R. [sic] G. Lewis, Esq[r] 1821. This picture belongs to Magdalene Countess of Dysart.'; the additional inscription on No.202 is given as 'No.5. Malverne Hall Warwickshire. John Constable.' Unfortunately, the label and additional inscription (which seems to have been on the stretcher) formerly on the back of No.202 have not been preserved, so the wording cannot be verified. If the second transcription was correct, a case might be made out for No.202 being the 'Malvern Hall, Warwickshire' which Constable exhibited at the R.A. in 1822. He showed five works that year and the '5' in the inscription might refer to his own listing of the items he submitted. The date on the front of the painting later in the collection of M. J. Perry and the dates reported to have been given in the inscriptions on the backs of the pictures suggest that both were painted in 1821 (whether or not they were also the Countess's property that year), so both can be considered as candidates for the 1822 exhibit. But other candidates also exist. There are two other versions of No.202, both approximately the same size as it. One, acquired by the Musée de Tesse, Le Mans, in 1863, is signed and dated 1821, like the ex-Perry picture, while the other, which lacks the peacocks, was sold from the Chéramy collection in 1908 and is untraced today. We do not know whether the exhibited work depicted Malvern Hall from the lake (in which case it would probably have been the ex-Perry picture) or from the front. If the latter, it could have been one of three recorded versions. No.202 is therefore presented here as a candidate for the work shown in 1822 rather than as a positively identified exhibition piece.

202

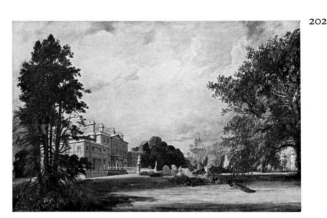

203

204

205

206

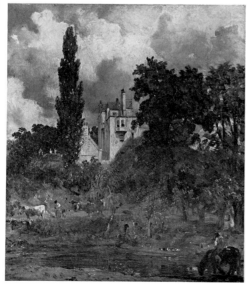

203 **'A study of trees from Nature' (Trees at
Hampstead)** ?exh.1822
Oil on canvas, 36 × 28½ (91.4 × 72.4)
Exh: ?R.A. 1822 (314)
Prov: bequeathed to the V. & A. by Isabel
Constable 1888
Victoria and Albert Museum (R.223)

Hampstead church appears in the distance at the ex-
treme left. In her will Isabel Constable said that the
picture was also known as 'the path to Church'.

No.203 has been identified with a work described by
Constable in his letter to Fisher from Hampstead on
20 September 1821: 'I have done some studies, carried
further than I have yet done any, particularly a natural
(but highly elegant) group of trees, ashes, elms & oak
&c – which will be of quite as much service as if I had
bought the feild and hedge row, which contains them,
and perhaps one time or another will fetch as much for
my children. It is rather larger than a kit-cat, & upright'
(JCC VI p.73). As Reynolds points out, the only objec-
tion to No.203 being the study in question is its size,
which is barely larger than kit-cat (36 × 28 inches).
However, if it was the same picture it might well also
have been the painting called 'A study of trees from
Nature' which appeared at the R.A. the following year,
always supposing that Constable had either changed
his mind about wanting to keep the study for his own
reference or was not offering it for sale at the R.A.

204 **The Spaniards, Hampstead** d.1822
Oil on paper, laid on canvas, 12¼ × 20½
(31.1 × 52.1)
Inscribed on verso (presumably a transcription of
original inscription on back of paper):
'Hampstead. Monday 2 July 1822 looking
NW 3PM painted in a thunder squall wind
N West'
Prov: 11 July 1887 (82), bt. Agnew; ?T. Wright;
bt. from Agnew by John G. Johnson 1894
John G. Johnson Collection, Philadelphia

A view from East Heath at Hampstead looking towards
the inn called 'The Spaniards'.

205 **Distant View of the Admiral's House,
Hampstead** d.1822
Oil on paper, laid on canvas, 11½ × 9½ (29.2 × 24.1)
Inscribed on verso (presumably transcribed from
original inscription on back of paper): '29–July
1822. looking East 10 in the morning – Silvery
Clouds'
Prov: presented to the R.A. by Isabel Constable
1888
Royal Academy of Arts, London

See No.206.

206 **The Admiral's House, Hampstead**
circa 1820–5
Oil on canvas, laid on board, 14 × 11⅞ (35.5 × 30)
Prov: presented to the National Gallery by
Isabel Constable 1888; transferred to Tate
Gallery 1962
Tate Gallery (1246)

The principal building in No.206, and seen from a dis-
tance in No.205, is known as 'The Admiral's House'
today but was formerly called 'The Grove'. It was built

for Admiral Matthew Barton (?1715–95), who is said to have arranged its roof like the quarter-deck of a man-of-war, complete with cannons and ensign. Constable exhibited a painting entitled 'A romantic house at Hampstead' at the R.A. in 1832. It may have been of this subject but the usual supposition that it was No.206 itself is unconvincing – this looks like a work of Constable's early years at Hampstead. Another version of No.206 is in the collection of Sir Colin Anderson. At least two other paintings of the house by Constable are known: one in the Nationalgalerie, Berlin, the other in the V. & A. (R.402).

207 Cloud Study d.1822

Oil on paper, 12 × 19¼ (30.5 × 49)

Inscribed on verso '5 Sep.ʳ 1822 10 o clock Morng. looking South-East. very brisk wind at West. very bright & fresh Grey Clouds running very fast over a yellow bed. about half way in the Sky very appropriate for the Coast at Osmington.'

Prov: . . . ; C. R. Leslie by 1843 (see below) and possibly one of the 'Seventeen Studies of Skies' in his sale, Foster's 25 April 1860 (86); . . . ; Sir Michael Sadler; bt. from Spink's for Felton Bequest, National Gallery of Victoria

National Gallery of Victoria, Melbourne

Constable talked of the intensive study of skies which he began at Hampstead in 1821 (and continued there in 1822) in a now famous letter to Fisher on 23 October that year. The *apologia* which it includes for the role of skies in landscape painting was provoked by remarks, relayed by Fisher, made by an unnamed 'grand critical party' on the sky in 'Stratford Mill' (No.177): 'I have not been Idle and have made more particular and general study than I have ever done in one summer . . . I have done a good deal of skying – I am determined to conquer all difficulties and that most arduous one among the rest . . . That landscape painter who does not make his skies a very material part of his composition – neglects to avail himself of one of his greatest aids. Sir Joshua Reynolds speaking of the "Landscape" of Titian & Salvator & Claude – says *"Even their skies seem to sympathise with the Subject"*. I have often been advised to consider my *Sky* – as a *"White Sheet drawn behind the Objects"*. Certainly if the Sky is *obtrusive* – (as mine are) it is bad, but if they are *evaded* (as mine are not) it is worse, they must and always shall with me make an effectual part of the composition. It will be difficult to name a class of Landscape, in which the sky is not the *"key note"*, the *standard of "Scale"*, and the chief *"Organ of sentiment"*. You may conceive then what a *"white sheet"* woud do for me, impressed as I am with these notions, and they cannot be Erroneous. The sky is the "source of light" in nature – and governs every thing. Even our common observations on the weather of every day, are suggested by them but it does not occur to us. Their difficulty in painting both as to composition and execution is very great, because with all their brilliancy and consequence, they ought not to come forward or be hardly thought about in a picture – any more than extreme distances are' (JCC VI pp.76–7).

The only parallel to be found for the campaign of 'skying' which Constable entered on in 1821 lies in the work of Turner, though in his case the medium employed was watercolour rather than oil. Turner apart, no other artist went to such extraordinary lengths as Constable to pin down this most transient, and therefore least tractable, of natural phenomena. There were few models for him to turn to. Alexander Cozens' engravings of skies (see No.210) provided a series of *schemata* which he refined beyond recognition. Otherwise we know little of his approach to the task. The idea that his sky studies of 1821–2 were inspired by the publication in 1820 of Luke Howard's *The Climate of London* is now, and not before time, being generally discredited. There is simply no evidence that he knew Howard's book, and the only evidence of interest in the classification of clouds which Howard introduced as early as 1803 – a dubious inscription on a single sky study, No.208 below, which may read 'cirrus' – is hardly impressive. Constable certainly did own, at some time or other, a copy of the 1815 edition of Thomas Forster's *Researches about Atmospheric Phaenomena*, in which Howard's nomenclature is repeated, but his annotations to this are often highly critical (see JC:FDC pp.44–5) and in 1836 he summed up the work as 'the best book' but 'far from right' (JCC V p.36). The crude illustrations to Forster's volume are perhaps the clearest indication of how little Constable the painter could have learned from contemporary meteorology.

Celebrated as his sky studies have long been, it seems never to have been asked what use Constable actually made of them. The inscription on No.207 – 'Very appropriate for the coast at Osmington' – is the only pointer to a direct connection with a finished work of art, but, even so, no version of an 'Osmington Coast' is known in which this sky is incorporated. In fact, no sky study by him appears ever to have been transferred to a more complete painting. His 'skying' was, it seems, too specific to be usable in a direct fashion. This is not to say that he may not have referred to the studies in a more general way for ideas of suitable sky types for his pictures. The unrivalled body of reference they supplied was enhanced by the explanatory inscriptions with which he often provided them and which so well show his understanding of weather as a continuing process. These notes he eventually developed in the form of (yet untraced) 'observations on clouds and skies . . . on scraps and bits of paper' (JCC V p.36).

On 7 October 1822 Constable told Fisher that he had made 'about 50 carefull studies of *skies* tolerably large' (JCC VI p.98). Leslie's comments on these 1822 studies, together with the dated examples which survive from both years, help us to differentiate between the studies of 1821, which include trees or buildings at the bottom, and the 'pure' sky studies of 1822: 'Twenty of Constable's studies of skies made during this season, are in my possession, and there is but one among them in which a vestige of landscape is introduced. They are painted in oil, on large sheets of thick paper, and all dated, with the time of day, the direction of the wind, and other memoranda on their backs; on one, for instance [No.207], is written, "5th of September, 1822. 10 o'clock, morning, looking south-east, brisk wind at west. Very bright and fresh grey clouds running fast over a yellow bed, about half way in the sky. Very appropriate to the 'coast at Osmington'"' (1843 p.32, 1951 p.94). No.197 above is an example of the type of

207

208

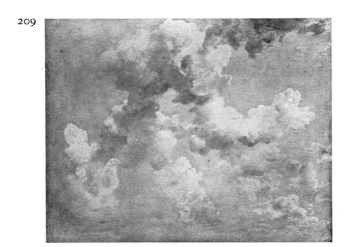

209

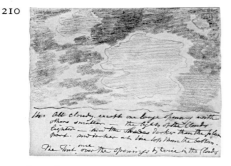

210

sky study made in 1821, No.207 and probably Nos.208–9 of the kind made in 1822. A sky study made about two hours after No.207 is in the V. & A. (R.249).

208 Cloud Study ?1822
Oil on paper, $4\frac{1}{2} \times 7$ (11.4 × 17.8)
Inscribed: an inscription on the back has been tentatively read as 'cirrus'; it is obscured by a later one which states 'Painted by John Constable R.A.'
Prov: presented to the V. & A. by Isabel Constable 1888
Victoria and Albert Museum (R.250)

See No.207. Despite its small size, this study may be one of the series made in 1822. No painted study purely of sky is known to date from before that year, though an example in crayons (No.169) is inscribed 1819.

209 Cloud Study ?1822
Oil on paper, $18\frac{7}{8} \times 23\frac{1}{4}$ (48 × 59)
Inscribed on verso '31st Sepr. 10–11 o'clock morning looking Eastward a gentle wind to East'
Prov: . . . ; Paterson Gallery 1928; presented to the Ashmolean Museum by Sir Farquhar Buzzard 1933
The Visitors of the Ashmolean Museum, Oxford

See No.207. The large size and absence of any land at the bottom point to this being another of the 1822 group of studies.

210 Copies after Alexander Cozens' Engravings of Skies
Twenty pencil drawings with ink inscriptions, each approximately $3\frac{5}{8} \times 4\frac{1}{2}$ (9.3 × 11.4)
Prov: . . . ; presented to the Courtauld Institute by Lord Lee of Fareham 1932
Courtauld Institute of Art

These are copies of the engravings of sky types included in Alexander Cozens' treatise *A New Method of Assisting the Invention in Drawing Original Compositions of Landscape* (*circa* 1785). They are usually supposed to date from early in Constable's career but the fact that he copied another set of Cozens' schematic designs around 1823 (see No.224) suggests that they could equally well have been made about the time of his own concentrated 'skying' in 1821–2.

211 Lady Lucy Digby in oriental dress (Copy after Catherine Read) d.1822
Oil on canvas, $17\frac{3}{4} \times 14\frac{1}{4}$ (45.1 × 36.2)
Inscribed on verso 'John Constable, A.R.A. pinxit 1822, First Copy'
Prov: apparently painted for the Revd. William Digby; . . . ; Anon., sold Christie's 21 June 1974 (144), bt. Dr J. W. B. Matthews.
J. W. B. Matthews

A letter of 12 September 1822 from Constable to the Revd. William Digby of Offenham, Evesham, Worcestershire (sold with the painting in 1974) indicates that Constable made two copies of Catherine Read's portrait of Lady Lucy Digby, then in the possession of Lord Ilchester, and that one was intended for him, the Revd. Digby, and the other for 'Chantry', presumably the sculptor Sir Francis Chantrey. Lady Lucy Digby, who died in 1787, was a daughter of the first Earl of

195 **Sunset Study of Hampstead Heath**, 1821 (entry on pp.121-2) ▶

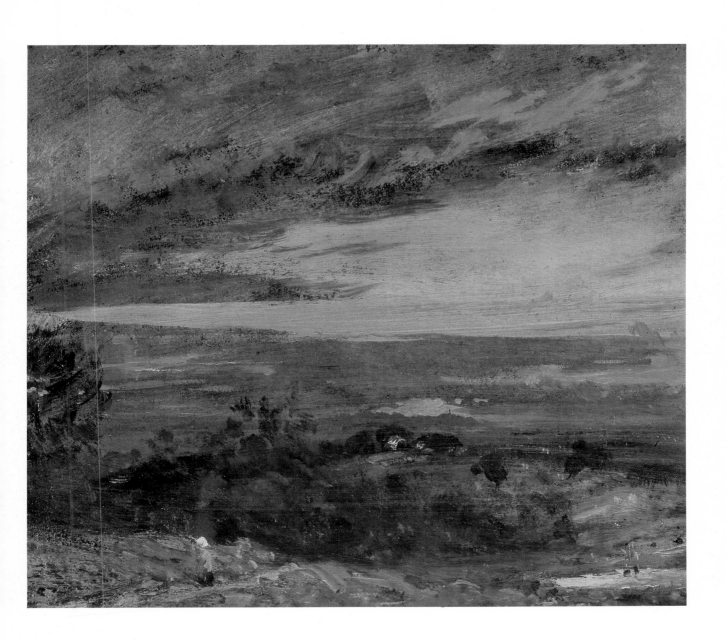

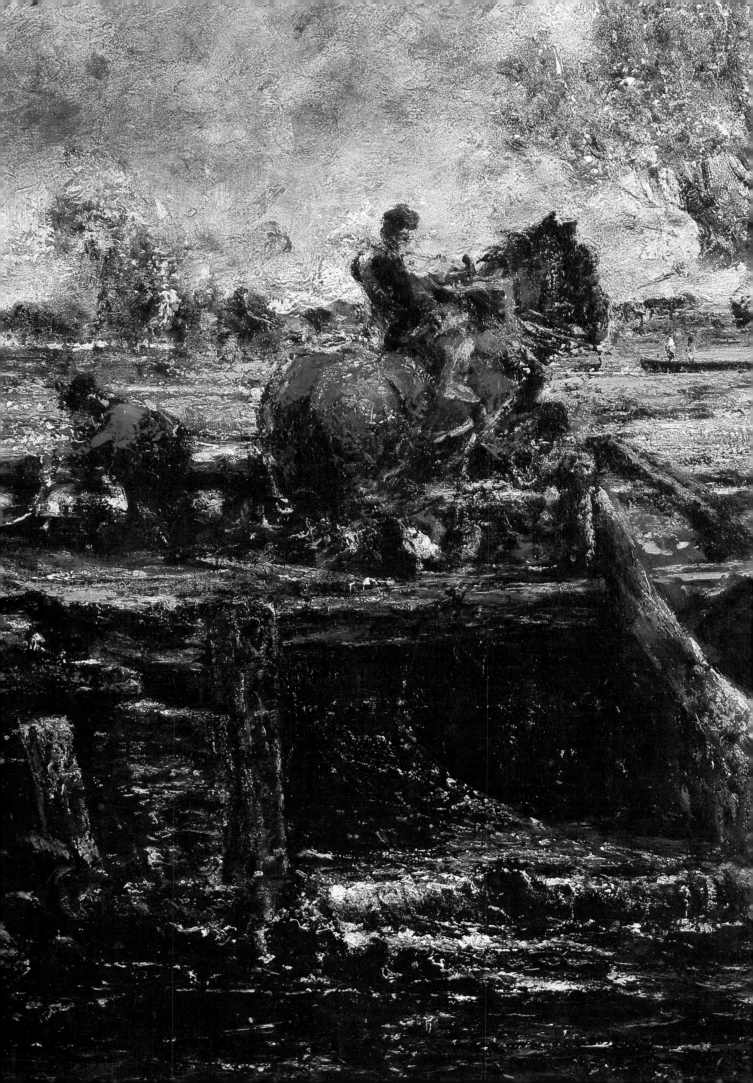

Ilchester and the wife of one of the sons of the sixth Baron Digby. The Revd. William Digby was a relative but it is not clear what Chantrey's interest in the matter was. The artist of the original portrait, Catherine Read (died 1778), was a fashionable portraitist of the day who exhibited several pictures of members of the royal family. See also the note on p.206.

210

212 The Risen Christ 1822
Oil on canvas, 63 × 50 (160 × 127)
Prov: painted for St. Michael's church, Manningtree, on the closure of which in 1965 it was acquired for All Saints church, Feering, Essex
By permission of the Vicar and Church-wardens of Feering church, near Colchester

The first of the three altarpieces which Constable painted for Suffolk and Essex churches has been shown above as No.56. 'The Risen Christ', painted for St. Michael's, Manningtree in 1822, was the last of the three. The commission came from a distant cousin of Constable's, the Manningtree brewer Edward Daniel Alston, but he seems not to have had Constable specifically in mind when he first decided to spend £200 on an altarpiece for the church: Constable only heard about the matter in a roundabout way in July 1821 from his brother Abram, who had got the news from a friend (see JCC I pp.200–1). However, Constable secured the commission and on 13 April 1822 told Fisher that he was 'going into Suffolk about an altarpeice – a gift of compunction I hear from a gentleman who is supposed to have defrauded his family – shall add this motto, from Shakespeare, "may this expiate"' (JCC VI p.88). A different motive was subsequently attributed to Alston. 'My altarpeice, for the chapel at Manningtree, is gone by –', Constable told Fisher on 6 December 1822, 'the man would not have it. He says I had harmed his future – but my brother tells me, "the whole concern of these brewers was a low sneak to Archdeacon Jefferson (who could license or not their blackguard publick houses) & on his death they were glad to get clear of as much of the expence as they had not actually incurred, as they could." This is a loss to me. The frame is 5 £, being of mahogany without a joint, and of large dimensions' (*ibid.*, p.106). From this it would seem that Constable received no payment for the work, though the altarpiece was nevertheless set up in the church. As Joseph Jefferson, Archdeacon of Colchester, had died in December of the previous year, it is odd that Constable was encouraged to proceed with the work at all. Perhaps the brewers needed time to try the amenability of Jefferson's successor before abandoning the idea.

211

1823

January: children and servants ill; nursing and anxiety keep him from his easel. *February:* Reinagle elected R.A. *March:* accused of spreading gossip about Linnell. *April:* at Bergholt, possibly to arrange for his brother Golding to work for Lady Dysart. Back by *30th*

212

◀ 236 **Full-size Sketch for 'The Leaping Horse'** 1824–5 detail (entry on p.140)

for A.G.B.I. meeting. *May:* busy 'both in portrait and in landscape'. *June:* settles his family in Stamford Lodge, Hampstead. *5 July:* Fisher writes invitingly from Gillingham of '*three* mills, old small and picturesque on this river.' Sir George Beaumont a visitor again. *August:* Bishop Fisher orders another 'Salisbury', this time for his daughter. *19th:* arrives at Salisbury for a holiday with Fisher. Having failed to get a large picture, Tinney orders two smaller ones. *24th:* writes from Gillingham, 'the mills are pretty. and one of them wonderfull old & romantic.' He and Fisher view the sale at Fonthill. Reports that he has painted, but not sketched much. *10 September:* returns to London; the family want to stay on at Hampstead; he yearns for his painting room in Charlotte St. *10 October:* receives invitation to stay with the Beaumonts at Coleorton, Leicestershire. *21st:* tells Maria of his arrival at Coleorton; writing 'in a room full of Claudes . . . real Claudes and Wilsons and Poussins &c. almost at the summit of my earthly ambitions'; spends most of his time with Sir George in his painting room copying two Claudes; is won over by the Beaumonts' kindnesses. *9 November:* Delacroix sees one of his oil sketches in Paris, – 'admirable chose et incroyable!'. *17th:* Maria expecting his return. *21st:* Maria still expecting his return. *28th:* makes sketches in the grounds of Coleorton. *2 December:* at A.G.B.I. meeting. *16th:* tells Fisher he is laid up with neuralgia.

Exhibits. B.I.: (35) 'Landscape', frame 68 × 90 inches (Huntington Art Gallery – 'View on the Stour, near Dedham'); (148) 'Yarmouth Jetty', frame 20 × 27 inches (No.213). R.A.: (59) 'Salisbury Cathedral, from the Bishop's grounds' (No.216); (179) 'Study of trees'; (244) 'A cottage'.

213 'Yarmouth Jetty' exh. 1823
Oil on canvas, 12½ × 20 (31.7 × 50.8)
Inscribed 'John Constable pinxt 1822'
Exh: B.I. 1823 (148, size with frame
20 × 27 inches)
Prov: . . . ; John Gibbons, who died 1851; Revd.
B. Gibbons, sold Christie's 26 May 1894 (6), bt.
Agnew for Sir Charles Tennant; by descent in
the family; sold to present owner 1975
Private collection

Two other versions of the picture survive today (Nos. 214-15) but the inscription on No.213 and its greater degree of finish point to it being the one exhibited in 1823. It is not known when Constable visited Great Yarmouth, Norfolk, or what drawing or oil sketch made there formed the basis of his pictures of the pier. The sky introduced in the Yarmouth paintings had been used earlier for 'Harwich light-house', also known in several versions (see Nos.178-9). From Constable's letter to Fisher of 18 August 1823, quoted in the entry on No.179, it would seem that the 'Yarmouth Jetty' exhibited at the B.I. had by that time been sold. The early history of the Yarmouth pictures is referred to in the entry on the following version.

214 Yarmouth Jetty
Oil on canvas, 13 × 20½ (33 × 52.1)
Prov: (for discussion of early provenance, see text); ?George Young; Frederick Winslow
Young, sold Rushworth & Jarvis 30 January 1857 (99), bt. Charles Fishlake Cundy; his nephew the Revd. T. S. Cooper; his son O. S. Cundy-Cooper, from whom acquired by Lord Ivor Spencer-Churchill; Agnew's 1949; R. P. Silcock; Mrs J. M. Stephens; acquired by present owner from Leggatt's 1975
Private collection

Although the previous picture, No.213, is almost certainly the 'Yarmouth Jetty' which Constable exhibited at the B.I. in 1823, this version and No.215 are shown beside it so that direct comparisons can be made. It is, in any case, possible that both Nos.214 and 215 were also, in one sense or another, exhibited works. The dealer John Arrowsmith bought a version of the picture, possibly No.215, in 1824 (JCC VI p.156) and probably showed it at his Paris gallery later that year, while Constable himself exhibited another 'Yarmouth pier' at the R.A. in 1831. Like the 'Harwich light-house' composition (see Nos.178-9), the Yarmouth subject was comparatively popular and Constable was able to dispose of several versions of it. Replication, often with the help of Johnny Dunthorne, was an important factor in Constable's output during this part of his career.

The early history of the Yarmouth pictures is confused. No.213 can certainly be traced back to John Gibbons, who died in 1851, No.214 to F. W. Young, whose collection was sold in 1857, and No.215 only to around 1900. Constable himself said (JCC V p.89) that his doctor, Robert Gooch, had one of the pictures and that it was acquired after his death (in 1830) by George Jennings (later the owner also of No.334). When No.214 was sold from F. W. Young's collection in 1857, the catalogue stated that it had 'passed into the possession of the late Mr. Young¹, by a bequest from Dr. Gooch, to whom it was presented by the artist'. Presumably either Constable or the 1857 cataloguer was wrong on this point, since Gooch is unlikely to have owned two versions of the same picture. The 1857 catalogue was almost certainly wrong in stating, as it also did, that Young's picture had been exhibited in 1823. Young could have acquired the picture from Jennings, or perhaps No.214 actually had nothing to do with the Gooch-Jennings painting. The matter is further complicated by the appearance of pictures of the same subject in the sale of the Pall Mall Gallery, run by Constable's patron John Allnutt, in 1838 (Christies, 20 March, lot 206), and in that of another early Constable collector, George Oldnall of Worcester, in 1847 (Christie's, 16 June, lot 110).

215 Yarmouth Jetty
Oil on canvas, 12¾ × 19⅞ (32.2 × 50.5)
Prov: . . . ; J. Staats Forbes, from whom (or his executors) bt. by Agnew 1905 and sold the same year to George Salting, by whom bequeathed to the National Gallery 1910; transferred to the Tate Gallery 1919
Tate Gallery (2650)

Another version of Nos.213-14. Of the three surviving versions, this one appears to be closest to David Lucas's engraving of the subject published in *English Landscape* as 'Yarmouth, Norfolk'. None of the paintings, however, includes the two women seen standing on the beach in the print. They seem to derive instead from

one of the figures in Constable's 'Chain Pier, Brighton' of 1827 (No.247).

216 'Salisbury Cathedral, from the Bishop's grounds' exh.1823

Oil on canvas, 34½ × 44 (87.6 × 111.8)
Inscribed: an inscription at the bottom left, now only partly legible, has been read in the past as 'John Constable A.R.A. London 1823' but other readings have been more recently suggested (see Reynolds 1973 p.156). A label on the stretcher, in the artist's hand, reads 'Salisbury Cathedral – from the Bishop's Grounds. John Constable. 35 Upper Charlotte Street Fitzroy Square'.
Exh: R.A. 1823 (59); B.I. 1824 (46, same title, size with frame given incorrectly as 36 × 57 inches[2]); Worcester Institution 1834 (26, same title)
Prov: painted for Dr John Fisher, Bishop of Salisbury 1822–3; returned to Constable for alterations 1824 and still with him when the Bishop died 1825; sent to the Bishop's nephew, Archdeacon John Fisher, 1826 and sold back by him to the artist 1829; 16 May 1838 (72, 'Salisbury Cathedral *from the Bishop's Garden. Exhibited* 1823'), bt. Tiffin, presumably for John Sheepshanks, by whom presented to the V. & A. 1857
Victoria and Albert Museum (R.254)

This is a south-west view of Salisbury Cathedral from the grounds of the Bishop's Palace. According to Archdeacon John Fisher, the figure at the left, pointing his stick towards the Cathedral, is the Bishop himself, Dr John Fisher, accompanied by his wife – 'Constable has put the Bishop & Mrs F. as figures in his view very like & characteristic' (JCC VI p.120). The painting was commissioned by the Bishop, who had taken a liking to the oil sketches Constable made on his visit to Salisbury in 1820 (*ibid.*, pp.56, 58), but the composition was actually based on an earlier drawing (No.104), made on Constable's first visit there in 1811. A reference to the Bishop having 'rummaged out the Salisbury' at Constable's house in Keppel Street in May 1822 (JCC II p.276) may be to a sketch of this subject but the first certain references to the composition occur in letters from the Bishop to Constable in November of that year. 'We are all disappointed at not seeing you here at this time', he wrote to the artist from Salisbury on 4 November, 'I am particularly so, because I was in hopes you would have taken another *peep* or *two* at the view of our Cathedral from my Garden near the Canal. But perhaps you retain enough of it in your memory to finish the Picture which I shall hope will be ready to grace my Drawing Room in London' (*ibid.*, pp.101–2). Thereafter the progress of the picture and the difficulties Constable encountered – illness, trouble with the Bishop's frame-maker, etc. – are recorded in some detail in the correspondence (*ibid.*, pp.103–13). The painting was finished in time for the R.A. exhibition in 1823 but at the expense of one of Constable's larger canvases, as he explained to Fisher on 9 May that year: 'I had many interruptions to my works for the Exhibition as you know from various causes so that I have no large canvas there. My Cathedral looks very well. Indeed I got through that job uncommonly well considering how

213

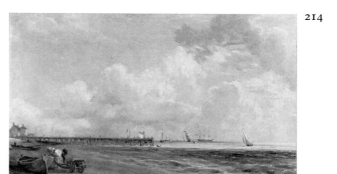
214

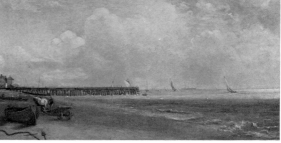
215

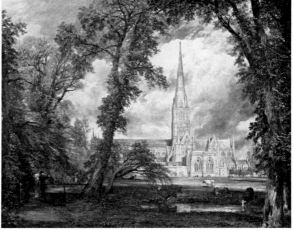
216

much I dreaded it. It is much approved by the Academy and moreover in Seymour St. [the Bishop's London residence] though I was at one time fearfull it would not be a favourite there owing to a *dark cloud* – but we got over the difficulty, and I think you will say when you see it that I have fought a better battle with the Church than old Hume, Brogham and their coadjutors have done. It was the most difficult subject in landscape I ever had upon my easil. I have not flinched at the work, of the windows, buttresses, &c, &c, but I have as usual made my escape in the evanescence of the chiaroscuro' (*ibid.*, p.115). The Bishop subsequently ordered a smaller version as a present to his daughter Elizabeth on her marriage in 1823 to John Mirehouse. This descended through the Mirehouse family and is now in the Huntington Art Gallery, San Marino (25 × 30 inches, signed and dated 1823). He seems to have grown dissatisfied, however, with the 'evanescence of the chiaroscuro' in the original picture. 'The Bishop has been fishing up some old drawings of Bucklers against your arrival in Salisbury', John Fisher reported on 16 October 1823, 'With the intent I guess that you should copy & improve them. Retaining so much of Buckler as shall exclude light & shadow (the Bishops detestation) & improving his rawness with some of your colour & facility. – "[If] Constable would but leave out his black clouds! Clouds are only black when it is going to rain. In fine weather the sky is blue"' (*ibid.*, p.138). The Bishop's sense of unease finally led to the original painting being returned to Constable in July 1824 so that he could 'improve' it or – though this may have been Constable's own suggestion – make a new, more acceptable version of it (JCC II p.344, VI p.167). Constable adopted the latter course and Johnny Dunthorne layed in the outlines of a replica. This was nearly complete in November 1825 (JCC VI pp.206–7), six months after the Bishop's death, and appears to have been sent in due course to the Bishop's daughter Dolly, Mrs Pike-Scrivener. The provenance of the 'Salisbury Cathedral from the Bishop's Grounds' which is now in the Frick Collection, New York, as well as the date inscribed on it, 1826, points to it being this second version. The original painting, No.216, seems to have been sold to Archdeacon Fisher in 1826 and to have been delivered to him together with his 'White Horse' when the latter returned from exhibition at Lille. 'The two pictures arrived safe on Friday', Fisher told Constable on 1 July 1826, '& within an hour were up in their places; the white horse looking very placid & not as if just returned from the continent . . . The Cathedral looks splendidly over the chimney peice. The picture requires a room full of light. Its internal splendour comes out in all its power, the spire sails away with the thunder-clouds' (*ibid.*, pp.221–2). Three years later, however, Fisher's financial difficulties obliged him to sell back to Constable both 'The White Horse' and No.216 (*ibid.*, pp.245–5).

Reynolds (1973 pp.156–64) gives a full account of all these proceedings and lists the other known versions of the composition. A sketch of the subject, measuring 24 × 29 inches, in the collection of Anthony Bacon (on loan to the City Art Gallery, Birmingham) is presumably a preparatory study for No.216. As in the 1811 drawing, the Chapter House is masked in this sketch by a tree omitted in the finished pictures. In the second version of No.216 (Frick Collection) the foreground trees framing the view of the Cathedral are opened out at the top to admit more sky – perhaps one of the alterations requested by the Bishop. The smaller 'wedding' version was also returned to Constable for alterations, which are mentioned in a note by Elizabeth Mirehouse on the back of the picture: 'This picture was Painted in the year 1823 by John Constable Esq. R.A. and given to me by my dear Father the Bishop of Salisbury as a wedding present. At his especial request the small piece of blue sky was inserted as making it a more suitable marriage gift than the cloudy skies usual in his Pictures. E. Mirehouse, July 1877.'

217 Bentley d.1823
Pencil, $6\frac{5}{8} \times 9\frac{7}{8}$ (16.5 × 25.1)
Inscribed 'Bentley 21. April 1823'
Prov: 11 July 1887 (5), bt. Colnaghi for British Museum
Trustees of the British Museum (L.B.9)
See No.218.

218 Boathouse at Flatford d.1823
Pencil, $6\frac{11}{16} \times 10$ (17 × 25.4)
Inscribed 'E. B. April 20. 1823'
Prov: presented to the British Museum by Isabel Constable 1888
Trustees of the British Museum (L.B.11a)

Nos.217 and 218 provide the only evidence we have of a visit by Constable to Suffolk in 1823. It is possible to hazard a guess as to his reason for being there. At Bentley, hardly five miles from East Bergholt, the woods formed part of the Helmingham estate. Somehow, Constable managed to interest the owner of the woods, his old patroness the Countess of Dysart, in the idea of making his elder brother, Golding, their Warden. Until now Golding (who did not work in the family business) had only been distinguished for his skill with a gun. We hear of the appointment for the first time in a letter Golding wrote to his brother in February of the following year, but from this it is evident that by then he had already been in charge of the woods for some time. It seems reasonable to suppose that Constable's visit was in some way connected with his brother's appointment. This is the only known drawing of Bentley.

Small river craft, hardly suitable for more than an oarsman at the stern and a passenger, are to be seen in a great many of Constable's sketches and paintings of the waters around Flatford. One of these little boats appears to have served as a ferry plying between Willy Lott's house and the south bank below Flatford Lock. A tumble-down boathouse situated just downstream from Willy Lott's farm with a skiff moored alongside it forms a central feature in 'The White Horse', as it does in the sketch without the boat, No.165. The pencil drawing we have here (No.218) is of the same thatched shelter, but the craft inside, with its two thwarts, appears to be rather larger than the one in 'The Valley Farm' and its attendant sketches.

219 House at Hampstead *circa* 1823
Pencil, $6\frac{5}{8} \times 10$ (16.9 × 25.4)
Prov: presented to the British Museum by Isabel Constable 1888
Trustees of the British Museum (L.B.11b)

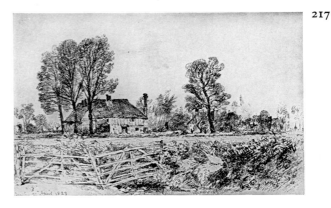

217

Both style and measurements of this drawing are consistent with the date, 1823, to which it has been assigned (Beckett, Typescript Catalogue). Hampstead also appears to be the most likely location. See No.316 for observations on Constable's practice of fixing drawings made with a soft pencil.

220 The Abbey Church, Sherborne d.1823

Pencil, 7⅛ × 10¼ (18.1 × 26.1)
Inscribed 'Sherborne Sep 2. 1823'; verso, added later by the artist, 'Sherborne Collegiate Church Sepr. 2. 1823. [the year repeated] went in the autumn to Coleorton Hall'
Prov: presented to the V. & A. by Isabel Constable 1888
Victoria and Albert Museum (R.257)

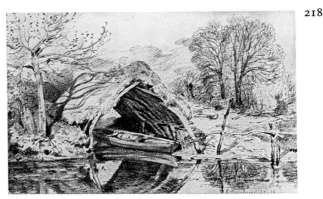

218

In his letters to his wife Constable gives a fairly full account of his stay with Fisher this year (1823): of their three days at Salisbury; their ride to Gillingham via Fonthill and Mere; their return to Fonthill to see the art treasures; the poor harvest; and Fisher's medical care for the impoverished and melancholy population. Although he enjoyed Fisher's company, it was not a very productive holiday. 'We have had some beautifull Evens', he wrote on 5 September, 'I have not done much in the Sketching way – I have been a good deal about with Fisher. I have as you know seen Fonthill. & on Monday Fisher took me a magnificent Ride to Sherborne a fine old Town – with a magnificent Church finer than Salisbury Cathedral . . . I am afraid I shall have but a poor account of my pencil to give you –' (JCC II p.287). The professional topographers and their engravers produced vast numbers of drawings and prints of subjects such as this, but Constable was not working for that side of the art market; why, then, do we find him sitting down to make such a study at this stage in his career?

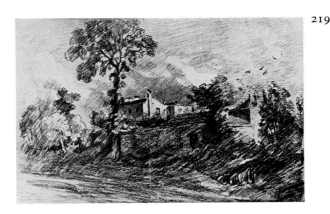

219

221 The Bridge at Gillingham 1823

Oil on canvas, 12⅝ × 20¼ (32.2 × 51.5)
Prov: presented to the National Gallery by Isabel Constable 1888; transferred to the Tate Gallery 1897
Tate Gallery (1244)

The Vicarage of Gillingham, Dorset was added to Fisher's other livings in 1819 and Constable visited the place with him briefly in July of the following year. Drawings made on this excursion are in the V. & A. (R.189, 190, 192) and the British Museum (1910-2-12-229). Constable's only other visit to Gillingham was in 1823, when, without Maria, he stayed there with the Fishers from 22 August until 10 September. In a letter to Maria postmarked 8 September Constable said 'I shall wait here 'till wednesday to get a "*line only from you*". and it will enable me to make a little picture of this village rather more compleat it is for fisher – a present to his mother – I shall bring it to London – this is to be paid for' (JCC II p.288). The picture in question seems to have been No.221. Because it was presented to the National Gallery by Isabel Constable it is unlikely that Fisher did in fact buy it. His cousin Dorothea Fisher, however, certainly borrowed the painting in April and May 1824 and made a copy of it. There are a number of references to the copy, which Constable retouched, in the artist's correspondence between April

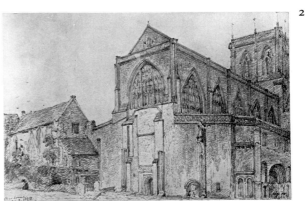

220

221

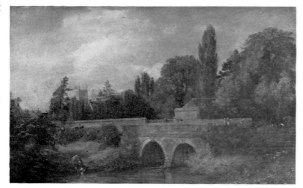

222

223

and July that year (JCC II pp.318, 346, 355, VI pp.156, 160, 163 – a letter from Bishop Fisher specifying 'my Daughters copy of your Picture of the Gillingham Bridge' – and 168). Dorothea's copy (repr. Shirley 1937 Pl.83a) was sold by the Fisher family at Sotheby's on 4 December 1957 (152) and is now in a private collection in New York. An inscription on the back by John Fisher's son Osmond reads 'I perfectly recollect seeing him [Constable], sitting with his easel in the meadow at the right hand corner of this picture'.

In No.221 Constable has omitted the small spire which can be seen on the church tower in one of his 1820 drawings (V. & A., R.189). According to Beckett (JCC VI p.54), the spire did not actually go until 1838. For the studies which Constable made of Perne's Mill near Gillingham on this visit see No.243.

222 House amidst trees: Evening d.1823
Oil on paper, $9\frac{7}{8} \times 12\frac{1}{8}$ (25.1 × 30.7)
Inscribed on verso 'Saturday Evg 4th Oct 1823'.
Prov: presented to the V. & A. by Isabel
Constable 1888
Victoria and Albert Museum (R.258)

This study was painted between Constable's return from his holiday at Salisbury and his departure for Coleorton. It seems to have been done at Hampstead.

223 Landscape with Goatherd and Goats (Copy after Claude) ?1823
Oil on canvas, $21 \times 17\frac{1}{2}$ (53.3 × 44.5)
Prov: 15 May 1838 (49, 'An upright Landscape, from the original, by Claude, in the National Gallery'[3]), bt. ?Marshall, *or* 23 June 1894 (60, 'A Woody Landscape, with shepherd and animals, after Claude'), bt. Colnaghi; . . . ; Anon., sold Christie's 1 February 1924 (10), bt. Pawsey & Payne; . . . ; bt. from Appleby's by National Art-Collections Fund and presented to the Art Gallery of New South Wales 1961
Art Gallery of New South Wales, Sydney

Sir George Beaumont was, as we have seen, one of Constable's earliest mentors. The access Constable enjoyed to the Baronet's collection in London around the turn of the century played an important part in his education as an artist. After about 1802 however their acquaintance seems to have lapsed and only after Constable became an A.R.A. in 1819 did Beaumont grow interested in him again (see JC:FDC p.145). The climax of their renewed association was the six-week visit Constable paid to the Beaumonts' seat, Coleorton Hall, Leicestershire, from 21 October to about 28 November 1823. Constable reckoned this visit as likely to form 'one of the epocks' of his life and as an experience which would be, he told Maria, 'ultimately of the greatest advantage to me and I could not be better employed to the advantage of all of us by its making me so much more of an artist indeed what I see and learn here is prodigeous' (JCC II pp.292, 301). He saw himself as going back to school (*ibid.*, p.304). The experience was, in fact, a sort of refresher course for him in the art of the past, and a highly enjoyable, even self-indulgent, one at that. Removed temporarily from his own family concerns, Constable lived surrounded by paintings which had long assumed especial importance for him – Beaumont's Claudes – and he relished the

Baronet's anecdotes of Reynolds, Wilson, Cozens and other artists he had known in his youth. 'you would laugh to see my bed room', he told Maria on 5 November, 'I have draged so many things into it. books portfolios – prints canvases – pictures &c. and I have slept with one of the Claudes every night – so may well indeed be jealous – and wonder I do not come home' (*ibid.*, p.296). The life-style at Coleorton appealed to him greatly: the painting-room in the morning, a carriage ride in the afternoon, portfolios to peruse in the evening while his host read aloud from Shakespeare or Wordsworth. He was flattered by Sir George and Lady Beaumont's easy manner with him and he resolved in future to 'have a proper opinion of myself' and to 'not let Vulgar [?writers] come and insult and intrude upon [me]' (*ibid.*, p.292). The visit was originally due to last three weeks. As it extended itself gradually to six, Constable grew guilty about leaving Maria and the children, though no less anxious to remain where he was. He grasped at a variety of justifications for his continued absence but, not unnaturally, Maria became very impatient. After hearing about the copies he was making of the Claudes, she wrote on 17 November: 'I begin to be heartily sick of your long absence as to your Claude I would not advise you to show it to me for I shall follow Mr Biggs advice & throw them all out of the window' (*ibid.*, p.299). Soon after, Constable made the mistake of telling Maria that he had turned down the Beaumonts' invitation to stay until Christmas. 'I shall expect you the *end of next week* certainly', she responded, 'it was complimentary in Sir George to ask you to remain the Xmas, but he forgot at the time that you had a wife' (*ibid.*, p.302).

Constable seems to have made two copies of the Claude 'Goatherd and Goats', which picture Beaumont eventually left to the National Gallery. One was included (and, apparently, sold) in his sale in 1838, and another in Clifford Constable's sale in 1894. Farington recorded Constable's enthusiasm for this picture in 1801, saying that Constable went to Beaumont's London house 'to study – prefers the little wood scene of Claude to all others' (Farington Diary 25 March 1801). He may have made one of the copies at this time. His copying of the work at Coleorton in 1823 is amply documented. 'I have likewise begun the little Grove by Claude', he told Fisher on 2 November, '– a noon day scene – which "*warms and cheers but which does not inflame or irritate*" – Mr. Price. [It] diffuses a life & breezy freshness into the recess of trees which make it enchanting. Through the depths are seen a water-fall & ruined temple – & a solitary shepherd is piping to some animals' (JCC VI pp.142–3). Three days later he wrote to Maria: 'I have a little Claude in hand a Grove scene of great beauty and I wish to make a nice copy from it to be usefull to me as long as I live – It contains almost all that I wish to do in Landscape' (JCC II p.295), and, soon after, 'I do not wonder at your being jealous of Claude if any thing⟨s⟩ could come between our love it is him. but I am fast advancing a beautifull little copy. of his Study from Nature of a little ⟨Copies⟩ grove scene which will be of service to me for life – and by being realy finished will ⟨. . . something of⟩ be worth something and a piece of property – it is so well' (*ibid.*, p.297).

224 'A Spacious or extensive Landscape' (Copy after Alexander Cozens) 1823

Pen and ink, $4\frac{1}{2} \times 7\frac{1}{4}$ (11.4 × 18.4)
Inscribed '16 A Spacious or extensive Landscape.'
Prov: . . . ; acquired by Fogg Art Museum 1926
Fogg Art Museum, Harvard University, Cambridge, Massachusetts

As mentioned in the previous entry, one of the attractions of the Coleorton visit was Sir George Beaumont's talk of the artists he had known in his youth – heroic figures for Constable. 'He is very entertaining – so full of delightfull stories about painting', Constable told Maria (JCC II p.296). He seems to have recorded a few of Beaumont's anecdotes and other recollections on sheets of note paper which were much later inserted in the copy of Leslie's *Life* that contains the early drawing, No.9 above. One of these anecdotes, about Gainsborough, is dated 9 November 1823, and the other notes, on identical paper, appear likewise to have been made on the Coleorton visit. Included on these sheets are some remarks about Cozens (presumably Alexander, from whom Beaumont had learned drawing at Eton): 'Cousins often ⟨began⟩ did his foregrounds first he said it is often neglected –', 'Cousins said the figures in Landscape should . . . hardly be seen – to be "as if rising out of the ⟨. . .⟩ ground –" and passing by', and so on. The sheets also include a list by Constable of the titles of Alexander Cozens' series of etchings entitled 'The Various Species of Composition of Landscape, in Nature' and a copy by him of a rhyming version of the titles drawn up by Beaumont's early tutor the Revd. Charles Davy. Constable copied not only the titles but the prints themselves. His versions, in pen, wash and pencil, of Nos.1–15 of Cozens' sixteen etchings are now in the collection of Denys Oppé. Eight of them reveal fragments of the watermark 'W THOMAS 1822'. Constable's copy of No.16 is the present item, which seems not to have been previously recognised for what it is. Bearing in mind the watermarks on some of these copies and the transcriptions of the titles made at Coleorton, it is almost certain that the copies themselves were also made there in 1823.

Further evidence of interest in Cozens can be found on another of the Coleorton sheets of notes, where Constable has listed twenty-six 'Circumstances' – 'Dawn', 'before Sun rising', 'Sun rising' and so on. This appears to be a more complete record than any other we have of part of a system of classification which Cozens never finished and which was never published. Hitherto it has been known only from a set of brief notes by Cozens in the British Museum (1888-1-16-9-2 . . . 5), where the final section of the system is referred to as 'Circumstances of Landskip. 4 Accidents 4 Seasons 8 Characters', with no other details given. With the aid of Constable's list it is possible to identify examples of the 'circumstances' among Cozens' own works, some of which bear titles corresponding to those on the list. For example, three oil studies sold at Christie's on 4 March 1975 are inscribed 'Before Storm' (lot 13, now Tate Gallery = No.20 on Constable's list, 'before storm'), 'Close of the Day' (lot 14 = No.9, 'close of day') and 'Rising Sun' (lot 15 = No.3, '⟨rising⟩ Sun rising'). The first of these oil studies is closely related to a drawing in Denys Oppé's collection (exh. *Alexander Cozens*, Tate Gallery 1946 No.64) which is

224

225

226

inscribed with the number '20', the same number given to the corresponding subject on Constable's list.

Constable appears to have spent some time studying Cozens' various systems of classification – of skies (see No.210), of types of landscape composition, and of 'circumstances' (or phenomena, as Constable would have called them). Apart from any more immediate use they may have had for him, Cozens' systems must surely have played some part in the thinking that led in the 1830s to Constable's own survey of the 'endless varieties of effect' in nature – *English Landscape*.

225 Cenotaph to Sir Joshua Reynolds in the Grounds of Coleorton Hall d.1823

Pencil and grey wash, $10\frac{1}{4} \times 7\frac{1}{8}$ (26 × 18.1)
Inscribed: on the back is a copy by Constable of the lines by Wordsworth inscribed on the actual cenotaph, with the subscription 'Coleorton Hall. Novr. 28. 1823.'
Prov: presented to the V. & A. by Isabel Constable 1888
Victoria and Albert Museum (R.259)

On 30 October 1812 Sir George and Lady Beaumont, with Joseph Farington and William Owen in attendance, laid the first stone of a monument in the grounds at Coleorton to the memory of their friend – and the artist whom above all others Beaumont reverenced – Sir Joshua Reynolds. Another friend, Wordsworth, was called in to provide an inscription for the cenotaph, expressing Beaumont's feeling of 'what England lost when Reynolds died'. Constable's own reverence for Reynolds as the founder of the British school is evident from his lectures in the 1830s. He had been a life-long, though not uncritical, admirer. As early as 1802 he was quoting Reynolds' *Discourses* in support of his own ideas about art (see No.33), and of Reynolds' paintings he wrote to Maria in 1813: 'form your mind of what painting is from them here is no vulgarity or Rawness and yet no want of life or vigor – it is cirtainly the finest feeling ⟨for⟩ of art that ever existed' (JCC II p.106). It was natural therefore that Beaumont's act of homage to Reynolds should appeal to Constable. 'In the dark recesses of these gardens', he wrote to Fisher from Coleorton, 'and at the end of one of the walks, I saw an urn – & bust of Sir Joshua Reynolds – & under it some beautifull verses, by Wordsworth' (JCC VI p.143). This drawing of the cenotaph or urn, as he (and Wordsworth) called it, was one of the last things Constable did before leaving Coleorton. Several years later he turned back to the drawing and used it as the basis of a painting which was finally exhibited in 1836 (No.330).

226 A Stone dedicated to Richard Wilson in the Grove at Coleorton Hall d.1823

Pencil and grey wash, $10\frac{1}{4} \times 7\frac{1}{8}$ (26 × 18.1)
Inscribed on verso 'Stone in the Grove Coleorton Hall. Dedicated to the Memory of Richard Wilson. Novr. 28. 1823.' together with an imitation Wilson monogram
Prov: presented to the V. & A. by Isabel Constable 1888
Victoria and Albert Museum (R.260)

Beaumont chose to commemorate Wilson, another of his (and Constable's) heroes with a massive boulder such as often figured in the foregrounds of his land-

scapes, for example the 'Distant View of Mæcenas' Villa' which Beaumont owned and eventually left to the National Gallery (now Tate Gallery No.108). The stone itself bears the inscription 'Brought here 6 Jan 1818', which, in its laconic way, seems as appropriate for Wilson as does Wordsworth's stately invocation – 'Ye Lime-trees, ranged before this hallowed Urn . . .' – for Reynolds.

1824

A critical year. *15 January:* Payne Knight, connoisseur and writer on the Picturesque, calls. Arrowsmith negotiates for both 'The Hay Wain' and 'View on the Stour'. *February:* brother, Golding, now Warden of Lady Dysart's woods near Bergholt. *March:* Fisher in town; finds him at work on Academy picture. Early *April:* sells the two large pictures and a small 'Yarmouth' to Arrowsmith for £250. To Bergholt to see Golding about his woods; returns after a few days via Feering. *May:* his only picture at the Academy, 'A boat passing a lock', is bought by a merchant, James Morrison, on the opening day; tells Fisher he hopes his exertions may 'at last turn towards popularity – 'tis you that have too long held my head above water'; Fisher replies, 'English boobies, who dare not trust their own eyes, will discover your merits when they find you admired at Paris'; takes wife and family to Brighton for the season – 'the warm weather has hurt her a good deal, and we are told we must try the sea'. *19th:* back in London, begins keeping a journal for Maria. Johnny Dunthorne joins him as assistant. *22nd:* Arrowsmith calls, bringing another dealer, Schroth, to see him, and orders more pictures. *30th:* spends day at Ham with Lady Dysart. *June:* much distracted from work by stream of visitors, including some from France. *8th:* to Brighton for a week. *14th:* Fisher in town; they spend much time together. Beaumont a regular caller. Receives news from Paris of the stir his pictures are causing. *30th:* learns that his pictures are to be on exhibition at the Louvre. *July:* many visitors, including Ottley, Collins, Danby, Beaumont. *17th:* to Brighton taking his work with him. *20th:* tells Fisher he has been harassed by small commissions; receives advance payment from Schroth for work ordered. *25 August:* opening of the Paris Salon. Overheard in the Louvre – 'look at these English paintings – the very dew is upon the ground'. An attempt is made to buy 'The Hay Wain' for the French nation, but Arrowsmith will only sell it as a pair with 'View on the Stour'. *5 October:* Arrowsmith entreats him to come to Paris. *18th:* last dated drawing of Brighton. *1 November:* suffering a reaction; depressed. Cannot complete Tinney's order for two pictures. *2nd:* his family return from Brighton. Starts planning a new picture – 'The Leaping Horse'. Working on a series of drawings to be engraved and published in Paris. *17 December:* tells Fisher he has a 6-foot canvas in hand.

Exhibits. B.I.: (46) 'Salisbury Cathedral, from the Bishop's Grounds', frame 36×57 inches (No.216).

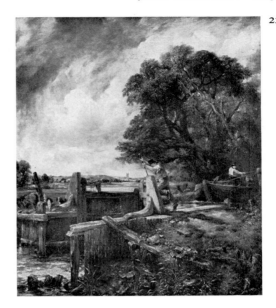

227

228

229

230

R.A.: (180) 'A boat passing a lock' (No.227). Salon, Paris: (358) 'Une charette à foin traversant un gué au pied d'une ferme; paysage' (No.192); (359) 'Un canal en Angleterre; paysage' (Huntington Art Gallery, San Marino, California – 'View on the Stour, near Dedham'); (360) 'Vue près de Londres; Hampstead Heath'.

227 **'A boat passing a lock'** exh.1824
Oil on canvas, 56 × 47½ (142.2 × 120.7)
Exh: R.A. 1824 (180); *Living Artists of the English School* (loan exhibition), B.I. 1825 (129, 'The Lock')
Prov: bt. at the 1824 R.A. by James Morrison; by descent to present owners
Trustees of the Walter Morrison Pictures Settlement

Constable's fifth large river picture, though this time not a 'six-footer', No.227 shows a man opening the downstream gates of Flatford Lock while a barge waits in the basin for the water-level to drop. The towing horse meanwhile grazes in an adjacent field. In the distance is Dedham church. Numerous cross-beams seen on the lock in, for example, No.98 above, have been omitted, presumably for aesthetic reasons.

Constable planned to have this composition ready for the 1823 exhibition (JCC VI p.112) but illness and the difficulties he had with 'Salisbury Cathedral, from the Bishop's grounds' (No.216), which did appear that year, forced him to postpone the work until around January 1824 (*ibid.*, p.150). On 15 April 1824 he was able to report to Fisher: 'my *friends* all tell me it is my best. Be that as it may I have done my best. It is a good subject and an admirable instance of the picturesque' (*ibid.*, p.155). On 8 May he told the same correspondent: 'My picture is liked at the Academy. Indeed it forms a decided feature and its light cannot be put out, because it is the light of nature – the Mother of all that is valuable in poetry, painting or anything else – where an appeal to the soul is required . . . My execution annoys most of them and all the scholastic ones – perhaps the sacrifices I make for *lightness* and *brightness* is too much, but these things are the essence of landscape . . . I sold this picture on the day of opening, 150 guins including the frame' (*ibid.*, p.157). Two other letters (JCC II p.330, IV p.280) show that the purchaser was James Morrison (1790–1857) of Balham Hill and later Basildon Park, a highly successful draper who was afterwards M.P. for, successively, St. Ives, Ipswich and Inverness.

The engraver S. W. Reynolds borrowed the picture in 1824 to make a print of it, telling Constable that 'since the days of Gainsborough and Wilson, no landscape has been painted with so much truth and originality, so much art, so little artifice' (JCC IV p.266), but the engraving was never finished. A full-size version of the work in the Philadelphia Museum of Art, usually regarded as a preparatory sketch for No.227, has not been seen by the organisers. For a replica of No.227 which Constable painted in 1825 see No.312, and for a horizontal version of the composition see No.262.

228 **Brighton Beach with colliers** d.1824
Oil on paper, 5⅞ × 9¾ (14.9 × 24.8)
Inscribed in pencil on verso (probably in the artist's hand but partly inked over): '3d tide receeding left the beach wet – Head of the Chain Pier Beach Brighton July 19 Evg., 1824 My dear Maria's Birthday Your Goddaughter – Very lovely Evening – looking Eastward – cliffs & light off a dark [?grey] effect – background – very white and golden light'. Also inscribed 'JC' and 'Colliers on the beach'
Prov: presented to the V. & A. by Isabel Constable 1888
Victoria and Albert Museum (R.266)

Constable first visited Brighton in May 1824 when he took his wife there for the sake of her health. She remained until November and also spent August 1825–January 1826 there. Constable paid her frequent visits. In addition he went to Brighton for a few days in September 1826 and paid three visits when Maria returned there in 1828. A visit in 1830 is also recorded. Many drawings and oil sketches were made on these excursions, especially on the early ones, and one large canvas of a Brighton subject was produced (No.247).

No.228 was painted two days after Constable arrived at Brighton on 17 July 1824 for a visit which lasted until October. His daughter Maria Louisa's birthday was on 19 July and the inscription on the back of this sketch was partly addressed to her godfather John Fisher. No.228 was probably one of the batch of studies which Constable lent to Fisher in January 1825: 'I have enclosed in the box a dozen of my Brighton oil sketches – perhaps the sight of the sea may cheer Mrs F – they were done in the lid of my box on my knees as usual' (JCC VI p.189). When returning them Fisher sent 'as a sort of remunerating fee, 2 vols of Paleys posthumous sermons . . . They are fit companions for your sketches, being exactly like them: full of vigour, & nature, fresh, original, warm from observation of nature, hasty, unpolished, untouched afterwards' (*ibid.*, p.196).

229 **Brighton Beach** *circa* 1824
Pencil, pen and grey wash, 7 1/16 × 12¾ (18 × 32.4)
Prov: . . . ; bequeathed to the British Museum (through the N.A.-C.F.) by P. C. Manuk and Miss G. M. Coles 1948
Trustees of the British Museum (1948-10-9-10)
See No.230.

230 **Worthing** d.1824
Pencil, pen and grey wash, 7 × 10⅛ (17.8 × 25.8)
Inscribed 'Worthing 22 Sep 1824'
Prov: . . . ; J. P. Heseltine; P. M. Turner
Private collection

Although Constable was staying at Brighton on 22 September, the date inscribed on the drawing of Worthing, it is possible that both these beach scenes were in fact completed in Charlotte Street some weeks after his return from Brighton. In a letter to Fisher of 17 November he said that he was busy with a sketchbook that he had apparently been going to send him, a sketchbook containing boats and coast scenes, subjects 'more fit for *execution* than sentiment' (JCC VI p.182). In his next letter, of 17 December, he again apologises for not having sent his sketchbook: 'Just at the time you wrote to me my Frenchman [the Paris dealer, Arrowsmith] was in London. We were settling about work and he has engaged me to make twelve drawings (to be engraved here, and published in Paris), all from this

book, size of the plates the same as the drawings, about 10 or 12 inches. I work at these in the evening' (*ibid.*, p.184). Later in the letter he tells Fisher that the engraver of the drawings was to be S. W. Reynolds, who was already at work on a plate of his 'Lock' (No.227). In his reply, Fisher thanked him for the offer to send his book; his wife, he said, would feel obliged for any of his sketch books, as she lacked a landscape engraving to copy, and not one could he find in Bath.

Rather more than a dozen pen and wash drawings of beach scenes similar to Nos.229 and 230 are known. In fact, stylistically they provide quite a distinctive group and might well have been done for an engraver – worked up with the pen and brush in the evenings from pencil drawings made on the spot with this very purpose in mind.

231

231 Studies of tackle on the beach at Brighton
circa 1824
Pen, pencil and wash, $7\frac{1}{8} \times 10\frac{3}{8}$ (18.1 × 26.4)
Prov: presented to the V. & A. by Isabel
Constable 1888
Victoria and Albert Museum (R.273)
This sheet was originally part of the same sketchbook that contained Nos.220 and 225–6 above. On the back are further studies made on the beach at Brighton. The two anchors on the *recto* were introduced in the large painting of 'Chain Pier, Brighton' exhibited in 1827 (No.247).

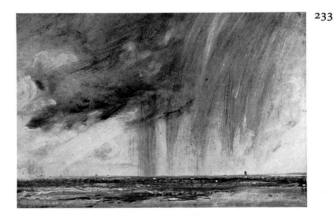

232

232 Brighton Beach *circa* 1824–6
Oil on canvas, $9\frac{1}{2} \times 11\frac{1}{2}$ (24.2 × 29.2)
Prov: ?17 June 1892 (255, 'A Coast Scene, with fishing boats')[1], bt. Dowdeswell; . . . ; bequeathed by P. L. Halsted to Dunedin Public Art Gallery 1943
Dunedin Public Art Gallery, New Zealand
This is apparently quite similar in character to a sketch of the same size showing a boat being beached, which is related to 'Chain Pier, Brighton' and is referred to in the entry on that work (No.247). Two of the motifs in No.232 are also similar to those in the 'Chain Pier' composition – the upturned boat with a figure beside it and the two women sheltering under an umbrella. The first of these is more closely paralleled in the two Philadelphia sketches mentioned in the entry on No.247 than in the final painting. See also the note on p.206.

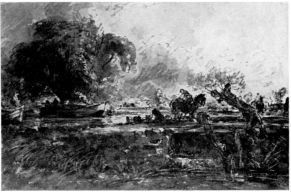

233

233 Seascape with Rain Clouds *circa* 1824–8
Oil on paper laid on canvas, $8\frac{3}{4} \times 12\frac{1}{4}$ (22.2 × 31)
Prov: presented to the R.A. by Isabel Constable 1888
The Royal Academy of Arts, London
Almost certainly painted on one of Constable's visits to Brighton in the years 1824–8.

234 First Study for 'The Leaping Horse' 1824
Pencil, pen (?) and wash, $8 \times 11\frac{7}{8}$ (20.3 × 30.2)
Prov: presented to the British Museum by Isabel Constable 1888
Trustees of the British Museum (L.B. 10a)
See No.235.

234

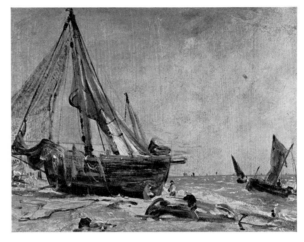

235 Second Study for 'The Leaping Horse' 1824
Pencil and wash, 8 × 11⅞ (20.3 × 30.2)
Prov: presented to the British Museum by
Isabel Constable 1888
Trustees of the British Museum (L.B. 10b)

Nos.234 and 235, compositional studies for 'The Leaping Horse' (No.238), have been given the titles 'first' and 'second study' here partly for the sake of convenience, but mainly because it is possible that they were conceived in that order. When searching for an idea for a new picture it was Constable's habit to look through his sketchbooks for promising material. It is possible that 'The Leaping Horse' began with a small sketch from nature in the Courtauld Institute (Witt Collection). This depicts a river bank with a distant church tower (Dedham?), cattle, a bird flying over the water and, in the foreground, a hollow willow tree with its side pierced by the rail of a broken fence – all of which elements played a part at one stage or another in the development of the composition. It is this willow which features in the 'first' study. The 'second' study is most like the finished work. But if Nos.234 and 235 were started in the order suggested, it is very possible that Constable worked on them together, on first one and then the other.

The two studies are discussed in the entry for the exhibited version of 'The Leaping Horse', No.238.

236 Full-size Sketch for 'The Leaping Horse'
1824–5
Oil on canvas, 51 × 74 (129.4 × 188)
Prov: ?16 May 1838 (part of 38, 'Two – Sketches
of Landscapes, *the pictures now in France*'²), bt. in
by Purton for the Constable family; in Leslie's
care for some time; acquired by D. T. White,
probably before 1853, and sold by him to Henry
Vaughan; lent by Vaughan to the V. & A. from at
least 1862 until his death in 1900, when
bequeathed by him to the Museum
Victoria and Albert Museum (R.286)
(colour plate facing p.129)

The history of the painting of this subject, 'The Leaping Horse', and a discussion of the changes made in the composition during the progress of the work are given in the entry for the exhibited version, No.238. The four full-size sketches for Constable's big canvases to be seen in this exhibition – 'The Hay Wain' (No.190), 'View on the Stour' (No.201), the present work (No.236), and 'Hadleigh Castle' (No.261) – will show how various were his approaches towards the achievement of final statements on the subjects chosen for his major works.

Constable had abandoned his 6-foot sketch for 'The Hay Wain' (No.190) at a comparatively early stage, presumably when he could fully visualise the final design. Work appears to have continued on No.236 for considerably longer. A possible dichotomy in the original idea may have been partly responsible for this, but it is also quite possible that during his work on No.236 the painting assumed command, as it were, and that he found himself taking it further than he had intended.

At some stage Constable had the canvas taken off its original stretcher and relined to gain an extra two or three inches at the top and at the sides. Nail holes where the canvas was turned over its first stretcher can still just be seen.

237 A Moorhen *circa* 1824
Oil on panel, 5¾ × 6 (14.6 × 15.2)
Prov: always in the Constable family
The Executors of Lt. Col. J. H. Constable

No.237 is apparently a study for the 'more-hen frightened from her Nest' in the bottom right-hand corner of 'The Leaping Horse' (No.238). From Mary Constable's letters to her brother we gather that a moorhen was sent from Flatford in March or April of this year to help him with the painting of the bird in the picture (JCC I pp.219, 221). It may have been shot for him by his brother Golding. In 1807 he had asked for a woodpecker, a 'Woodspite', to be sent to him, and Golding had taken 'the *fatal* aim' and shot him one (*ibid.*, p.23). If the bird flying across the water in the Witt Collection drawing (see No.235) is a moorhen, as it appears to be, then it is likely that the oil study of startled moorhens similar to No.237 (No.260) is also related to 'The Leaping Horse'.

1825

5 January: to cheer Fisher up, sends him a dozen oil-sketches of Brighton 'done in the lid of my box'. *20th:* to Woodmansterne (Croydon) for ten days to paint a portrait of the Lambert children and their donkey. Learns he has been awarded gold medal by Charles X for his paintings in Paris. Schroth orders another three pictures. *March:* Didot, publisher and collector from Paris, orders three small pictures. *29th:* birth of fifth child, Emily. Receives his medal from the French Ambassador. *May:* 'The Leaping Horse' well noticed. *8th:* death of Bishop Fisher. Sells two landscapes at the Academy. Busy painting for Paris. *17th:* Schroth writes and introduces bearer of letter, Delacroix. Borrows 'The White Horse', 'Stratford Mill' and 'The Lock' for an exhibition of modern masters at the British Institution. The family again at Hampstead: at 'Hooke's cottage'. *20 August:* sends 'The White Horse' to an exhibition at Lille. John Charles seriously ill; takes the family to Brighton on *31st* and returns next day. *7 September:* re-works 'The Leaping Horse'. C. R. Leslie becomes a frequent visitor. In Brighton for a few days; back by *30th*. Has seven pictures in hand; all paid for. Working on the 'Waterloo'; Stothard suggests an alteration – it is adopted. *7 October:* Ward, the engraver, tells him he is a great man in Paris. Spends a few days at Brighton. *31st:* 'getting in the large picture of the Waterloo, on the real canvas'. Early *November:* at Brighton again for a short time; in London by *12th.* Arrowsmith calls; he is pleased with his pictures and orders more. *15th:* considers Arrowsmith's manner offensive and loses his temper. *16th:* the dealer apologises, but it is too late; the advanced money is returned and the relationship broken off. Another short visit to Brighton between *28th* and *6 December.* Johnny Dunthorne working with him on a 'Lock' and 'Waterloo'. *12th:* Arrowsmith's insolvency rumoured. *24th:* joins family at Brighton for Christmas.

Exhibits. R.A.: (115) 'Landscape' (No.239); (186) 'Landscape' (see under No.239); (224) 'Landscape'

(No.238). B.I. loan exhibition, *Living Artists of the English School*: (114) 'Landscape; a Water-mill, with Children angling' (No.177); (118) 'Landscape; a River Scene' (Frick Collection, New York – 'The White Horse'); (129) 'The Lock' (No.227). Salon, Lille: (98) 'Deux vues des Canaux d'Angleterre, *même numéro*' ('The White Horse' and one other).

238 'Landscape' (The Leaping Horse) exh.1825
Oil on canvas, 56 × 73¾ (142.2 × 187.3)
Exh: R.A. 1825 (224)
Prov: probably 16 May 1838 (35, River Scene and Horse Jumping'), bt. Samuel Archbutt, ?sold Christie's 13 April 1839 (97, 'The towing-horse: the capital well known picture'), bt. in; . . . ; ?William Taunton, sold Christie's 16 May 1846 (42, 'Dedham – the companion' [to lot 41, 'Salisbury Cathedral']), bt. in and offered again, Christie's 27 May 1849 (111, 'Dedham, with the towing path': lot 110, referred to as the companion in 1846, was 'Salisbury Cathedral, from the meadows', i.e. No.282 in this exhibition), bt. in; . . . ; Charles Birch, sold Christie's 7 July 1853 (41), bt. Gambart; . . . ; Charles Pemberton 1863; . . . ; Charles Sartorious, whose wife, later Mrs Dawkins, presented it to the Royal Academy 1889
Royal Academy of Arts, London

The subject of 'The Leaping Horse', one of the most complex of Constable's major works, was described thus by the artist in a letter to Francis Darby, a potential purchaser: 'Scene in Suffolk, banks of a navigable river, barge horse leaping on an old bridge, under which is a floodgate and an Elibray[1], river plants and weeds, a more-hen frightened from her Nest – near by in the meadows is the fine Gothic tower of Dedham' (1 August 1825: Leslie 1937 p.192; JCC IV p.97).

Constable's correspondence with Fisher provides a brief history of the work up to its showing in the Academy of 1825. On 13 November Fisher told Constable that he hoped he would 'a little diversify' the subject of his picture this year as to time of day. 'Thompson [sic] you know', he said, 'wrote, not four Summers but *four Seasons*. People are tired of Mutton on top Mutton at bottom & Mutton at the side dishes, though of the best flavour & smallest size' (JCC VI p.180). Stung by this, Constable replied almost by return, and at length, for it seems he had already begun to compose his next painting. 'I am planning a large picture', he wrote on 17 November, 'I regard all you say but I do not enter into that notion of varying ones plans to keep the Publick in good humour – subject and change of weather & effect will afford variety in landscape . . . Reynolds the engraver tells me my "freshness" exceeds the freshness of any painter that ever lived – for to my zest of "colour" I have added "light": Ruisdael (the freshest of all) and Hobbema, were *black* – should any of this be true, I must go on. I imagine myself driving a nail. I have driven it some way – by persevering with this nail I may drive it home – by quitting it to attack others, though I amuse myself, I do not advance them beyond the first – but that particular nail stands still the while' (*ibid.*, p.181). He continues by stating his belief that no man can be born with more than one 'high and original feel', an echo of an opinion

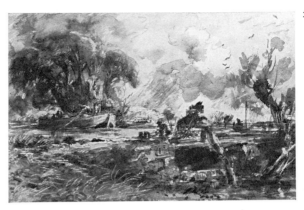

235

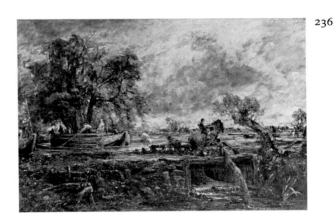

236

237

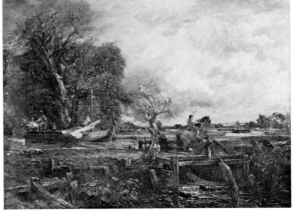

238

of Fisher's[2].

His next reference to the new painting is a brief one in a letter of 17 December: 'I am putting a 6 foot canvas in hand' (*ibid.*, p.187). He has something to say about the work three weeks later, on 5 January 1825: 'I am writing this hasty scrawl [in the] dark before a six foot canvas – which I have just launched with all my usual anxieties. It is a canal scene – my next shall contain a scratch with my pen of the subject' (*ibid.*, p.190). Nothing is known of the pen 'scratch' he mentions. His fullest description of the picture is in a letter to Fisher on 23 January: 'The large subject now on my easil is most promising and if time allows I shall far excell my other large pictures in it. It is a canal and full of the bustle incident to such a scene where four or five boats are passing with dogs, horses, boys & men & women & children, and best of all old timber – props, waterplants, willow stumps, sedges, old nets, &c &c &c' (*ibid.*, p.191).

While he was completing the work, his wife was in the final stages of a difficult pregnancy, and in the event was prematurely confined in the same week that 'The Leaping Horse' was sent to the Academy. Constable tells Fisher on 8 April of his anxious time with Maria, and then continues: 'I have worked very hard – and my large picture went last week to the Academy – but I must say that no one picture ever departed from my easil with more anxiety on my part with it. It is a lovely subject, of the canal kind, lively – & soothing – calm and exhilarating, fresh – & blowing, but it should have been on my easil a few weeks longer. Nevertheless, as my most numerous admirers are for my mind in these things – I thought I would send it' (*ibid.*, pp.197–8).

Two entries in the Journal Constable nearly always kept for his wife while she was in Brighton reveal that Constable had the picture on his easel again after its return from the Academy and made at least one important modification in its composition. 7 September 1825: 'Got up early – set to work on my large picture took out the old willow stump by my horse – which has improved the picture much – almost finished made – one or two other alterations – & am getting on in arrangements – ' (JCC II p.385). The last reference comes in a passage where he is giving an account of the work he is engaged on: 'I am getting my dead horses [commissioned works] off my hands – as fast as I can. I shall do as You say not much mind my little jobs – but stick to my large pictures . . . Then I am making my last Exhibition picture saleable – getting the outline on the Waterloo – &c, &c' (*ibid.*, p.397).

Leslie describes the scene as follows: 'The chief object in its foreground is a horse mounted by a boy, leaping one of the barriers which cross the towing paths along the Stour (for it is that river, and not a canal), to prevent the cattle from quitting their bounds. As these bars are without gates, the horses, which are of a much finer race, and kept in better condition than the wretched animals that tow the barges near London, are all taught to leap, their harness ornamented over the collar with crimson fringe[3] adds to their picturesque appearance, and Constable, by availing himself of these advantages, and relieving the horse, which is of a dark colour, upon a bright sky, made him a very imposing object.' The next passage was omitted from the second edition. 'So carefully did he study this subject, that he

made, in the first place, two large sketches, each on a six-foot canvass. One was, I believe, intended to be the picture, but was afterwards turned into a sketch, not an unusual occurrence with him' (Leslie, 1843 p.51, 1951 p.142).

At least four of the works concerned with the composing and execution of No.238 are to be seen in this exhibition: the two wash drawings from the B.M. (Nos.234 & 235); the full-size oil sketch from the V. & A. (No.236); and the oil study of a moorhen from the family collection (No.237). A third drawing, possibly the study which gave Constable the original idea for the work (see under Nos.235 and 237) belongs to the Courtauld Institute (Witt Collection; repr. Ian Fleming-Williams, *Constable Landscape Drawings and Watercolours*, 1976, fig.61)[4].

Though an actual spot was possibly in the artist's mind when he started, Constable seems to have felt himself bound by topographical accuracy less in No.238 than in any other of his large paintings of the Stour valley. The view he appears to have had in mind when making the two compositional drawings (Nos.234 & 235) is to be obtained from a point on the south bank, nearer Dedham than Flatford, where there is still a cut running away from the river. The footbridge to be seen indicated in the distance near the centre of both drawings agrees with this identification, as Fen Bridge (see No.48) might well have been visible downstream from this spot, and certainly it could have been visualised so in the memory of the artist.

The Witt drawing, undoubtedly from nature, depicts a leaning and hollow willow-stump (the one in Nos.234 & 236), cattle on the opposite bank of the river, and to the right the tower of Dedham church. This could not have been drawn from the spot Constable had originally had in mind for his picture, for Fen Bridge lay in one direction (N.E.) and Dedham in almost exactly the opposite one behind the spectator, in fact, in Nos.234 & 235. In the final work, No.238, Dedham church tower, painted with the greatest care and very like, is to be seen almost against the right-hand edge of the canvas; Fen Bridge has disappeared. We are evidently not expected to orientate ourselves on a known scene: the picture was not painted for his friends in the valley.

It has been pointed out above that Leslie omitted from the second edition of his *Life* the account of Constable having initially made two 6-foot sketches, one of which was intended to be the picture but was afterwards turned into a sketch. Graham Reynolds has observed that this suggests Leslie may have considered the statement to be ill founded (1973 p.177). Reynolds is probably correct, but there remains a possibility that there was an element of truth in Leslie's statement after all, that there *were* two initial compositional sketches – the two studies from the B.M., Nos.234 & 235. If this was the case, and if the two drawings were in being as alternative designs before Constable started working in oils on a full-size canvas, this might well account for some of the troubles that he appears to have had with the final painting, neither of the compositions ever having quite succeeded in gaining the ascendancy.

The two initial compositions differ in the following respects: in No.234 the horse stands while his rider scrambles on to his back, the willow-stump leans towards the horse, a second horse and rider are just beyond, a

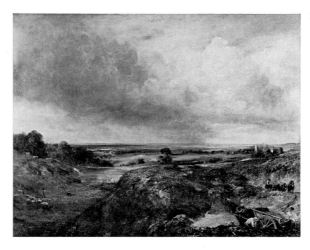

239

pair of barges drift downstream; in No.235 the scene
is one of greater activity, a riderless horse jumps the
barrier, the willow-stump is more erect, beyond it there
is a masted vessel, a man poles a single barge, clouds
and birds suggest a windy sky.

In the full-size sketch, No.236, Constable combined
elements from both compositions; the willow, the pair
of barges, and (in the distance) the second horse from
No.234; the horse, the man at the pole and the wilder
sky from No.235. To these he added a pole in the hands
of the man on the second barge, a cow at the water's
edge, a rider on the jumping horse, a pair of distant
barges, further timbers in the left fore-ground (taken
from p.76 of the 1813 sketchbook, No.119), and under
the bridge what appears to be a net trailing in the over-
spill. Traces of overpainting suggest that at one stage
there was a willow in the centre of the composition,
leaning slightly to right of vertical, a feature similar to
the one in the final painting, No.238.

Some of the alterations Constable made to the ex-
hibited work, No.238, are plain to see – the one barge
with its mast and half-furled sail, the cattle, the upright
willow newly positioned, Dedham church, the new
timbers in the left foreground, and the startled moorhen
to the right. It is only from pentimenti – places where
underpainting shows through – and from x-ray photo-
graphs that we learn just how many changes were made
on the final canvas. The following features were initially
taken over from the full-size sketch: the second barge
on the extreme left; the port bow of the main barge, just
beyond the stem; the sloping pole; the cow at the water;
and the leaning willow-stump (when subsequently
painted out, for some reason the lowest part was left
untouched). X-ray photography reveals two new fea-
tures: a man standing amidships in the main barge and
holding the pole as if trailing it, and a sail, about the
height of the church tower, to the right of the now
vanished willow. It also reveals that Constable initially
worked as vigorously with the palette-knife on this, the
final version, as he did on the other, the so-called sketch.

Both the canvas of this final version and that of the
6-foot sketch (No.236) were taken off their stretchers by
Constable at some stage and relined so that he could
extend his composition, but this proved insufficient for
his needs in the present work (No.238) and he had to
have a further 2½-inch strip tacked along the top so that
the uppermost branches of the trees did not awkwardly
'tickle' the edge of the picture.

See also the note on p.206.

240

239 'Landscape' (Branch Hill Pond, Hampstead)

exh.1825
Oil on canvas, 24½ × 30¾ (62.2 × 78.1)
Exh: R.A. 1825 (115)
Prov: bt. from Constable by Francis Darby 1825;
his son Alfred Darby, from whom bt. by Agnew's
(?1908) and sold to Sir Joseph Beecham, sold
Christie's 3 May 1917 (8)[5], bt. Agnew and sold to
Knoedler's 1918; Chester Johnson; Mrs F.
Weyerhaeuser; Newhouse & Co., New York,
from whom bt. by A. D. Williams; presented to
Virginia Museum by Mrs A. D. Williams 1949
Virginia Museum of Fine Arts, Richmond, Virginia
Constable made a large number of paintings of the
view over Branch Hill Pond on Hampstead Heath. Two

241

compositions predominate: what may be called type A., in which a bank rises steeply across the right foreground, obscuring the distant view, and type B., in which the viewpoint is higher and the horizon is clearly visible above a small plateau. Examples of type A. are a sketch in the V. & A. (R.171) dated 1819, a painting exhibited in 1828 (No.254 below), a small picture of the 1820s in the Tate Gallery (No.1813) and a painting made in 1836 (No.334 below). Type B. is seen in the present work, No.239, in the version of it in the Oskar Reinhart Collection at Winterthur and in an unfinished painting in the Tate Gallery (No.4237).

Constable described the work which he exhibited at the R.A. in 1825 as No.115, 'Landscape', in a letter to Francis Darby on 1 August that year: 'No.115. A scene on Hampstead Heath, with broken foreground and sand carts, Windsor Castle in the extreme distance on the right of the shower. The fresh greens in the distance (which you are pleased to admire) are the feilds about Harrow, and the villages of Hendon, Kilburn, &c.' (JCC IV p.97). In the same letter he gave the size of the frame as 36 × 42 inches. A few days later Darby, son of the Abraham Darby who built the Iron Bridge at Coalbrookdale, agreed to buy the picture and its companion (see below) for 130 guineas the pair, which price Constable had reduced, on Darby's request, from 150 guineas (ibid., pp.97–8). No.239 is identifiable with the picture Darby bought because of its provenance from Darby's son and because its subject and size correspond with the information supplied in Constable's letter to Darby. The other work Darby bought was described by Constable in the same letter as follows: 'No. 186. Companion to the above. Likewise a scene on Hampstead Heath, called Child's Hill. Harrow with its spire in the distance. Serene afternoon, with sunshine after rain, and heavy clouds passing off. Harvest time, the foreground filled with cattle & figures, and an Essex market cart'. This, like No.239, descended to Darby's son and was also acquired by Sir Joseph Beecham, in whose sale in 1917 it figured as lot 9. The composition appears to have been based on an oil study now in the V. & A. (R.333).

On 22 May 1824 the Paris dealer Claude Schroth ordered three pictures from Constable, two of them Hampstead views measuring 21 × 30 inches (JCC II p.314). Constable told Fisher on 17 December that year: 'They will soon go but I have copied them, so it is immaterial which are sent away' (JCC VI p.187). Schroth's pictures are thought to have been of the same subjects as the two that Darby bought the following year. Darby's are usually regarded as having been the copies but in view of Constable's remark about it not mattering which were sent away, we cannot be certain who actually had the first of the two pairs that he painted. Schroth's versions seem to have been repatriated after his bankruptcy in 1839–40 and to have been the originals of the engravings Lucas made of the subjects in the 1840s. In the text accompanying Bohn's edition of the prints in 1855 the 'Branch Hill Pond' was said to belong to Mrs Gibbons and the 'Child's Hill' to Edwin Bullock. The former is now in the Oskar Reinhart Collection. The present whereabouts of both the Darby and the Schroth pictures of 'Child's Hill' is unknown to the organisers. A version of this subject sold at Christie's on 23 June 1972 (117) is inscribed 'John Constable R.A. [sic] 1824' – an obstacle to its identification with either of the documented versions, since Constable was elected as an R.A. only in 1829.

240 Landscape with Trees (Copy after Claude)
d.1825
Pen, brown and grey wash, $11\frac{5}{16} \times 7\frac{7}{8}$ (28.8 × 20)
Inscribed on verso 'Copied from a drawing by Claude Lorraine left to Sir Thos Lawrence. Hampstead July 1825' and in another hand: 'Copied by J. Constable ARA. – from a drawing by (as–it is said) Claude Lorraine done at Hooke's Cottage Hamp^d. July 1825.'
Prov: . . . ; Dr J. Percy; Squire Gallery, from whom bt. by L. G. Duke 1934; bt. by present owners from Colnaghi's 1961
Mr and Mrs Paul Mellon

Constable's only known remark on the drawings of Claude occurs in a letter to Fisher of 17 January 1824 (JCC VI pp.149–50). In its context, it will be seen that his comment need not be taken too seriously. He is writing to explain his unwillingness to send 'Stratford Mill' (No.177) for exhibition at the British Institution. '. . . I am sure every man who has a reputation to lose is in hazard of it at that place. Consider who are our judges – Carr, the Magnus [the Revd. W. Holwell Carr, a noted collector of early Masters] – Sir Cs. Long [later Lord Farnborough] – Priapus Knight [Richard Payne Knight, so called from his notorious work on the worship of that deity] – none of them had any affection for *new* art. The latter gentleman called on me the day before yesterday – he admired (so he said) my pictures, called me a "most successful landscape painter" – saw me hard at work for my four infants – and went away – & that day gave "Sixteen Hundred Pounds", for some drawings or slight sketches by Claude. I saw them – drawings – they looked just like papers used and otherwise mauled, & purloined from a Water Closet – but they were certainly old, & much rent, & dissolved, &c. but their meer charm was their age.' The 'slight sketches' were of course the great collection of Claude drawings which Payne Knight bought from Colnaghi's, where Constable had presumably viewed them, and which Knight left to the British Museum on his death.

The whereabouts of the original Claude drawing is not known, but in appearance one would expect it to have looked very like No.240. It was Constable's practice to follow the model as closely as he could when making a copy.

The cottage referred to in the inscription was the house rented this year by Constable for his family from a shoemaker, a Mr Hook (see JCC II pp.384, 391).

241 Brighton Beach d.1825
Pencil, $4\frac{9}{16} \times 7\frac{5}{16}$ (11.5 × 18.5)
Inscribed 'Brighton friday 14 Oct. 1825'
Prov: Hugh Constable, from whom acquired by Leggatt's 1899 (label on back); . . . ; Sir Harry Baldwin, sold Sotheby's 19 June 1933 (125), bt. Sir Robert Witt; bequeathed by him to Courtauld Institute 1952
Courtauld Institute of Art (Witt Collection)

The colliers on the shore at Brighton had a particular fascination for Constable, perhaps because the shipping

and retailing of coal formed part of the family business. The brigs are to be seen in the oil-sketches he made on the beach – No.228, for example – and there are sketches of these square-rigged vessels, high and dry, among the last drawings he made at Brighton in 1828. A fine undated watercolour of three colliers against a sunset sky (of which the V. & A. has a copy, R.285, possibly by one of the sons) is at the Cecil Higgins Museum, Bedford.

Sketches such as No.241 are in some ways more re-vealing of the artist's 'hand' than drawings executed less hastily. Such brilliant notation, brief and forceful, is not to be found in the work of Constable's imitators, or in the work of those, such as Agostino Aglio, who are sometimes mistaken for him.

1826

1 January: paints a small oil of the sea (No.244). Works on a 'Gillingham Mill'. *13th:* receives a gold medal from Lille. Has work in hand to the tune of £400, but regrets his quarrel with Arrowsmith. Lawrence (P.R.A.) calls to see the unfinished 'Waterloo'; expresses ap-proval. The family returns from Brighton. *February:* fails in the elections for R.A.; Leslie and Pickersgill successful. By *8 April*, has sent 'The Cornfield' to the Academy; tells Fisher this has occupied him wholly, he could think of and speak to no one while painting it. *12th:* learns that Abram is seriously ill; takes the mail that night for Suffolk. Returns four days later. *May:* in charge of the children while Maria and Minna are at Putney. *16th:* most unusually, goes to a dance, at the Chalons'. Works on a portrait. Fisher, Leslie, Beau-mont among his visitors. *July:* work on the 'Waterloo' continues. *13th:* Schroth writes to say he is ceasing to deal in pictures. Takes a house on Downshire Hill, Hampstead, for his family's benefit. *September:* takes John Charles to Brighton for his health; reports to Leslie that Maria, now pregnant again, is 'very far from well'; has been painting a 'Glebe Farm'; paints a pic-ture for James Carpenter, bookseller, possibly the new version of the 'Lock' (No.262). *14 November,* sixth child born, prematurely, Alfred Abram; considers his children as blessings '– only, that I am now satisfied and think my quiver full enough'. Is looking for a perman-ent home in Hampstead. Lets the upper part of 35 Charlotte Street; retains his painting-room and lives in his 'parlors'. *December:* Maria slow to recover from childbirth.

Exhibits. R.A.: (122) 'A mill at Gillingham, in Dorset-shire' (No.243); (225) 'Landscape' (No.242).

242 **'Landscape' (The Cornfield)** d. & exh.1826
 Oil on canvas, 56¼ × 48 (143 × 122)
 Inscribed 'John Constable. f. London. 1826.'
 Exh: R.A. 1826 (225); B.I. 1827 (101,
 'Landscape; Noon', size with frame
 70 × 63 inches); Salon, Paris 1827 (4 Nov. 1827 –
 Spring 1828, 219, 'Paysage avec figures et
 animaux')[1] but not returned to England until

September 1828 (JCC IV pp.157–8); Birmingham Society of Arts 1829 (opened 24 Sept., 122, 'Noon')[2]; Worcester Institution 1835 (opened June, 50, 'Harvest – Noon; a Lane Scene')[3]
Prov: purchased from the artist's executors 1837 by a body of subscribers for presentation to the National Gallery
National Gallery (130)

'I have dispatched a large landscape to the Academy', Constable wrote to Fisher on 8 April 1826, '– upright, the size of my Lock [No.227 above] – but a subject of a very different nature – inland – cornfields – a close lane, kind of thing – but it is not neglected in any part. The trees are more than usually studied and the extremities well defined – as well as their species – they are shaken by a pleasant and healthfull breeze – "at noon" – "while now a fresher gale, *sweeping with shadowy gust the feilds of corn*" &c, &c.' (JCC VI p.216.) Constable's quotation is from Thomson's *Summer*, lines 1654–6. We know that the 'Landscape; Noon' which he exhibited at the British Institution in the following year was the same work because the lines appeared in the catalogue on that occasion (the italics are Constable's, not Thom-son's):

> A fresher gale
> Begins to wave the woods and stir the stream,
> *Sweeping with shadowy gust the fields of corn.*

Although Constable associates these lines with noon, they are actually part of Thomson's account of 'sober Evening', which may suggest that he was quoting from memory and had forgotten the context, or that he was deliberately adapting the lines. The special attention which Constable told Fisher he had given to the trees may have had something to do with his botanist friend Henry Phillips of Brighton, who, on 1 March 1826, had sent him a letter with details of the plants which could be expected to be in flower in the month of July (JCC V p.80, taken from Leslie 1843 p.55). The tree at the extreme left closely follows (or is closely followed by) one in the so-called 'Scene in Helmingham Park' in the Art Gallery of Ontario, Toronto, which is otherwise unrelated: the organisers have not seen this work.

In 1869 Constable's son Charles Golding Constable identified the lane in the foreground as the one which led down from East Bergholt to the path across the fields to Dedham[4], and Beckett has pointed out (JCC II p.425) that it would have been by this route that Con-stable walked to school at Dedham as a boy. The church in the distance is not, however, that of Dedham. As C. G. Constable also said, 'The little church in the distance never existed; it is one of the rare instances where my father availed himself of the painter's license to improve the composition'. The church does not appear in the study for the picture in the collection of Anthony Bacon (on loan to the City Museum and Art Gallery, Birmingham), which also lacks the figures and animals. Constable seems to have utilised a lot of disparate early material when adding these to the com-position. A similar figure of a boy drinking from a stream appears in an oil sketch of about 1810, 'A Country Lane', in the Tate Gallery (No.1821). The donkey is a repetition of the one in the 1811 'Dedham Vale' (No.100) and there is a separate study of it, to-gether with its foal, in the V. & A. (R.287). An oil study of ploughs made in 1814 and now also in the V. & A.

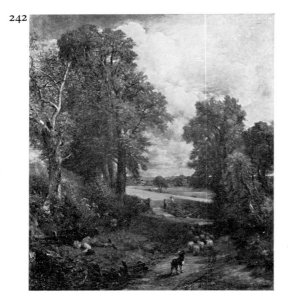

242

243

244

(R.136) appears to have been used for the plough introduced near the gate. It was presumably these rustic accessories – and the dog, sheep and 'picturesque' broken gate – that Constable had in mind when he told Fisher: 'I do hope to sell this present picture – as it has certainly got a little more eye–salve than I usually condescend to give to them' (JCC VI p.217). But, although exhibited five times by Constable, the picture remained unsold until 1837, when a body of subscribers purchased it for 300 guineas from his executors and presented it to the National Gallery – the first work by Constable to become national property. Leslie (1845 p.293, 1951 pp.267–8) relates that it was Constable's Hampstead friend the amateur artist William Purton who suggested that a picture should be so presented but that the work Purton had in mind, 'Salisbury Cathedral from the Meadows' (No.282 below), was rejected because 'it was thought by the majority of Constable's friends that the boldness of its execution rendered it less likely to address itself to the general taste'. The committee which selected 'The Cornfield' was chaired by Sir William Beechey and the 105 subscribers included Faraday and Wordsworth as well as many painters and personal friends of the artist (a list is at the National Gallery).

There is some reason to think that Constable saw 'The Cornfield' as a pendant to 'The Lock' (No.227 above), even though the latter had probably been sold to Morrison before 'The Cornfield' was begun. S. W. Reynolds began an engraving of Morrison's picture in 1824 and later on, possibly early in 1826, he wrote to Constable: '*You was to have painted me* a companion to the *Lock*, Avez vous' (JCC IV p.267). Reynolds never finished 'The Lock' but his former pupil David Lucas engraved another plate of the same composition which was published as a companion to one of 'The Cornfield' in 1834.

243 'A mill at Gillingham, in Dorsetshire'

exh.1826

Oil on canvas, $19\frac{3}{4} \times 23\frac{3}{4}$ (50.2 × 60.4)

Exh: R.A. 1826 (122); B.I. 1827 (321, 'A Mill at Gillingham, Dorset', size with frame 30 × 34 inches)

Prov: painted for Mrs Hand 1826, sold Christie's 12 June 1847 (54), bt. Vokins; Lewis Fry by 1882 and until at least 1889; C. A. Barton, sold Christie's 3 May 1902 (5), bt. Falke; S. B. Joel, sold Knight Frank & Rutley 8 December 1931 (268), bt. Vicars for Sir Bernard Eckstein, sold Sotheby's 8 December 1948 (65), bt. Vicars; W. L. Lewis, New York; bt. by present owners from J. S. Maas 1962

Mr and Mrs Paul Mellon

Constable visited Gillingham in Dorset on two occasions: briefly in July 1820 and for a longer stay in 1823. On the latter visit, which lasted from 22 August until 10 September, he painted a picture of Gillingham bridge (No.221) and made studies of Perne's (or Parham's) Mill about a mile to the north of Gillingham. This water-mill had caught his eye on the 1820 visit and was one of the reasons why he wanted to return. Twice during the early months of 1823 he told Fisher of his desire 'to do something' at the mill (JCC VI pp.113,116). It was probably Perne's Mill that he had in mind when

he wrote to Maria from Gillingham that year, 'the mills are pretty. and one of them wonderfull old & romantic' (JCC II p.283). Constable was just in time. In 1825 the mill burned to the ground and Fisher reported, 'A huge misshapen, new, bright, brick, modern, improved, patent monster is starting up in its stead' (JCC VI p.206).

A small study of Perne's Mill in the collection of Lord Binning probably dates from the 1823 visit. A replica of it made for Fisher in June 1824 is in the Fitzwilliam Museum. No.243 follows the composition of these small paintings very closely but the donkeys and ducks were only added when Constable came to paint the larger version. The rather amorphous roof of the mill was also given more shape by the invention of a gable at the right, and the chimneys were altered.

No.243 was painted for a Mrs Hand, who later, and perhaps also at this time, lived at Richmond. She seems to have been a friend of the Chancellor of the Diocese of Salisbury. Mrs Hand first appears on the scene in July 1824 when Constable said that she was 'anxious about a small picture of mine of the Gillingham Mill' (JCC II p.362). Presumably she had seen one of the two early studies already mentioned. Constable did not, however, find time to paint her a version of the composition until January 1826 when he stayed at Brighton with his family. 'I staid a fortnight with them', he told Fisher, '& did there one of my best pictures – the subject was the Mill (Perne's) at Gillingham – it is about 2 feet, and is so very rich & pleasing that if you are at Salisbury and would like to see it, I will beg the proprietor Mrs Hand (a friend of the Chancellor's) to let me send it to you – *Mere* church is in the distance' (JCC VI p.212). It is the reference to Mere church in this letter that enables us to identify No.243 as Mrs Hand's picture since this detail does not appear in the other versions. Maria read to Constable from Quatramère de Quincy's edition of Poussin's letters while he was at work on the picture, presumably translating as she read (*ibid.*; see also JC:FDC pp.34–5).

Constable exhibited pictures of the mill at the R.A. in 1826 and the B.I. and R.A. in 1827. No.243 can be identified with the 1826 exhibit for the following reasons. Only two candidates for the exhibited works are known (the small studies previously mentioned can presumably be ruled out), this painting and one in the V. & A. (No.246 below). Of these two, No.243 must have been the picture shown at the B.I. in 1827 because the size of the V. & A. painting is quite inconsistent with the measurements given in the B.I. catalogue, whereas No.243 fits the given size very well, allowing

for a frame just over 5 inches wide. If it had been shown at the B.I. in 1827, No.243 cannot also have been exhibited at the R.A. later that year, the Academy's rules (or at least its custom) forbidding the display of previously exhibited paintings. The picture sent to the R.A. in 1827 would therefore have been the other version, the V. & A. painting (No.246). For the same reason, the work shown at the R.A. in 1826 must have been a different picture from the one exhibited there in 1827, that is, it must, in the absence of any other candidate, have been No.243.

The composition was engraved, perhaps by Ebenezer Landells, for a vignette[5] in William Yarrell's *A History of British Fishes* (1836, Vol.I, p.59). The engraving follows the 1823–4 studies rather than No.243 in the treatment of the right-hand part of the roof but lacks various details seen in the studies.

244 The Sea near Brighton d.1826

Oil on paper laid on card, 6⅛ × 9⅜ (17.3 × 23.9)
Inscribed on label on backing board (in C. G. Constable's hand and presumably copying inscription on back of paper): 'Brighton. Sunday, Jan.ʸ 1ˢᵗ 1826. From 12 till 2 P.M. Fresh breeze from S.S.W.'
Prov: 23 June 1890 (80, 'Brighton, Jan. 1st, 1826'), bt. Dowdeswell (whose label is still on the back); George Salting by 1902 and bequeathed by him to the National Gallery 1910; transferred to Tate Gallery 1961
Tate Gallery (2656)

Constable went to Brighton to be with his wife and family over New Year 1826. On 14 January 1826, a Saturday, he told Fisher that he had returned on Thursday, i.e. the 12th., having stayed a fortnight, and that he had painted Mrs Hand's picture of Gillingham Mill (No.243) there (JCC VI p.212). No.244 must be one of the very few oil sketches which Constable is known to have painted outdoors in winter.

245 Marine Parade and Chain Pier, Brighton

1825 or 1826
Pencil and pen, 4⅜ × 16¾ (11.1 × 42.5), on two pieces of paper, watermarked 1824
Prov: presented to the V. & A. by Isabel Constable 1888
Victoria and Albert Museum (R.289)

Constable used this drawing in the preparation of his painting 'Chain Pier, Brighton' (No.247) in the winter of 1826–7. As the paper is watermarked 1824, the

245

drawing is likely to date from one of his visits to Brighton in 1825 or 1826. Reynolds (1973 p.181) proposes 1826 on the grounds that the Albion Hotel, built that year, is shown, but the drawing does not extend far enough on the left to include the hotel, which is the building at the extreme left of the final painting.

1827

Little is known of him in the first months. *7 February:* death of Sir George Beaumont. George Morant, a fellow-Director of the A.G.B.I. buys a 'Glebe Farm' at the British Institution. *April:* at Downshire Hill, Hampstead; youngest child, Alfred, seriously ill. By *7th*, has completed his 'Chain Pier, Brighton' for the Academy; Fisher has seen it and approves. *The Times* refers to him as being 'unquestionably the first landscape painter of the day', when reviewing 'Chain Pier' (Johnny Dunthorne exhibits for the first time: 'Glade in a Wood'). *June:* publication of W. J. Ward's engraving after Constable's portrait of one-time Headmaster of Westminster, Dr Wingfield. *12 August:* death of William Blake. *14th:* writes to Linnell that A.G.B.I. should help Blake's widow. By *26th*, settled in newly leased house, No.6 Well Walk, Hampstead, a permanent home. Begs Fisher for a loan of £100. Presents a small landscape to Comte de Forbin, Director-General of the Royal Museums in France. *3 September:* Fisher writes that he is 'destitute'. Jack Bannister the actor, a neighbour and admirer, dines with the Constables on venison sent by Lady Dysart. Colnaghi acts as agent for the picture he sends to the Paris Salon, 'The Cornfield'. Proposes to Abram that he should bring his children down to Flatford Mill for a holiday; Abram demurs –'a more dangerous place for children could not be found upon earth.' *4 October:* writes to Maria from Flatford; he has his two eldest with him, John and Minna, the first visit by any of his children to Suffolk; he sketches while they fish. *15th:* his last dated drawing of the holiday. *2 November:* takes the chair at a meeting of the A.G.B.I. Directors. *30th:* Fisher writes that he intends to spend two days with them at Hampstead in December and will bring £30 to help out.

Exhibits. B.I.: (101) 'Landscape; Noon', frame 70 × 63 inches (No.242); (314) 'The Glebe Farm', frame 31 × 37 inches (see under No.321); (321) 'A Mill at Gillingham, Dorset', frame 30 × 34 inches (No.243). R.A.: (48) 'Mill, Gillingham, Dorset' (No.246); (186) 'Chain Pier, Brighton' (No.247); (290) 'Hampstead Heath'[1]. Salon, Paris: (219) 'Paysage avec figures et animaux' (No.242).

246 'Mill, Gillingham, Dorset' exh.1827
Oil on canvas, 24¾ × 20½ (63 × 52)
Exh: R.A. 1827 (48); probably Birmingham Institution 1828 (31, 'Mill at Gillingham, Dorset'); Worcester Institution 1835 (68, 'A Water Mill')[2]
Prov: 16 May 1838 (57, 'Gillingham Mill, Dorsetshire'), bt. in by Leslie; bequeathed to the

V. & A. by Isabel Constable 1888
Victoria and Albert Museum (R.288)
Constable's visits to Gillingham in 1820 and 1823 have already been mentioned in the entries on No.221, 'The Bridge at Gillingham', and No.243, the painting of Perne's Mill which Constable exhibited at the R.A. in 1826. The present painting shows Perne's Mill from a different angle and was presumably based on a now lost drawing or oil study. The reasons for identifying it with the work shown at the R.A. in 1827 are given in the entry on No.243.

No.246 may have originated in a commission from the owner of Constable's 'Stratford Mill', John Pern Tinney, who probably had some family connection with Perne's Mill. The commission was not, however, fulfilled (see Reynolds 1973 pp.180–1). Lucas published a mezzotint of the picture in 1845 (Shirley 1930 No.43).

247 'Chain Pier, Brighton' exh.1827
Oil on canvas, 50 × 72 (127 × 183)
Exh: R.A. 1827 (186); B.I. 1828 (64, 'The Beach at Brighton, the Chain Pier in the distance', size with frame 68 × 99 inches)
Prov: 16 May 1838 (68, 'Brighton and the Chain Pier'), bt. Tiffin who sold it the same year to the Revd. T. Sheepshanks; by descent to Lt. Col. A. C. Sheepshanks who sold it to Agnew's 1948; bt. from them 1948 by H. A. C. Gregory, sold Sotheby's 20 July 1949 (136), bt. in; bt. by Tate Gallery through Agnew's 1950
Tate Gallery (5957)
(colour plate facing p.160)

Although Constable made many drawings and oil studies in the Brighton area, he produced only one 'set-piece' of a Brighton subject. In a letter to Fisher of August 1824 he explained his mixed feelings about the place and about its suitability as a subject for painting. Some such antithesis of the natural and the artificial as is expressed here may have been in his mind when he came to paint 'Chain Pier'. 'Brighton', he wrote, 'is the receptacle of the fashion and off-scouring of London. The magnificence of the sea, and its (to use your own beautifull expression) everlasting voice, is drowned in the din & lost in the tumult of stage coaches – gigs – "flys" &c. – and the beach is only Piccadilly . . . by the sea-side. Ladies dressed & *undressed* – gentlemen in morning gowns & slippers on, or without them altogether about *knee deep* in the breakers – footmen – children – nursery maids, dogs, boys, fishermen – *preventive service men* (with hangers & pistols), rotten fish & those hideous amphibious animals the old bathing women, whose language both in oaths & voice resembles men – all are mixed up together in endless & indecent confusion. The genteeler part, the marine parade, is still more unnatural – with its trimmed and neat appearance & the dandy jetty or chain pier, with its long & elegant strides into the sea a full ¼ of a mile. In short there is nothing here for a painter but the breakers – & sky – which have been lovely indeed and always varying. The fishing boats are picturesque, but not so much so as the Hastings boats . . . But these subjects are so hackneyed in the Exhibition, and are in fact so little capable of that beautifull sentiment that landscape is capable of or which rather belongs to landscape, that they have done a great deal of harm to the art – they form a class of

art much easier than landscape & have in consequence almost supplanted it, and have drawn off many who would have encouraged the growth of a pastoral feel in their own minds – & paid others for pursuing it. But I am not complaining – I only meant to call to your recollection that we have Calcott & Collins – but not Wilson or Gainsborough' (JCC VI p.171).

The central portion of the composition of No.247 was derived from a drawing made at Brighton in 1825 or 1826 (No.245). No.231 provided some of the foreground accessories and the boat at the left was taken from a drawing later in the Heseltine collection (sold Sotheby's 25 March 1920, lot 117, repr. in catalogue). The organisers have not seen the two oil sketches of the composition at Philadelphia, one in the Johnson Collection and the other in the Wilstach Collection at the Philadelphia Museum of Art, and therefore find it difficult to assess them. It is worth noting, however, that a small oil study which seems undoubtedly to be by Constable (lot 254 in the 17 June 1892 sale; now in a private collection) corresponds very closely to the right-hand side of the Wilstach sketch, showing a man watching a boat being beached, and that in the Johnson sketch this watching figure has been moved to the centre of the composition, as in the final painting, while the boat (or, rather, a boat) remains at the right. In the finished painting, No.247, the boat-beaching incident is given up altogether and a different boat appears a short distance off the beach at the right.

Various alterations were made during the painting of No.247, at Hampstead in the winter of 1826–7, and these can still be traced on the surface of the picture. The pier was originally shorter, ending at the point now occupied by the last of the towers. Having decided to lengthen it, Constable had also to paint out a sail on the boat to the right of the pier, which would otherwise have masked the new pier head. The angle of the sail on the boat seen between the third and fourth towers of the pier was also changed.

Constable wrote to Dominic Colnaghi on 6 April 1827 to tell him that he had just completed the picture and that 'Fisher rather likes my coast, or at least beleives it to be a usefull change of subject' (JCC IV p.155). Mrs Fisher was informed by her husband that 'It is most beautifully executed & in a greater state of finish and forwardness, than you can ever before recollect. Turner, Calcott and Collins will not like it' (JCC VI p.230). But such established marine painters had in fact little to fear: the work found no buyer when exhibited at the R.A. that year. 'My Brighton was admired – "*on the walls*"', the artist told Fisher, '– and I had a few nibbles out of doors. I had one letter (from a man of rank) inquiring what would be its "*selling*" price. Is not this too bad – but that comes of the bartering at the Gallery – with the keeper &c.' (*ibid.*, p.231). Despite another airing at the B.I. in 1828 and the publication by Colnaghi of an engraving of it (No.248) in 1829, 'Chain Pier, Brighton' remained with Constable until his death. The 1829 print shows that the painting was later cut down on the left by about one eighth of its length: originally the composition was more emphatically closed at the left by a large sail on the beached boat; a second boat and several figures have also been lost.

The Chain Pier was opened on 25 November 1823 and destroyed by a storm on 4 December 1896.

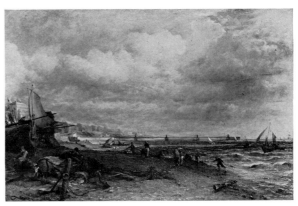
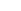

249

250

Turner's pictures of it (Tate Gallery and Petworth House) appear to have been painted about the same time as No.247.

FREDERICK SMITH after CONSTABLE

248 'View of Brighton with the Chain Pier'
published 1829
Line-engraving, $7\frac{1}{2} \times 12\frac{1}{4}$ (19 × 31.1)
Trustees of the British Museum (1841-11-13-203)
As well as slightly altering the proportions of the picture, Smith's engraving of 'Chain Pier, Brighton' (No.247) shows the painting before it was cut down at the left. The print, published by Colnaghi (and 'Mr. Folker, Brighton') in 1829, was the first engraving after one of Constable's major compositions to be completed, an earlier plate by S. W. Reynolds of 'The Lock' having been left unfinished.

249 Flatford d.1827
Pencil, $8\frac{11}{16} \times 12\frac{13}{16}$ (22.1 × 32.9)
Inscribed 'Flatford Octr 5 1827'
Prov: 17 June 1892 (177, 'Flatford, 1827'), bt. Gooden for National Gallery of Ireland
National Gallery of Ireland, Dublin
See No.250.

250 Flatford Old Bridge and Bridge Cottage on the Stour 1827
Pencil, $8\frac{7}{8} \times 13$ (22.5 × 33)
Prov: presented to the V. & A. by Isabel Constable 1888
Victoria and Albert Museum (R.297)
Constable's fortnight at Flatford with his two eldest children, John and Minna, in October 1827 was the first holiday he had had in Suffolk since his summer with Maria in 1817. It was the children's first visit to their father's boyhood haunts and they were immensely taken with it. John 'is crazy about fishing – he caught 6 yesterday and 10 to day some of which we are going to have for dinner', Constable reported home (letter to Maria, 4 October 1827; JCC II p.439). Most of the sketches from this visit, of which No.249 is one and No.250 probably another, were of subjects on the river bank – perhaps because someone had to keep an eye on the children while they fished and played at the water's edge.

No.249 is of a view Constable had already drawn in his sketchbook of 1814 (No.126), the view he had painted in the fourth of his large canvases, 'View on the Stour, near Dedham' (see No.201).

251 A Lock on the Stour d.1827
Pencil, $8\frac{7}{8} \times 13\frac{1}{8}$ (22.4 × 33.2)
Inscribed '11 Oct 1827'
Prov: presented to the V. & A. by Isabel Constable 1888
Victoria and Albert Museum (R.293)
There can be little doubt that this drawing is of Flatford lock. Once again Constable has omitted the posts and lintels that formed part of the box-construction of the lock, the timbers that are to be seen so clearly in No.97 and No.98 but which were found to be pictorially unacceptable in Nos.227 and 262.

251

252 Water Lane, Stratford St. Mary, Suffolk
d.1827
Pencil and grey wash, 13 × 8⅞ (33 × 22.5)
Inscribed 'Stratford Water Lane. Oct 1827'
Prov: presented to the V. & A. by Isabel
Constable 1888
Victoria and Albert Museum (R.291)

252

Constable made two pencil and wash drawings of this house during his stay at Flatford in 1827. Lt. Col. Brooks has identified it as one which still stands. Situated on the road that runs across the fields from Stratford St. Mary to Dedham, it was once known as Old Valley Farm. In its original pink wash it is clearly to be seen in the centre of 'Dedham Vale: Morning', No.100. Here, in No.252, we are approaching it from the north; the other sketch, V. & A., R.296, was taken from the opposite viewpoint.

1828

2 January: his seventh child, Lionel Bicknell, born. Begins round of calls on Academicians, canvassing for the forthcoming election; Turner receives him at his door. Leslie is his confidant in these matters. *9 February:* Etty is elected by 18 votes to his 5. *9 March:* death of Maria's father; valuation of his estate much greater than expected; they stand eventually to gain a sum approaching £20,000. *May:* Johnny Dunthorne in Suffolk; appears to have thoughts of a change in his position as assistant. Maria's condition deteriorates; for a while she is at Putney, but by *June* has been moved to Brighton. *11th:* Fisher is told she is 'sadly ill'. *23 July:* tells dealer friend that he is with his easel in Brighton 'attending a very sick wife and afflicted child', that it has done them very little good and that they will be moving back to Hampstead shortly. Maria suffering from pulmonary tuberculosis, now enters the last stage of her illness. *October:* asks Fisher to join him but his friend is unable to leave Dorset. *November:* Leslie visits him at Hampstead – though cheerful in Maria's company, 'before I left the house, he took me into another room, wrung my hand, and burst into tears without speaking'. *23rd:* Maria dies. Moves temporarily to Charlotte Street with all his children. *25 December:* Fisher writes to say he will be in London for a month and will devote the greatest part of that time to him & his painting room.

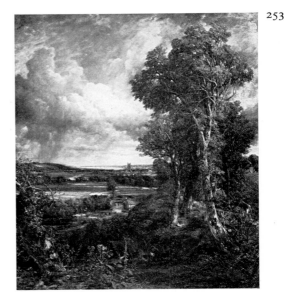
253

Exhibits. B.I.: (64) 'The Beach at Brighton, the Chain Pier in the distance', frame 68 × 99 inches (No.247). R.A.: (7) 'Landscape' (No.253 or 254); (232) 'Landscape' (No.253 or 254). Birmingham Institution: (31) 'Mill at Gillingham, Dorset' (probably No.246).

253 'Landscape' (Dedham Vale) exh.1828
Oil on canvas, 57⅛ × 48 (145 × 122)
Inscribed on a label on the stretcher 'No.1
Landscape John Constable 35 Charlotte Street
Fitzroy Square'. This seems to relate to the 1828
R.A. exhibition. One of two other labels on the
back probably refers to the Dublin exhibition

254

Exh: R.A. 1828 (7 or 232)[1]; B.I. 1834 (329, 'The Stour Valley, which divides the Counties of Suffolk and Essex; Dedham and Harwich Water in the distance', size with frame 72 × 63 inches); Royal Hibernian Academy, Dublin 1834 (opened May, 46, 'Landscape, morning, valley of the Stour, which divides the county of Suffolk and Essex, Dedham and Harwich, water in the distance'); Worcester Institution 1835 (opened June, 185, 'Valley of the Stour – Morning')
Prov: 16 May 1838 (75, 'View of Dedham, Suffolk; *Gipsies in the fore-ground Exhibited 1828*'), bt. Bone (?H. G. Bohn); ...; ?William Taunton, sold Christie's 16 May 1846 (42), bt. in, sold Christie's 27 May 1849 (111), bt. in, but these items are more likely to have been No.238 above q.v.; ...; Sir John Neeld by 1877; by descent to L. W. Neeld, from whom bt. by National Gallery of Scotland 1944
National Gallery of Scotland, Edinburgh
(colour plate facing p.161)

This is Constable's definitive treatment of a subject which had been a favourite with him in his early years – the view from near Gun Hill, Langham, looking down the Stour valley to Dedham, with Harwich in the distance. In composition the picture follows No.33 of 1802 fairly closely but Stratford St. Mary bridge and its adjacent buildings, seen for example in another early depiction of the view, No.55, are now also included. The composition of the 1802 picture was, as we have seen, derived from the Claude 'Hagar' in Sir George Beaumont's collection. Constable may have had a fresh sight of the Claude in 1827 when it entered the National Gallery on Beaumont's death, and possibly this event turned his mind again to the Dedham Vale subject.

The 1802 painting was one of those works in which Constable had aspired to 'a pure and unaffected representation'. By 1828, however, he had gone back to 'running after pictures' – this time his own – and was prepared in No.253 to introduce the decidedly affected motif of the gypsy mother: another drop of the 'eye-salve' he had applied in 'The Cornfield' (No.242).

Constable told Fisher on 11 June 1828 that he had 'Painted a large upright landscape (perhaps my best). It is in the Exhibition, noticed (*as a redeemer*) by John Bull, & another, less in size but better in quality, *purchased by Chantrey*' (JCC VI p.236). The latter is the following work, No.254.

254 'Landscape' (Branch Hill Pond, Hampstead) exh.1828

Oil on canvas, 23½ × 30½ (59.6 × 77.6)
Inscribed on a label on the stretcher 'No.2 Landscape John Constable 35 Charlotte Street Fitzroy Square'. This seems to be the label applied for the 1828 R.A. exhibition.
Exh: R.A. 1828 (7 or 232)
Prov: 'bought' by Sir Francis Chantrey at 1828 R.A. but apparently not paid for until at least 1832 (see text below); ...; John Sheepshanks, by whom presented to V. & A. 1857
Victoria and Albert Museum (R.301)

Constable's frequent depiction of the view over Branch Hill Pond on Hampstead Heath has been mentioned in the entry on No.239. The present work is an example of

the composition referred to there as type A. We know from Leslie (1843 p.61, 1951 p.166) that one of Constable's two exhibits at the R.A. in 1828 was a view of Dedham Vale (No.253) and that the other was a smaller Hampstead Heath picture. According to Constable's letter to Fisher of 11 June 1828, quoted under No.253, this smaller work was sold to Francis Chantrey, the sculptor. Annotating Leslie's reference to it, Lucas said that the picture was 'in the first instance ... sold to Sir Francis Chantry afterwards to Mr. Sheepshanks for 80 guineas' (JC:FDC p.60). Confirmation that the 'Branch Hill Pond' which Sheepshanks presented to the V. & A., i.e. No.254, was the one Chantrey bought at the R.A. in 1828 is provided by Lucas's mezzotint 'A Heath', the original of which is referred to as 'Chantrey's Heath' in a list of subjects proposed for engraving by Lucas (JCC IV p.444). Lucas's print is clearly based on No.254 rather than on any of the other versions of the subject. The closest of these appears to be a work now in the Cleveland Museum of Art, which differs however in the detail of the figure on the bank at the extreme right, who is definitely shown seated rather than standing, as he seems to be in No.254 and in Lucas's print. The Cleveland picture is discussed in a footnote to the list of Constable's 1827 exhibits, q.v.

Although Constable reported to Fisher in June 1828 that Chantrey had bought the picture, a letter written to Leslie on 4 March 1832 indicates that Chantrey was still uncertain whether he really wanted it and suggests that he had not in fact paid for it. The painting had been seen at Constable's house the previous day by Francis Lawley, a potential patron introduced by Mrs Leslie: 'he has taken a great fancy to my "Heath," ... That picture is somehow got intangled with Chantrey in a most ridiculous way – who will neither take it nor refuse it. It is plain he must have considered it his by his telling the Watts Russells so ... But when I wrote to him to know his pleasure – & to ask if my "delay" or "any seeming lukewarmness on my part," had "caused me to forfeit his patronage, of which I should be proud at all times," &c &c – he made me no answer nor did he write any answer to my letter. So the matter stands – & I want much your never failing advice on this (to me) momentous subject – for I don't catch above one fish in seven years. Mr. Lawley will call again to know his & the pictures fate' (JCC III pp.63–4). The outcome is not known, and we cannot be sure whether it was from Chantrey, Lawley, Constable himself, or some other party, that Sheepshanks ultimately acquired the painting.

255 Coast scene at Brighton 1828

Pencil, pen and grey wash 4½ × 7⅜ (11.5 × 18.7)
Prov: presented to the V. & A. by Isabel Constable 1888
Victoria and Albert Museum (R.306)
See No.256.

256 Coast scene at Brighton: ships riding a squall 1828

Pencil and grey wash, 4½ × 7⅜ (11.5 × 18.7)
Prov: presented to the V. & A. by Isabel Constable 1888
Victoria and Albert Museum (R.307)
Nos.255 and 256 are from a sketchbook Constable used

255

at Brighton in the summer of 1828. Three of the drawings from it, of the same group of vessels high and dry on the shore, are dated 30 May (V. & A., R.304 and 305, and 'A Beached Vessel', Coll. H. A. E. Day). With Maria now entering the final stages of her illness, Constable does not seem to have been able to attempt much more than sketches such as these rapid notes of incidents and things seen on the shore. The depth to which he was an artist is well illustrated by the fact that even at this time, he could yet bring a bleak scene such as No.256 so miraculously to life on paper.

257 Study of Plants d.1828
Oil on canvas, $6 \times 9\frac{1}{2}$ (15.2 × 24.1)
Inscribed 'Brighton July 24th 1828.'
Prov: ?17 June 1892 (242, 'Study of Weeds,
Brighton, July 1828'), bt. Smith; . . . ; acquired
by British Museum 1919
Trustees of the British Museum (1919-4-15-6)
This study and No. 259 were made shortly before Constable took Maria back to Hampstead after her final visit to Brighton: she died four months later.

256

258 Study of Plants ?1828
Oil on canvas, $6 \times 9\frac{1}{2}$ (15.2 × 24.1)
Prov: . . . ; acquired by British Museum 1919
Trustees of the British Museum (1919-4-15-7)
Perhaps made on the same visit to Brighton as Nos.257 and 259.

259 Study of Plants d.1828
Oil on paper, $4\frac{1}{2} \times 5\frac{7}{8}$ (11.4 × 14.9)
Inscribed 'July 25. 1828'
Prov: . . . ; acquired by British Museum 1919
Trustees of the British Museum (1919-4-15-4)
See No.257.

257

260 Study of Moorhens ?*circa* 1824
Oil on paper, $6\frac{3}{8} \times 5\frac{1}{4}$ (16.2 × 13.3)
Prov: . . . ; acquired by British Museum 1919
Trustees of the British Museum (1919-4-15-5)
Perhaps made at the same time and for the same purpose as the study of a moorhen (No.237) used in 'The Leaping Horse', which was exhibited in 1825.

261 Sketch for 'Hadleigh Castle' *circa* 1828–9
Oil on canvas, $48\frac{1}{4} \times 66$ (122.5 × 167.5)
Prov: 16 May 1838 (31, 'Sketch of Hadleigh
Castle'), bt. Revd. J. H. Smith; by descent to his
granddaughter Mrs Violet Becket Williams, from
whom bt. through Ernest Marsh by Leggatt's
1930 and sold by them to Percy Moore Turner;
purchased from him by National Gallery 1935;
transferred to Tate Gallery 1956
Tate Gallery (4810)
(colour plate facing p.176)
This is the full-scale study for No.263, which was exhibited in 1829. The history of the design is discussed in the entry on that work. This composition appears to have been the last for which Constable made such a large preliminary sketch. At £3. 13s. 6d., No.261 must be accounted one of the bargains even on that day of bargains, 16 May 1838, and it is interesting that Constable's executors were prepared to let it go for so little – the finished picture went for £105. At some date, per-

258

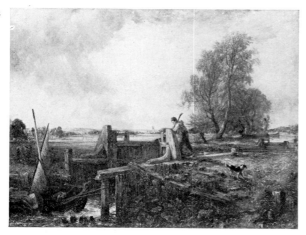

haps while with the Smith family, the sketch was enlarged by the addition of strips several inches wide at the left and bottom. These additions, crudely painted, were presumably based on the corresponding sections of the final work.

1829

January: Fisher postpones his visit; commissioned by H. G. Lewis to paint a sign for The Mermaid and Greswolde Arms Inn, Knowle; disinclined to canvas for this year's election at the Academy. *10 February:* elected Academician by 14 votes to Francis Danby's 13; Turner and George Jones call on him that evening; they part at 1.00 a.m., 'mutually pleased with one another'. His family and a few close friends rejoice. Calls on the President, who does not conceal the fact that he considers him to have been fortunate. Moves back to Well Walk to work on his Academy picture, 'Hadleigh Castle'. *May:* first reference to David Lucas, who is shortly to start engraving for him; Johnny Dunthorne has set himself up as a picture restorer. *7 July:* takes his two eldest children, John and Minna, to stay with the Fishers at Salisbury; an active sketching holiday; last dated drawing, *28th.* Returns to London, leaving Minna to stay on. *28 August:* first extant note to Lucas. *3 September:* urged by Fisher to begin soon on his next big picture. By *15th,* Lucas has begun on the mezzotints from Constable's works to be published by the artist in parts over the next two or three years under the title *Various Subjects of Landscape, Characteristic of English Scenery* (short title: *English Landscape*). *27 October:* Lawrence thanks him for the gift of an early pull of Lucas's mezzotint 'Old Sarum'. *November:* fetches Minna from Salisbury; first and last dated drawings of this stay: *13th* and *26th.* *10 December:* receives his Diploma from the President of the Royal Academy. *15th:* Fisher asks him to buy back 'The White Horse' and 'Salisbury Cathedral, from the Bishop's grounds'; he agrees.

Exhibits. B.I.: (38) 'Landscape and Lock', frame 58 × 67 inches (No.262); (348) 'Landscape; a Cottage Scene', frame 40 × 51 inches. R.A.: (9) 'Landscape'[1]; (322) 'Hadleigh Castle. The mouth of the Thames – morning, after a stormy night' (No.263). Birmingham Society of Arts: (122) 'Noon' (No.242).

262 'Landscape and Lock' (A Boat passing a Lock) d.1826; exh.1829
Oil on canvas, 40 × 50 (101.6 × 127)
Inscribed 'John Constable. f. 1826'
Exh: B.I. 1829 (38, size with frame 58 × 67 inches)
Prov: apparently painted for James Carpenter in 1826; bt. back from him by Constable in 1829 after its exhibition at the B.I. and presented by him to the R.A. as his Diploma picture that year.
Royal Academy of Arts, London
This is a variation on the painting which Constable exhibited at the R.A. in 1824 and which James Morrison bought (No.227). In that work a barge waits in

the lock basin to pass downstream, whereas here a sailing boat lies below the lock, waiting to move upstream. More significantly, the new composition is horizontal, being extended especially on the right, so that the upper gate of the lock is included, and beyond it the footbridge. The whole effect is more open and spacious, and a more elegant group of trees has been substituted for the denser mass seen in the earlier picture. There seems to have been some competition for the purchase of the latter: Constable heard that Lord Fitzwilliam would have bought it if Morrison had not got in first (JCC II p.330) and Constable's cousin J. B. Savile seems also to have been interested (JCC VI p.156). Constable may well have been encouraged to produce other versions as a result. A fairly precise replica, No.312 below, was made in 1825. The present variant, No.262, seems to have been painted in 1826 (the date given in the inscription) for Constable's old friend James Carpenter, the Bond Street bookseller, and to have been worked on further in 1828. On 1 October 1825 Constable listed 'Mr. Carpenter's picture' among the 'dead horses' he still had to attend to (JCC II p.397). The work in question may have been the one he referred to in a letter to Carpenter (undated but, from other matters mentioned in it, apparently of 1826): 'I have been at the picture ever since I saw you & it is now all over wet . . . I wish your picture was as good as Claude Lorraine – for I beg to assure you that your conduct to me about it, has been most liberal and kind' (JCC IV p.138). A further letter to Carpenter of 23 July 1828 refers to a canvas which Constable had been re-working for him: 'I hope you like the "*new Edition of your picture*" and that you do not think it the worse for the retouch . . . Accept my dear Sir my best thanks for the loan of the picture. You are aware I hope that I have no further claim upon you for any thing that I have now done to your picture – it is a sufficient reward that you afforded me an opportunity of making it better' (*ibid.*, p.139). We cannot be sure whether these references are all to the same picture, but there is a good chance that they are and that the work concerned was No.262. The latter was certainly Carpenter's property when Constable was elected as a Royal Academician in February 1829. Beckett describes, but unfortunately does not transcribe, an agreement signed by Constable when he found himself in need of a picture to present to the R.A. on the receipt of his Diploma later that year: 'Constable having asked for his *Lock* back in order to present it to the Royal Academy, the owner agreed to let him have it on his depositing 100 guineas till he had painted for owner a picture of the same size by June 1830: the owner would also be grateful if Constable painted him a *Heath* of the same size as that for Mr. Chantrey [No.254]' (*ibid.*, p.140). The owner is not named in the document but a letter of 2 April 1830 shows him to have been Carpenter: in this Constable requests Carpenter 'to decline the picture I am now about – and allow me to forfeit the 100 guineas now in the hands of Sir C. Scott's banking house . . . I have no motive whatever in asking this favor of you than that the picture be my own property and that I do it and send it to the Academy independently of all other considerations. I shall consider still (& of course) myself indebted to you a picture of a Heath' (*ibid.*, p.142).

From its shape and subject No.262 seems to be the 'Landscape and Lock' which Constable exhibited at the B.I. in 1829. A reference in *John Bull* on 16 February 1829 to the picture having been in Constable's painting-room for some time makes the identification more likely. Beckett mentions a report in a newspaper (unnamed) that the work had been purchased by James Carpenter but Whitley found only a reference to it having been sold, with no name given.[2]

Carpenter, it will be remembered, was also the owner of 'Landscape: Boys fishing', which he had bought at the B.I. in 1814. His 1826 picture is a different view of Flatford lock and – if the 1814 picture is correctly identified with No.118 above – the two works were almost identical in size. Possibly Carpenter hung them as a pair. Whether or not this was his intention, by altering the group of trees depicted in the Morrison 'Lock' Constable avoided what might have seemed too obvious a repetition when Carpenter's pictures were seen together, since the 'Morrison' trees are basically those that appear in 'Boys fishing'. The new trees were probably derived from a pencil drawing of the scene now in the British Museum (L.B.15: a horizontal treatment, as in No.262, but including one of the lintels shown in early oil studies such as No.98), which is on paper watermarked 1824: if they were, the drawing would have been made on Constable's brief visit to Suffolk in April 1826. This drawing, the topographical accuracy of which there seems no reason to doubt, raises an interesting question about the trees as they appear in the original, Morrison, version and, before that, in 'Boys fishing'. The trees at the left of the latter work (see No.118) are, fairly clearly, the same ones which are seen, from the opposite side, in the right foreground of the 1817 'Flatford Mill' (No.151) – reference to page 54 of the 1813 sketchbook (No.119) and to the oil study, No.97 above, confirms this. These trees were close to the footbridge at Flatford, not near the lock as they appear to be in 'Boys fishing' and the Morrison 'Lock'. In those compositions Constable seems to have moved them forward, suppressing the large silvery tree seen close to the lock in the 1817 'Flatford Mill' and which is the principal feature in the British Museum drawing. The horizontal version of 'The Lock', No.262, for which the British Museum drawing was probably used, therefore restores the trees to something like their actual position in Constable's day. The trees which are brought forward in the Morrison version now appear, more accurately, in the distance of No.262.

A version of No.262 in the National Gallery of Victoria, Melbourne has been regarded as a full-size sketch for the Diploma work, but more probably is an unfinished replica of it: parts are as highly finished as No.262, while elsewhere the painting is very thin. Two rather curious pen and wash drawings in the Fitzwilliam Museum, Cambridge, show the composition in its horizontal form, one (P.D.11-1951) with the trees more or less as they appear in No.262 but including, like the British Museum drawing, one of the lintels over the lock (seen, however, in very odd perspective), and the other (3309) with the trees and barge much as they figure in the Morrison picture. The latter drawing is inscribed on the back with notes for the arrangement of prints in *English Landscape*: these Beckett ascribed, by comparison with other, dated lists of the prints, to

about June 1831 (JCC IV p.447, item VII A), and the drawing on the recto presumably dates from around the same time. The former Fitzwilliam drawing (P.D.11-1951) has been claimed as a preliminary study for No.262 but no satisfactory explanation has been given for the false perspective of the lintel over the lock.

263 'Hadleigh Castle. The mouth of the Thames – morning, after a stormy night' exh.1829
Oil on canvas, 48 × 64¾ (122 × 164.5)
Exh: R.A. 1829 (322)
Prov: 16 May 1838 (78, 'Hadleigh Castle *Exhibited* 1829'), bt. Tiffin; . . . ; Hogarth, sold Christie's 13 June 1851 (46), bt. Winter (= ?bt. in: Hogarth still named as owner in Bohn's edition of *English Landscape* 1855); . . . ; Louis Huth by 1863 and until at least 1888; . . . ; an American private collection until 1960; bt. by present owners from Agnew's 1961.
Mr and Mrs Paul Mellon

Constable's only recorded visit to Hadleigh Castle, near Southend, was in June 1814 during his stay with the Revd. Walter Wren Driffield at Feering (see No.125). 'While Mr. D. was engaged at his parish', he told Maria, 'I walked upon the beach at South End. I was always delighted with the melancholy grandeur of a sea shore. At Hadleigh there is a ruin of a castle which from its situation is a really fine place – it commands a view of the Kent hills, the Nore and North Foreland & looking many miles to sea' (JCC II p.127). A slight pencil sketch of the castle made on this visit (V. & A., R.127) was the basis of the painting, No.263, which Constable exhibited fifteen years later. Another pencil sketch of the same size (Courtauld Institute of Art, Witt Collection No.2873), showing the ruins from quite a different point of view, was the origin of an oil painting measuring 16½ × 24½ inches now in the collection of Anthony Bacon. Reynolds (1973 p.94) records a pen drawing in which the composition seen in the V. & A. drawing is extended to the right so that it corresponds more closely with that of the final painting. A further pencil drawing in the Tate Gallery (T.1146) is less closely related than the V. & A. drawing to the finished composition.

It is not known when Constable began work on either the full size sketch, No.261, or the final painting. When Abram wrote to his brother on 13 February 1829 he said 'You will now proceed with your Picture of the Nore – & I think it will be beautiful' (JCC I p.255 – 'The Nore' was one of Constable's titles for the picture). This may suggest that Constable was about to return to the composition after an interval away from it – he may, for example, have started one of the two large canvases before Maria died in the previous November and then put it aside – but there is no definite evidence on the point. He expressed his uncertainty about the final painting in a letter to Leslie on 5 April 1829: 'Since I saw you I have been quite shut up here. I have persevered on my picture of the Castle which I shall bring to Charlotte [Street] early tomorrow morning. Can you oblige me with a call to tell me whether I can or ought to send it to the ⟨Pandemonium⟩ Exhibition. I am greivously nervous about it – as I am still smarting under my election. I have little enough of either self-knowledge or prudence (as you know) and I am pretty willing to submit to what you shall decide – with others whom I value' (JCC III p.20). Leslie says that he 'witnessed an amusing scene before this picture at the Academy on one of the varnishing days. Chantrey told Constable its foreground was too cold, and taking his palette from him, he passed a strong glazing of asphaltum all over that part of the picture, and while this was going on, Constable, who stood behind him in some degree of alarm, said to me, "there goes all my dew." He held in great respect Chantrey's judgment in most matters, but this did not prevent his carefully taking from the picture all that the great sculptor had done for it' (1843 p.66, 1951 p.177).

At the 1829 exhibition 'Hadleigh Castle' was accompanied in the catalogue by lines 165–170 of Thomson's *Summer*, quoted here as they appear in the catalogue:

> The desert joys
> Wildly, though all his melancholy bounds
> Rude ruins glitter; and the briny deep,
> Seen from some pointed promontory's top,
> Far to the dim horizon's utmost verge
> Restless, reflects a floating gleam.

The restless character of the painting, echoed in the lines chosen from Thomson, is often seen as a reflection of Constable's unhappy state of mind following Maria's death. 'I shall ⟨I⟩ never feel again as I have felt – the face of the World is totally changed to me', he told his brother Golding on 19 December 1828 (JC:FDC p.81). Images of desolation and ruin certainly occupied him more frequently from now on: 'Old Sarum' (No.311), which he saw as a fitting illustration of the 'words of the poet – "Paint me a desolation"', 'Stonehenge' (No.331), 'standing remote on a bare and boundless heath', and the engraving of 'The Glebe Farm' in *English Landscape* to which he said he had added a ruin – 'for, *not* to have a symbol in the book of myself . . . would be missing the opportunity' (JCC IV p.382). But the darker side of nature had begun to draw him some years before Maria died. 'I wish', he told Fisher in 1821, 'it could be said of me as Fuselli says of Rembrandt, "he followed nature in her calmest abodes and could pluck a flower on every hedge – yet he was born to cast a stedfast eye on the bolder phenomena of nature"' (JCC VI p.74). The placid subjects which had earlier occupied him were joined in the 1820s by more dramatic material as he became increasingly conscious of the changefulness of nature – of the 'bolder phenomena' which could so quickly follow the calms. This polarity he was to express in the text to *English Landscape* as the 'Chiar'oscuro of Nature', and it is this more complicated response to nature as a whole, as much as his personal grief, that underlies 'Hadleigh Castle' and gives it force.

264 Old Sarum d.1829
Pencil, 9 1/16 × 13 1/16 (23 × 33.2)
Inscribed 'Evening July 20 1829'
Prov: . . . ; Sir Edward Marsh, by whom bequeathed to National Art-Collections Fund 1952 and presented to Bath 1953
Victoria Art Gallery, City of Bath
See No.265.

265 A Cottage and Trees near Salisbury d.1829
Black chalk and watercolour,
9¼ × 13¼ (23.5 × 33.6)
Inscribed 'July 28. 1829 near Salisbury'
Prov: presented to the V. & A. by Isabel
Constable 1888
Victoria and Albert Museum (R.315)

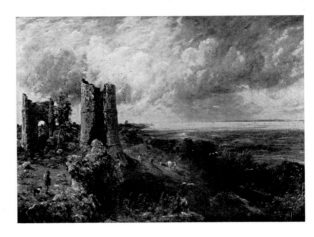

263

After the sterile months following the death of his wife, Constable's desire to work again from nature appears to have re-awoken during his three weeks' stay at Salisbury with the Fishers. Nos.264 and 265, two of the dated drawings made during this visit, show how radically his mood and way of handling the medium could alter within a relatively short time.

266 Salisbury Cathedral from the North-West
1829
Pencil, 9¼ × 13⅛ (23.5 × 33.2) on paper watermarked 1822
Inscribed on verso, probably not in artist's hand: 'Salisbury 1829'
Prov: ?17 June 1892 (part of either lot 149 or lot 151, comprising, respectively, four and two 'Sketches for the Large Salisbury'), bt. Charles Fairfax Murray; presented by him to the Fitzwilliam Museum 1917
Fitzwilliam Museum, Cambridge

264

This is one of the studies related to Constable's last big Salisbury picture, 'Salisbury Cathedral from the Meadows' (No.282), exhibited in 1831. The composition is discussed in the entry on that work. No.266 is also closely related to the small mezzotint of Salisbury Cathedral which Lucas began in 1831 but which was not published until after Constable's death (Shirley 1930 No.30). Like this, it shows an angler on the bank rather than, as in the big painting, a wagon crossing the river. The drawing comes from the same sketchbook as Nos.264–5, which are both dated July 1829.

267 View from Archdeacon Fisher's House, Salisbury 1829
Oil on canvas, 7⅞ × 9⅞ (20 × 25.1)
Prov: presented to the V. & A. by Isabel Constable 1888
Victoria and Albert Museum (R.320)

Beckett (Typescript Catalogue) identified this study as having been made from a window of the, since demolished, south wing of Fisher's house, Leadenhall, in the Close at Salisbury. Harnham Ridge is glimpsed behind the trees in the distance. At least two other oil studies seem to have been made from windows of the house in 1829: No.268 below and V. & A., R.311, which is inscribed as having been done from the library on 12 July.

265

268 Harnham Ridge from Archdeacon Fisher's House, Salisbury 1829
Oil on paper laid on canvas, 11½ × 15 (29.2 × 38.1)
Prov: 17 June 1892 (258, 'Salisbury: from my bed-room'), bt. Agnew, from whom bt. by National Gallery of Ireland 1893
National Gallery of Ireland, Dublin

If the provenance recorded for this work is correct, it can be assumed that the sub-title given in the 1892 sale catalogue – 'from my bed-room' – was at one time

266

267

268

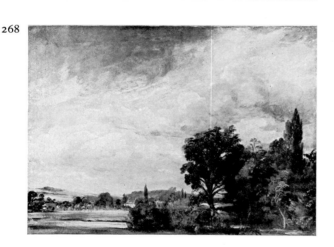

269

inscribed on the back and that this is another of the sketches Constable painted from the windows of Fisher's house. Like No.267 above, the work is attributed to one of Constable's two Salisbury visits of 1829 because of its similarity to two dated sketches in the V. & A., R.311 and 312. Closely related in subject to the latter pair is an oil study in the Ashmolean Museum, Oxford and one sold from the collection of J. Johnston at Christie's on 20 June 1975 (129).

1830

Serves on the Council of the Academy during this and the following year. *7 January:* death of Lawrence, the President. Pays Lucas for the work he has done so far on the mezzotints. Much time is spent on this enterprise. *25th:* M. A. Shee is elected President. *March:* at work on his main picture for the exhibition, 'Helmingham Dell', a medium-sized canvas. *April:* witnesses the rejection of one of his own paintings by the Council selecting works for the exhibition. Serves on the committee which arranges the exhibition. *May:* resumes work with Lucas on the plates for *English Landscape*. *24th:* tells Fisher (who has been seriously ill) that the first number is forthcoming. *19 June:* buys Sir Joshua Reynolds' palette at the Lawrence sale, and presents it to the Academy. *26th:* the first number of *English Landscape*, with four prints (2 or 1½ guineas according to quality), reviewed in the *Athenaeum*. For some time he has been lending money to penurious artists, tradesmen, etc.; such affairs take up time and necessitate correspondence. *3 July:* has a short article on Michelangelo's 'Tondo' (presented by Beaumont to the Academy) in the *Athenaeum*. *6th:* hears from Fisher at Newbury on his Visitation (the last known letter from Fisher to him). *10th:* joins the Archdeacon at Windsor for a few days. *23rd:* presentation copies of *English Landscape* sent out, e.g. to De Wint. Takes the children to Hampstead for the summer. Sends his son John to Brighton after an illness; later, takes Charles to Sussex to see him. All the family together again at Hampstead by *14 November*. He plans to winter there with them. *29 December:* presents Leslie with the second number of *English Landscape*, 'the first yet sent'.

Exhibits. R.A.: (19) 'Dell scene, in the park of the Right Hon. the Countess of Dysart, at Hatmingham [i.e. Helmingham], Suffolk' (see under No.295); (94) 'Landscape'; (248) 'A heath'[1].

269 **'Landscape – a Study' (Water-meadows near Salisbury)** rejected exhibit 1830
Oil on canvas, 18 × 21¾ (45.7 × 55.3)
Prov: 16 May 1838 (50, 'Salisbury Meadows; painted from nature'), bt. Smith for John Sheepshanks, by whom presented to the V. & A. 1857.
Victoria and Albert Museum (R.321)
Although not actually shown at the Academy, this work is included here among the 'exhibited' items because

270

Constable submitted it for the R.A. exhibition of 1830 and – but for a very curious incident – it would have been hung that year. Certainly it should have been hung, since, as a Royal Academician, Constable now enjoyed the right of having his works automatically included in the annual exhibition. In 1830 he was, as a newly elected R.A., serving on the Council and was one of the people responsible for making a selection for the exhibition from the works submitted by outsiders. What happened on this occasion is related by, among others, W. P. Frith (*My Autobiography and Reminiscences*, 1887, I, pp.237–8), who had the following account from someone else serving on the Council that year, Abraham Cooper:

> When Constable was a member of the selecting Council, a small landscape was brought to judgement; it was not received with favour. The first judge said, 'That's a poor thing;' the next muttered, 'It's very green;' in short, the picture had to stand the fire of animadversion from everybody but Constable, the last remark being, 'It's devilish bad – cross it.' Constable rose, took a couple of steps in front, turned round, and faced the Council.
>
> 'That picture,' said he, 'was painted by me. I had a notion that some of you didn't like my work, and this is a pretty convincing proof. I am very much obliged to you,' making a low bow.
>
> 'Dear, dear!' said the President [Shee] to the head-carpenter, 'how came that picture amongst the outsiders? Bring it back; it must be admitted, of course.'
>
> 'No! it must not!' said Constable; 'out it goes!' and, in spite of apology and entreaty, out it went.

In 1866 Richard Redgrave recorded in his diary another version of the incident, which he had from F. R. Lee, who was not, however, an eye-witness: '"Cross it," said one; "It won't do," said another; "Pass on," said a third, and the carpenter was just about to chalk it with a cross when he read the name of "John Constable". Of course, there were lame apologies, and the picture was taken from the condemned heap, and placed with the works of his brother Academicians. But after work was over, Constable took the picture under his arm, and, despite the remonstrances of his colleagues, marched off with it. – "I can't think," said he, "of its being hung after it has been fairly turned out."' (F. M. Redgrave, *Richard Redgrave*, 1891, pp.284–5). Yet another version is given by J. H. Anderdon (see W. T. Whitley, *Art in England 1821–1837*, 1930 p.189), who tried to buy the painting at the 1838 sale but gave up when he learned that he was in competition with the wealthy collector John Sheepshanks. Anderdon says that Leslie told him, 'You would never have got it in any case . . . I have tried in vain to obtain it, and have offered in exchange to paint for Sheepshanks anything he liked. But I can't shake him. He clings to it all the more, because he knows it was thrown out by the Academy Council as "a nasty green thing". Then one of them recognised it as the work of Constable and there was a change of opinion – it was at once to be admitted. But Constable, who was himself on the Council, would not permit this. "It has been properly condemned as a daub", he said. "Send it out."'

It is difficult to know what actually happened. Was the picture really included among the outsiders by mistake? If so, why was it not more immediately recog-

271

272

nised as Constable's work when it came before the Council? Were other members of the Council engaged in some elaborate practical joke on Constable? Did he even contrive the whole thing himself?

The title which No.269 would have borne in the 1830 exhibition – 'Landscape – a Study' – is supplied by the list of his exhibits for that year which he sent, as usual, to the Secretary of the R.A., Henry Howard (JC:FDC p.221). The work is usually presumed to have been painted during or shortly after Constable's last two visits to Salisbury in 1829.

270 Study of clouds from Hampstead d.1830
Pencil and watercolour, 7½ × 9 (19 × 22.8)
Inscribed on verso 'about 11 – Noon – Sepr 15 1830. Wind – W'
Prov: presented to the V. & A. by Isabel Constable 1888
Victoria and Albert Museum (R.328)
See No.272.

271 London, from the Drawing Room at Well Walk d.1830
Pencil and watercolour, 3⅝ × 4½ (9.2 × 11.4)
Inscribed on verso 'Hampstead. drawing Room 12.oclock noon Sept. 1830'
Prov: presented to the British Museum by Isabel Constable 1888.
Trustees of the British Museum (L.B.31a)
See No.272.

272 London from Hampstead d.1832
Pencil and watercolour, 4⅜ × 7⅜ (11.1 × 18.7)
Inscribed on verso 'Hamd Window Augt 1832'
Prov: presented to the British Museum by Isabel Constable 1888.
Trustees of the British Museum (L.B.31b)

The inscriptions on the backs of Nos.271–2 were revealed when the two drawings were recently lifted from their mounts. It had long been suspected that Nos.270–2 and others of the same subject (e.g. Nos.283 & 305, V. & A., R.409, and British Museum, L.B.21a–b) were taken from Hampstead, and a watercolour of a similar subject in the family collection, inscribed on the mount as having been made from Constable's window, made it likely that they were all views from the southward-facing windows of No.6 Well Walk. However, it was not until the discovery of the inscriptions on Nos.271–2 that this could be confirmed.

On renting the house in the summer of 1827, Constable had written to Fisher: 'It is my wife's heart's content . . . and our little drawing room commands a view unequalled in Europe . . . The *dome* of *St Paul's* in the air, realizes Michael Angelo's idea on seeing that of the Pantheon – "I will build such a thing in the sky"' (26 August 1827; JCC VI p.231).

273–81 'English Landscape' (first published 1830–2)

Until he entered the field himself in the 1830s, Constable had only a limited experience of the world of print-making and print-publishing. Unlike many of his contemporaries, he did not make drawings for the publishers of topographical works and annuals, and there was little enough demand for his paintings, let alone for

prints after them. Before 1829 one or two of his things were used as book illustrations (see, for example, No.61) and there were a few separately issued plates of modest ambition, for example an engraving by Ogborne of 'A Mill on the Banks of the River Stour', published by Thane in 1810, a small mezzotint by Henry Dawe of 'Leathes Water' which Constable himself published in 1815, and a mezzotint by W. J. Ward of Constable's portrait of Dr Wingfield, published in 1827. A more ambitious project initiated in 1824 by S. W. Reynolds, an engraving of the Morrison 'Lock' (No.227), was abandoned before the plate was finished, and even less came of Arrowsmith's scheme to publish a series of prints by Reynolds after Constable's Brighton drawings (see No.230). In 1829 Colnaghi's issued an engraving by Frederick Smith (No.248) after 'Chain Pier, Brighton', the first major work by Constable to be reproduced, though there is no reason to suppose that it was much of a success. More significantly, Constable himself decided that year to embark on the publication of a series of mezzotints after his compositions.

The engraver he chose was David Lucas (1802–81), a recent pupil of S. W. Reynolds and as yet not much known. Work on the project was underway by 15 September 1829 (see JCC IV p.322) and continued up to, and after, Constable's death. The initial series, entitled *Various Subjects of Landscape, Characteristic of English Scenery, From Pictures Painted by John Constable, R.A.,* or *English Landscape* for short, appeared in five parts at irregular intervals between 1830 and 1832. The first four parts, or 'numbers' as they were called, comprised four prints each and the last, six, making twenty-two altogether. A second edition of the same plates but arranged in different order was ready by May 1833, and a new series, referred to as the 'Appendix', was projected but had not advanced very far when Constable died in 1837. Some of the plates intended for the latter appeared among a further six which Moon issued in 1838 and another fourteen published by Lucas himself in 1845. Independent of the *English Landscape* series, Lucas engraved several much larger plates, both before and after Constable's death.

English Landscape was conceived by Constable as an epitome of, and as an *apologia* for, his art, which even by 1829 had few admirers, of whom fewer still had much understanding of what he had been up to in landscape during the previous thirty years. In an introductory text he contrasted those artists who had eyes only for 'what others have accomplished' with those who by going to the 'PRIMITIVE SOURCE, NATURE' added to Art 'qualities of Nature unknown to it before'. 'The results of the one mode,' he continued, 'as they merely repeat what has been done by others, and by having the appearance of that with which the eye is already familiar, can be easily comprehended, soon estimated, and are at once received. Thus the rise of an Artist in a sphere of his own must almost certainly be delayed; it is to time generally that the justness of his claims to a lasting reputation will be left; so few appreciate any deviation from a beaten track, can trace the indications of Talent in immaturity, or are qualified to judge of productions bearing an original cast of mind, of genuine study, and of consequent novelty of style in their mode of execution' (the *English Landscape* texts are reprinted in Shirley 1930 pp.219–68 and JCD pp.7–

247 **'Chain Pier, Brighton'** exh. 1827 detail (entry on p.148) ▶

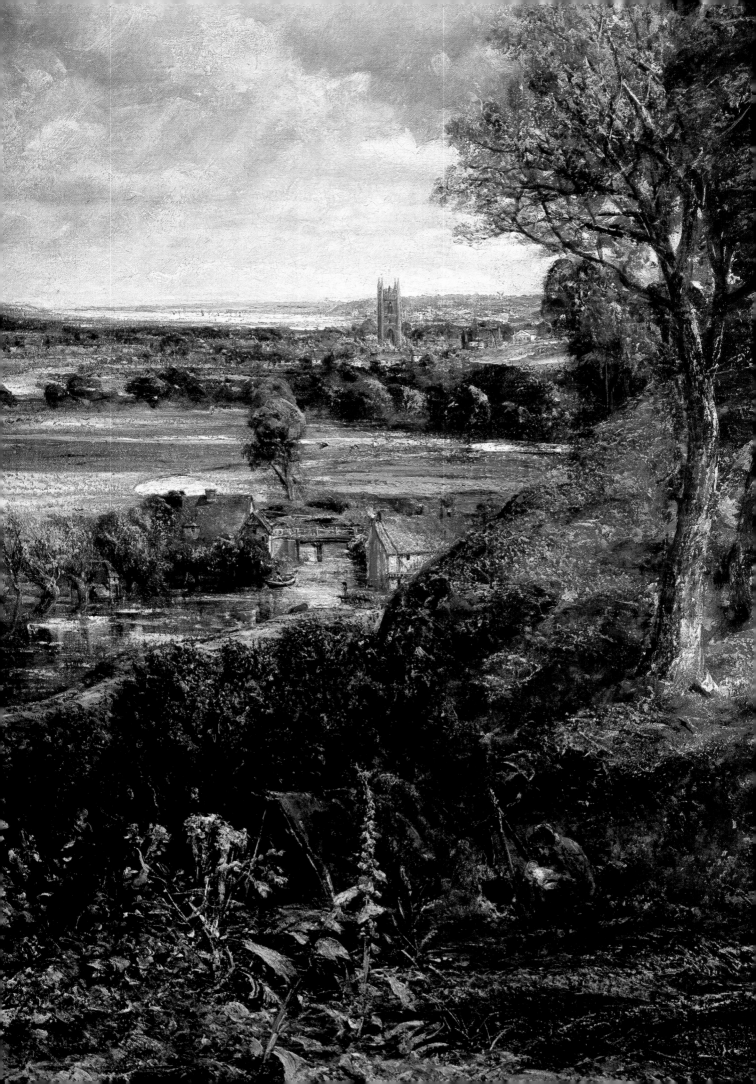

273

27). As well as seeking in these terms to justify his own neglect, Constable expounded in his Introduction an artistic principle which had come to mean much to him, 'the "CHIAR'OSCURO OF NATURE"'. He had aimed, he said, 'to mark the influence of light and shadow upon Landscape, not only in its general effect on the "whole," and as a means of rendering a proper emphasis on the "parts," in Painting, but also to show its use and power as a medium of expression, so as to note "the day, the hour, the sunshine, and the shade." In some of these subjects of Landscape an attempt has been made to arrest the more abrupt and transient appearances of the CHIAR'OSCURO IN NATURE; to shew its effect in the most striking manner, to give "to one brief moment caught from fleeting time," a lasting and sober existence, and to render permanent many of those splendid but evanescent Exhibitions, which are ever occuring in the changes of external Nature'.

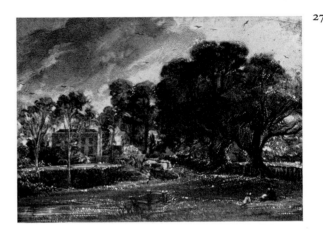

274

The idea of chiaroscuro as not merely a technical, illusionistic device, but as an expression of the transitory character of nature, by the mastery of which the artist might preserve, in Wordsworth's phrase, brief moments 'caught from fleeting time', was one that Constable seems to have meditated for many years. Since the beginning of the 1820s he had grown increasingly conscious of the changefulness of nature. It had become ever more difficult for him to look to nature, as he had done in 1814 – in the words of the Revd. Archibald Alison – as the 'one gentle and unreproaching friend' (JCC II p.131). While the Bishop of Salisbury demanded settled weather and blue skies, Constable persisted in painting black clouds and in making his 'escape in the evanescence of the chiaroscuro' (see No.216). His intensive 'skying' at Hampstead must have been both cause and effect of this growing awareness of time and change. Increasingly, he tended to identify his states of mind with the blacker and more dramatic phenomena of nature – with storms, rainbows, sudden gleams of light. In 1834 he told Lucas, on seeing his large prints of 'The Lock' and 'The Cornfield',

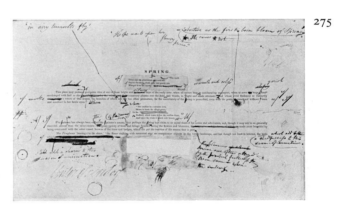

275

'Now for some wise purpose is every bit of sunshine clouded over in me. I can never now look at these two flattering testimonies of the result of my singularly marked life . . . without the most painfull emotions' (JCC IV p.414), and talking of the same prints he told Leslie, 'every gleam of sunshine is blighted to me in the art at least. Can it therefore be wondered at that I paint continual storms? "Tempest o'er tempest rolled" – still the "darkness" is majestic' (JCC III p.122). The technique of mezzotint, in which light is created from darkness only by some effort, and in which a contrast of the two – chiaroscuro – can most forcibly be expressed, was peculiarly appropriate to his purpose in *English Landscape*.

Delays and difficulties with the production of the prints, coupled with lack of public response when they finally appeared, deepened Constable's pessimism. 'I have added a "Ruin", to the little Glebe Farm –', he told Lucas, referring to one of the plates, 'for, *not* to have a symbol in the book of myself, and of the "Work" which I have projected, would be missing the opportunity' (JCC IV p.382). So few copies of *English Landscape* were sold by Constable that his daughter Maria was able to supply 186 sets (over 4000 prints) to Carpenter in 1843 to illustrate Leslie's biography of the

278

◀ 253 **'Landscape' (Dedham Vale)** exh. 1828 detail (entry on p.151)

artist. *English Landscape*, said Leslie in his Preface to the *Life*, was 'a work which, to use the words of Coleridge, was "*a secret committed to the public, and very faithfully kept.*"'

273 Design for the Frontispiece to 'English Landscape': 'East Bergholt, Suffolk' d.1831
Ink, 3 1/16 × 4 3/8 (7.8 × 11.1)
Inscribed 'FRONTISPICE' and '1831'
Mr and Mrs W. Katz
A design for the frontispiece but presenting a view of East Bergholt House from an angle different from that given in the plate as engraved (see No.274). *English Landscape* has features in common with Turner's *Liber Studiorum*, for example its author's deliberate choice of a range of different sorts of landscape, and it is interesting to find Constable here placing his frontispiece within a frame as Turner had done with his own title-page subject. The idea was not, however, carried over onto the engraved plate.

DAVID LUCAS after CONSTABLE
274 Frontispiece to 'English Landscape': 'East Bergholt, Suffolk' 1831
Mezzotint, (area of subject) 5 1/2 × 7 5/16 (14 × 18.6)
Inscribed on verso by David Lucas 'Touched with his Penknife at Padington'
Prov: . . . ; Sir Henry Theobald, from whom bt. by John Charrington and presented to the Fitzwilliam Museum 1910
Fitzwilliam Museum, Cambridge
This is a progress proof of the frontispiece (Shirley 1930, No.27), worked over by Constable with a knife to bring up the lights. As the inscription indicates, this 'scratching' was done at Lucas's house at Paddington. Apart from showing various changes to the subject itself, when published (in the fifth and final number in 1832) the plate was captioned with some Latin verses of which Fisher had given Constable the following translation in 1820:

> This spot saw the day spring of my Life,
> Hours of Joy, and years of Happiness,
> This place first tinged my boyish fancy
> with a love of the art,
> This place was the origin of my fame.

(JCC VI p.54 but correcting the mistake pointed out in JC:FDC p.117.)

Having already written an Introduction to the whole work, around 1834 Constable began to compose commentaries on the individual plates. 'I have been busy in making a fly leaf to each of my prints', he told Leslie on 20 January that year, 'I send a specimen or two that are ready, to hear how you think on that plan. Many can read print & cannot read mezzotint' (JCC III p.108). Only a few of these 'fly-leaves' ever got into print. Some contain a lot of guide-book type information but Constable also tells us much about the particular effects he had tried to capture – about their 'natural history' and, drawing heavily on poetry, about their appeal to the human imagination. In the text accompanying the 'Frontispiece', a view of his birthplace, East Bergholt House, he indulged his nostalgia for childhood scenes: 'Perhaps the Author with an over-weening affection for these scenes may estimate them too highly, and may have dealt too exclusively upon them; but interwoven

as they are with his thoughts, it would have been difficult to have avoided doing so; besides, every recollection associated with the Vale of Dedham must always be dear to him, and he delights to retrace those scenes, "where once his careless childhood strayed," among which the happy years of the morning of his life were passed'.

275 Corrected Letterpress to 'Spring' in 'English Landscape'
The Executors of Lt. Col. J. H. Constable
This printer's nightmare is one of many corrected proofs of the texts for *English Landscape* which survive in the family collection. It shows very clearly how seriously Constable took his commentaries on the plates.

276 Transcripts of Verses intended for the letterpress to 'English Landscape'
The Executors of Lt. Col. J. H. Constable
Poetry played an important role in Constable's response to landscape and when, in *English Landscape*, he came to sum up his efforts, it was to Shakespeare, Milton, Thomson, Akenside, Wordsworth, Crabbe and others that he turned for literary parallels which would help his (supposed) public to understand his intentions.

277 Letter from Constable to Lucas, 12 March 1831
Fitzwilliam Museum, Cambridge
'. . . I have thought much on my book, and all my reflections on the subject go to oppress me – *its duration, its expence, its hopelessness of remuneration*, all are unfavorable – added to which I now discover that the print-sellers "are watching it as their lawfull prey" . . . The expence is too enormous for a work that has nothing but your beautifull feeling and execution to recommend it – the painter himself is totally unpopular and ever will be, on this side of the grave certainly . . . Remember dear Lucas that I mean not to think one reflection on you – every *thing* with the *plan* is my own – and I want to releive my mind of that which now harrases it like a disease – & looking forward as I now do I think of it with delight as an occupation, though utterly hopeless in its result . . . Nobody will do me any good – even that man who thinks he is sure of going to heaven by dipping his arse under water – I mean Mr. White of Brownlow Street [presumably a Baptist] – offers to propagate & guarantee the money for Turner and his liber stupidorum for *15 per cent*, & will not do the same for me under *35 per cent*' (JCC IV pp.344–5).

DAVID LUCAS after CONSTABLE
278 'Stoke-by-Neyland' 1830
Mezzotint, touched with pencil, (area of subject) 5 5/8 × 8 5/8 (14.3 × 21.9)
Prov: as for No.274
Fitzwilliam Museum, Cambridge
A progress proof (Shirley 1930, No.9, proof 'd') of 'Stoke-by-Neyland', which appeared in the second number of *English Landscape* in 1830. This subject, like many of the others, was considerably altered during the work on the plate. The church and other buildings, especially, were originally very different. Constable's pencil markings indicate further work required from

Lucas, including the making out of a rutted track in the right foreground.

'Stoke-by-Neyland' was one of the plates for which Constable composed a commentary. 'The solemn stillness of Nature in a Summer's Noon, when attended by thunder-clouds, is the sentiment attempted in this print;' he wrote, 'at the same time an endeavour has been made to give an additional interest to this Landscape by the introduction of the Rainbow . . .'. A lengthy analysis of rainbows follows, for which the diagrams shown below (No.279) appear to be preparatory material. Although he had made studies of the rainbow from a fairly early date (see, for example, No.111), it was only in the 1830s that the phenomenon assumed an especial emotional significance for Constable. 'Nature, in all the varied aspects of her beauty,' he wrote in the text to 'Stoke-by-Neyland', 'exhibits no feature more lovely nor any that awaken a more soothing reflection than the Rainbow, "Mild arch of promise"'. Conventional though it was, this sentiment appears to have been a very necessary one to him in his last years. Rainbows figure prominently in, for example, 'Salisbury Cathedral from the Meadows' (No.282), 'Cottage at East Bergholt' (No.329), 'Stonehenge' (No.331) and 'Hampstead Heath with a Rainbow' (No.334).

279 Diagrams of Rainbows ?1834
The Executors of Lt. Col. J. H. Constable
Two sheets (one watermarked 1832) of diagrams and notes, originally part of the same piece of paper. The geometrical analyses of rainbows they contain were probably made in preparation for the account of this phenomenon which Constable gave in the letterpress to 'Stoke-by-Neyland' in *English Landscape* (see No.278 above).

280 Letter from Constable to Lucas, 4 December 1831
Fitzwilliam Museum, Cambridge
The *English Landscape* prints were by no means straightforward reproductions of existing paintings and oil sketches. Although he did not engrave on the plates himself, Constable worked in close co-operation with Lucas, modifying the designs as they progressed. In one case, at least, Lucas himself took the initiative, making changes to the first 'Glebe Farm' plate without Constable's knowledge. He received this letter for his pains: '. . . How could you dear Lucas think of touching it after bringing me *such a proof* & without consulting me . . . I know very well it can be *blotched* up, with *dry point burr*, regrounding, &c &c, but that is hatefull . . . I am now writing with the *two proofs* before me and I frankly tell you I could burst into tears – never was there such a *wreck*. Do not touch the plate again on any account . . . I could cry for my poor wretched wreck of the Glebe Farm – a name that once cheered me in progress – now become painfull to the last degree . . .' (JCC IV pp.360–1, where Constable's mis-dating of the letter – 'Nov.4.' – is explained). Constable subsequently transformed the subject of the plate into 'Castle Acre Priory', which, as we have already seen, he adopted as a symbol of his own ruin.

DAVID LUCAS after CONSTABLE
281 Vignette to 'English Landscape': 'Hampstead Heath, Middlesex' 1829
Mezzotint, (area of subject) $3\frac{3}{16} \times 6$ (8.1 × 15.3)
Prov: as for No.274
Fitzwilliam Museum, Cambridge
A progress proof (Shirley 1930, No.3, proof 'a') of the 'Vignette' to *English Landscape*, the first of the plates to be engraved but not published until the final number in 1832. In its published form, the plate shows several changes from the early state exhibited here: a rainbow is introduced at the right, a distant view of St. Paul's Cathedral at the left, and some donkeys in the right foreground. The man on the hill-top, upright and unencumbered in No.281, was later altered to a bowed figure carrying a pick-axe on his shoulder. According to Lucas (JC:FDC p.60), this figure was 'Collins the painter' – William Collins R.A., one of Constable's least favourite artists – 'who happened to be sketching on the heath at the time'.

The plate was published with the tag 'Ut Umbra sic Vita', the motto on the sundial of East Bergholt Church (see No.99) and an apt colophon to a work on 'light and shadow'.

1831

January: Visitor at the R.A. Life Academy for the month; poses the model and instructs the students. *2 February:* at work on a new large canvas ('Salisbury Cathedral from the Meadows'); suffering from a heavy cold. Third number of *English Landscape* in preparation. *26th:* first two numbers reviewed in the *Spectator* – 'hasty mezzotinto scrapings'. Appoints a tutor for his sons to avoid sending them to school. *8 March:* initial payment to the tutor, Charles Boner. Depressed and weak from nights spent coughing, he begins to doubt a successful outcome for *English Landscape*. *April:* again, a member of the R.A. Committee of Arrangement. *May:* both his hanging of the exhibition and his paintings savagely attacked in the *Observer*. *17th:* revises his plans for *English Landscape* and Lucas starts work again. *27 June:* takes his three daughters to stay with his sister Martha Whalley, now living in Dedham. Returns for meeting of Academy Council on *4 July*. *28th:* fetches his girls from Dedham. *25 August:* the President (Shee), Leslie, Howard, Bannister (the actor), and possibly others, dine with him off half a buck sent by Lady Dysart. *8 September:* attends Coronation of William IV in Westminster Abbey. *12th:* sends Leslie his copy of third number of *English Landscape*. *23rd:* spends a night with his friend Digby Neave at Epsom. Gives much time to Lucas and the mezzotints. *Mid-October:* Leslie finds him unwell and depressed; the Reform Bill much on his mind. By *4 November*, he is better, 'all my illness has been fretting – pining for my children'. Hampstead now his 'home', Charlotte Street his 'office'. Copies 'A Girl with Doves' by Greuze for Lady Jackson, a distant relative. Fourth number of *English Landscape* published. *17 December:* ill again with acute rheumatism.

Exhibits: R.A.: (123) 'Yarmouth pier' (possibly No.214 or No.215); (169) 'Salisbury cathedral, from the meadows' (No.282).

282 'Salisbury cathedral, from the meadows'
exh.1831
Oil on canvas, 59¾ × 74¾ (151.8 × 189.9)
Exh: R.A. 1831 (169); B.I. 1833 (155, 'Salisbury from the meadows', size with frame – presumably not very accurate – 72 × 82 inches); Birmingham Society of Arts 1834 (317, 'Salisbury Cathedral, from the Meadows, Summer Afternoon, A retiring Storm'); Worcester Institution 1836 (2, 'Salisbury Cathedral from the Meadows – Summer Afternoon – A retiring Tempest')
Prov: 16 May 1838 (79, 'Salisbury Cathedral, from the Meadows *Exhibited* 1831'), bt. Ellis; . . . ; William Taunton, sold Christie's 16 May 1846 (41), bt. in, sold Christie's 27 May 1849 (110), bt. Rought; Agnew's, from whom bt. by Samuel Ashton 29 April 1850; by descent to present owner
Lord Ashton of Hyde

As with many of his late productions, the rainbow is the key-note of this, Constable's last big Salisbury picture. With its dramatic chiaroscuro and emphasis on the 'splendid but evanescent Exhibitions' of nature, the work relates closely to the sentiments expressed in *English Landscape.* When it appeared at the Academy in 1831, Constable captioned the painting with lines 1223–32 from Thomson's *Summer* (quoted here in the form in which they appear in the catalogue):

As from the face of heaven the scatter'd clouds
Tumultuous rove, th'interminable sky
Sublimer swells, and o'er the world expands
A purer azure. Through the lightened air
A higher lustre and a clearer calm
Diffusive tremble; while, as if in sign
Of danger past, a glittering robe of joy,
Set off abundant by the yellow ray,
Invests the fields, and nature smiles reviv'd.

Constable used some of the same lines in the text he composed to accompany 'Stoke-by-Neyland' (No.278) in *English Landscape,* where he wrote at some length about the formation of rainbows, but the 'Mild arch of promise', as he there called it, is now become an almost apocalyptic phenomenon. Had he lived to see the picture, the Bishop of Salisbury, who had been disturbed enough by the 'black clouds' in the earlier big 'Salisbury Cathedral' (No.216), would have been startled indeed by the artist's final vision of his church.

The composition began life in a harmless enough way, with pencil sketches of the view (which is from near Fisherton Mill, north-west of the city) made on Constable's last two visits to Salisbury in 1829. Of these the most relevant to No.282 are No.266 above and one in the Lady Lever Art Gallery, Port Sunlight (repr. Selby Whittingham, *Constable & Turner at Salisbury,* 2nd. ed. 1973, fig.35). The former establishes the basic shape of the composition but includes an angler on the bank at the left instead of the wagon and horses which provide the main figurative interest in the final painting. The Port Sunlight drawing shows these new features and also another – a man crossing the footbridge at the right, followed by a dog. In No.282 the man is omitted but a different dog appears in the centre foreground.

The idea of the man and dog crossing a bridge probably derived from a drawing of Fisher and his dogs which Constable also made in 1829 (V. & A., R.313). It will be recalled that Fisher's uncle had been introduced in the earlier 'Salisbury Cathedral, from the Bishop's Grounds' (No.216). The Port Sunlight drawing, which is squared for transfer, is followed fairly closely in an oil sketch at the Tate Gallery (No.1814), where the dramatic atmospheric effects of the final picture (though not the rainbow) are also indicated.

The dog in the finished work is a replica of the one Constable had stationed in the foreground of 'The Cornfield' (No.242) in 1826. The rowing-boat had also been used before, in 'The Hay Wain' (No.192), where it was similarly accompanied by a figure with a stick. There are, of course, other points of similarity with 'The Hay Wain' (of which No.282 is in some ways an updated version), not least the image of the slow-moving wagon fording water, watched from the bank by a dog.

The first mention of the idea of No.282 may occur in Fisher's letter to Constable on 9 August 1829: 'I am sure the "Church under a cloud" is the best subject you can take' (JCC VI p.251). A lot is heard about Constable's continued work on the painting after its initial exhibition at the Academy (JCC III pp.88–9, 112, IV p.147, V p.42) and he likewise devoted much time to the large mezzotint of the picture which Lucas made (Shirley 1930, No.39). The latter was the subject of what seems to be the last letter he ever wrote, one to Lucas on 29 March 1837: 'I am quite pleased to see how well you are preparing for the new bow. The proof is about what I want . . . I took the centre from the elder bush – a blossom to the left – you will do possibly the same . . . We cannot fail of this plate with a proper bow' (JCC IV p.438).

283 View over London with Double Rainbow
d.1831
Watercolour, 7¾ × 12¾ (19.7 × 32.4)
Inscribed on verso: 'between 6. & 7. oclock Evening [?June] 1831'
Prov: presented to the British Museum by Isabel Constable 1888
Trustees of the British Museum (L.B.32b)

In his *Life,* Leslie tells us that he had been unable to find among Constable's papers the observations on skies and clouds which he told George Constable he had made, and regrets his inability to recall the artist's remarks on atmospheric effects well enough to repeat them. However, he is at least able to give us one of these observations in his own words: 'I remember that he pointed out to me an appearance of the sun's rays, which few artists have perhaps noticed, and which I never saw given in any picture, excepting in his "Waterloo Bridge" [No.286]. When the spectator stands with his back to the sun, the rays may be sometimes seen *converging* in perspective towards the opposite horizon. Since he drew my attention to such effects, I have noticed very early in the morning the lines of the rays diminishing in perspective through a rainbow' (Leslie 1845 p.310, 1951 p.282). No.283, another view over London presumably taken from a window of the house in Well Walk, might well have been made to illustrate the effect Leslie describes. On the back of the drawing are two rapidly drawn pencil sketches or dia-

grams: a cloud with beams of light radiating from be-
hind it, and a repeat of the view of the City with lines
converging radially on St Paul's from a cloud overhead –
perhaps drawn while discussing the effect.

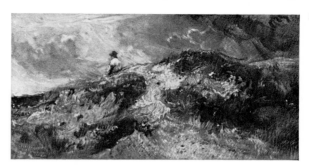
281

284 Old Houses on Harnham Bridge, Salisbury
d.1821 and 1831
Pencil and watercolour, 6¾ × 10¼ (17.2 × 26)
Inscribed '14 Nov 182[1]' and on verso 'Old
Houses on Harnham Bridge. Salisbury Novr. 14
1821.' and 'retuouch at Hampstd. the day after
the Coronation. of Wm. 4th, at which I was
present – being ⟨11⟩ eleven hours in the Abbey.'
Prov: presented to the V. & A. by Isabel
Constable 1888
Victoria and Albert Museum (R.240)

Constable must have begun this drawing on the second
of his two holidays with Fisher in 1821, during the fort-
night or so he spent with the Archdeacon at Salisbury
in November of that year. The 'retuouch' took place
very nearly ten years later, on 9 September 1831, the
day after Constable had attended the Coronation of
William IV. Little of the original work is to be seen;
most if not all of the colouring is likely to have been
done at the later date. It is interesting to see Constable
attempting an equivalent in watercolour of the flecks of
white he so vigorously applied with the palette knife
when working on canvas.

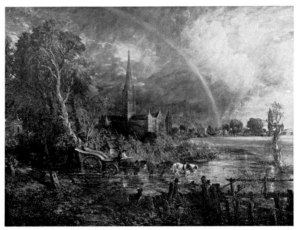
282

In the British Museum there is a tinted pen drawing
of Harnham Bridge (L.B.29) from a viewpoint close to
that from which No.284 was taken. It is inscribed '23
Novr 1829' – when Constable was certainly in Salisbury
and could therefore have drawn it – but very little of
the work looks like his. Could Fisher, who was a keen
amateur artist, have had a hand in it?[1] See Nos.346a, b
and d for drawings by Fisher.

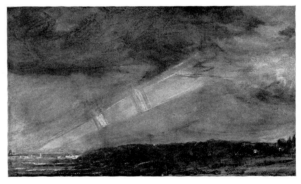
283

285 The root of a tree, at Hampstead d.1831
Pencil, 8⅞ × 7¼ (22.5 × 18.4)
Inscribed '22d Sepr. 1831 Well Walk'
Prov: presented to the V. & A. by Isabel
Constable 1888
Victoria and Albert Museum (R.335)

An unusual subject for Constable at this stage in his
career. Doubtless, a drawing made for its own sake, for
enjoyment. The animated swirl of little touches of the
pencil over the paper is, again, reminiscent of the flecks
of white with which he 'aerated' his larger paintings.

DANIEL MACLISE (1806–1870)
285a Constable Painting ?1831
Pencil, 5⅞ × 4½ (14.9 × 11.4)
Prov: ?Clifford Constable; bt. by the National
Portrait Gallery from E. E. Leggatt 1907
Trustees of the National Portrait Gallery

This drawing is usually supposed to be the 'little sketch'
of Constable in the R.A. Life Academy that Maclise
sent to Leslie when he was preparing his biography of
the artist. In his accompanying letter Maclise said that
it 'was made under the disadvantage of my being on
the upper and back seat, looking down on him as he sat
on the front and lower one in the Life School, and must
have been when he set the Eve, although I should not
have thought it was so long ago as 1830' (Leslie 1843

p.111, 1951 p.263). Constable was a Visitor in the Life
Academy in 1831 and 1837; he should also have per-
formed this duty in 1832 but was prevented by ill-
health. It was in 1831 that he set the model as Eve,
against a background of evergreens. No.285a, however,
does not really correspond with Maclise's description
of the sketch he sent to Leslie. It appears to have been
drawn from close to and on the same level as the sitter,
rather than from some distance above.

284

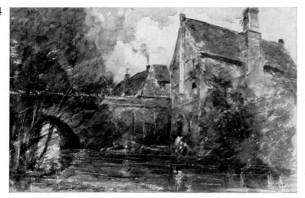

285

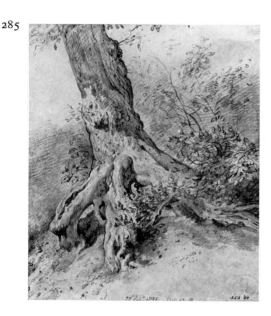

285a

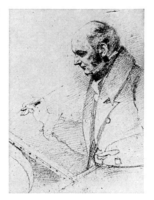

286

1832

January: too ill to perform his duties as Visitor at the Academy; unable to use his right hand, his letters have to be written for him; Abram visits him from Suffolk. By *17th:* recovering fast. Writes his own notes to Lucas. *21 February:* at work on the final 'Waterloo' canvas. *28th:* talks of 'dashing away at the great London', the 'Waterloo', but despairs of the work with Lucas. Especially anxious about the 'Waterloo' when he sends it in to the Academy – 'unfinished', Stothard calls it, correctly so in Constable's opinion. *May:* in rivalry, Turner paints in a daub of red on his neighbouring 'Helvoetsluys' – 'He has been here and fired a gun', says Constable. *June:* Lucas continues work on the plates; Minna seriously ill with scarlet fever; she recovers, and later convalesces with the Leslies at Brighton. *July:* the fifth number of *English Landscape* completed; copies are sent to various friends; Johnny Dunthorne very ill. *26th:* takes Minna to stay with the Whalleys at Dedham; he sleeps at Flatford. Back in London by *11 August. 22nd–25th:* in Berkshire, sketching for commissioned portrait of Englefield House. *25th:* death of John Fisher in Boulogne, where he had gone for his health. *September:* copies Robert Peel's Ruisdael, the 'winter peice'. *October:* Boner takes on secretarial duties. *30th:* visits Johnny Dunthorne, who dies on *2 November,* aged 34. *8th:* to Bergholt for Dunthorne's funeral; returns on *13th. December:* at work on 'Englefield House'; start of a new friendship, with George Constable, a brewer and maltster of Arundel, Sussex; spends Christmas at Hampstead with his children.

Exhibits. R.A.: (147) 'Sir Richard Steele's cottage, Hampstead'[1]; (152) 'A romantic house at Hampstead' (see No.206); (279) 'Whitehall stairs, June 18th, 1817' (No.286); (286) 'Moonlight'[2]; (492) 'Jaques and the wounded stag' (see No.327); (632) 'A church'; (643) 'A mill'; (644) 'Farm-house' (see No.294). Birmingham Society of Arts: (171) 'The Ferry'.

286 'Whitehall stairs, June 18th, 1817' (The Opening of Waterloo Bridge) exh.1832
Oil on canvas, 53 × 86½ (134.6 × 219.7)
Exh: R.A. 1832 (279)
Prov: 16 May 1838 (74, 'The Opening of Waterloo Bridge *Exhibited* 1832'), bt. Moseley; Charles Birch by 1839 (when lent by him to Birmingham Society of Arts), sold Christie's 7 July 1853 (42), bt. in, sold Foster 27 February 1857 (LXVI), bt. Henry Wallis, sold Foster 3 February 1858 (104), bt. in, sold Foster 6 February 1861 (86), bt. Davenport; . . . ; Kirkman D. Hodgson; . . . ; Sir Charles Tennant by 1892; by descent to Lord Glenconner; Harry Ferguson 1955; present owner
Private collection

Three studies connected with the early stages of this composition have already been shown above as Nos.174–6. One, at least, may date from around 1819. Constable worked on the subject from then until 1832, when No.286 was exhibited at the Royal Academy. No other composition occupied him for so long or caused him so much trouble. Even if his original excitement is

understandable, we do not know why he stuck so persistently to a subject so far outside his normal range.

Rennie's Waterloo Bridge (demolished in the 1930s) was opened by the Prince Regent on 18 June 1817, the second anniversary of the Battle of Waterloo. The occasion was one of great festivity, with crowds thronging the river and neighbouring streets. Constable's painting shows the Prince embarking at Whitehall Stairs beside Fife House for the short river journey to the new bridge; the Lord Mayor's barge figures prominently at the right. Beyond the left hand end of the bridge can be seen Somerset House, at this time the home of the Royal Academy (and the place where No.286 hung in 1832). On the right bank the Shot Tower, only built in 1826, makes an anachronistic appearance.

Constable was in London on 18 June 1817 and presumably witnessed the opening ceremonies but he does not seem to have thought of making a picture of them until 1819. On 17 July that year he told Fisher, 'I have made a sketch of my scene on the Thames' (JCC VI p.45). This sketch may be the one which he showed to Farington on 11 August 1819 and which Farington objected to as being too much a bird's-eye view (see No.174). The many subsequent, and generally not very explicit, references can be summarised as follows. On 19 April 1820 Fisher requested Constable not to part with his 'London and Westminster view' without telling him (ibid., p.53). In September that year Constable was putting a Waterloo Bridge subject 'on a large canvas' (JCC VI p.56), which may have been the 'new begun picture, "A view on the Thames on the day of opening Waterloo Bridge"' which he took to show Farington on 21 November that year and which Farington advised him to put aside in favour of something more in his usual vein. Presumably it was this abandoned Waterloo picture that the Bishop of Salisbury sat on the floor to admire, saying it was 'equal to Cannalletti', on 10 May 1822 (JCC II p.276). At the end of 1823 Constable revived his determination to exhibit a painting of the subject at the next R.A. show (JCC VI pp.144, 146) and by 17 January 1824 had produced a small version, 'a small balloon to let off as a forerunner of the large one' (ibid., p.149 and Leslie 1843 p.42, 1951 p.120). But the painting did not appear at the R.A. that year. On 18 July 1824 Constable said, 'I have no inclination to pursue my Waterloo. I am impressed with an idea that it will ruin me' (JCC VI p.168). The composition was revived yet again in October 1825, when Constable began a new, large canvas (JCC II pp.397, 407), in which he planned to incorporate 'a very capital alteration' suggested by Stothard, which would 'increase its consequence and do every thing for it' (ibid., p.398). In December 1825 Dunthorne was helping him with the 'intricate outline' of the picture (ibid., p.421) and, once more, Constable planned to finish the work in time for the following year's exhibition (JCC VI p.206). Once again, too, the plan was abortive. However, a fresh impetus was given in July 1826, when Constable said he 'made several visits to the terrace at Lord Pembroke's; it was the spot of all others to which I wanted to have access. I have added two feet to my canvas' (ibid., p.223). From then on little is heard of the painting until Constable got it ready for the R.A. exhibition in 1832. On 28 February that year he told David Lucas, who

was engraving a plate of the subject with a view to it being included in *English Landscape*, 'I am dashing away at the great London – and why not ? I may as well produce this abortion as another – for who cares for landscape ?' (JCC IV p.368). On 8 April he received a visit from the Pulhams, during which Mrs Pulham (whose portrait is No.158 above) said to her husband, 'Pulham – come here – I am quite in love with the Lord Mayor's bottom', referring to the large barge at the right (JCC III p.66).

During the varnishing days at the Academy occurred the much-cited incident in which Turner saw that his own sea-piece 'Helvoetsluys' was challenged by Constable's 'Whitehall stairs', which hung next to it, and put 'a round daub of red lead' on his sea to redress the balance, eventually shaping it into a buoy[3].

It is difficult to relate the mass of documentation which exists to the surviving pictorial material. The documents seem to indicate that Constable painted: 1. a bird's-eye view in 1819; 2. the 'London and Westminster view' referred to by Fisher in April 1820; 3. a larger painting, begun in September 1820; 4. a 'small balloon', finished in January 1824; 5. a new large canvas begun in October 1825, incorporating alterations suggested by Stothard, which was probably the canvas that Constable extended by 2 feet in 1826. No.5 is no doubt the final painting, No.286, though the latter is said[4] to show no sign of the extension referred to; it does however include a terrace in the foreground which appears in none of the other versions and which was presumably added following Constable's visit to Lord Pembroke's in 1826. No.286 also seems to be the only version to include the Lord Mayor's barge which Mrs Pulham so admired shortly before the picture went to the R.A. No.1 might be the oil sketch sold at Sotheby's on 30 November 1960 (122) and now in a private collection which certainly gives more of a bird's-eye view than any of the other works excepting the drawing shown as No.174 above. But Nos.2–4 cannot certainly be matched with any of the other known paintings. These include an oil sketch measuring $11\frac{1}{2} \times 19$ inches in the V. & A. (R.174), a painting of $60\frac{1}{2} \times 96$ inches in the Fairhaven Collection at Anglesey Abbey, the Royal Academy and Cincinnati pictures, which omit the ceremonies (see No.176), and the painting formerly in the collection of Lord Camrose, which presents a totally different, and otherwise unknown, view of the proceedings from the opposite side of Waterloo Bridge. The Fairhaven picture might be thought to be the first of the two large paintings mentioned in the correspondence – the 'large canvas' begun in September 1820 – but if, as suggested above, the latter was also the picture Constable took to show Farington, the identification is unlikely since the Fairhaven work is hardly portable. The fact that it is actually larger than the final painting is only one of its several odd characteristics. Nor is it easy to know exactly where the 'unceremonial', water-level view represented by the Royal Academy oil study (No.176) fits in. Did Constable try out this view after Farington's disapproval of the bird's-eye sketch ? If so, did he then proceed to the slightly higher viewpoint used for the V. & A. study, R.174 ? Another unknown factor is the advice Stothard gave Constable in 1825, though this may have been connected with the introduction of the bow-fronted house at the left of the picture. The many

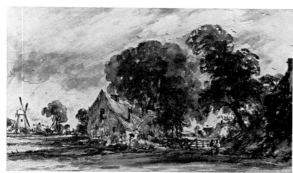

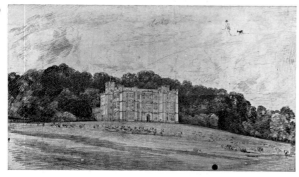

problems that remain echo the difficulties that Constable himself experienced with the composition.

287 Cottages at East Bergholt d.1832
Pencil, pen and ink, and watercolour,
4½ × 7⅜ (11.4 × 18.7)
Inscribed 'E.B July 31 1832'
Prov: presented to the British Museum by
Isabel Constable 1888
Trustees of the British Museum (L.B.19a)
See No.288.

288 Cottages and Windmill
Pencil, pen and ink, and watercolour,
5 × 8⅛ (12.7 × 20.6)
Prov: presented to the British Museum by
Isabel Constable 1888
Trustees of the British Museum (L.B.19b)
The subjects of these two views made on the visit to Suffolk in July/August 1832 have not so far been identified. It is possible that the windmill in No.288 was the one on East Bergholt Common owned by the Constables, but in appearance it does not altogether agree with the best-known of Constable's sketches of the windmill, the little oil-painting known as 'Spring. East Bergholt Common' in the V. & A. (R.122). Constable's next visit to Bergholt the following November, a brief one for the funeral of his one-time assistant Johnny Dunthorne, was to be his last.

There are other drawings at the V. & A. made during his stay at Flatford this summer. Two of these, of cottages (R.339) and a barn and trees (R.338), were drawn on the same day and in the same sketchbook as No.287. It is possible that a further drawing in the V. & A., 'A windmill and a flock of sheep' (R.394), was done on the same visit, the watermark, 'J. WHAT[. . .] 182[. . .]', being identical to that of No.288, and the subject, medium and handling of the two drawings being so much alike.

289 Englefield House, Berkshire 1832
Pencil, 12⅝ × 18⅝ (32.2 × 47.4), on paper extended by the addition of strips from proofs of the introduction to *English Landscape*
Inscribed in the sky, near a sketch of a man with a dog, 'Carter'
Prov: presented to the V. & A. by Isabel Constable 1888
Victoria and Albert Museum (R.341)
See No.291.

290 Englefield House, Berkshire 1832
Pencil, 11⅛ × 8⅞ (28.4 × 22.4), squared for transfer
Inscribed along the top with various notes on the architecture (see Reynolds 1973 p.206)
Prov: presented to the V. & A. by Isabel Constable 1888
Victoria and Albert Museum (R.343)
See No.291.

291 Englefield House: detail of left-hand turret
1832

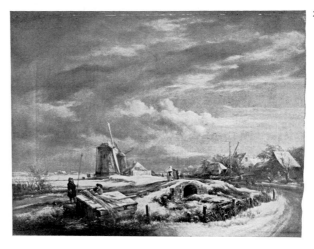

292

Pencil, $5\frac{1}{2} \times 8\frac{7}{8}$ (14.1 × 22.4)
Inscribed 'They are all alike'
Prov: presented to the V. & A. by Isabel
Constable 1888
Victoria and Albert Museum (R.344)

Constable visited Richard Benyon-De Beauvoir's seat, Englefield House, near Reading, in August 1832 to make drawings for a picture of the house which the owner had commissioned. Nos.289–91 are some of these. The painting, which was exhibited at the Academy in 1833, is No.296 below, where the commission is discussed in detail.

292 Winter (Copy after Jacob van Ruisdael)

d.1832

Oil on canvas, $22\frac{7}{8} \times 27\frac{7}{8}$ (58.1 × 70.8)
Inscribed with an imitation Ruisdael signature, and on the stretcher: 'Copied from the Original Picture by Ruisdael in the possession of Sir Rob.t Peel, Bar.t. by me John Constable R.A. at Hamp.d Sep. 1832. P. S. Color [. . .] Dog added [. . .] only [. . .] Size of the Original [. . .]' and 'Showed this Picture to Dear John Dunthorne Oct.r 30. 1832 [. . .] this was the last time I [. . .] poor J Dunthorne died on friday (all Saints) the 2.d of November. 1832 – at 4 o clock in the afternoon Aged 34. Years.'
Prov: 15 May 1838 (45, 'A Winter Scene from the original, by Jacob Ruysdael, in the possession of Sir Robert Peel'); . . . ; Edward Gambier Howe by 1902; thence by descent
Trustees of the Will of H. G. Howe, deceased (on loan to the Minories, Colchester)

293

For Constable, copying the 'old masters' was not simply a student exercise but a life-long activity. The earliest of several such copies included in the present exhibition (No.3) is dated 1795; the present work dates from thirty-seven years later, when Constable was aged 56. Even at this late stage in his career, he found it instructive to make so exact a copy of Ruisdael's 'Winter', then in Sir Robert Peel's collection, that (according to Lucas) its owner insisted on his providing some means of distinguishing the original from the replica: 'The loan of this picture was accompanied by a condition that some addition or omision should be made in order that the composition might be some what different he complied by introducing a dog behind the princepal figure in all other respects the imitation was so perfect that looking on the surface only few could detect any difference' (JC:FDC pp.61–2). The copy was made shortly after the death of Constable's greatest friend, John Fisher: 'I cannot tell how singularly his death has affected me', he told Leslie on 4 September 1832, 'I shall pass this week at Hampstead, to copy the winter peice – for which indeed my mind seems in a fit state' (JCC III pp.79–80). As the inscription on the back indicates, the premature death of his one-time assistant Johnny Dunthorne, son of his first mentor in art, also came to be associated with this work.

It was probably this copy of the Ruisdael that Constable showed and talked about in the third of his lectures at the Royal Institution in 1836. The original painting by Ruisdael is now in the Johnson Collection in Philadelphia.

294

293 A Willow beside water, a church beyond
d.1832
Pencil, pen and watercolour, 8¾ × 6½ (22.2 × 16.5)
Inscribed 'John Constable R.A. 1832'
Private collection

The restrained, decorous style, and the rather formal
signature and date, suggest that this is a drawing done
with a particular audience in mind – for an illustration,
maybe, or perhaps for a young lady's album. A similar
drawing of Salisbury Cathedral is in the Henry E.
Huntington Library and Art Gallery. This is also signed
in a formal hand, but is more specifically dated: 19 July
1832 (repr. *John Constable Drawings and Sketches*, Henry
E. Huntington Library and Art Gallery, San Marino,
1961, No.40, pl.8).

294 The Farmhouse near the Water's Edge
circa 1832
Pen, brown & grey ink and watercolour,
5⅝ × 7¹¹⁄₁₆ (14.2 × 19.6)
Prov: presented to the British Museum by
Isabel Constable 1888
Trustees of the British Museum (1888-2-15-33)

Although Bergholt and the banks of the Stour con-
tinued to provide Constable with a supply of subjects
for his watercolour and oil compositions, with the pas-
sage of time he adhered less and less to a precise topo-
graphy. The farmhouse depicted in No.294 is doubtless
once again Willy Lott's house, only this time as seen (or
as visualised in the artist's memory) from downstream
on the same bank – that is, from a position near the
boat-house depicted in 'The White Horse' and
the oil-sketch, No.165. The scene, however, has been
tidied up and, as it were, 'rose-tinted'. The complete-
ness and the general character of the work suggests that
it may have been intended for exhibition. In 1832 and
1833 Constable showed, respectively, four and three
drawings at the Academy. In the catalogue of the
former year, No.644 is called 'Farm-house'; No.639 in
the 1833 catalogue is described as 'An old farm-house'.

In the British Museum there is a pen and ink outline
drawing of the same composition inscribed on the verso
'X'.mas day Even^g. 1829 Charlotte Street [?Sqr]'
(1971-1-23-1). This could have been the initial realisa-
tion of the idea, but, though slight, it somehow does not
quite look like the artist's first thoughts about the view –
more like a copy made from another drawing (repr.
Graham Reynolds, *Constable: The Natural Painter*,
1970, pl.53b).

See No.328 for a variant of this composition.

1833

January: at work on 'Englefield House' and other
smaller pictures for the Academy; starts on a new
canvas, 'The Cenotaph'. *February:* sends his second son,
Charles, to school at Folkestone; keeps Lucas busy with
improvements to *English Landscape* plates in prepara-

tion for a new edition. *March:* occupied with his exhi-
bition paintings; 'The Cenotaph' is laid aside. *April:* is
visited, and greatly irritated, by the wealthy collector
William Wells of Redleaf. *17th:* considers himself to be
'weak' at the exhibition this year. *21–27th:* exchanges
notes with Reinagle (on the hanging committee) about
the framing and positioning of his pictures. *4 May:*
advertises *English Landscape* in the *Literary Gazette*;
the order of prints now changed, a new title-page and
introduction provided, and the price reduced. *June:*
upset by Leslie's decision to leave England for a post at
West Point. *17th:* lectures on Landscape to the Hamp-
stead Literary and Scientific Society. Boner arbitrates
in the concluding stages of his working partnership with
Lucas. *29th:* by a mischance, a 'Helmingham Dell' is
sold at Christie's for £2 15s; much is made of this by
the *Morning Chronicle*; he considers sueing the paper
but is advised not to. *3 August:* takes his elder sons to
Suffolk; they hunt for fossils; Charles draws; he does
nothing at all. *20th:* takes John and Charles to school at
Folkestone. *30th:* sends a 'Lock' to an exhibition at
Brussels. His cousin, Ann Gubbins, acts as house-
keeper for some months. *12 September:* Leslie and his
family sail for America. Designs illustrations for an
edition of Gray's *Elegy*. *10 October:* his son John
injured by a fall; hastens to Folkestone. *23rd:* catches a
chill returning on the coach and loses the full use of his
right hand. *December:* though ill, begins on a new large
canvas.

Exhibits. B.I.: (155) 'Salisbury from the meadows',
frame 72 × 82 inches (No.282); (156) 'Dell scene',
frame 38 × 46 inches (No.295). R.A.: (34) 'Englefield
house, Berkshire, the seat of Benyon de Beovoir, Esq. –
morning' (No.296); (94) 'A heath, showery – noon';
(344) 'Cottage in a corn-field' (No.297); (402) 'Land-
scape – sunset'; (639) 'An old farm-house' (see
No.294); (645) 'A miller's house'; (647) 'A windmill –
squally day'. Exposition Nationale des Beaux Arts,
Brussels: 'A Barge passing a Lock'¹ (?No.312). Society
of British Artists (Winter Exhibition): (236) 'Land-
scape – a Sketch'².

295 'Dell scene' (Helmingham Dell) exh.1833
(painted 1825–6)
Oil on canvas, 27⅞ × 36 (70.8 × 91.5)
Exh: B.I. 1833 (156, size with frame
38 × 46 inches)
Prov: painted 1825–6 for James Pulham, after
whose death in 1830 repurchased by Constable
from his widow and given in 1833, in exchange
for 'two or three old pictures', to Robert Ludgate,
who died the same year; put up for auction by
his widow, Christie's 29 June 1833 (not
catalogued), bt. Charles Scovell; by descent to
J. Scovell, sold Christie's 8 June 1883 (243),
bt. Fielder; . . . ; John G. Johnson by 1914
John G. Johnson Collection, Philadelphia

As with many of Constable's pictures, the Helmingham
Dell composition was based on a drawing made many
years earlier. There are several versions of the painting
and all appear to derive from No.21, drawn on his visit
to Helmingham, the Dysarts' Suffolk seat, in 1800. It
seems to have been in the early 1820s that Constable
began painting the subject in oils. In July 1823 he told

Fisher that Sir George Beaumont was pleased with 'a large wood' (one of Constable's names for the subject) which he had been toning (JCC VI p.125). Leslie says this was 'A large sketch' (1843 p.38, 1951 p.104) and it has often been identified with a sketchy version measuring 40 × 50 inches which is now in the Louvre. The version shown here, No.295, was ordered by Constable's Woodbridge patron James Pulham (for whom, see No.158) in 1824 but not painted until 1825–6 (JCC IV pp.92–3, II p.381). Its subsequent history is documented by Constable himself in a letter of 12 November 1833 to Charles Scovell, who had bought it at the sale that June of pictures belonging to Robert Ludgate, a well-known collector (see JC: FDC pp.90–91). 'I painted it in 1826, for my friend the late Mr. Pulham of Woodbridge in Suffolk, and purchased [it] afterwards of his widow at a greater price than I received for it – to prevent its going into an auction in the country. Having long been engaged to do something for poor Ludgate, and as he liked this subject, I offered according to his desire to retouch it for him, and during his last illness I constantly worked upon it in his presence . . . At his request it was sent to the British Institution . . . His death however taking place before the close of the Gallery, it was sent to my house. I received no money for it from Mr. Ludgate, but it was done in exchange with him for two or three old pictures . . . Mrs. Ludgate demanded the picture of me, rather abruptly moreover, through her friend Major Chapman – and without giving me the least notion of their intention sent it to Christie's . . . As it went late in the sale it was not even inserted in the catalogue. No one would bid for it [at] the time, doubting its originality – and several whom I know, who wished to possess it, went away on not finding it there . . .' (JCC IV pp.104–5). Constable told Boner that many people attending the sale thought it was by Watts, presumably F. W. Watts, one of Constable's earliest imitators (JCC V p.164). Curiously, the picture was again challenged when Scovell's son lent it to the International Exhibition in 1874; this time the doubter was the artist's own son Captain Charles Constable, but the owner was able to prove its authenticity by referring to the letter from Constable to Charles Scovell quoted above.

No.295 is reported to bear on the back the stencilled number '58', which is the one applied for the Scovell sale in 1883. Its size also agrees with the measurements given in the 1833 B.I. catalogue, whereas, with one exception, those of the other known versions do not. The exception is a work in the Anthony Bacon collection, which is, however, clearly a sketch rather than an exhibited painting. A picture of the same subject shown at the R.A. in 1830 was originally intended for James Carpenter, to be given in exchange for 'The Lock' (No.262) which Constable had got back from him in 1829 in order to present it to the Royal Academy as his Diploma picture. As related in the entry on No.262, Constable then decided that he wanted to keep the new 'Dell' himself and that he would therefore forfeit the 100 guineas he had deposited as security against the replacement of 'The Lock'. This version was still with him when he died and was lot 73 in the 16 May 1838 sale. It is thought to be the one now in the William Rockhill Nelson Gallery of Art, Kansas City. The size of the Kansas City picture, $44\frac{5}{8} \times 51\frac{1}{2}$ inches, is more or less consistent with one of the terms of Constable's original agreement with Carpenter – that he should replace 'The Lock' with a work of the same size.

296 **'Englefield house, Berkshire, the seat of Benyon de Beovoir, Esq. – morning'**
exh.1833
Oil on canvas, 40 × 51 (101.6 × 129.5)
Exh: R.A. 1833 (34)
Prov: commissioned by Richard Benyon-De Beauvoir; by descent to the present owners
Private collection

Although the genre did not appeal to him ('a gentleman's park – is my aversion', he declared in 1822), Constable accepted several commissions to paint portraits of country houses. Some of these works, as one would expect, were made very early in his career, when any road to advancement was welcome (see, for example, Nos.20 and 27) but others, including 'Wivenhoe Park' and the various depictions of Malvern Hall (see No.202) date from his maturity. It is strange, though, to find him tackling work of this kind so late as 1832–3, when No.296 was painted. By this time his financial position was secure enough for him not to have to engage in uncongenial tasks. The explanation may well be that he had promised the owner a picture of his house some years earlier and was only now fulfilling the promise.

The wealthy landowner Richard Benyon-De Beauvoir, Deputy Lieutenant and High Sheriff of Berkshire, engaged Constable's friend Samuel Lane to paint his portrait in 1824 and, according to Leslie (1843 p.86, 1951 p.215), Lane recommended Constable to him for a portrait of his house, Englefield House, near Reading. In June that year Lane told Constable that De Beauvoir was going to write to him about the matter (JCC II p.323). Nothing more is heard until 1832 when Constable visited Englefield House with Lane to make drawings for the picture. An inscription on the back of one of these drawings (V. & A., R.340) records their departure from London on 22 August. Three others are shown above as Nos.289–91 and one more is also in the V. & A. (R.342). Of this group, R.340 and No.289 present views of the house more or less as in the painting, R.342 gives a more distant view of the building in its park setting, and Nos.290–1 are detailed architectural studies.

Constable probably began the painting not long after his return from Englefield. On 17 December 1832 he told Leslie, who had been advising him about it, that he had 'made all the cows in the foreground of the house picture, bigger, and put in another bigger than all the rest put together. This has had all the effect you anticipated and sent the house back and also much enhanced & helped to realize my foreground, which indeed this blank canvas wants to aid it. But I must try at one of the elements – namely air – & if that include light, I ought not to despair' (JCC III p.84). By the early months of 1833 the work had definitely begun to pall. 'My House tires me very much', he wrote to Leslie, 'The windows & window frames & chimneys and chimney pots are endless – but I shall fill the canvas beyond repentance' (*ibid.*, p.97). Apart from his own frustration with it, Constable had to counter complaints

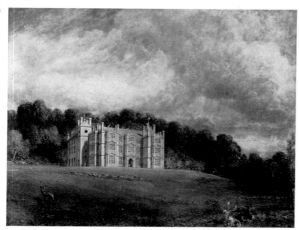

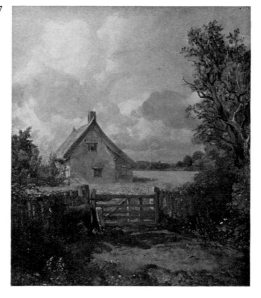

about the picture from both Mr De Beauvoir and the Royal Academy, where it was exhibited in 1833. There was a lot of trouble over the hanging of the work at the Academy, which, though finally resolved, left Constable in no doubt that the authorities frowned upon pictures of houses. 'They have pulled down my picture again, and put it where it is quite destroyed', he told Leslie, 'It could not *maintain its place* in the house as it was "an Academy" – & only could look at the higher walks of art. Mine was only a "gentleman's *house*" and excellence (if it had it) has nothing to do with the higher walks of art. I was told that had mine been a "drawing," instead of a picture, it would have been placed in the Architectural Room' (*ibid.*, p.101). Constable gave Lane a similar account: 'S[hee] told me it was "only a *picture of a house*, and ought to have been put into the Architectural Room." I told him it was "a picture of a summer morning, *including a house*."' (Leslie 1843 p.88, JCC IV p.254). However, by attempting to produce something more than a house-portrait, Constable found himself in even greater difficulties with Mr De Beauvoir, who, Lane reported in March of the following year, had 'wanted the house to be the prominent figure, and all the rest subordinate': 'He pointed out to me several things which displeased him, he liked the house by itself, but his principal objection seemed to be the specky or spotty appearance of your touch, and the quantity of sheep, oxen, &c which are in the foreground, and which he said looked as if he had his farm yard before his Drawing Room windows' (JCC IV p.113). The offending cows (still visible as *pentimenti*) were replaced by deer but De Beauvoir refused to accept the painting or to take up Constable's offer to produce a new one in which he would concentrate on 'the picturesque beauty of the Elizabethan architecture', entering 'minutely into its elegant detail' (*ibid.*, p.114). Since the picture descended through the Benyon family, some sort of compromise must finally have been reached. Beckett shows that there is reason to think De Beauvoir gave the painting to his cousin the Revd. Edward Benyon. The history of 'Englefield House' epitomises a dilemma facing the nineteenth-century artist: how to reconcile his own interests, his patron's and those of the Academy. While working on the picture, Constable remarked to Leslie, 'to please one person is no joke, now a days'.

297 'Cottage in a corn-field' exh.1833
Oil on canvas, $24\frac{1}{2} \times 20\frac{1}{4}$ (62 × 51.5)
Inscribed on a label now removed from the back: 'No 3. Cottage in a Corn field – John Constable 35 Charlotte Street'. This seems to be the label applied for the 1833 R.A. exhibition. It is written on the back part of a proof of the May 1832 Introduction to *English Landscape*
Exh: R.A. 1833 (344); B.I. 1834 (128, 'A Cottage in a Field of Corn', size with frame 34 × 30 inches).
Prov: 16 May 1838 (52, 'Cottage in a Corn Field'), bt. in by Burton for Constable family; bequeathed to the V. & A. by Isabel Constable 1888
Victoria and Albert Museum (R.352)
Because it can be dated to 1832, the label described above shows that No.297 was the cottage picture which Constable exhibited at the R.A. in 1833 rather than the

one he showed there in 1817. In addition, the earlier exhibit almost certainly reappeared at the B.I. in 1818, when its framed measurements were given as 19 × 17 inches. These are obviously inappropriate to No.297, whereas those given when No.297 was re-exhibited at the B.I. in 1834 do tally. All the same, this does not look at all like a work of the 1830s, and it can only be supposed that it was painted many years earlier and brought out when Constable needed to support 'Englefield House' (No.296) with other works at the R.A. in 1833. As Reynolds (1973 p.212) points out, Constable's reference to the picture in his letter to Leslie on 2 March 1833 – 'I have licked up my Cottage into a pretty look' – may suggest that he had been retouching an earlier work.

The cottage picture exhibited in 1817 and 1818 was probably purchased by a Mr Venables, with whom Constable was bargaining over the price of a 'Cornfield' in March 1818 (see JCC IV pp.165–6). The price Venables offered was £20. Constable told Farington on 6 April that year that he had sold 'two of his landscapes – one for 45 guineas & the other for 20 guineas': the latter could have been the cornfield picture. We do not know what became of this work or even, with any certainty, what it looked like. Reynolds suggests that the earlyish appearance of No.297 may be explained by it being a replica of the 1817 composition. No.297 fairly closely follows a drawing which was probably made in 1815 (No.136) and the latter – considering only its date – could therefore have served also as the basis of the 1817 exhibit. There may be a difficulty here, however. We know works already exhibited could not be re-exhibited at the R.A. Would Constable have been permitted to show, in 1833, even a replica of a painting he had previously exhibited there? Although it is tempting to associate the 1817 and 1833 exhibits, the possibility that the former was altogether a different composition should be borne in mind.

298 Design for an illustration to Gray's 'Elegy' (Stanza V) 1833
Watercolour, $4\frac{1}{2} \times 7\frac{1}{4}$ (11.4 × 18.4)
Prov: presented to the British Museum by Isabel Constable 1888
Trustees of the British Museum (L.B.35a)
See No.301.

299 Alternative design for an illustration to Gray's 'Elegy' (Stanza V) 1833
Pen and watercolour, $4\frac{5}{8} \times 6\frac{7}{8}$ (11.8 × 17.5)
Prov: presented to the British Museum by Isabel Constable 1888
Trustees of the British Museum (L.B.35b)
See No.301.

300 Design for an illustration to Gray's 'Elegy' (Stanza III) 1833
Charcoal and grey wash, $4 \times 6\frac{3}{8}$ (10.1 × 16.2)
Prov: presented to the V. & A. by Isabel Constable 1888
Victoria and Albert Museum (R.355)
See No.301.

298

299

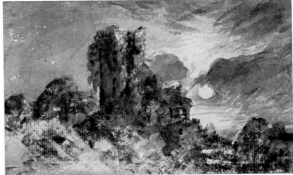

300

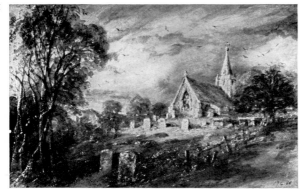

301

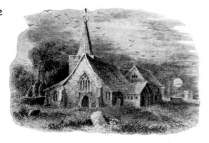

302

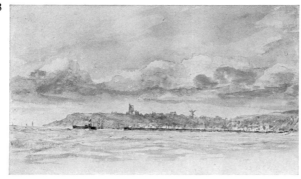

303

304

301 Stoke Poges Church: preliminary design for Gray's 'Elegy' d.1833
Watercolour, $5\frac{1}{4} \times 7\frac{3}{4}$ (13.3 × 19.7)
Inscribed on verso 'Stanza 5th – "The breezy call of incence breathing morn, [. . .] No more shall rouse them from their lowly bed" John Constable R.A. July 1833.'
Prov: presented to the V. & A. by Isabel Constable 1888
Victoria and Albert Museum (R.354)

No.298 is a design from which an engraving on wood was made to illustrate Stanza V in an edition of Gray's *Elegy* published by the artist's friend, John Martin, the bibliographer. Nos.299–301 are preparatory designs for the same work. Illustrated with wood engravings from No.298 and two other designs by Constable, the first edition appeared in 1834. A second edition, with an additional vignette of Stoke Poges Church on the title-page, was published in 1836 (see No.302).

No.298 was designed to illustrate Stanza V of the *Elegy*:

The breezy call of incense-breathing Morn,
The swallow twittering from the straw-built shed,
The cock's shrill clarion, or the echoing horn,
No more shall rouse them from their lowly bed.

The vignette on the title-page of the second edition is a fairly accurate rendering of the west end of the church, and from this one might assume that Constable had been to Stoke Poges and sketched there, but neither of the churches in the other two designs – Nos.298 and 301 – bears the slightest resemblance to Gray's church and it is possible that he had worked from an engraving or from someone else's drawing for the title-page design.

In Constable's illustration for Stanza V (No.298) we have yet another example of him turning to an old sketchbook for an idea. In this case he found what he wanted in a composition in the 1813 sketchbook (No.119). On page 49 of this veritable storehouse we find three sketches; one of these ($2\frac{1}{2} \times 1\frac{3}{4}$ inches) is of a man leaning on a fence with a building (roofed at two levels) on the left, and above – a crescent moon. For the trees and the tombstones he used another source, a slight pencil drawing of an unidentified churchyard (Coll. Dr D. Darby, repr. catalogue of *Exhibition of Drawings by John Constable*, William Darby, May 1972, No.24).

No.300 appears to be an early design for the illustration to Stanza III, 'Save that, from yonder ivy-mantled tower, / The moping Owl does to the Moon complain /. . .'. It has been pointed out that the design derives from Constable's 'Hadleigh Castle', and that in the Isabel Constable sale of 1892, lot 253 among the pictures and sketches in oils was described in the catalogue as 'Hadleigh: an illustration to Gray's Elegy'[3].

In the Academy of 1834 Constable exhibited two *Elegy* subjects: 582 'Stoke Pogis Church, near Windsor, the scene of *Gray's Elegy* – also where he was buried. "In this neglected spot is laid, / A heart once pregnant with celestial fire."'; and 586 'From *Gray's Elegy*, stanza 11. "Can honour's voice provoke the silent dust?"'. At present the whereabouts of neither is known. Leslie says that the two drawings were bought by Samuel Rogers, but only the first appears to have come up for sale at Christie's after the poet's death. A

watercolour of the second subject was in the collection of the late R. B. Beckett.

302 Thomas Gray, ed. John Martin, 'Elegy Written In A Country Church-Yard'
2nd. ed. 1836
Private Collection
This is a copy of the second edition of Martin's edition of Gray's *Elegy*, originally published in 1834. As explained above under No.301, Constable made three designs for the first edition and an additional one for the second. The latter – the title-page vignette – is shown here. A note by the editor reads: 'The vignette on the title-page, engraved by W. H. Powis, is a view of Stoke-Pogis church, Buckinghamshire, the churchyard of which is the scene of this celebrated poem . . . The drawing by John Constable, Esq. R.A. has been kindly offered to the editor since the publication of the former edition, and is in the possession of Samuel Rogers, Esq.'. The drawing used for the vignette was presumably the one which Constable exhibited at the R.A. in 1834 as 'Stoke Pogis Church, near Windsor, the scene of *Gray's Elegy* – also where he was buried' and which Leslie said Rogers bought (see No.301). Powis's wood-engraving seems to be the only record of its appearance.

Martin's edition, which was dedicated to Rogers, was intended, the editor explained in a foreword, to exploit 'The great improvement that has taken place, within a few years, in the art of Engraving on Wood'. Unfortunately, very few of the engravings support this claim and, with the exception of those by Constable and Mulready, few of the original designs were worthy of the enterprise. In the same year that Martin's second edition appeared, its publisher, John van Voorst, also issued Yarrell's *A History of British Fishes*, which included a wood-engraving after Constable's 'Gillingham Mill' (see No.243).

303 Folkestone d.1833
Pencil and watercolour, $5 \times 8\frac{1}{4}$ (12.7 × 21)
Inscribed '16 Oct. 1833 Folkestone'
Prov: presented to the British Museum by Isabel Constable 1888
Trustees of the British Museum (L.B.30a)
See No.304.

304 Folkestone Harbour 1833
Pencil, pen and watercolour $5 \times 8\frac{1}{4}$ (12.7 × 21)
Inscribed 'All grey' in the sky, above the stern of the nearest boat
Prov: presented to the British Museum by Isabel Constable 1888
Trustees of the British Museum (L.B.30b)
Constable paid two visits to Folkestone, both in 1833. The first was in August, when he took his two eldest sons to a boarding school there and remained for two or three days while they settled in. The second was in October when he hurried down to be with the elder boy after he had injured himself sleep-walking. On this second trip he found his son rather worse than he had been led to expect and so had stayed on, altogether, for nearly a fortnight. During these two weeks he made a number of watercolour drawings. Other sketches of Folkestone are to be found in the British Museum, the V. & A., and the Fitzwilliam Museum, Cambridge.

Charles, the other boy, was a keen young artist. One of his friends at school had been infected by his enthusiasm for sketching, and artists' materials and manuals had been sent for this 'Mr Colville'. The written colour-note in No.304, unusual for Constable, indicates that the drawing was not coloured on the spot. The simple treatment and readily understood colouring suggest that it was done for an audience, possibly by his son's bedside, with a little group of admirers looking on.

305 View at Hampstead looking towards London d.1833
Watercolour, $4\frac{1}{2} \times 7\frac{1}{2}$ (11.5 × 19.1)
Inscribed on verso 'Hampd December 7, 1833 3 oclock – very stormy afternoon – & High Wind –'
Prov: presented to the V. & A. by Isabel Constable 1888
Victoria and Albert Museum (R.358)
A fine example of Constable catching a passing effect of sun and rain 'on the wing' from one of the back windows of his house in Well Walk (see No.272).

306 Fir Trees *circa* 1833
Pencil, $28\frac{7}{8} \times 22\frac{15}{16}$ (73.4 × 58.2)
Prov: . . . ; Gilbert Davis; bt. by present owners from Colnaghi's 1959
Trustees of the Cecil Higgins Art Gallery, Bedford
In the catalogue of the Constable exhibition at Manchester (1956), it is stated that this drawing bears an inscription 'J C 1815'. It has been suggested more recently that the inscription should be read rather as 'John . . . 181 . . . ' and that 1817 would bring it more happily into line with the two large tree studies (Nos.154 and 156) which are so dated[4]. In this exhibition No.306 has been placed among the work of the 1830s because it is felt that this is nearer to where it belongs stylistically and because there is even a possibility that it may have been an exhibited piece, the work described in the catalogue of the 1834 Academy as '548 Study of trees, made in the grounds of Charles Holford, Esq., at Hampstead'.

A characteristic of much of Constable's pencil work of the thirties is a renewal of vitality in his handling, a translation into linear terms of the expressive energy to be seen in works such as the Hadleigh sketch (No.261). In a more controlled form, it is the presence of this same rhythmic manipulation of the pencil-point which seems to rule out the possibility of No.306 having been done much before this time. A stylistically similar work is a drawing in the V. & A. inscribed 'July 5, 1833 West End feilds' (R.353).

The pencil-marks which have been read as an inscription are to be seen near the bottom margin of the drawing almost in the centre. Three of these marks look very like the figures '181', but their size, hardly more than $\frac{1}{8}$ inch in height, the fact that they are vertically aligned, whereas Constable wrote a consistently slanting hand, and the central placing instead of the customary position for an inscription to left or right, make it unlikely that these touches of the pencil were intended by the artist to be anything more than part of the pencilling descriptive of the texture and surface of the ground.

305

306

307

307–10 Constable's Lectures on Landscape 1833–6

Between 1833 and 1836 Constable delivered ten lectures on the history of landscape painting: one in 1833 to the Literary and Scientific Society of Hampstead, another to the same company in 1835, three the same year to the Worcestershire Institution for promoting Literature, Science and the Fine Arts, four to the Royal Institution, London in 1836, and a final one to the Hampstead society in 1836. None were published by him and what we know of them is from second-hand accounts, chiefly by Leslie, and from Constable's surviving drafts – the sources are summarised in JC:FDC pp.6–10.

Constable was not by nature a public performer and, as he told his friend H. W. Pickersgill in 1836, he had been 'temp[t]ed to may [i.e. make] this exposure of myself – only in the belief that I may do the profession some good & that I may rescue ourselves from the Obliquy of being in "total Ignorance of the Principles & theory of that art we profess"' (JC:FDC p.265). To Wilkie he wrote similarly of 'a sad freak with which I have been long "*possessed*" of feeling a *duty* – *on my part* – to *tell* the world that there is such a thing as Landscape existing with "Art" – as I have in so great measure failed to "*show*" the world that it is possible to accomplish it' (*ibid.*, p.5). His account of the rise of landscape painting was thus directed to a very particular end: a justification of the genre itself, at a time when its intellectual status was still negligible to Academic minds. 'In tracing the history of landscape', Leslie reported him as saying in his first Hampstead lecture, '. . . I shall endeavour to render it clear, useful, and interesting, by pointing out the *epochs* which mark the development, progress, and perfection of this department of art, – a department than which there is none more efficient, impressive, or delightful, and none that has more completely succeeded in the attainment of its object. – My endeavour shall be to separate it from the mass of historical art in which it originated, and with which it was long connected. Considering, as I do, that landscape has hitherto escaped a distinction to which it is entitled, I propose to trace it to its source, to follow its progress to its final success, to show how by degrees it assumed form until at last it became a distinct and separate class of painting, standing alone, when from being the humble assistant, it became the powerful auxiliary to that art which gave it birth, greatly enriching the dignity of history' (Leslie 1843 pp.129–30, 1951 p.290). In his first Royal Institution lecture he depicted landscape as 'the child of history' which came to the support of the parent in its decrepitude (Leslie 1843 p.138, 1951 p.303). The inference was that landscape had grown to be the equal of 'History Painting', the highest category in the Academic hierarchy of genres. Certainly, Constable thought it equally able to 'raise the thoughts, and extend the views of the spectator', the function ascribed to History Painting by Reynolds.

For Constable the 'epochs' in the evolution of landscape painting were the works of Dürer, Titian, Domenichino, Poussin, Claude, Rubens, Rembrandt, Ruisdael, Wilson and Gainsborough, many of which he brilliantly characterised in these lectures. Living artists were not mentioned, but there can be little doubt that by this historical survey he was seeking to place his own contribution to the art.

261 **Sketch for 'Hadleigh Castle'** *c.*1828–9 detail (entry on p.153) ▶

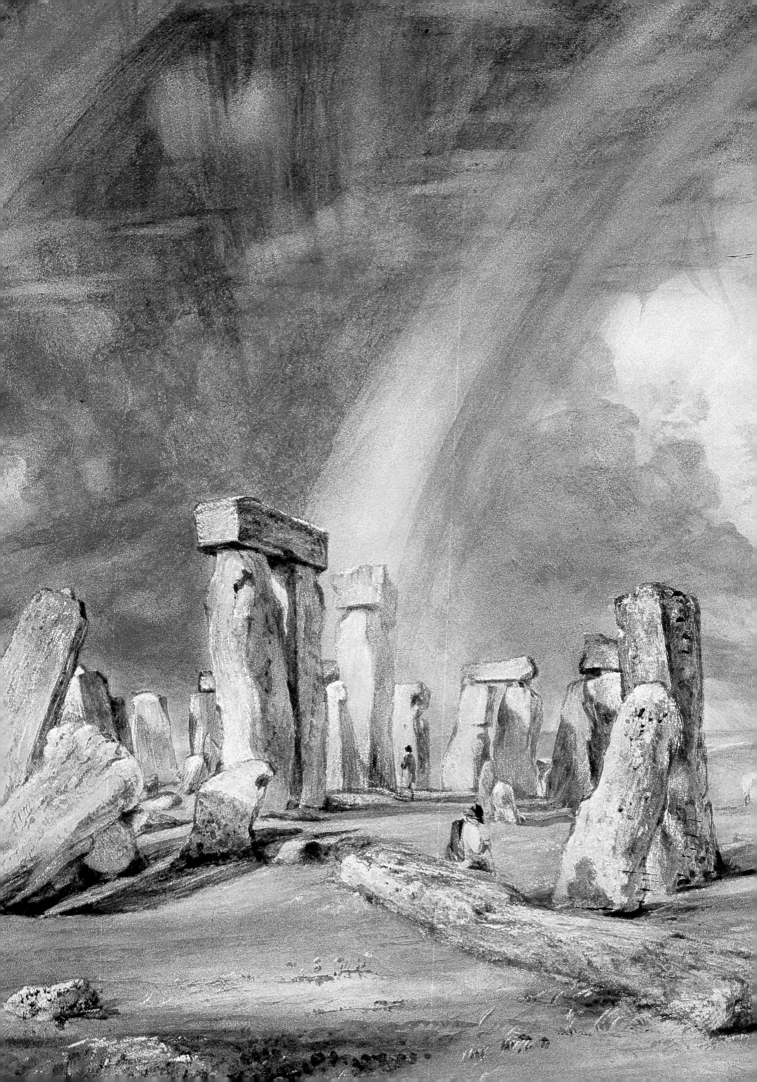

307 Draft for Constable's Lecture at Hampstead in 1833

The Executors of Lt. Col. J. H. Constable

One of several drafts for this lecture which survive in the family collection. In this one (published in JC:FDC pp.13–14, Sheet 3) Constable sketches his exposition of the 'Peter Martyr' by Titian, for him 'the Great Master and Father of all Landscape Painting'. It was in this picture that Constable, like Fuseli and Turner before him, saw landscape as having first made a great mark – here for the first time it was not merely a background but an essential element in the creation of the mood of the work.

308 Draft for Constable's last Lecture at Hampstead in 1836

The Executors of Lt. Col. J. H. Constable

In his final lecture Constable was less concerned to account for the development of landscape than to justify its significance in more general terms. In this draft (published in JC:FDC p.22, Sheet 13) he writes: 'In conclusion I must again repeat the necessity of keeping ones mind alive to that external nature with which we are surrounded, for few there are who seem to be aware of the beauty of the Paradise in which we are placed. We exist but in a Landscape and we are the creatures of a Landscape'. In the lecture itself, according to Leslie (1843 p.151, 1951 p.329), he said: 'There has never been an age, however rude or uncultivated, in which the love of landscape has not in some way been manifested. And how could it be otherwise? for man is the sole intellectual inhabitant of one vast natural landscape. His nature is congenial with the elements of the planet itself, and he cannot but sympathize with its features, its various aspects, and its phenomena in all situations'.

309 Chronological Chart prepared for the lectures

The Executors of Lt. Col. J. H. Constable

Constable drew up a number of such charts in preparation for his lectures. This one is written on the back of a proof of the Introduction to *English Landscape* dated 28 May 1832.

310 Syllabus for the Royal Institution lectures 1836

The Executors of Lt. Col. J. H. Constable

1834

20 January: tells Leslie he has been ill and depressed and scarcely 'able to do any one thing', but that he is at work on a large canvas; has been writing letterpress for *English Landscape*. *February:* seriously ill with rheumatic fever; nursed by Boner. *14 March:* Leslie writes to say he is returning to England. *April:* on request from the President, Cregan, sends four works to the Royal Hibernian Academy exhibition in Dublin. Is only

able to send four drawings to the Academy; two of these, illustrations to Gray's *Elegy*, bought by Samuel Rogers. *2 June:* exhibition of works by living artists at Worcester; two of his, a 'Salisbury' and a 'Lock', shown. *19th:* attends meeting at A.G.B.I.; now a Vice-President, from this time on he is closely concerned with the affairs of the charity. *July:* he and John spend a week or so at Arundel with the George Constables; makes several drawings; calls on Lord Egremont at Petworth; is invited to stay there. *August:* works on 'Salisbury Cathedral from the Meadows', and sends it to a show at Birmingham. Twice visits Lady Dysart at Ham House to advise about her business matters. *10 September:* joins the Leslies at Petworth; most of his drawings made on expeditions from the house. *25th:* last sketch of the trip. *16 October:* takes his eldest boys to see Houses of Parliament burning. *December:* poses for a head in Wilkie's 'Columbus'. *17th:* reports that he is 'foolishly bent on a large canvas', probably 'The Valley Farm'. Wrangles with Lucas over the engraving of 'Stratford Mill', etc. *24th:* the Leslies, Bannister, Wilkie and his sister and Samuel Rogers to dinner.

Exhibits: B.I.: (128) 'A Cottage in a Field of Corn', frame 34 × 30 inches (No.297); (174) 'A Heath scene, showery day', frame 32 × 42 inches; (329) 'The Stour Valley, which divides the Counties of Suffolk and Essex; Dedham and Harwich Water in the distance', frame 72 × 63 inches (No.253). R.A.: (481) 'The mound of the city of Old Sarum, from the south' (No.311); (548) 'Study of trees, made in the grounds of Charles Holford, Esq., at Hampstead' (see No.306); (582) 'Stoke Pogis Church, near Windsor, the scene of Gray's *Elegy* – also where he was buried' (see Nos.298–302); (586) 'From Gray's *Elegy*, stanza 11' (see Nos.298–302). Royal Hibernian Academy, Dublin: (46) 'Landscape, morning, valley of the Stour, which divides the county of Suffolk and Essex, Dedham and Harwich, water in the distance' (No.253); (56) 'A Sea Piece, Yarmouth Pier, Norfolk, morning'; (92) 'A Heath'; (241) 'Jacques and the wounded stag' (see No.327). Worcester Institution: (26) 'Salisbury Cathedral – from the Bishop's Grounds' (No.216); (141) 'Landscape – a Barge passing a Lock on the Stour' (see No.312). Birmingham Society of Arts: (194) 'Warwick' (lent by Charles Birch); (317) 'Salisbury Cathedral, from the Meadows, Summer Afternoon, A retiring Storm' (No.282).

311 'The mound of the city of Old Sarum, from the south' exh.1834

Watercolour, 11⅞ × 19⅛ (30 × 48.7)

Exh: R.A. 1834 (481)

Prov: bequeathed to the V. & A. by Isabel Constable 1888

Victoria and Albert Museum (R.359)

Constable sketched Old Sarum on several of his visits to Salisbury but the place seems to have interested him most on his stay there in July 1829. A number of drawings of it made then survive, including No.264 above. An oil sketch in the V. & A. (R.322) was presumably painted not long after since it was the basis of the first of the two plates of 'Old Sarum' (Shirley 1930, No.8) engraved by Lucas for *English Landscape* and a proof of this plate is dated 1829. The character of the present

◄ 331 'Stonehenge' exh. 1836 detail (entry on p.188)

watercolour, No.311, strongly points to it being the work exhibited at the R.A. in 1834, and it is mounted in a similar way to the Stonehenge watercolour, No.331 below, which was certainly shown there two years later.

We know something of Constable's feelings about Old Sarum from the text which he composed to accompany the plate in *English Landscape*. 'The subject of this plate, which from its barren and deserted character seems to embody the words of the poet – "Paint me a desolation," – is grand in itself', he wrote, 'and interesting in its associations, so that no kind of effect could be introduced too striking, or too impressive to portray it; and among the various appearances of the elements, we naturally look to the grander phenomena of Nature, as according best with the character of such a scene. Sudden and abrupt appearances of light, thunder clouds, wild autumnal evenings, solemn and shadowy twilights, "flinging half an image on the straining sight," with variously tinted clouds, dark, cold and gray, or ruddy and bright, with transitory gleams of light; even conflicts of the elements, to heighten, if possible, the sentiment which belongs to a subject so awful and impressive . . . The present appearance of Old Sarum – wild, desolate, and dreary – contrasts strongly with its former greatness. This proud and "towered city," once giving laws to the whole kingdom – for it was here our earliest parliaments on record were convened – can now be traced but by vast embankments and ditches, tracked only by sheep-walks: "The plough has passed over it"' (Shirley 1930, p.258; JCD pp.24–5). As Leslie commented, 'A city turned into a landscape, independently of the historical associations with Old Sarum, could not but be interesting to Constable' (1843 p.76, 1951 p.196).

As one of the notorious 'rotten boroughs', Old Sarum also had more recent associations – only by the passing of the 1832 Reform Act did this uninhabited place lose its right to return two members to Parliament. The idea of 'Reform' was one that had greatly disturbed Constable: 'this tremendous attack on the constitution of the country', he told Leslie in 1831, '. . . goes to give the government into the hands of the rabble and dregs of the people, and the devil's agents on earth, the agitators' (Leslie 1843 p.77, JCC III p.49). As a churchman, Fisher had been even more apprehensive of the 'vulture of reform' (JCC VI p.110), and when he called the subject of Constable's 'Salisbury Cathedral from the Meadows' (No.282) the 'Church under a cloud', he was not thinking only of the weather.

312 'Landscape – a Barge passing a Lock on the Stour' painted 1825; exh. ?1833 and ?1834
Oil on canvas, 55 × 48 (139.7 × 122)
Exh: ?Exposition Nationale des Beaux Arts, Brussels 1833 ('A Barge passing a Lock');
?Worcester Institution 1834 (141, title as at head of entry)
Prov: 16 May 1838 (76, 'The Lock; Companion to the picture of the Corn Field, now in the National Gallery *Exhibited* 1824 [sic]'), bt. Charles Birch, sold Foster's 15 February 1855 (XVIII), bt. in, sold Foster's 28 February 1856 (61), bt. William Holmes for W. Orme Foster of Apley Park, Bridgnorth; by descent to Major

A. W. Foster, from whom inherited by present owner
Major General E. H. Goulburn

This is a replica of the painting which James Morrison bought at the 1824 Royal Academy exhibition (No.227). No.312 includes birds in the sky but is otherwise almost identical to the earlier picture. The replica is presumably the work which Constable told Fisher about on 26 November 1825: 'I have a half length of a lock in hand – far better than usual' (JCC VI p.211) and of which he wrote to Maria two days later: 'I am now finishing a copy of my Lock, which rejoices me a good deal – it is a very lovely subject' (JCC II p.415). Constable's printed scale of charges for landscapes, dated 1826, indicates that 'Half length size' was 50 × 40 inches, which is near enough the size of No.312.

If the replica was a commissioned work, something must have gone wrong with the transaction since the picture was still with Constable when he died. 'The Lock' included in the 1838 sale must have been this one because the other version belonged to Morrison. The reference in the sale catalogue to the picture having been exhibited in 1824 may be a confusion with Morrison's picture, which had been shown that year, or a printing error for 1834, when No.312 may have been exhibited at Worcester. The account in the *Worcester Herald* (10 June) of the 'Landscape – a Barge passing a Lock on the Stour' which Constable sent to the exhibition leaves no doubt that it was this composition but it is not clear which version, the Morrison or No.312, was shown. Beckett refers to Windsor 1903, pp.123–6 for a description in Berrow's *Worcester Journal* (23 July) which, he says, identifies No.312 as the 1834 exhibit (R. B. Beckett, 'Constable's "Lock"', *Burlington Magazine*, XCIV, 1952, p.255). But what Windsor quotes there is the *Worcester Herald* account already mentioned, and there seems nothing in this to identify the exhibited version. If No.312 *was* the one exhibited, two difficulties need to be explained. Writing to Edward Leader Williams, Honorary Secretary of the Worcester Institution, Constable said, 'That you should really have taken the trouble to visit my "Lock" so often is a sincere compliment to the picture. I cannot now forbear to tell you that the picture of "The Lock" was greatly esteemed by the fastidious critic Fuseli, when it was at the Academy. It was his constant visit (leaning on the porter's arm) every Sunday morning' (JCC V p.61). The 'Lock' shown at the Academy was, of course, the one Morrison bought in 1824. Was Constable suggesting that this was the same picture that Williams admired at Worcester, or was he talking about two different works? On 8 September 1834 Constable told Leslie, 'I have got my picture back from Worcester' (JCC III p.119). In fact Constable exhibited two works at Worcester, the other being No.216 above. If the 'Lock' shown there was No.312, Constable would have been expecting the return of *two* pictures since No.216 was also his property. If he really did receive only one picture, could the other exhibit have been returned direct to its owner, Morrison? Or did Constable simply write 'picture' in error for 'pictures'?

Annotating Leslie's account of the Morrison picture, Lucas wrote: 'The. upright Lock. there are two pictures of this subject one of which was copied in a great degree by Mr Dunthorn and worked on by Mr. C

311

afterwards. but it was not comparable with the first painting for. vigeour and richness' (JC:FDC p.58). This seems to mean that there were two versions, Nos.227 and 312, and that Johnny Dunthorne worked on the latter. However, a reference in Constable's journal for 6 December 1825 suggests that Dunthorne also made a copy for himself: 'John has done all he can to his large Lock' (JCC II p.416). This sounds like something Dunthorne had been doing by himself rather than work on the copy which Constable himself was finishing in November 1825. If Dunthorne did make his own copy, it was presumably 'that copy of the Lock which hung up at Mr. Dunthorne's' which Constable wished to borrow in September 1832, saying he would 'take great care of it' (JCC IV p.381).

No.312 seems the most likely candidate for the 'Lock' picture which Constable exhibited at Brussels in 1833, but, again, we cannot rule out the possibility that it was Morrison's picture that went. All the same, it would have been unnecessary for Constable to trouble Morrison for his Brussels and Worcester exhibits when he already had a perfectly good replica on his hands. Further research in the Brussels and Worcester newspapers might resolve the issue.

313 Hampstead Heath, from near Well Walk
d.1834
Watercolour, $4\frac{3}{8} \times 7\frac{1}{8}$ (11.1 × 18.1)
Inscribed verso 'Spring Clouds – Hail Squalls – April 12. 1834 – Noon Well Walk –'
Prov: presented to the V. & A. by Isabel Constable 1888
Victoria and Albert Museum (R.360)

Among Constable's later drawings there are several as expressive as is the present study of emotional tension and of a release of nervous energy. Seldom, however, does the artist appear to have paid less attention to the conventional niceties of watercolour painting.

314 Petworth House from the Park 1834
Pencil and watercolour, $8\frac{1}{8} \times 10\frac{3}{4}$ (20.7 × 27.2)
Prov: presented to the V. & A. by Isabel Constable 1888
Victoria and Albert Museum (R.372)

Constable visited west Sussex for the first time in July 1834 when, with John Charles, he stayed with his namesake (though no relation), George Constable of Arundel, brewer, maltster and amateur artist. Their friendship dated from 1832, when George Constable had sent an appreciative letter about *English Landscape*. On one of their excursions in July 1834 they paid a visit to Petworth, in preparation for which Constable had armed himself with a letter of introduction to Lord Egremont from Thomas Phillips, the portrait painter. The Earl came out to greet him and, Constable told Leslie in a letter, was most courteous. 'He wanted me to stay all day – nay more he wished me to pass a few days in the house. This I was much pleased at, but I excused myself for the present, saying I would so much like to make that visit while you was there – which he took very agreeably, saying let it be so then' (JCC III p.112).

Despite this cordial invitation, when Leslie was at Petworth in September with his family, he had the greatest difficulty in persuading Constable to overcome his scruples, to take Egremont at his word and to join

312

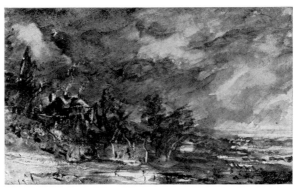

313

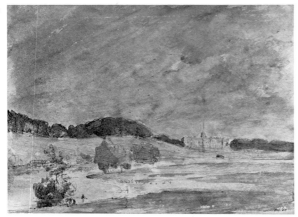

them under the Earl's roof. After much palaver, Constable finally agreed to come, and on 10 September, for the second time that year, left London for Sussex.

No.314 is a fair example of the drawings made in the immediate vicinity of the house. Constable never seems to have been quite at his ease in what he called 'great houses' (JCC V p.23) and it may be indicative that his better drawings were of subjects well outside the grounds.

315 Cathanger, near Petworth d.1834
Pencil, $8 \times 13\frac{9}{16}$ (20.4 × 34.5)
Inscribed 'Petworth Sepr. 12 1834 – Cat
Hanger –'
John Baskett Ltd
See No.316.

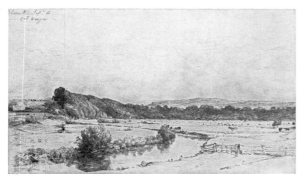

316 Ruins at Cowdray, Sussex d.1834
Pencil and watercolour, $10\frac{7}{16} \times 10\frac{13}{16}$ (26.5 × 27.4),
this width includes the $2\frac{3}{4}$ inch strip on the
right-hand side
Inscribed 'Sept 14 1834'; verso, on the main
sheet 'Mowbray, Castle Sep 14 1834', on the
narrow strip 'Internal – of Cowdray – the oriel
window'
Prov: presented to the British Museum by
Isabel Constable 1888
Trustees of the British Museum (L.B.24)

'Lord Egremont', Leslie tells us, 'with that unceasing attention which he always paid to whatever he thought would be most agreeable to his guests, ordered one of his carriages to be ready every day, to enable Constable to see as much of the neighbourhood as possible. He [Constable] passed a day in the company of Mr. and Mrs. Phillips, and myself, among the beautiful ruins of Cowdry Castle, of which he made several very fine sketches; but he was most delighted with the borders of the Arun, and the picturesque old mills, barns, and the farm-houses that abound in the west of Sussex.' (Leslie 1843 p.96, 1951 pp.235–6). Constable mentions these trips in a letter of 14 September to George Constable of Arundel: '. . . Mrs Phillips is going to take me to see a castle about five miles off. Yesterday I visited the river banks, which are lovely indeed – Claude nor Ruysdael could not do a thousandth part of what nature here presents' (JCC V p.19). It was evidently scenes such as No.315 that had so charmed Constable. 'Cat Hanger', the name inscribed on the drawing, is that of a farm on the Petworth estate, a property that lies within sight of the house to the south on the far side of the Rother, a tributary of the better-known Arun.

During Constable's stay at Petworth Leslie saw something of his friend's working habits. 'He rose early, and had often made some beautiful sketch in the park before breakfast. On going into his room one morning, not aware that he had yet been out of it, I found him setting some of his sketches with isinglass. His dressing-table was covered with flowers, feathers of birds, and pieces of bark with lichens and mosses adhering to them, which he had brought home for the sake of their beautiful tints' (Leslie 1843 p.96, 1951 p.236). The reference here to Constable 'setting', i.e. fixing, his drawings to prevent the pencil-work rubbing is of particular interest. He appears to have used isinglass (a pure form of gelatin), or some other fixative, when he

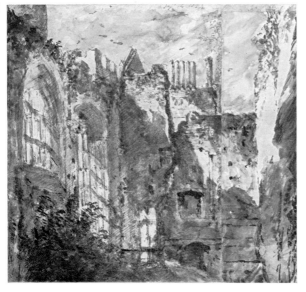

had been working with a soft pencil. When brushing the fixative over the drawing, quite often he missed a patch or two. In time, the pencilling in such patches would be rubbed away by abrasion, leaving a more faintly marked area. There are two of these patches in No.315 on the left: the larger in the bottom corner, the other about half-way up. Similar patches appear in Nos.217 and 219.

317 Landscape study after 1833
Pencil and watercolour, $8\frac{3}{8} \times 7\frac{1}{4}$ (21.3 × 18.3)
Prov: presented to the V. & A. by Isabel
Constable 1888
Victoria and Albert Museum (R.415)

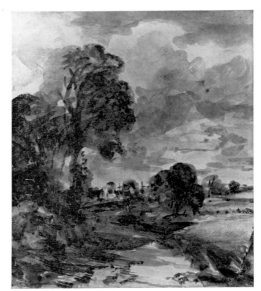
317

The problem of dating this fine drawing has exercised Constable scholars for some time. Shirley assigned it to 1831; it was dated 1832–5 in the catalogue of the Exhibition of British Art at the Royal Academy in 1934. Graham Reynolds, who first noted the fact that the drawing was on paper watermarked 1833, has pointed out that if it was a study from nature, and of a Suffolk subject, then it must have been done during the visits of 1833 or 1835 (1973, p.242). If Constable meant what he said when he told Leslie that on his visit to Suffolk in August of the former year his son Charles 'made drawings and I did nothing at all' (JCC III p.105), then we must rule out 1833. In 1835, as far as we know, Constable was only in Suffolk once, in January, to vote at the Ipswich elections, when there would have been no leaves on the trees.

In character, No.317 is not unlike the monochrome studies (e.g. No.318 and V. & A., R.410) which, as we know, were based on earlier works. As Reynolds has observed, the composition of No.317 bears a generic resemblance to that of 'The Cornfield'. If it was not a study from nature, then it could have been done at any time between 1834 (bearing in mind the watermark) and March 1837.

318 Trees and a stretch of water ?*circa* 1834
Pencil and brown wash, $8 \times 6\frac{3}{8}$ (20.3 × 16.2)
on paper watermarked 1829
Prov: presented to the V. & A. by Isabel
Constable 1888
Victoria and Albert Museum (R.411)

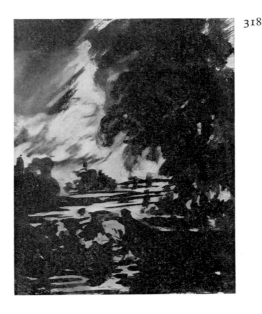
318

This well-known drawing was done on one half of a sheet of writing paper torn in two. Its counterpart, 'View on the Stour: Dedham Church in the distance' (V. & A., R.410), is on the other half of the sheet. As Graham Reynolds has explained ('Constable at Work', *Apollo*, July 1972, pp.12–19), both drawings are re-workings of earlier compositions: R.410 being based on the central section of the familiar 'Dedham Lock and Mill' (Nos.166 & 180); No.318 on a pen and wash composition in the V. & A. (R.347), a drawing of a river landscape with a white horse standing in the water, ahead of a barge, while a boy scrambles up on to its back. Further examples of Constable's use of wash in this 'blottesque' manner are in the V. & A. (R.412 & 413), and in private collections[1]. Reynolds sees No.318 and R.410 as reflecting the artist's 'concern for chiaroscuro, the search for a complete statement of his art in monochrome, which had been strengthened in him by his association with David Lucas in preparing the mezzotints for *English Landscape Scenery*' (ibid., p.18).

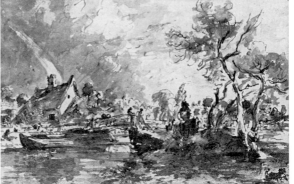
319

319 Flatford Old Bridge and Bridge Cottage on the Stour ?*circa* 1834

Pencil, pen and brown ink, grey wash

7 × 10⅝ (17.8 × 27)

Prov: presented to the V. & A. by Isabel Constable 1888

Victoria and Albert Museum (R.324)

There can hardly have been a subject that appears more often in Constable's drawings and paintings than that of the footbridge and thatched cottage at Flatford. The present composition seems to have been based on a drawing in the 1813 sketchbook, No.119 (p.29), a sketch of the bridge and cottage from the same viewpoint with a passing barge in almost exactly the same position. In composing his design, Constable has once again made free use of the topography. The trees on the right-hand side are those to be seen in 'Flatford Mill' (No.151), and as we know from that painting and from his studies of the group (e.g. No.154), they were in fact well downstream from the bridge.

1835

By *6 January* in Suffolk to vote at the Ipswich elections. Returns to London a few days after the *18th*. *14 February*: writes to Dunthorne for some of his son Johnny's drawings of ash trees. *March*: Robert Vernon, the collector, buys 'The Valley Farm' off the artist's easel before it is sent to the R.A. Charles Boner leaves his employ and goes to Germany. *May*: finds a place for his son Charles as midshipman in an East Indiaman, the *Buckinghamshire*. *22 June*: gives the second of his lectures at Hampstead on Landscape. *27th*: appears as a witness in a law-suit about the authenticity of a Claude. *7 July*: takes his two eldest children to stay with George Constable at Arundel. *19th*: last dated drawing of the visit. *August*: Charles joins the *Buckinghamshire*; John goes to Paris with the George Constables. Early *September*, paints his 'Stonehenge'. *8th*: the *Buckinghamshire* sails for Bombay. *6, 8* and *9 October*: lectures on Landscape at Worcester. Stays with his wife's half-sister at Bewdley. *15th*: last dated drawing in the area. *2 November*: fails in an attempt to have Lucas elected A.R.A. *16 December*: visited by Abram, who brings him a 6-gallon cask of linseed oil from the mill at Higham. *24th*: to Flatford with his son, John, for a week.

Exhibits. R.A.: (145) 'The valley farm' (No.320). Worcester Institution: (50) 'Harvest-Noon; a Lane Scene' (No.242); (62) 'A Heath Scene'; (68) 'A Water Mill' (No.246); (171) 'The Glebe Farm' (No.321); (185) 'Valley of the Stour – Morning' (No.253).

320 'The valley farm' exh.1835

Oil on canvas, 58 × 49¼ (147.3 × 125)

Inscribed 'John Constable R.A. [? fecit] 1835'

Exh: R.A. 1835 (145); B.I. 1836 (43, 'The Valley Farm', size with frame 73 × 65 inches)

Prov: bt. from the artist by Robert Vernon March 1835 and presented by him to the National

Gallery 1847; transferred to Tate Gallery 1919

Tate Gallery (327)

Constable painted Willy Lott's house or The Valley Farm, as it was sometimes known, throughout his life. Apart from the long sequence of paintings and drawings connected in one way or another with the final picture of 1835 (No.320), the house figures prominently in other compositions, including 'The Mill Stream' (No.129) and 'The Hay Wain' (No.192). Even Flatford Mill did not receive the coverage Constable afforded to the humbler building that faced it. He seems, in fact, to have had an obsession with Willy Lott's home. According to Leslie, the farmer Lott 'was born in it, and it is said, has passed more than eighty years without having spent four whole days away from it' (1843 p.18, 1951 p.45). He was there when Constable was born and there when Constable died. Lott must have seemed very much part of the landscape, and his cottage may well have become for Constable a nostalgic symbol of a 'natural' way of life which was no longer his own. The tortured surface of No.320, the last 'Valley Farm', suggests an almost desperate attempt to recreate the past.

So far as we know, Willy Lott's house is first depicted in No.35, probably painted in 1802. In this, however, the view later used for 'The Valley Farm' pictures occurs only as a detail at the extreme left. A drawing here dated *circa* 1812 (No.115) is a more direct and more detailed study of the view adopted in the paintings. Two slight pencil sketches of the subject are on pp.31 and 70 of the 1813 sketchbook (No.119) and two oil studies in the V. & A. (R.373–4) appear also to belong to this early stage of the composition's development. In both, a man in a boat is introduced, though in neither is he placed as in the final painting. The possibility that Lord Forteviot's 'Valley Farm' (which shows the man and his boat in yet another place) was exhibited at the R.A. in 1814 has been mentioned under No.129. This work would, in any case, seem to be Constable's first attempt at a large painting of the subject. The smaller 'Valley Farm' shown as No.137 appears to be later in date. Some of the details it includes – the post in the left foreground, the figures on the far bank and the bird skimming the water – were adopted with little alteration in the final painting. *Pentimenti* at the right suggest that there might even originally have been a boat similar to that in No.320.

It is not known exactly when the final 'Valley Farm', No.320, was begun. It might have been the 'large picture' which in November 1833 Constable told H. S. Trimmer he had planned (JCC V p.67). Fairly certainly it was the 'large canvass' that he said he was 'foolishly bent on' in December 1834 (*ibid.*, p.43). Thereafter its progress is well documented. The collector Robert Vernon saw it in Constable's painting-room before it went to the Academy: 'he saw it free from the mustiness of old pictures – he saw the daylight purely – and he bought it – it is his – only I must talk to you about price', Constable wrote to Leslie in March 1835 (JCC III p.124). The price eventually determined was £300, paid in September. Work continued on the picture up to the time it went to the Academy, was resumed when it returned and was still going on in October 1835, when Constable told J. J. Chalon that he had been 'very busy with Mr. Vernon's picture. Oiling out, making out, polishing, scraping, &c. seem to have agreed with it

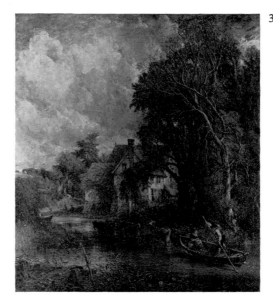

320

exceedingly. The "sleet" and "snow" have disappeared, leaving in their places, silver, ivory, and a little gold' (JCC IV p.278).

Between the earlier versions and the 1835 picture Constable made important changes to the trees at the right, using a drawing of an ash tree (V. & A., R.163), probably made at Hampstead[1], as the basis of a full-scale drawing (V. & A., R.375) which he then transferred to the canvas, where the new tree is recognisable as the one with the broken branch hanging down above the ferryman. He also reshaped the trees at the left of the group so that the side of the house became clearly visible, as in the original drawing, No.115. A study for the girl in the boat is in the V. & A. (R.377).

321 **'The Glebe Farm'** ?painted *circa* 1830;
 exh.1835
 Oil on canvas, $25\frac{1}{2} \times 37\frac{5}{8}$ (65 × 95.5)
 Exh: Worcester Institution 1835 (171)
 Prov: 16 May 1838 (70, 'The Glebe Farm
 Exhibited 1835'), bt. in by Leslie for Constable
 family; bequeathed by Isabel Constable to the
 National Gallery 1888; transferred to Tate
 Gallery 1919
 Tate Gallery (1274)

Constable's first painting of the Glebe Farm at Langham is an oil sketch in the V. & A. (R.111), which is usually dated *circa* 1810–15. When he later came to make pictures of the subject, Constable moved Langham church so that it would appear beside the farm, and in one of Lucas's mezzotints of the subject made an even more radical departure from topography by converting the whole thing into 'Castle Acre Priory'.

The first of the Glebe Farm pictures was exhibited at the B.I. in 1827. Of Constable's two other exhibits there that year, one (No.243 above) was already sold and the other (No.242) remained with him until his death. When *The Courier* reported on 3 February 1827 that Mr Morant had purchased a Constable at the exhibition, his purchase must therefore have been 'The Glebe Farm'. George Morant presumably knew Constable since they were both Directors of the A.G.B.I. His picture is said to have been with Tooth's in 1910 but its present whereabouts is unknown.

No.321 can be identified as 'The Glebe Farm' exhibited at Worcester in 1835 from the reference in the 1838 sale catalogue quoted above. If, as seems to be the case, it was the version Lucas engraved for the second Glebe Farm plate in *English Landscape* (Shirley 1930, No.29), the painting must have been in existence by 1831, when the plate was begun. Another version in the Tate Gallery (No.1823) was given by Constable to Leslie, the catalogue of whose sale in 1860 recalled that 'Mr Leslie saw Constable at work on this picture, and told him he liked it so much he did not think it wanted another touch. Constable said, "Then take it away with you that I may not be tempted to touch it again." The same evening the picture was sent to Mr Leslie as a present'. This incident seems to have taken place by February 1830 (see JCC III p.25) and certainly by August 1831 (see JCC IV p.351). Many other versions of the composition are known, few of them genuine.

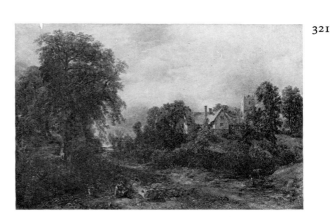

321

Two pages (29 & 33) of No.322

323

324

325

322 Sketchbook used in 1835 d.1835
Pencil, pen and ink, and watercolour,
$4\frac{1}{2} \times 7\frac{3}{8}$ (11.5 × 18.8)
The sketchbook of 50 pages is half-bound in green
leather, gold tooled, marbled boards. Inside, the
front cover bears a label: S. & J. Fuller, Temple
of Fancy, 34, Rathbone Place, London.
The paper is watermarked: J WHATMAN 1832
Prov: presented to the V. & A. by Isabel
Constable 1888
Victoria and Albert Museum (R.382)

This sketchbook was used by Constable during his visit
to Sussex in July 1835 when, as in the previous July, he
stayed with George Constable at Arundel. He also had
it with him later in the month when he went to
Kingston-on-Thames to fetch his eldest daughter,
Maria, who had been staying there with Mrs Philip
Fisher, the mother of his friend the Archdeacon.

13 and 27 July are the earliest and latest dates in-
scribed on drawings in No.322, but it is possible that he
may have started using the book on his arrival at
Arundel, as a watercolour of Littlehampton (No.324),
which appears to have come from the sketchbook, is
dated 8 July. The book contains sketches of Little-
hampton, Middleton Church, Arundel Castle (includ-
ing, on p.33, a drawing he later used for the exhibited
painting, No.335), Fittleworth, and Canbury House,
Kingston. On the inside of the back cover, Constable
noted details of some Sussex antiquaries and their
writings. There are drawings on twenty-five of the
pages. They vary from slight pencil outlines (e.g.
Middleton Church, p.14) and a pen and ink line sketch
of the pier at Littlehampton (p.1), to fairly elaborately
worked-up watercolours (p.9, A cottage, and p.17, A
view in the grounds of Arundel Castle). Middleton
Church is recorded by four drawings, one of these being
a delicately executed watercolour of a skeleton in the
churchyard revealed by erosion. On page forty-six
Constable made a watercolour of a parrot for his
daughter Maria.

323 The Ruins of the Maison Dieu, Arundel
d.1835
Pencil, $8\frac{5}{8} \times 11$ (22 × 28.1)
Inscribed 'Arundel July 8th. 1835 Maison Dieu'
Prov: presented to the V. & A. by Isabel
Constable 1888
Victoria and Albert Museum (R.378)

This drawing appears to have been made on the first
day after Constable's arrival at Arundel to stay with
George Constable. It may be noted that there was an
expedition to Littlehampton on that day (see No.324).

The remains of the Maison Dieu, a hospital or alms-
house of the fourteenth century, stand close by the
bridge at Arundel.

324 Stormy effect, Littlehampton d.1835
Watercolour, $4\frac{7}{16} \times 7\frac{1}{4}$ (11.3 × 18.4)
Inscribed 'Little Hampton July 8 1835.'
Prov: presented to the British Museum by
Isabel Constable 1888
Trustees of the British Museum (L.B.18a)
See No.325.

325 Folkestone ?1833–5
Pencil and watercolour, 5 × 8¼ (12.7 × 21)
Prov: presented to the British Museum by
Isabel Constable 1888
Trustees of the British Museum (L.B.18b)

325
326

In treatment, the view of the mole at Folkestone from
the seaward side (No.325) bears little resemblance to
the watercolours Constable made during his visit to
Folkestone in 1833 (see No.304 for a view of the mole
from inshore). In those, the colour-washes are simple,
and there is little or no evidence of scratching and
scraping out to obtain the lights. The similarity in the
handling of the medium in No.325 to that in the water-
colour of Littlehampton (No.324), suggests that the
former may have been over-worked at a later date, pos-
sibly in 1835. In his later watercolours Constable would
scrape away vigorously at the surface of the paper to
achieve what he wanted, but there does not appear to
have been a single instance of his resorting to opaque
colour to obtain his effects.

326 Arundel Mill and Castle d.1835
Pencil, 8⅝ × 11 (21.9 × 28.1)
Inscribed 'Arundel Castle & mill' and 'Arundel
Mill July 9 1835'
Prov: presented to the V. & A. by Isabel
Constable 1888
Victoria and Albert Museum (R.379)

327

This is another drawing made on Constable's visit to
Arundel in July 1835. Together with a study on page
33 of the sketchbook used on this trip (No.322), it
formed the basis of the painting of Arundel Castle
which Constable was working on at the time of his
death (No.335) and which was exhibited posthumously.

327 The Melancholy Jaques *circa* 1835
Pencil, ink and wash, 5⅝ × 4½ (14.3 × 11.4)
Prov: . . . ; Professor J. Isaacs, sold Sotheby's
24 July 1963 (221), bt. Oscar & Peter Johnson Ltd
Private collection

This is one of many designs Constable made for an
illustration intended for *The Seven Ages of Shakespeare*,
published by John van Voorst in 1840. In an introduc-
tion the Editor, John Martin (for whom see Nos.298–
302), wrote: 'The interest which [Constable] took in
the trifling affair required of him, is best evinced by the
fact that he made nearly twenty sketches for the
"melancholy Jaques", which by the kindness of C. R.
Leslie, Esq. R.A. now accompanies this work; that
gentleman having selected the design he judged most
appropriate, and careful of the reputation of his de-
ceased friend, took the additional trouble upon himself
of transferring it to the wood'. The wood-engraving, by
S. Williams, appeared on p.18 of the book. Of three
surviving preparatory sketches, one in the British
Museum (L.B.4) seems closest to the published design.
Another is in the V. & A. (R.407). We do not know when
Constable made his sketches but the work was certainly
being planned in 1835. On 10 February that year
Leslie, another contributor to the book, told Constable
that 'Martin was here to day with his seven ages, he is
pleased with my idea of the fates' (JC:FDC p.242).
Leslie made his selection of Constable's designs in
August 1837: John Charles Constable recorded a visit
to Leslie on 5 August when he 'took him some draw-

328

ings of the Jaques, in order that he might choose one for Mr. Martin' (*ibid.*, p.99).

The 'Jaques' subject (*As You Like It*, II. i) chosen by, or perhaps allotted to, Constable was one that he had previously illustrated in a watercolour, different in composition, shown at the R.A. in 1832 and at Dublin in 1834. This was made in or before 1828 (see JCC IV p.157) and is usually identified with a work now in the British Museum (1940-4-13-14). The latter, however, does not seem to be of sufficient quality to be by Constable himself. A more impressive version is in a private collection.

328 A river scene, with a farmhouse near the water's edge ?*circa* 1835
Oil on canvas, 10 × 13¾ (25.4 × 34.9)
Inscribed on verso, possibly in Isabel Constable's hand, 'J. Constable Valley Farm'
Prov: presented to the V. & A. by Isabel Constable 1888
Victoria and Albert Museum (R.403)
See No.329.

329 Cottage at East Bergholt(?) ?*circa* 1835
Oil on canvas, 34½ × 44 (87.6 × 111.8)
Prov: . . . ; Engleheart family; James Orrock by 1893, sold Christie's 4 June 1904 (64), bt. Agnew for W. H. Lever, later 1st. Viscount Leverhulme
Trustees of the Lady Lever Art Gallery, Port Sunlight

In his last years Constable appears to have made a number of studio sketches of the sort of subjects which had occupied him since youth – river scenes, cottages, and so on. Although some are of more or less recognisable places, it is clear that 'effect' rather than topography was his main concern. Why such sketches were made in the first place, however, is not clear. None seem to be preparatory studies for known finished paintings. Two examples are shown here, a small one, No.328, which is related to the watercolour No.294 above and may be based on memories of Willy Lott's house, and a larger sketch, No.329, which is said to be of a cottage at East Bergholt. The ferryman in No.328 is, of course, the one seen poling his way through the 'Valley Farm' sequence, while the donkey in No.329 looks as though it has strayed from the earlier 'Cottage in a Cornfield' (No.297).

These two sketches are also examples of the sort of work by Constable often pastiched or faked later in the century. 'One marked feature of all these productions', Leslie's son Robert wrote of such forgeries, 'being founded upon the mistake, that in order to manufacture an authentic Constable, it was only needful to load so many square feet of old canvas with unmeaning dabs of paint, clumsily laid on with something like a small trowel . . . spurious Constables were constantly brought to my father by dealers; at times singly, at others in batches; nearly all being of the extreme palette knife type, or what would now, perhaps, be called "impressionist" examples' (Introduction to Robert Leslie's edition of the *Life*, 1896). No.329 was itself questioned when shown at the R.A. Winter exhibition of 1893 (it 'raised a storm of discussion' said Sir Charles Holmes) but it now seems a perfectly acceptable example of – in all senses of the phrase – Constable's 'final manner'.

1836

Attends most of the A.G.B.I. meetings this year; much correspondence with his sister Mary about farm property; offers to lecture on Landscape to Royal Institution. *16 February:* Faraday tells him the offer is accepted. *March:* discusses the lectures with Samuel Rogers. *18th:* is visited by the collector John Sheepshanks. *1 May:* arrangements completed by Abram for purchase of the Old House Farm near Flatford. *12th:* writes of the exhibition at the Academy – 'Turner has outdone himself – he seems to paint with tinted steam, so evanescent, and so airy'. *26th:* gives his first lecture at the R.I., 'The Origin of Landscape', to an audience of two hundred. *2 June:* second lecture, the 'Establishment of Landscape'. *9th:* third lecture, 'Landscape of the Dutch and Flemish Schools'. *16th:* fourth lecture, 'The decline and revival [in England] of Art'. *25 July:* delivers his last lecture to the Literary and Scientific Society, Hampstead. *30th:* his son Charles returns from his first voyage to the East. *October/November:* works with Lucas on the large plate of 'Salisbury Cathedral from the Meadows'. *27th:* Charles sails again, for the Far East; they do not meet again. *December:* tells Leslie that Sheepshanks means to have his 'Glebe Farm'. *10th:* attends the meeting at the R.A. when Visitors for the Life Academy are chosen for the next year: A. Cooper, Constable, Eastlake, G. Jones, Turner appointed.

Exhibits. B.I. (43) 'The Valley Farm', frame 73 × 65 inches (No.320). R.A.: (9) 'Cenotaph to the memory of Sir Joshua Reynolds, erected in the grounds of Coleorton Hall, Leicestershire, by the late Sir George Beaumont, Bart.' (No.330); (581) 'Stonehenge' (No.331). Worcester Institution: (2) 'Salisbury Cathedral from the Meadows – Summer Afternoon – A retiring Tempest' (No.282); (32) 'Sir Richard Steele's Cottage, Hampstead'; (48) 'A Farm Yard near a navigable River in Suffolk – Summer Morning'; (61) 'Summer Evening' (possibly No.103); (141) 'Effect of Moonlight through Trees'; (156) 'A River Scene – Noon'; (157) 'An Early Study – Painted in the Wood – Autumn'; (219) 'Portrait of a Gentleman'; (227) 'Portrait of a Lady and Children' (these last two were hung on screens used for miniatures).

330 'Cenotaph to the memory of Sir Joshua Reynolds, erected in the grounds of Coleorton Hall, Leicestershire, by the late Sir George Beaumont, Bart.' exh.1836
Oil on canvas, 52 × 42¾ (132 × 108.5)
Inscribed on the cenotaph: only the word 'REYNOLDS' legible
Exh: R.A. 1836 (9)
Prov: 16 May 1838 (71, 'The Cenotaph, erected by *Sir George Beaumont*, to the Memory of *Sir Joshua Reynolds Exhibited* 1836'), bt. in by Carpenter on behalf of the Constable family; bequeathed to the National Gallery by Isabel Constable 1888
National Gallery (1272)
The circumstances of the erection of the cenotaph to Reynolds at Coleorton are related in the entry on

No.225, a drawing Constable made on his visit there in 1823. This drawing was the basis of No.330 but in the latter considerable alterations were made to the trees, a stag introduced and busts of Michelangelo and Raphael added. When No.330 was exhibited at the Academy Constable accompanied it in the catalogue with the lines which Wordsworth had composed for the inscription on the cenotaph (quoted here as they appear in the catalogue):

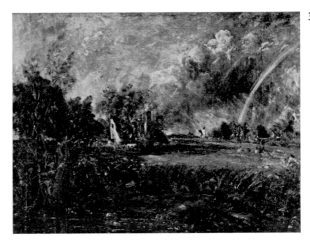
329

Ye lime trees ranged before this hallowed urn
Shoot forth with lively power at spring's return,
And be not slow a stately growth to rear
Of pillars branching off from year to year,
Till they have framed a darksome aisle,
Like a recess within that sacred pile,
Where REYNOLDS 'mid our countrey's noblest
 dead,
In the last sanctity of fame is laid;
And worthily within those sacred bounds
The excelling painter sleeps – yet here may I,
Unblamed amid my patrimonial grounds,
Raise this frail tribute to his memory –
An humble follower of the soothing art
That he professed – attached to him in heart,
Admiring, loving – and, with grief and pride,
Feeling what England lost when Reynolds died.
 Inscribed by Wordsworth, at the request, and in the
 name of Sir George Beaumont

While Beaumont's cenotaph was an act of homage to Reynolds, Constable's painting was a memorial to both Beaumont and Reynolds. When he found that he could not complete both 'The Cenotaph' and 'Arundel Mill and Castle' (No.335) in time for the 1836 exhibition, the last to be held in the Academy's old premises at Somerset House, Constable submitted the former, telling George Constable: 'I preferred to see Sir Joshua Reynolds's name and Sir George Beaumont's once more in the catalogue, for the last time in the old house' (JCC V p.32).

330

The busts of Michelangelo and Raphael appear to be Constable's own invention, intended, no doubt, to add a further dimension to his tribute to past art, perhaps even to suggest a pedigree for British art. While No 330 hung at the Royal Academy, Constable was lecturing at the Royal Institution with similar ends in view. Certainly Reynolds would have approved the allusion to Michelangelo as the Academy prepared to leave Somerset House. The same name had been on his lips as he left Somerset House on the conclusion of his final Discourse: 'I should desire that the last words I should pronounce in this Academy, and from this place, might be the name of – MICHAEL ANGELO'.

Constable began 'The Cenotaph' in 1833, telling Leslie around February, 'I contemplate a half length of my Sercophagi' (JCC III p.93) and, probably in March, 'I have laid by the Cenotaph *for the present*' (*ibid.*, p.96). Work resumed in 1836, Leslie hearing on 26 March: 'I have not neglected the "Avenue," and it is perhaps safe' (*ibid.*, p.136). Leslie was able to help with the problem of the inscription on the cenotaph. Constable's 1823 drawing (No.225) gives an illegible indication of the lines and Constable obviously felt that something more distinctive was needed in the painting. Leslie sent him a sketch in which the name 'REYNOLDS' is picked out but the rest left to the imagination (see

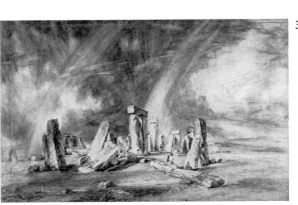
331

JC:FDC p.244) and it was this solution that Constable adopted.

331 **'Stonehenge'** exh.1836
Watercolour, 15¼ × 23¼ (38.7 × 59.1)
Exh: R.A. 1836 (581)
Prov: bequeathed to the V. & A. by Isabel Constable 1888
Victoria and Albert Museum (R.395)
(colour plate facing p.177)

The original mount is inscribed with the following lines, which were also printed in the R.A. catalogue in 1836: 'Stonehenge "The mysterious monument of Stonehenge, standing remote on a bare and boundless heath, as much unconnected with the events of past ages as it is with the uses of the present, carries you back beyond all historical records into the obscurity of a totally unknown period"'. Constable's only recorded visit to Stonehenge was on 15 July 1820, when he made the drawing shown as No.181 above. By way of various intermediary studies[1], he transformed this sensitive tonal drawing into the dramatic watercolour seen here. Perhaps even more than 'Old Sarum' (No.311), it bears out Constable's conviction that no effect of nature was too grand for such a naturally 'sublime' subject. As in many of his late works, the rainbow – transient symbol of hope – is the chief 'Organ of sentiment'. The text chosen to accompany the watercolour points up Constable's acute consciousness of time. In the work itself the apparent permanence of the stones is contrasted with the most fleeting effects of nature, and with the most fleet of animals – a hare running out of the picture at the left.

332 **Milford Bridge, with a distant view of Salisbury** *circa* 1836
Pencil, pen and watercolour, 7⅛ × 9½ (18.1 × 24.1), on a thin, gilt-edged card
Prov: presented to the V. & A. by Isabel Constable 1888
Victoria and Albert Museum (R.401)
See No.333.

A. R. FREEBAIRN after CONSTABLE
333 **Milford Bridge, with a distant view of Salisbury**
Engraving, 2⅝ × 3¾ (6.5 × 9.5)
Lettered 'Constable, R.A.' and 'Freebairn'
Victoria and Albert Museum (*mounted with* R.401)

A pencil drawing of Milford Bridge in the family collection[2] appears to have been the original sketch from which Constable made this watercolour (No.332) for the engraver, A. R. Freebairn. Constable followed the pencil sketch fairly closely in one of his rare etchings[3]. In this, he left the spire of the cathedral half-hidden behind the distant trees, but gave rather more emphasis to the fisherman on the bridge and the willow on the right-hand side. For the engraver, he enlarged the tower and spire of the cathedral and added the horse and wagon on the bridge; in the print itself the fisherman and his rod were further modified.

A proof of Freebairn's engraving in the British Museum is inscribed, 'Touched by J. Constable RA 30 April 1836. (first & only time)'. The engraving appeared as the headpiece to an extract from Thomas

Warton's *An Ode to Summer* in the second volume of *The Book of Gems*, ed. S. C. Hall, 1837, p.189. In the list of plates it is given the title 'The English Landscape'.

334 **Hampstead Heath with a Rainbow** d.1836
Oil on canvas, 20 × 30 (50.8 × 76.2)
Possibly inscribed 'J C [...]'; inscribed on verso: 'Painted by John Constable RA for me W: Geo Jennings 1836'
Prov: painted for W. G. Jennings; reacquired by Constable family at an unknown date and bequeathed to the National Gallery by Isabel Constable 1888; transferred to Tate Gallery 1954
Tate Gallery (1275)

As mentioned under No.239, Constable made a large number of paintings showing the view over Branch Hill Pond on Hampstead Heath. This, his final one, was painted for a Hampstead friend, the amateur artist W. George Jennings. 'I have lately turned out one of my best bits of Heath', he told George Constable of Arundel on 16 September 1836, 'so fresh, so bright, dewy & sunshiny, that I preferred to any former effort, at about 2 feet 6, painted for a very old friend – an amateur who well knows how to appreciate it, for I now see that I shall never be able to paint down to ignorance. Almost all the world is ignorant and vulgar' (JCC v p.35). To the usual ingredients of the composition Constable this time added a rainbow with, at its foot, a windmill that never existed at that spot. Was this, perhaps, a nostalgic allusion to his Suffolk childhood?

1837

January: working on proofs of Lucas's large plate of 'Salisbury Cathedral' – 'how I wish I could scratch & tear away at it with your tools on the steel'. *17 February:* at work 'on a beautifull subject, Arundel Mill . . . It is, and shall be, my best picture.' *27th:* sets the male model in the life class at the Academy in the attitude of the assassin in Titian's 'St. Peter Martyr'; continues as Visitor at the Academy Schools each evening until *25 March* when he is responsible for posing the model for the last time at Somerset House; makes a short speech to the students at the end of the evening, after which (we are told) he is most heartily cheered. *30th:* attends meeting of the Directors of the A.G.B.I. and a General Assembly of the Royal Academy. *31st:* works on 'Arundel Mill'; goes out on an errand in connection with the A.G.B.I. Dies that night.

Exhibit (posthumous). R.A.: (193) 'Arundel mill and castle' (No.335).

335 **'Arundel mill and castle'** exh.1837
Oil on canvas, 28½ × 39½ (72.4 × 100.3)
Exh: R.A. 1837 (193)
Prov: 16 May 1838 (81), bt. in by John Charles Constable, who died 1841; sold by his brother Charles Golding Constable to Holbrook Gaskell 1878[1]; his sale, Christie's 24 June 1909(8), bt. Knoedler; Edward Drummond Libbey, Toledo,

1909 and presented by him to Toledo Museum of Art 1925

The Toledo Museum of Art, Toledo, Ohio (Gift of Edward Drummond Libbey)

332

This was the painting Constable was working on at the time of his death. Although not quite finished, it was included in the 1837 R.A. exhibition under a rule allowing a deceased artist's work to be shown at the first exhibition following his death. The 1837 exhibition was the first to be held in the Royal Academy's new building in Trafalgar Square, now the National Gallery.

Constable's two visits to stay with his friend George Constable at Arundel have been mentioned in the entries on Nos.314 and 322. It was upon a drawing made on the second visit in 1835 (No.326) that this painting was based. Constable probably also consulted two drawings in his 1835 sketchbook (pages 33 and 35 of No.322) when painting the picture. On 16 December 1835 he asked George Constable to bring to London 'the sketch I made of your mill – John [Constable's son John Charles] wants me to make a picture of it' (JCC V p.28; see also p.30). The sketch was probably No.326. Constable started the painting with the intention of exhibiting it at the Academy in 1836 but then decided to send 'The Cenotaph' (No.330) instead so that the names of Reynolds and Beaumont could appear once more in the catalogue before the Academy moved from Somerset House to its new quarters. Explaining this to George Constable on 12 May 1836, Constable said that the Arundel picture had been 'prettily laid in as far as chiaroscuro' before he changed his mind (JCC V p.32).

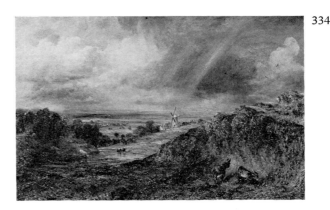

334

The painting was taken up again for the 1837 exhibition. On 17 February that year the artist informed his namesake that he was 'at work on a beautifull subject, Arundel Mill, for which I am indebted to your friendship. It is, and shall be, my best picture – the size, three or four feet. It is safe for the Exhibition, as we have as much as six weeks good' (*ibid.*, p.37). Six weeks to the day after this optimistic prediction he was dead. It is curious that George Constable did not buy the picture at the exhibition. Perhaps he knew that John Charles, who had accompanied his father on both his visits to Arundel, wanted it. It was one of the three paintings Leslie bought in for John Charles at the Executors' sale in 1838.

In 1844 Leslie had to warn Constable's daughters Maria and Isabel against visiting Arundel because of his discovery that George Constable was responsible for a number of Constable forgeries which had been circulating (see JCC V pp.38–9). This is a strange coda to George Constable's undoubtedly genuine friendship with the artist but Leslie's evidence seems incontrovertible.

336 Death Mask of Constable 1837

The Executors of Lt. Col. J. H. Constable

On 31 March 1837, wrote Leslie, Constable 'was busily engaged finishing his picture of Arundel Mill and Castle. One or two of his friends who called on him saw that he was not well, but they attributed this to confinement and anxiety with his picture, which was to go in a few days to the Exhibition. In the evening, he walked out for a short time on a charitable errand connected with the Artists' Benevolent Fund. He returned about nine o'clock, ate a hearty supper, and feeling chilly, had

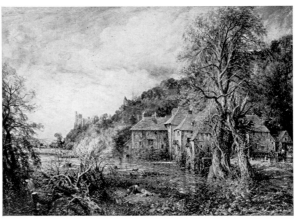

335

336

his bed warmed, a luxury he rarely indulged in. It was his custom to read in bed; between ten and eleven, he had read himself to sleep, and his candle, as usual, was removed by a servant. Soon after this, his eldest son, who had been at the theatre, returned home, and while preparing for bed in the next room, his father awoke in great pain, and called to him. So little was Constable alarmed, however, that he at first refused to send for medical assistance; he took some rhubarb and magnesia, which produced sickness, and he drank copiously of warm water, which occasioned vomiting; but the pain increasing, he desired that Mr Michele, his near neigh-

bour, should be sent for, who very soon attended. In the mean time Constable had fainted, his son supposing he had fallen asleep; Mr Michele instantly ordered some brandy to be brought, the bed room of the patient was at the top of the house, the servant had to run down stairs for it, and before it could be procured, life was extinct; and within half an hour of the first attack of pain' (Leslie 1843 p.113, 1951 pp.265–6). Leslie heard the news next morning. 'On the 1st of April, 1837', he recalled, 'as I was dressing, I saw, from my window, Pitt (a man employed by Constable to carry messages) at the gate. He sent up word that he wished to speak to me, and I ran down expecting one of Constable's amusing notes, or a message from him; but the message was from his children, and to tell me that he had died suddenly the night before. My wife and I were in Charlotte Street as soon as possible. I went up into his bed-room, where he lay, looking as if in a tranquil sleep; his watch, which his hand had so lately wound up, ticking on a table by his side, on which also lay a book he had been reading scarcely an hour before his death. He had died as he lived, surrounded by art, for the walls of the little attic were covered with engravings, and his feet nearly touched a print of the beautiful moonlight by Rubens, belonging to Mr. Rogers. I remained the whole of the day in the house, and the greater part of it in his room, watching the progress of the casts that were made from his face by his neighbour, Mr. Joseph, and by Mr. Davis. I felt his loss far less then than I have since done – than I do even now' (C. R. Leslie, *Autobiographical Recollections*, 1860, I, p.158). In a footnote Leslie identifies the book Constable had been reading as 'a volume of Southey's "Life of Cowper", containing many of the poet's letters'.

Friends and Followers

When Constable died, Leslie was the chief of those friends who rallied round to help sort out his affairs and to protect the interests of his seven children, then aged between nine and twenty. He was, John Martin said, 'careful of the reputation of his deceased friend' (see No.327). This solicitude extended to the buying-in of works on behalf of the children at the 1838 sale to prevent their being knocked down for trifling sums, and the storing of the larger pictures for them when they moved to a smaller house in St. John's Wood. But Leslie's greatest effort to preserve and enhance Constable's reputation was the biography which he immediately embarked on and which appeared in 1843. The image of Constable which he there projected has remained the accepted one almost until the present day. Dissident voices have been heard, for example Redgrave complaining in the 1840s that Leslie had made Constable 'all amiability and goodness' and, more recently, Phoebe Pool's nice observation that Leslie was determined to make him 'a martyr, and a martyr of ineffable mildness'. But only with the publication in the 1960s of Constable's correspondence more or less in its entirety and with the still more recent realisation of the range and complexities of his art, are we beginning to appreciate just how simple Leslie's picture of the man and his work was.

If our image of Constable himself is only now coming into focus, our view of the Constabelian hinterland remains hazy indeed. Those artists whose work, for one reason or another, and in varying degrees, resembles his own have hardly been investigated at all. The landscapes by them which follow in this section can only be pointers to this uncharted territory. A fuller survey would need to identify work by many other people associated with Constable who are known to have painted or drawn: Constable's own wife, Maria, Archdeacon Fisher, Dorothea Fisher, George Constable, Richard Digby Neave, George Harrison, the Revd. T. J. Judkin, George Jennings and William Purton, to name a few.

CHARLES ROBERT LESLIE (1794–1859)

337 John Constable
Oil on canvas, $6\frac{1}{2} \times 4\frac{1}{2}$ (16.5 × 11.5)
Royal Academy of Arts, London
Engraved in mezzotint by David Lucas for the frontispiece to the first edition of Leslie's *Life* of Constable, 1843.

338 C. R. Leslie, 'Memoirs of the Life of John Constable, Esq. R.A. Composed Chiefly of His Letters' 1843
Trustees of the British Museum
An extra-illustrated copy of the first edition of Leslie's *Life*. Facing the title-page is Leslie's original pencil portrait of Constable which R. J. Lane lithographed for the frontispiece to the second edition of 1845.

340

341

342

343

JOHN DUNTHORNE Senior (1770–1844)

339 Flatford Lock d.1814
Oil on panel, 9¼ × 14⅛ (23.5 × 35.9)
Inscribed on verso 'Oct^t 1814 John Dunthorn'
Colchester and Essex Museum

Plumber, glazier, village constable and amateur artist of East Bergholt, the elder Dunthorne was Constable's first tutor in art, their association dating from the 1790s. Little of his work has so far been identified and the precise role he played in Constable's early development is uncertain. The present work was probably painted at the same time that Constable was engaged on 'Boat building' (No.132), a short distance upstream on the other bank of the Stour (see Ian Fleming-Williams, 'John Dunthorne's "Flatford Lock" ', *The Connoisseur*, December 1973). The same ferryman appears in many of Constable's paintings and Dunthorne's version of him is most closely paralleled in 'The Mill Stream' (No.129) which may have been painted at about the same time. No.97 above is an oil sketch by Constable of the same view as No.339.

JOHN DUNTHORNE Junior (1798–1832)

340 Salisbury Cathedral and Archdeacon Fisher's House from across the Avon 1827
Oil on canvas, 21 × 30 (53.3 × 76.2)
Dr D. M. McDonald

The younger Dunthorne, usually known as 'Johnny', became Constable's studio assistant in May 1824 and remained with him until 1829, when he set up as a picture restorer in Grafton Street. He exhibited a landscape each year at the R.A. from 1827 until 1832. Dunthorne's work for Constable included the preparation of replicas of his more successful compositions and he seems to have been responsible for a fair amount of the actual painting of these as well as the initial work of transferring the designs to canvas. He is said to have had a large hand in No.312 above, but the extent of his participation in other repetitions, for example of the Harwich and Yarmouth compositions, has still to be determined.

The present painting of Salisbury Cathedral represents another aspect of his involvement with Constable's art. Although derived from Constable's oil sketch of the subject (National Gallery No.2651), the picture is clearly intended to be a 'Dunthorne' rather than something which would have gone out under Constable's own name. As it descended in the Fisher family (sold by J. P. Fisher, Sotheby's 22 November 1967), the work was presumably bought by Archdeacon Fisher from Dunthorne. Constable referred to the picture in a letter to Fisher on 26 August 1827: 'John Dunthorne has compleated a very pretty picture of your lawn & prebendal house, with the great alder & cathedral' (JCC VI p.232). The figures seated beneath the alder are probably intended to be the Archdeacon and Mrs Fisher. Another instance of Dunthorne making a copy on his own account of one of Constable's compositions is mentioned under No.312 above.

341–6 Constable's Children

Of Constable's seven children, at least five drew and/or painted. Three of them do not concern us here because they were not primarily interested in landscape: John Charles, who made some studies of shipping before his

early death in 1841, Charles Golding, who also drew and painted marine subjects, and Isabel, who was a botanical artist. Alfred Abram and Lionel Bicknell, however, followed more closely in their father's footsteps – at times so closely that their work is mistakable for his own. A selection of their early drawings is shown here. Their later drawings and their works in oil have still to be identified and investigated.

344

345

ALFRED ABRAM CONSTABLE (1826–1853)
341 A Tree at Great Wenham d.1846
Pencil, 9$\frac{1}{16}$ × 5$\frac{7}{16}$ (23.2 × 13.8)
Inscribed 'June th 5. 1846. Gt Wenham' and on verso in another hand 'Alfred'.
The Executors of Lt. Col. J. H. Constable

LIONEL BICKNELL CONSTABLE (1828–1887)
342 A Windmill ?1846
Pencil, 2$\frac{1}{8}$ × 3 (5.4 × 7.6)
Inscribed on verso 'I did this on the spot so it is like that kind of mill. The day Minna [his sister Maria Louisa] named for me to come home was Saturday the 10 Oct. but I will write again if I am going but I think I shall go with Mrs Atkinson.'.
Also inscribed in another hand 'Toby', one of Lionel's pet-names.
The Executors of Lt. Col. J. H. Constable

The message on the back, perhaps addressed to his brother Alfred, gives a clue to the date of the drawing, since the 10th of October fell on a Saturday in 1846 and not again until 1857. Comparison with the drawings which follow suggests that 1846 is the most likely year.

LIONEL BICKNELL CONSTABLE
343 A Harvest Field d.1846
Pencil, 4$\frac{5}{8}$ × 6$\frac{3}{8}$ (11.7 × 16.2)
Inscribed '⟨July⟩ Augt 1846' and on verso in another hand 'Lar', one of Lionel's pet-names
The Executors of Lt. Col. J. H. Constable

LIONEL BICKNELL CONSTABLE
344 A Lane among Trees d.1846
Pencil, 4$\frac{5}{8}$ × 5$\frac{1}{4}$ (11.7 × 13.3)
Inscribed 'Aug 1846'
The Executors of Lt. Col. J. H. Constable

LIONEL BICKNELL CONSTABLE
345 Study of a Tree d.1847
Watercolour, 4$\frac{1}{2}$ × 6$\frac{9}{16}$ (11.4 × 16.7)
Inscribed 'Sept. 1847.' and 'Lar'
The Executors of Lt. Col. J. H. Constable

ALFRED or LIONEL CONSTABLE
346 Trees beside Water d.1849
Pencil, 7$\frac{1}{8}$ × 10$\frac{3}{16}$ (18.1 × 25.9)
Inscribed 'first sketch this year May the 14th afternoon 1849.' and on verso in another hand 'T[i.e. Toby, Lionel's pet-name] or Alfred'
The Executors of Lt. Col. J. H. Constable

FREDERICK WATERS WATTS (1800–1870)
347 Hampstead Heath
Oil on canvas, 11$\frac{3}{4}$ × 15$\frac{1}{2}$ (29.8 × 39.4)
David Barclay
See No.348.

346

347

348

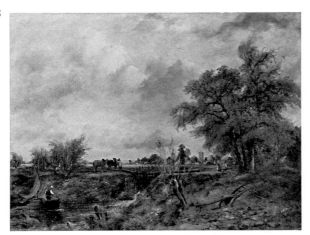

349

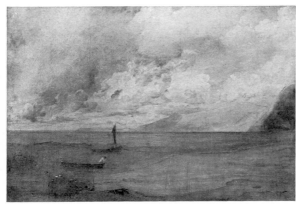

350

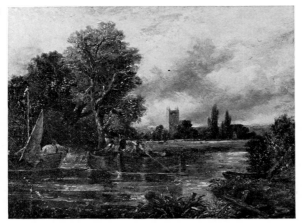

FREDERICK WATERS WATTS (1800–1870)
348 'Vale of Dedham'
Oil on canvas, 28 × 36 (71·1 × 91·5)
Private collection

The confusion of Constable's and Watts's work seems to have begun in Constable's own lifetime. When one of the Helmingham Dell pictures, No.295 above, appeared, uncatalogued, at auction in 1833, 'it was considered Watt's', said Constable, 'and at least not certain, if mine' (JCC V p.164). More usually the confusion has been the other way about. The Hampstead Heath picture shown here, No.347, for many years passed as a Constable and has only recently been recognised as a Watts. In this case, the subject matter may have encouraged the mistake, distant views over Hampstead Heath towards Harrow being, of course, one of Constable's own specialities. Watts apparently lived at Hampstead all his life, though there is no record of him being personally acquainted with Constable. He was certainly familiar, however, with Constable's larger canvases, which he would have seen at the R.A. and B.I., where he was a fellow-exhibitor from the early 1820s. From these, Watts formed a general idea of 'Constable country' which he relayed in his own larger compositions. So successfully did he do this that today many of his pictures are accepted as specific views in Suffolk, and some even as works by Constable himself. No.348 includes several Constabelian motifs and the picture as a whole distantly echoes Constable's lock paintings, for example No.262 above. So far as we know, Watts never actually painted in Suffolk; certainly, none of his exhibits at the R.A. or B.I. bore Suffolk titles.

In a letter recently presented to the Tate Gallery by Mr M. Bernard, Watts, writing from Hampstead in 1859, described his method of work to James P. Ley of Bideford, who had evidently enquired about the subjects of two pictures by Watts in his possession. 'I think from your description of the first picture the Lock scene', Watts wrote, 'that it is composed from Sketches. on the River Itchin between Winchester & Southampton In fact. but few of my Landscapes are. actual views therefore I doubt. if I saw the picture I could give it a place [? it is] no doubt much altered – It is in fact more the character of the Country generally The latter picture I know is composed from Sketches in my possession no actual View In fact. Lee & Creswick paint but seldom real scenes their pictures are generally Composition'.

JOHN CONSTABLE and an UNKNOWN ARTIST
349 Osmington Bay
Oil on canvas, 20⅝ × 29½ (52.4 × 75)
John G. Johnson Collection, Philadelphia
See No.350.

?JOHN CONSTABLE and an UNKNOWN ARTIST
350 View on the Stour near Dedham
Oil on panel, 11¾ × 15½ (29.8 × 39.4)
John G. Johnson Collection, Philadelphia

With Nos.349–50 we begin to move into the darker regions of what was referred to earlier as the Constabelian hinterland. In the first edition of his *Life* Leslie commented on 'the employment of artists to finish pictures left incomplete by their predecessors . . . I

am told some of Constable's sketches have thus been *finished* into worthlessness, and what is a still greater injury to his reputation, entire forgeries have been made of his works. Four of these I have seen, and they are put forth, no doubt, in reliance on the little real knowledge of his style that exists among our connoisseurs' (Leslie 1843 p.122). The situation was getting worse every day. When he came to publish his second edition in 1845, Leslie omitted 'I am told' in reference to the 'finished' sketches – presumably he had now seen some for himself – and had to alter the number of forgeries he had seen from 'Four' to 'Multitudes'. More will be said later about the forgeries. The two pictures shown here seem to belong to the other category Leslie spoke of – unfinished works by Constable worked on or finished by other hands. No.349 clearly began life as another version of the Osmington Bay composition represented in the main part of this exhibition by No.150. The sky certainly appears to be by Constable but it is difficult to feel that he was responsible for the remainder. No.350 may have been begun by Constable and then crudely overpainted and otherwise 'finished' by another hand.

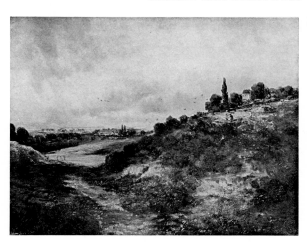

351

UNKNOWN IMITATOR of CONSTABLE
351 Branch Hill Pond, Hampstead
Oil on canvas, $14\frac{1}{16} \times 18$ (35.7 × 45.7)
Ipswich Borough Council
See No.352

UNKNOWN IMITATOR of CONSTABLE
352 Meadow Scene with Trees and Cattle
Oil on paper, $10\frac{1}{4} \times 13\frac{3}{4}$ (26 × 35)
Ipswich Borough Council

Neither of these paintings appears to be by Constable, though both are in his 'manner' and No.351 is of a subject frequently painted by him (see, for example, Nos.239, 254, 334). It is not possible to say that they are forgeries, the intentions of their authors being unknown, but certainly they are imitations of Constable's work.

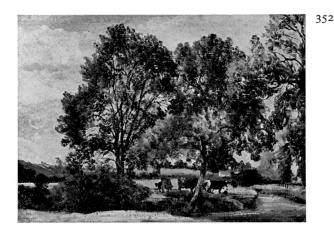

352

As mentioned under No.350, Leslie was very concerned about forged Constables as early as the 1840s. In 1844 he had to warn two of Constable's daughters not to visit George Constable of Arundel, whom he had identified as one of the sources of forgeries appearing on the market (see No.335). There were other sources but so far little work has been done to identify them or to distinguish between their products. Leslie's son Robert continued his father's surveillance, concluding in 1896 that 'from the quantity of works sold and exhibited under the name of Constable, I should not be surprised if the number of forgeries now greatly exceeded that of his genuine pictures' ('Introduction' to Robert Leslie's edition of C. R. Leslie's *Life*). Constable's son Charles Golding was even more watchful and his diaries during the 1860s and 1870s are dotted with references to 'sham Constables' which he had seen in exhibitions or in auctions. In one case, however, he himself was wrong. One of the sixteen fakes he detected at the London International Exhibition of 1874, and which he exposed in a letter ('Borrowed Plumes') to *The Times*, was No.295 above. In reply, its then owner, Colonel Scovell, was able to prove its authenticity by quoting

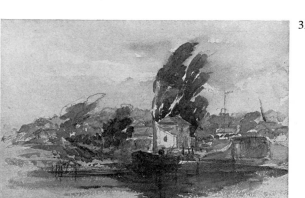

353

354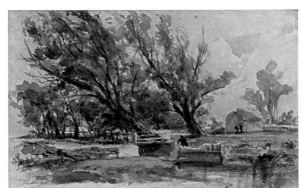

from the letter which Constable had sent to his father about it.

UNKNOWN IMITATOR of CONSTABLE

353 'On the Stour'
Watercolour, $6 \times 9\frac{1}{16}$ (15.3×23)
Inscribed '[. . .] on the Stour 25 [. . .] JC'
Trustees of the British Museum (1910-2-12-237)
See No.354

UNKNOWN IMITATOR of CONSTABLE

354 Landscape with trees, river and haystack
Watercolour, $6 \times 9\frac{1}{16}$ (15.3×23)
Trustees of the British Museum (1910-2-12-235)
Unless the 'JC' inscribed on No.353 refers to quite a different artist, or is a later addition, these two watercolours, which are clearly by the same hand, must be regarded as Constable forgeries. On the whole, it was Constable's oil paintings rather than his drawings and watercolours (in any case, much less well known) that attracted the forgers, the financial gains being obviously much greater.

Supplement

93a **Dedham Vale** *circa* 1810
　　Oil on paper laid on panel, $8\frac{1}{2} \times 12\frac{1}{2}$ (21.5 × 31.8)
　　Stephen Raphael
One of the studies which led up to the 'Dedham Vale:
Morning' of 1811 (No.100), this and other related
sketches are discussed in the entry on that picture.

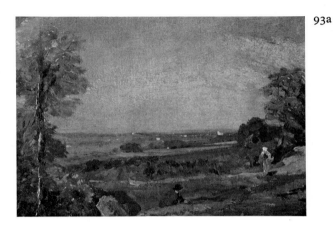

93a

96a **Flatford Lock** *circa* 1810–11
　　Oil on paper laid on canvas, $13\frac{1}{4} \times 14$ (33.7 × 35.5)
　　Private collection
See No.96 for a discussion of the oil studies which
Constable made at Flatford lock around 1810–11.
Larger than the others in this group, No.96a is also
distinguished by a blonder tonality.

125a **Feering Parsonage** d.1814
　　Pen and watercolour, 12 × 15 (30.5 × 38.1)
　　Inscribed 'John Constable. fecit. 1814.'
　　Private collection
An elaborate pencil drawing which Constable made of
Feering parsonage on his stay there in 1814 is men-
tioned under No.125 and reproduced on p.13. It was
presumably the basis of the present drawing, which
is clearly the work for which the Revd. W. W. Driffield
wrote to thank Constable in October 1815: 'it is framed
glazed and hung in my drawing room, in a point of view
to be seen only, exactly as it was taken, But you will see
it, when you favour me with your company, and try if
you can find it a better Birth – you will say I am very
Impertinent in my remarks; But you have not done
Ball justice, after the excursion He took you, and *I*
never Roll my Garden in *Black* Breeches' (JCC I p.129).
The details mentioned – the horse 'Ball' and the vicar
with his roller – do not figure in the original pencil
drawing.

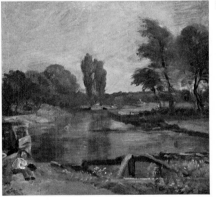

96a

209a **Cloud Study** ?1822
　　Oil on paper, $18\frac{11}{16} \times 22\frac{5}{8}$ (47.5 × 57.5)
　　Inscribed on old backing paper (now separately
　　preserved) '27 augt 11, o clock Noon looking
　　Eastward large silvery [?Clouds] wind Gentle at
　　S. West'.
　　Tate Gallery (6065)

DAVID LUCAS after CONSTABLE
274a **Frontispiece to 'English Landscape': 'East
　　Bergholt, Suffolk'** d.1831
　　Mezzotint (area of subject), $5\frac{1}{2} \times 7\frac{5}{16}$ (14 × 18.6)
　　Private collection
This is the Frontispiece in its first published state.
Although dated 1831, the print was issued with the
fifth and final number in 1832. See No.274 for a trans-
lation of the Latin verses.

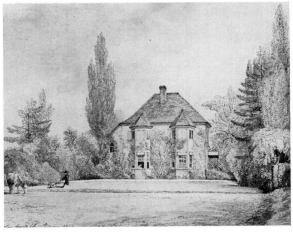

125a

209a

345a

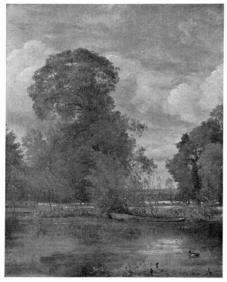

346a

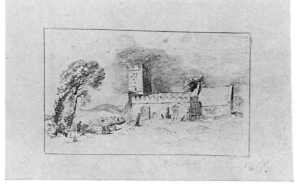

DAVID LUCAS after CONSTABLE

279a 'Summer Evening' d.1831
Mezzotint (area of subject), $5\frac{1}{2} \times 8\frac{1}{2}$ (14 × 21.6)
Private collection

Based on No.103 above, 'Summer Evening' was issued with the third number of *English Landscape* in 1831.

LIONEL BICKNELL CONSTABLE

345a Tottenham Park exh.1850
Oil on canvas, 18 × 14 (45.7 × 35.6)
Exh: R.A. 1850 (630)
The Executors of Lt. Col. J. H. Constable

Although Lionel exhibited thirteen works at the Royal Academy between 1849 and 1855, this is the only painting by him so far identified.

? LIONEL BICKNELL CONSTABLE

345b Sketchbook d.1847
The Executors of Lt. Col. J. H. Constable

The drawings and watercolours in this sketchbook were made in Dorset in 1847, the dates inscribed on some of the pages ranging from 1 August to 24 August. The artist, identified by a more recent member of the family as Lionel, visited some of the places where his father had worked in 1816, including Weymouth Bay, Preston and Osmington.

JOHN FISHER (1788–1832)

346a Sketchbook
Sketchbook of 38 pages, $6\frac{13}{16} \times 10\frac{1}{2}$ (17.3 × 26.7)
Private collection

This sketchbook derives from the Fisher family and contains original drawings by John Fisher as well as copies by him after drawings by Constable. The book opens with a watercolour by Fisher, inscribed 'From drawing room Osmington J F', of one of the views from his vicarage at Osmington, Dorset (see illustration). The copies after Constable are very meticulous and include replicas of the following drawings now in the V. & A.: R.144, Harwich, 1 September 1815; R.148 and R.150, Netley Abbey, October 1816; R.153, Preston Church, 21 November 1816. Fisher's copy of the latter is

346a

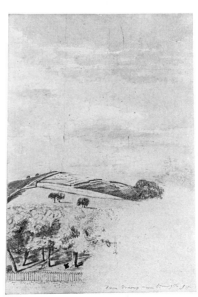

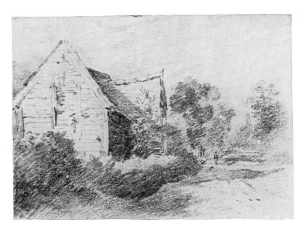

346c

illustrated here. The originals of several other copies after Constable have not yet been identified. A truncated watermark on one of the pages indicates that the sketchbook cannot have been used before 1821.

A similar sketchbook in the possession of Mr David Fisher has recently been identified as the work of John Fisher. Like No.346a, it contains a number of copies after Constable, including some from pages in his 1813 sketchbook and one after No.153 above. The paper in this second Fisher sketchbook is watermarked 1817.

JOHN FISHER after CONSTABLE
346b Landscape with Windmill
Pencil, 3 × 4½ (7.6 × 11.4)
Private collection
A copy of page 75 in Constable's 1814 sketchbook (No. 126 above). This drawing and No.346d were originally mounted in the Fisher sketchbook, No.346a.

JOHN CONSTABLE
346c Barn and Road
Pencil, 3¼ × 4⁵⁄₁₆ (8.3 × 11)
The Executors of Lt. Col. J. H. Constable

JOHN FISHER after CONSTABLE
346d Barn and Road
Pencil, 3¼ × 4½ (8.3 × 11.4)
Private collection
Fisher's copy of No.346c.

355

UNKNOWN IMITATOR of CONSTABLE
355 Flatford Mill
Oil on panel, 11½ × 13¼ (29.2 × 33.7)
The Lord Binning
A nineteenth-century copy of No.151.

UNKNOWN IMITATOR of CONSTABLE
356 The Lock
Oil on canvas, 40 × 50 (101.6 × 127)
Private collection
This is loosely based on No.262.

356

357
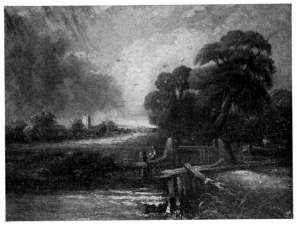

358

359

UNKNOWN IMITATOR of CONSTABLE

357 The Lock
Oil on canvas, 34 × 44 (86.4 × 111.8)
Inscribed 'John. Constable Pin.ᵡ 1832'
D. T. Morgan

Although the format echoes No.262, this imitation takes its main features from Constable's upright 'Lock' compositions, Nos.227 and 312.

FORMERLY ASCRIBED to CONSTABLE

358 'Barnes Common'
Oil on canvas, $9\frac{7}{8} × 13\frac{7}{8}$ (25.1 × 35.2)
Tate Gallery (1066)

See No.359.

FORMERLY ASCRIBED to CONSTABLE

359 Sketch of a Cornfield with Figures
Oil on canvas, $9\frac{3}{4} × 15\frac{7}{8}$ (24.8 × 40.3)
Tate Gallery (1065)

Nos.358 and 359 were purchased by the National Gallery in 1879 and passed as works by Constable until at least 1953, when they were catalogued by the Tate Gallery as examples of his style around 1805 and 1816 respectively. Their actual authors remain to be identified.

The area around East Bergholt, taken from the first edition of the one-inch Ordnance Survey, enlarged to $2\frac{1}{2}$ in : 1 mile ▶

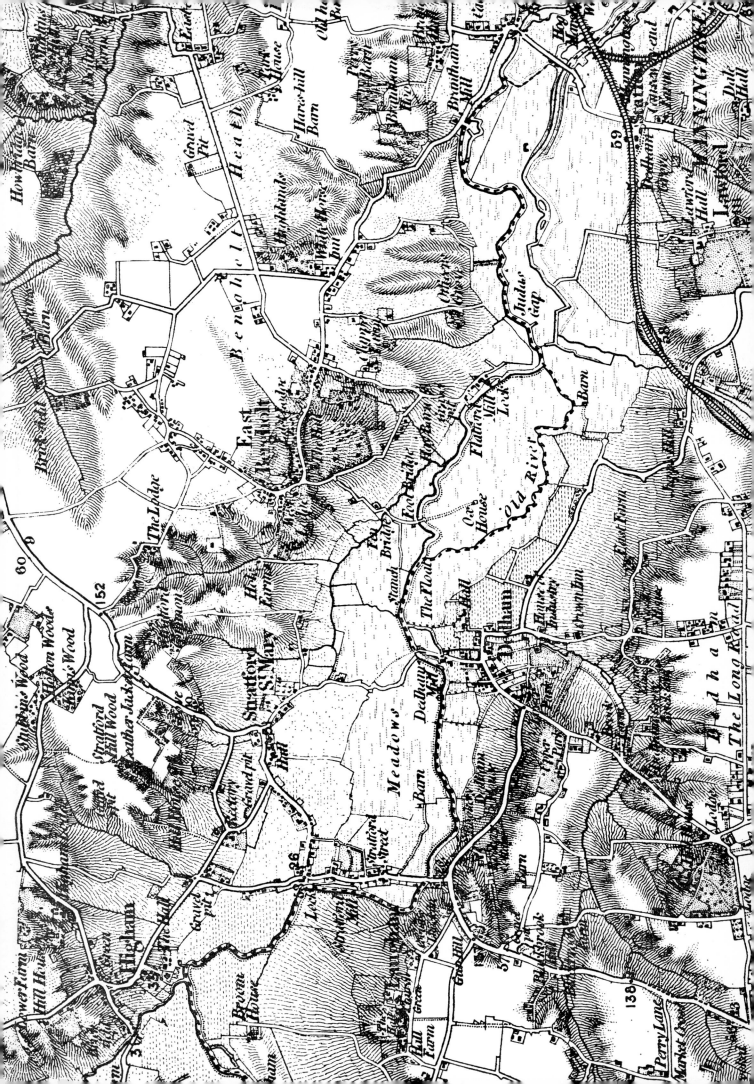

Constable Family Tree
For more comprehensive genealogies of the Constable,
Watts, Bicknell, Rhudde and other related families,
see the appendices to J C C I, II, V, and to J C D.

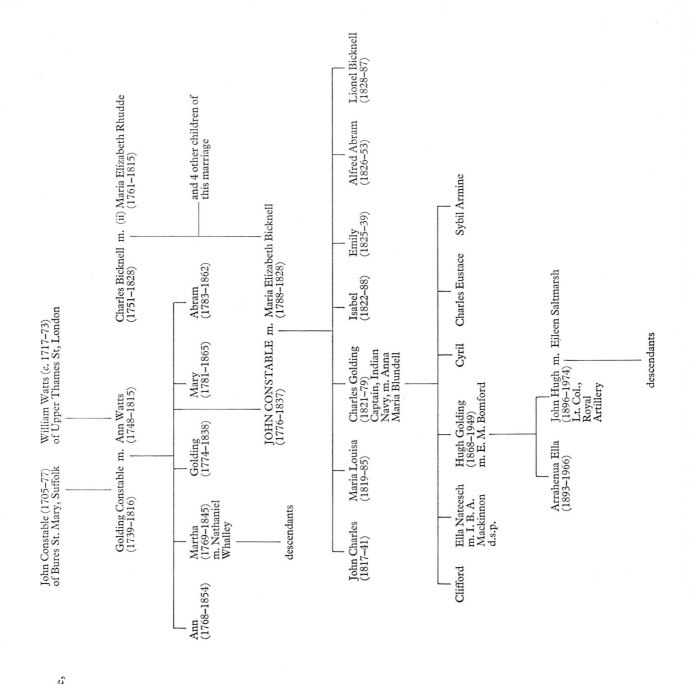

John Constable (1705–77)
of Bures St. Mary, Suffolk

William Watts (c. 1717–73)
of Upper Thames St, London

Charles Bicknell m. (ii) Maria Elizabeth Rhudde
(1751–1828) (1761–1815)

Golding Constable m. Ann Watts
(1739–1816) (1748–1815)

and 4 other children of
this marriage

Ann
(1768–1854)

Martha
(1769–1845)
m. Nathaniel
Whalley

Golding
(1774–1833)

Mary
(1781–1865)

Abram
(1783–1862)

JOHN CONSTABLE m. Maria Elizabeth Bicknell
(1776–1837) (1788–1828)

Isabel
(1822–88)

Emily
(1825–39)

Alfred Abram
(1826–53)

Lionel Bicknell
(1828–87)

descendants

John Charles
(1817–41)

Maria Louisa
(1819–85)

Charles Golding
(1821–79)
Captain, Indian
Navy, m. Anna
Maria Blundell

Cyril

Charles Eustace

Sybil Armine

Clifford

Ella Nateesch
m. I. B. A.
Mackinnon
d.s.p.

Hugh Golding
(1868–1949)
m. E. M. Bomford

John Hugh m. Eileen Saltmarsh
(1896–1974)
Lt. Col.,
Royal
Artillery

Arrahenua Ella
(1893–1966)

descendants

Notes and References

1799

[1] This provenance is given in a document prepared by Miss M. A. Blackburne for Vicars Brothers in 1934. A copy is at the Tate Gallery.

[2] In the document mentioned in note 1.

1800

[1] W. T. Whitley, *Art in England 1800–1820*, 1928, p.82, quoting the *Polytechnic Journal*, 1840. Whitley suggests that the anonymous author of the notes may have been Thomas Douglas Guest (*c.* 1780–1839), the history painter, who is registered on the list of students at the Academy Schools for 3 December 1801 and won a Gold Medal in 1805.

1801

[1] There is a report of his having made a sketching tour of Norfolk in his early youth, but no drawings from this visit have as yet been identified. It could well be argued that Constable's voyage down the Thames to the Downs in 1803 should be counted as a sketching tour: he certainly made enough drawings on that trip.

1802

[1] In his large notebook (National Gallery) Salting indicated that his picture had formerly belonged to Drake. The notebook was begun in October 1900.

1804

[1] The identification of this view was made by Lt. Col. C. A. Brooks.

[2] Freda Constable, *John Constable*, 1975, repr. p.13, as 'East Bergholt House'.

1806

[1] Holmes 1902, repr. facing p.36.

[2] E. V. Lucas, *Charles Lamb and the Lloyds*, 1898, repr. facing p.237.

1809

[1] The picture is referred to in the Anderdon catalogues at the Royal Academy and the British Museum (see Martin Davies, *National Gallery Catalogues, The British School*, 2nd ed. 1959, pp.23–4); the inscription on the stretcher is thought also to be in Anderdon's hand. In his catalogues Anderdon said that he had had the picture relined, and the inscription on the stretcher gives 1840 as the date of the relining.

[2] Sir Martin Davies (*op. cit.*) and, following him, R. B. Beckett ('Constable at Malvern Hall', *Connoisseur Year Book*, 1959) questioned the date in this inscription and Beckett, at least, sought to associate the picture with Constable's later visit to Malvern Hall. Although the last two digits of the date are, as Davies said, on top of an inky mess, they are nevertheless perfectly clear and show no sign of having been altered. The style of the painting seems completely in accordance with Constable's other work of and around 1809. If the picture was painted at Malvern Hall itself, 1809 would, in any case, be the only possible year, since Constable's only other recorded visit, in 1820, did not begin until September and the date given on the stretcher is 1 August.

[3] See JCC IV p.62 and the booklet *Malvern Hall* published by Malvern Hall school in 1974.

1810

[1] According to Ackermann's *Repository of Arts*, III, 1810, p.367, this was 'a fresh and spirited view of an enclosed fishpond'. From Farington's diary (10 July 1810) we learn that it was a 'kitcat', i.e. measured 28 × 36 inches, and was bought by the Earl of Dysart for 30 guineas.

1811

[1] The catalogue entry identifies the work offered for sale with the original of Lucas's engraving 'Summer Evening', i.e. No.103 in this exhibition. When it entered the V. & A. in 1888 No.103 was given the accession number 585. The following item in the 1869 sale, lot 105, is also in the V. & A. (R.252, 'View of Lower Terrace, Hampstead'). It entered the Museum in the same batch in 1888 and was given the number 584. Both pictures were bought in (by 'Bourne') at the 1869 sale and presumably stayed together until transferred to the V. & A.

[2] Until 1818 Lewis spelt his second name without the final 'e', which he seems to have added while researching his Norman ancestors.

[3] Reproduced in *Malvern Hall*, a booklet published by Malvern Hall school in 1974. This contains much useful information about the building and the Greswold family. The portrait in question was at Malvern Hall in 1974 but has since gone to Somerville College.

1813

[1] R. B. Beckett, 'Constable and Hogarth', *The Art Quarterly*, XXIX, 1966, pp.107–10. Beckett believed that the 'large picture' of Western was No.122 and that the earlier references in the correspondence were to a different version of the portrait. The correspondence does not, however, seem to support this interpretation. Judging from a photograph, the miniature portrait of Western lent to the Tate Gallery Constable exhibition in 1937 and mentioned by Beckett in this article, is not in fact by Constable.

1814

[1] The price is marked in the copy of the catalogue in the Liverpool Public Library.

[2] For further details of the agricultural activities depicted in this study and in the final picture, see Ian Fleming-Williams, 'A Runover Dungle and a Possible Date for "Spring" ', *Burlington Magazine*, CXIV, 1972, pp.386–93.

[3] As the organisers have not been able to see Lord Forteviot's painting, no further comment on it is made here.

[4] By Professor Charles Rhyne who first published the work in 'Fresh Light on John Constable', *Apollo*, LXXXVII, 1968, pp.229–30.

[5] The sale stencil is on the back, as is a label dating from Ella Constable's ownership which gives the title as in the sale catalogue. The other work in the sale with the same title, lot 133, was bought by Gooden, whereas No.131 is known to have descended through the Colquhoun family and must therefore be the work that was bought in.

1815

[1] Ian Fleming-Williams, 'John Dunthorne's "Flatford Lock" ', *The Connoisseur*, Vol.184, 1973, pp.290–1.

1817

[1] There are a number of other references in the correspondence to a large landscape around this time, but they occur between October 1815 and January 1816, i.e. a year before Constable is known to have been working on 'Flatford Mill'. Writing to Maria from East Bergholt on 19 October 1815, for example, he said he had 'put rather a larger landscape on hand than ever I did before and this it is my wish to secure in great measure before I leave this place' (JCC II p.156). Constable showed the painting to his dying father on 19 January 1816 (*ibid.*, p.169; see also pp.159, 163), after which it dropped out of the correspondence. His only exhibits in 1816 were 'The wheat field' and 'A wood: Autumn', both sent to the R.A. The former is likely to have been re-exhibited at the B.I. the following year as 'A Harvest Field: Reapers, Gleaners', the framed size of which was given as 33 × 42 inches. There may be a large picture of 'A wood' still to be discovered, but it is conceivable that 'Flatford Mill' was the work Constable showed to his father in January 1816. Two difficulties stand in the way of this identification, however: the picture Constable was working on at the end of 1815 was rather larger, he said, than any he had previously painted, yet 'Flatford Mill' is more or less the same size as 'Boys fishing' (see No.118) and actually smaller (at least, in one dimension) than the five-foot canvas of Borrowdale which he showed to Farington in 1809; in addition, Constable would presumably not have shown the picture to his father unless it was fairly well advanced, whereas 'Flatford Mill' seems not to have reached any degree of finish by September 1816 – on the 19th of that month he said he was 'now in the midst' of the picture that is assumed to have been 'Flatford Mill'.

1819

[1,2] A letter from C. R. Leslie to Maria Constable of 19 January 1841 (Constable Archive) includes quotations from Constable's letter to Fisher of 23 October 1821, sent because they 'may perhaps be interesting to Miss Spedding as they shew what were the feelings with which he painted such pictures as the one she possesses, which represents, as you have probably mentioned to her, Dedham Mill on the river Stour'. Leslie goes on to say that Constable's letter, which is the famous one about 'Old rotten Banks, slimy posts' etc., was written in 1821, 'the year after Miss Spedding's picture was painted'. A reference at the end of the letter suggests that Miss Spedding had only just become the possessor of the picture: 'I hope soon to hear from you that Miss Spedding has received the picture in safety'.

[3] Louis Hawes, 'Constable's Sky Sketches', *Journal of the Warburg and Courtauld Institutes*, XXXII, 1969, p.352, plate 53c–d.

[4] This provenance is given by Beckett in his catalogue of the 1956 Constable exhibition at Manchester, which supplies the same history for David Lucas's annotated copy of Leslie's *Life* (see JC: FDC p.53), also owned by Beckett at the time. The Lucas 'Leslie' has a stamped inscription on the cover indicating that it was purchased from Alfred Lucas in 1885: possibly No.173 was also acquired by Leggatt at this time.

[5] The verses were identified by Michael Rosenthal in 1973.

1820

[1] In a letter of 29 October 1887 to the then Director of the National Gallery, Sir Frederick Burton (National Gallery Archives).

[2] Conal Shields and Leslie Parris, *John Constable*, Tate Gallery, 1969 and 1973, p.12.

1821

[1] Information communicated by Paul Joannides to the National Gallery 1973. Constable's picture does not appear in the printed text of the catalogue but is entered by hand at the end of the British Museum copy. Boursault paid 2300 francs for the work.

[2] It is interesting to note that an English translation of this work appeared the following year.

[3] Ed. André Joubin, *Correspondance Générale d'Eugène Delacroix*, IV, 1938, p.60.

1822

[1] Leslie (1845 p.100, 1951 p.92) calls it 'A View of the Terrace, Hampstead'. We do not know whether his alteration of the title was a correction or a mistake. If Constable exhibited a view *from* the Terrace, it might have been a picture of the Admiral's House. If Leslie was correct and the picture was a view *of* the Terrace, it might have been the painting of this subject which is now in the V. & A. (R.252).

[2] With Andrew Shirley's papers. A copy is at the Tate Gallery.

1823

[1] According to notes (still with the picture) made before the sale by Osbert Cundy, presumably a relative of the Cundy who purchased the picture at the sale, the Mr Young in question was George Young, who is identified in further notes made by T. S. Cooper, a later owner, as a brother of the F. W. Young whose representatives sold the work in 1857.

[2] Presumably an error for 46 × 57 inches, which would allow for a frame 5¾–6½ inches wide. No known version of the picture corresponds with the measurements as given in the catalogue or even the proportions they indicate.

[3] Not the 'Hagar', Constable's copy of which was the preceding lot in this sale.

1824

[1] The sketch of a boat being beached which is mentioned in the entries on Nos.232 and 247 has a label on the back saying that it is from Isabel Constable's collection and giving the title 'A coast scene with fishing boat'. The title enables it to be identified with lot 254 in Isabel's sale on 17 June 1892. It had presumably been shown as No.276 in the Grosvenor Gallery exhibition of 1889 ('Beaching the Boat', 9½ × 11½ inches). Lot 255 in the 1892 sale, which we suggest may have been the Dunedin picture, had probably also appeared in the 1889 exhibition, the most likely item being No.248 ('Study of Boats', 9½ × 11½ inches).

[2] The full-size sketches for 'The Hay Wain' and 'The Leaping Horse' are known to have been together since at least the time when Henry Vaughan saw them at Leslie's house, probably in the 1850s. We also know that Leslie was not their owner but was storing them on behalf of the Constable family (see Reynolds 1973, pp.136–7). If they were in the 1838 sale at all, they must therefore have been bought in for the family. The only item in the sale catalogue specifically described as a 'Leaping Horse' picture was lot 35, 'River Scene and Horse Jumping', but this was bought by Samuel Archbutt and could not have been the sketch that remained with the family (it seems, in fact, to have been the finished painting of the subject, No.238). The 'pictures now in France' referred to under lot 38 would have been 'The Hay Wain' and 'View on the Stour', the only compositions at that time in France for which sketches are known. However, a 'Sketch for the picture, View on the Stour' had already figured in the sale as part of lot 36, and it has reasonably been supposed that the reference to *both* sketches in lot 38 having been made for 'pictures now in France' was a mistake, and that one of them was actually the 'Leaping Horse' sketch, No.236. Holmes (1902 p.232) reports that the two sketches in lot 38 'are said [by whom he does not indicate] to have

been the two large studies for "The Hay Wain" and "The Leaping Horse" '.

1825

[1] In his Typescript Catalogue Beckett says that the word is clearly written so, i.e. 'elibray'. Perhaps this was a variant of 'Eelery', which the O.E.D. defines as a place where eels are caught. It was customary to lay eel-traps by weirs and sluices.

[2] 'I should repeat to you an opinion I have long held; that no man had ever more than one conception: Milton emptied his mind in his first book of the P[aradise] L[ost], all the rest is transcript of self. The Odyssey is a repetition of the Iliad. When you have seen one Claude you have seen them all. I can think of no exception to this observation but Shakespeare: he is always various; however mannered' (JCC VI p.135).

[3] David Lucas, Constable's engraver, added the following in the margin of his copy of the first edition of Leslie's *Life*: 'This is a mistake on one occasion whilst painting from nature his fathers barge man came up to overlook his young master John. and found fault with his puting housings on a towing horse when he had to explain to his satisfaction that the object in doing so was that he might have the oppertunity of introducing the bright red colour of the fringe as an contrasting one in opposition to the greens.' (JC: FDC p.58).

[4] 'Study of a Willow', pencil, $3\frac{1}{2} \times 4\frac{1}{2}$ (8.9 × 11.4). Other works related to 'The Leaping Horse' include: a. an oil sketch on panel, $6\frac{13}{16} \times 9$ (17 × 22.8), Tate Gallery No.T.1240, repr. Conal Shields and Leslie Parris, *John Constable*, Tate Gallery, 1973, pl.19; b. an oil sketch on canvas, $19 \times 25\frac{1}{4}$ (48.3 × 64.1), formerly in the collection of Sir Evan Charteris, repr. Charles Johnson, *The Growth of Twelve Masterpieces*, 1947, pl.46; c. a copy of the full-size sketch (No.236) made by Robert Leslie, son of Constable's biographer, when the canvas was temporarily stored at his father's house, repr. Leslie 1896, facing p.175.

[5] The sale stencil is still on the picture. Another version of the composition was in the same sale, as lot 10, but the painting now at Virginia was definitely lot 8, as comparison with the reproduction in the sale catalogue shows. Lot 10 is the work now in the Reinhart Collection, which has several small variations. We can also be certain that lot 8, and not lot 10, was the Darby version. In the Beckett Papers at the Tate Gallery is a copy of a letter from Lockett Agnew of 10 May 1917 which identifies lots 8 and 9 in the Beecham sale as the pair which Agnew's had earlier purchased from Darby's son.

1826

[1,2] In a note to Dominic Colnaghi about the picture to be sent to the 1827 Salon Constable twice referred to the work as 'large' and gave the price as 200 guineas (JCC IV p.156). As Beckett points out (*ibid.*, pp.156–7), the only large landscape available at this time which could be called 'Paysage avec figures et animaux' is No.242. The picture shown at Birmingham in 1829 was called 'Noon', which corresponds with the title given to No.242 when exhibited at the B.I. in 1827. The description in *Aris' Birmingham Gazette* for 9 November 1829 also tallies with No.242 and the same account mentions that the picture had been shown in Paris.

[3] A detailed account in *Berrow's Worcester Journal* for 23 July 1835 (quoted in Windsor 1903, pp.126–7) confirms the identity of this exhibit with No.242.

[4] *The Art-Journal*, 1869, p.118.

[5] Reproduced on the title page of the catalogue of the Tate Gallery exhibition *Constable: The Art of Nature*, 1971. See also JC: FDC pp.45–6.

1827

[1] This exhibit has been taken to be the 'Branch Hill Pond' now in the Cleveland Museum of Art, which measures $23\frac{7}{8} \times 30\frac{11}{16}$. The Cleveland picture can fairly certainly be traced back to

Henry Hebbert. Hebbert had originally an option on the two Hampstead views which Constable exhibited at the R.A. in 1825 and which in the event were bought by Francis Darby (see No.239). He did not however take back the deposit he had paid: 'he would not have his forty back', Constable told Maria on 3 September 1825, 'but made me promise him one of my best pictures for it, for the ensuing exhibition' (JCC II p.382). From Constable's letter to Fisher of 10 September that year it is apparent that Hebbert had actually ordered *two* new pictures (JCC VI p.205). These he seems to have received more than two years later. On 19 November 1828 Constable wrote to Hebbert, who was clearly not satisfied with his acquisitions: 'I have never from the first to the last, ceased to regret for both our sakes that I ever engaged in these pictures. Your declining the first pair [the two Darby bought] and writing to me to find another customer ought to have been a sufficient proof to me, that they were not exactly such articles as you desired' (JCC IV p.101). In the same letter Constable said that he thought Hebbert's pictures were larger than Darby's – 31 inches wide as against 30, and also higher. If the Cleveland painting was one of the works in question, some explanation is needed for it being (at least now) slightly smaller, not larger, than the Darby pictures. This apart, the identification of the Cleveland work with No.290 in the 1827 exhibition is by no means straightforward. In September 1825 Constable had promised Hebbert a picture from 'the ensuing exhibition'. The work in question may well have not been ready for the 1826 show and may have appeared instead in 1827, but, if so, Hebbert seems to have had to wait rather a long time – until about November 1828 – to take delivery of it; either that or he was very slow to voice the complaints to which Constable replied that month. There seems also to be no reason why the other picture made for Hebbert (and presumably returned, since only the Cleveland painting appeared in his son's sale in 1894) should not have been the 1827 exhibit. Since the almost identical 'Branch Hill Pond' in the V. & A. (R.301) was, more or less certainly, exhibited at the R.A. in 1828 (see No.254), it has also to be asked whether Constable is likely, or would have even been allowed, to show virtually the same picture in successive exhibitions.

[2] The account in *Berrow's Worcester Journal* for 23 July 1835 (quoted in Windsor 1903, p.128) mentions the men grinding their scythes, a detail which does not appear in any of the other versions.

1828

[1] Leslie (1843 p.61, 1951 p.166) identifies as a view of Dedham Vale the 'large upright landscape' which Constable said (JCC VI p.236) he exhibited. The 1838 sale catalogue supplies the further information that the exhibited painting included gipsies in the foreground – they appear only in No.253. If Nos.253 and 254 were exhibited at the 1828 R.A. in the order indicated by the numbering on Constable's labels on their backs, No.253 would have been No.7 in the exhibition and No.254 would have been No.232.

1829

[1] Described by Constable as 'a rich cottage' (JCC VI p.244).

[2] *New Monthly Magazine*, 1829, p.158: 'We are glad to see the four magic letters SOLD in the corner of No.38' (quoted from the Whitley Papers, British Museum).

1830

[1] *The Morning Post* mentioned London being visible in the distance, so this was clearly a Hampstead Heath picture. Beckett (Typescript Catalogue) identified it with a work sold from the collection of J. Stewart Hodgson in 1893, which seems to have been the 'Hampstead Heath' sold from Captain Constable's collection on 11 July 1887 (68, bt. Stewart), when it was said to be dated 1830 and to have been exhibited at the 1862 International Exhibition; in the latter its size was given as 26 × 39 inches.

1831

[1] Reproduced: Graham Reynolds, *Constable; the Natural Painter*, 1965, pl.66.

1832

[1] Sometimes identified with a picture now in the collection of Mr and Mrs Paul Mellon (repr. Leslie 1937, pl.137, when in the Harmsworth collection) or with a similar work formerly belonging to Lord Clark.

[2] *The Morning Post* described this, as well as Nos.147 and 152 in the R.A. exhibition, as a small oil-painting of Hampstead.

[3] C. R. Leslie, *Autobiographical Recollections*, 1860, I, pp. 202–3.

[4] By Denys Sutton in 'Constable's "Whitehall Stairs" ', *The Connoisseur*, CXXXVI, 1955, pp.249–55. This is the only detailed account so far published of the composition.

1833

[1] This is Constable's title (see JC: FDC pp.327–8) rather than the one given in the Brussels catalogue, which the organisers have not been able to consult.

[2] Identified by *The Morning Chronicle* (7 Oct.) and *The Morning Post* (14 Nov.) as 'A Wood'.

[3] R. B. Beckett, 'Constable as Illustrator', *The Connoisseur*, CXXXIV, 1954, pp.79–84.

[4] Charles Rhyne, 'Fresh Light on John Constable', *Apollo*, LXXXVII, 1968, p.230, n.11.

1834

[1] See, for example, JC: FDC plate 9a and Ian Fleming-Williams, *Constable Landscape Drawings and Watercolours*, 1976, fig.81.

1835

[1] See Leslie Parris, *Landscape in Britain c. 1750–1850*, Tate Gallery 1973, p.98, for a more detailed discussion of the tree drawings used in this composition, and in particular of V. & A., R.163.

1836

[1] Courtauld Institute, Witt Collection No.993, V. & A., R.396, and British Museum, L.B.22a. All are illustrated in Louis Hawes, *Constable's Stonehenge*, H.M.S.O. 1975, where contemporary portrayals of Stonehenge in art and literature are examined at some length.

[2] $4\frac{5}{16} \times 6\frac{5}{16}$ inches, repr. Freda Constable, *John Constable*, 1975, p.142.

[3] Reproduced: Freda Constable, *op. cit.*, p.143, and Leslie 1937, pl.35a.

1837

[1] An entry in C. G. Constable's diary (Constable Archive) for 10 May 1878 reads: 'M.r Gaskell came to lunch . . . He gave me a cheque for £2200 . . . he took away Arundel Mill on the top of a cab'.

Additional Notes

No.65

Daphne Foskett has very reasonably suggested that this drawing was made at Brathay Hall during Constable's visit to the Lake District in 1806, and that it depicts Mr Worgan at the piano attended by Jessy Harden and Richard and Anne Shannon. John Harden's drawing of the same group, with the addition of Constable himself, is reproduced in Mrs Foskett's monograph *John Harden of Brathay Hall 1772–1847* (Abbot Hall Art Gallery, Kendal 1974), pl.VII, No.24.

No.79

Two people with local knowledge, Mr P. J. Chesmore and Mr Alastair Ross, have kindly written (independently) to confirm the identification of the highest peak in the distance as Causey Pike. Both suggest that Constable took his view from the slopes of Skiddaw. The lake at the right would therefore seem to be Bassenthwaite.

No.80

Mr Chesmore (see the above note) writes: 'The peak on the left is a poor but probable Bowfell & the crag is Gimmer Crag, an outlier of the Langdale Pikes'.

No.141

The glint of blue below the trees at the left may represent the brook known as the Ryber, which ran through the Constables' property at East Bergholt. Near the Rectory it passed through a deep little valley (seen in No.121) and was flanked on the west by a group of houses and out-buildings. Their roofs and smoking chimneys can be seen in the detail of No.135 reproduced opposite p.65. It is most likely these buildings that we see in No.141, and, if this is the case, the men at work here were in the Constables' employ.

No.182

The similarity of this drawing to V. & A., R.106-108 suggests that it may have been made in 1811 rather than 1820 as stated in the catalogue entry.

No.211

A monument of 1821 by Chantrey to the Countess of Ilchester, at Melbury Sampford, Dorset, indicates that the sculptor was working for the family at this time.

No.232

The title quoted from the 1892 sale catalogue in the provenance section of this entry appears on a label on the verso of the picture, leaving little doubt that it was lot 255 in the sale.

No.238

Lt. Col. Brooks identifies the viewpoint Constable had in mind when making the two compositional drawings for 'The Leaping Horse' as the place where the old river channel leaves the Stour, taking the county boundary with it (Alistair Smart and Attfield Brooks, *Constable and his country*, 1976, p.139). If this is correct, then, as Brooks so nicely puts it, the horse 'is leaping out of Essex into Suffolk' (*ibid.*, p.105).

Lenders

Private Collections

Thos. Agnew & Sons Ltd 90
Anonymous VI, 7, 8, 11, 12, 13, 14, 15, 25, 27, 36, 44, 46, 49, 74, 75, 77, 78, 91, 96, 107, 108, 116, 120, 123, 130, 131, 137, 141, 147, 157, 165, 166, 175, 177, 182, 193, 195, 213, 214, 230, 286, 293, 296, 302, 327, 348
Lord Ashton of Hyde 282
David Barclay 347
John Baskett Ltd 315
Lord Binning 35, 95
Miss Camilla Binny 16
Clonterbrook Trustees 21
Executors of Lt. Col. J. H. Constable I, III, IV, 23, 58, 80, 84, 86, 167, 237, 275, 276, 279, 307, 308, 309, 310, 336, 341–6
Richard Constable 161, 184
Harold A. E. Day 17
Downing College, Cambridge 26
East Bergholt Parish Church 24
Feering Church 212
Jane Findlater 122

Mr and Mrs D. M. Freudenthal 153
Mr and Mrs Tom Girtin 68
A. L. Gordon 169–172
Major General E. H. Goulburn 312
Trustees of the will of H. G. Howe (deceased) 292
Mr and Mrs W. Katz 37, 273
Dr D. M. McDonald 340
Dr J. W. B. Matthews 211
Mr and Mrs Paul Mellon 9, 18, 34, 52, 54, 121, 178, 240, 243, 263
Trustees of Walter Morrison Pictures Settlement 227
Ivor Moubray-Phillips 81
Denys Oppé 42
Major Sir Richard Proby, Bt. 100
Dr Roy Pryce 1
Royal Holloway College 201
St. Michael's Church, Brantham 56
Stanhope Shelton 39
Paul Steiner 82
Sir John and Lady Witt 162

Public Collections

Bath, Victoria Art Gallery 264
Bedford, Cecil Higgins Art Gallery 306
Berlin, Nationalgalerie 43
Birmingham, City Museum and Art Gallery 110
Boston, Massachusetts, Museum of Fine Arts 133, 149
Cambridge, Fitzwilliam Museum 51, 69, 83, 152, 159, 160, 187, 266, 274, 277, 278, 280, 281
Cambridge, Massachusetts, Fogg Art Museum 224
Colchester and Essex Museum 85, 339
Colchester, Victor Batte-Lay Trust 2, 3
Copenhagen, Royal Museum of Fine Arts 28, 114
Dublin, Municipal Gallery of Modern Art 189
Dublin, National Gallery of Ireland 50, 249, 268
Dunedin, New Zealand, Public Art Gallery 232
Edinburgh, National Gallery of Scotland 253
Enfield, Forty Hall Museum 6
Florence, Fondazione Horne 89, 117
Hartford, Connecticut, Wadsworth Atheneum 150
Ipswich Borough Council V, 19, 129, 134, 135, 144, 351, 352
Ipswich, Suffolk Record Office VIII
Leeds, City Art Galleries 76, 127

London, British Museum 59, 63, 64, 65, 66, 70, 168, 183, 217, 218, 219, 229, 234, 235, 248, 257, 258, 259, 260, 271, 272, 283, 287, 294, 298, 299, 303, 304, 316, 324, 325, 338, 353, 354
London, Courtauld Institute of Art 62, 109, 115, 155, 191, 210, 241
London, National Gallery 192, 242, 330
London, National Portrait Gallery 11, 285a
London, National Trust (Anglesey Abbey) 20, 118
London, Royal Academy of Arts 94, 97, 176, 194, 196, 197, 233, 238, 262, 337
London, Tate Gallery VII, 87, 88, 99, 113, 143, 151, 173, 179, 186, 206, 215, 221, 244, 247, 261, 320, 321, 334
London, Victoria and Albert Museum 4, 5, 10, 31, 32, 33, 38, 40, 45, 47, 48, 53, 55, 57, 60, 71, 72, 73, 98, 102, 103, 104, 111, 119, 126, 128, 132, 136, 154, 156, 163, 164, 174, 180, 181, 185, 188, 190, 198, 199, 200, 203, 208, 216, 220, 222, 225, 226, 228, 231, 236, 245, 246, 250, 251, 252, 254, 255, 256, 265, 267, 269, 270, 284, 285, 289, 290, 291, 297, 300, 301, 305, 311, 313, 314, 317, 318, 319, 322, 323, 326, 328, 331, 332
Manchester, Whitworth Art Gallery 22, 29, 125, 148

Melbourne, National Gallery of Victoria 146
New York, Metropolitan Museum of Art 158
Oldham, Metropolitan Borough 105, 106
Oxford, Ashmolean Museum 112, 209
Paris, Musée du Louvre 61, 67, 124, 139, 140
Philadelphia, John G. Johnson Collection 92, 93, 138, 204, 295, 349, 350
Port Sunlight, Lady Lever Art Gallery 101, 329

Rhode Island, School of Design 30
Southend-on-Sea, Beecroft Art Gallery 41
Sydney, Art Gallery of New South Wales 223
Toledo, Museum of Art 335
Truro, Royal Institution of Cornwall 142, 145
Virginia, Museum of Fine Arts 239
Williamstown, Massachusetts, Sterling and Francine Clark Art Institute 202

Acknowledgements

As well as those people mentioned in the Foreword, we should like to thank the following most warmly for the help and advice they have given during the preparation of the exhibition and the catalogue: Sir Geoffrey Agnew, C. F. Alsop, John Baskett, T. S. Bathurst, David Baxter, Patricia Butler, Malcolm Cormack, H. A. E. Day, H. K. Greenhalgh, Eric Harding, John Harris, Louis Hawes, Robert Hoozee, Mrs Paul Jennings, Evelyn Joll, Hugh Leggatt, C. Derek Lockett, Rosemary Miles, B. Mollo, David Posnett, John Quilter, Anthony Reed, Stephen Rees-Jones, Duncan Robinson, Michael Rosenthal, W. R. Serjeant, Dudley Snelgrove, Stephen Somerville, John Sunderland, Reginald Williams, Andrew Wilton, Peter Young; and, not least, the following members of the Tate Gallery staff: Corinne Bellow, Michael Duffett, Mrs Elliott, David Lambert, Matthew Lees (and 'the working party'), David Nye, Caroline Odgers, Ruby Stoltenhoff, and, of course, the staff of the Conservation Department.

L.P.
I.F-W.
C.S.